Women and Politics in the
Age of the Democratic Revolution

Women and Politics in the Age of the Democratic Revolution

Edited by
Harriet B. Applewhite and
Darline G. Levy

Ann Arbor
THE UNIVERSITY OF MICHIGAN PRESS

First paperback edition 1993
Copyright © by the University of Michigan 1990
All rights reserved
Published in the United States of America by
The University of Michigan Press
Manufactured in the United States of America

1993 4 3 2

Library of Congress Cataloging-in-Publication Data

Women and politics in the age of the democratic revolution / edited by
 Harriet B. Applewhite and Darline G. Levy.
 p. cm.
 Includes bibliographical references.
 ISBN 0-472-09413-0 (cloth) — ISBN 0-472-06413-4 (paper)
 1. Women in politics—Europe—History—18th century. 2. Women in
politics—United States—History—18th century. 3. Revolutions—
Europe—History—18th century. 4. Revolutions—United States—
History—18th century. I. Applewhite, Harriet Branson. II. Levy,
Darline Gay, 1939– .
HQ1236.5.E85w64 1990
320′.082—dc20 90-10738
 CIP

Acknowledgments

We wish to thank several individuals and organizations for essential support as we brought this project to completion. The book originated from discussions at an international workshop entitled "Insurrectionary Women in the Age of the Democratic Revolution," which was held at New York University in May, 1983. The Humanities Council of New York University and the Council for European Studies at Columbia University awarded us grants for that initial meeting. We are grateful to the Women's History Committee, New York University, for its support and to Nicholas Wahl, Director of the Institute of French Studies, New York University, who generously offered us the use of the institute's facilities for our sessions. We learned much from the contributions of several scholars at the workshop. Joan Wallach Scott offered insightful comments on general questions about women and insurrection, and Robert Barrie Rose illuminated the roles of women in local politics in Paris.

A conference grant from the Rockefeller Foundation made it possible for us to carry our project into a second stage and to organize an international conference entitled "Gender and Political Culture in the Age of the Democratic Revolution." We want to thank Charles Tilly and Louise A. Tilly for their most helpful suggestions about the organization of this second stage. The conference took place between July 29 and August 3, 1985, at the Rockefeller Foundation's Bellagio Study and Conference Center in Bellagio, Italy. We are particularly grateful to Susan Gardner of the Rockefeller Foundation for expertly attending to the complicated arrangements that brought many of us together in an ideal setting for the formal and informal exchange of ideas.

We would like to acknowledge our debt to Olwen Hufton, Vivian Cameron, and Marianne Elliott, who attended the conference but did not submit papers for this volume. All of them made valuable contributions to discussions.

Claire McCurdy acted as our administrative assistant for the Bellagio conference and produced a transcript that greatly facilitated our discussions with participants about revised versions of their papers for this anthology. Ms. McCurdy's knowledge of the field, her

energy, and her organizational and diplomatic skills contributed much to the success of our meeting and the preparation of the texts for publication.

The international conference was a crucial stage in the production of this volume; it provided the basis for the full reworking of papers for publication.

We wish to thank the Southern Foundation and Dr. J. Philip Smith, Dean of Arts and Sciences, Southern Connecticut State University; and the Office of the Dean of the Faculty of Arts and Science, New York University, for generous grants to support the cost of illustrations.

Finally, we would like to thank our families for cheerful assistance, encouragement, and support.

H.B.A.
D.G.L.

Contents

Introduction
Harriet B. Applewhite and Darline G. Levy 1

The Myth of the Feminine Food Riot: Women as
Proto-Citizens in English Community Politics, 1790–1810
John Bohstedt 21

Masculine and Feminine Political Practice during the
French Revolution, 1793–Year III
Dominique Godineau 61

Women, Radicalization, and the Fall of the
French Monarchy
Darline G. Levy and Harriet B. Applewhite 81

Women and Political Culture in the Dutch Revolutions
Wayne Ph. te Brake, Rudolf M. Dekker, and Lotte C. van de Pol 109

Women in Revolutionary Brussels: "The Source of
Our Greatest Strength"
Janet Polasky 147

"The Powers of Husband and Wife Must Be
Equal and Separate": The Cercle Social and the
Rights of Women, 1790–91
Gary Kates 163

The Women of Boston: "Persons of Consequence" in the
Making of the American Revolution, 1765–76
Alfred F. Young 181

"I have Don . . . much to Carrey on the Warr":
Women and the Shaping of Republican Ideology
after the American Revolution
Linda K. Kerber 227

Looking Back: Women of 1848 and the
Revolutionary Heritage of 1789
Laura S. Strumingher 259

Contributors 287

Introduction

Harriet B. Applewhite
Darline G. Levy

During the 1940s and 1950s, at the height of the Cold War, many of the historians and political theorists who undertook comparative studies of western nations were seeking to establish solid bases for cooperation among members of the Atlantic alliance by delineating shared traditions and institutions of liberal democracy. The publication in 1959 of the first volume of R. R. Palmer's *The Age of the Democratic Revolution* stands as a landmark. Palmer moved beyond the Anglo-American experience of democracy to posit a common eighteenth-century European-American heritage of values and institutions that carried more weight than the unique and specific features in each nation's political history. One can read Palmer's thesis as a double challenge to Marxist and conservative schools of historical analysis, both of which rejected eighteenth-century revolutions as models of democracy. Marxists interpreted these revolutions as the triumph of a bourgeoisie that rationalized its materialist interests in a universal language of rights, while conservatives distinguished between Anglo-American constitutional democracy, on the one hand, and, on the other, a totalitarian democracy for which the government of the Terror in Revolutionary France served as the prototype.

For R. R. Palmer, the age of the democratic revolution opened with massive and general challenges to the political institutions and prevailing values of the old orders in Europe and America. The challengers, aristocrats and democrats, emerged with competing models of government and politics, including competing definitions of legitimate authority; but as Palmer noted in his conclusion, the long-range trend established in these eighteenth-century revolutions was in the direction of a more broadly based egalitarian society and democratic polity. Referring to Alexis de Tocqueville's prediction "that the future

would see an increasing equality of conditions, brought about in ways that could not be foreseen, and were not prescribed," Palmer commented: "It was a prediction that even inequalities of wealth and income, like others, could be reduced, either by revolution or otherwise. Such has in fact proved to be the case."[1]

At the time Palmer wrote, the scholarship on social history and women's studies had not yet yielded data on the full nature and complexity of the democratic involvement in revolutionary struggle. The conference we organized at the Rockefeller Foundation's Bellagio Study and Conference Center was designed to connect the insights of new scholarship to an ongoing postwar inquiry into the origins, strengths, weaknesses, and prospects of modern democracy. The use of Palmer's work as a point of departure for an inquiry into women's political roles immediately brings into relief the double nature of the "democratic revolutions" as revolutions for liberty and equality that nonetheless perpetuated and reinforced prevailing inequalities of power. Contemporary scholarship has made us aware that gender, along with class and race, has historically shaped and circumscribed power relationships in all societies. There *is* a gender dimension to the way inequalities of power were distributed, exercised, represented symbolically, and challenged in all spheres of society—family, work, politics, and culture—in this age of democratic revolution.

Concepts of citizenship, civic virtue, and sovereignty were gendered in ways that signified sharp, deeply embedded cultural distinctions and differential valuations of human endeavor in both the public and private spheres. At the same time, some women drove past these gendered understandings of political identity. Eighteenth-century revolutionaries transmitted to their posterity assumptions about appropriate identities and roles for women and men that in many instances have been perpetuated in the institutions and values of modern democracies. They also passed on a legacy of struggle over the meaning of citizenship and sovereignty.

As preparation for our conference, we asked participants to address some of the following questions in their papers. Which pre-revolutionary organizations, such as guilds, religious institutions, and community networks, facilitated and which ones impeded the involvement of women and men in political activity? Which issues—subsistence? the legitimacy of political authorities?—engaged the attention of women and men? In addition, we wanted to inquire into the processes and agencies of women's political involvement—for example who the leaders were, who the intermediaries were—so that we could compare initiatives and responses of men and women and the degree

of their control over goals and actions. We also were interested in ideological formulations—republicanism, citizenship, civic virtue, liberty, and equality—as they recast, distorted, promoted, or frustrated the revolutionary claims men and women made. Finally, we wanted to investigate gendered representations of revolutions and the ways in which they shaped and limited fields of discourse and action for men and women of future generations.

We include here summaries of major themes in each essay that support some general conclusions about women and comparative political culture in the age of the democratic revolution.

In England, which did not experience a political revolution at the end of the eighteenth century, the food riot within local communities was one of the principal forms of political contestation in a period marked by social unrest and frequent civil violence. John Bohstedt shows how women's participation in riots was shaped by their roles in the household economy and by political structures and dynamics within communities of different sizes and at different levels of industrialization. Bohstedt compared the participation of women and men in 617 riots involving such conflict as subsistence crises, naval impressment, and political contestations, all occurring between 1790 and 1810 in English towns ranging in size from agrarian villages to the metropolis of London. Referring to these riots as the "plebeian branch of the constitution," Bohstedt points out that participation in riots amounted to a practice of proto-citizenship, a citizenship that was real, for women as well as for men, although based in fragile institutions and traditions.

In stable medium-sized manufacturing towns, food riots and women's roles in them were an organic part of town politics, although involvement was by no means exclusively the province of women. Riotous behavior was disciplined and infrequently violent; all parties wanted stable relationships among townsfolk, farmers, and merchants. Women were at once empowered and disciplined by close community ties of friendship, kinship, and patronage. Women and men, as coequal protectors of the household economy, could pressure local producers into lowering prices; they frequently compelled local magistrates to acquiesce in or support their acts of force. In what Bohstedt labels "industrial boom towns," that is, towns under pressures of urbanization, industrialization, and a generalized gender division of labor, the food riot as a form of political participation lost its efficacy. As men formed new organizations, such as labor unions and work groups, with their own political agendas and new claims on employers

and authorities, women were left as the principal food rioters; but they now participated as members of the work force exclusively— weavers or nailmakers, for example. They found themselves disconnected from the community matrices in which the food riot had a politically meaningful function and constituted a form of empowerment for common people of both sexes. Women rarely participated in London riots, particularly impressment riots or political conflicts that frequently included personal assault. In the changing English towns and cities that Bohstedt examined, an age of democratic revolution brought not political revolution but economic transformations and changes in the meaning of political involvement for women and men. Plebeian women who had been at the center of a practical politics of food riots now were pushed to the margins of community conflicts. Women continued to riot, often more violently than in the past, but food riots no longer carried the same meanings of political empowerment and proto-citizenship.

Two essays on gender and revolutionary politics in Paris, those by Dominique Godineau, and by Darline Levy and Harriet Applewhite, trace the roles of women of the popular classes in community networks and in municipal and national political institutions including section assemblies, popular societies, national legislatures and municipal government. When food riots broke out in Paris the *femmes sans-culottes* combined traditional acts of *taxation populaire* with maneuvering within new political organizations, where they petitioned, formed deputations, and marched in processions—and, in short, exercised de facto rights of citizenship.

Godineau's major theme is women's political self-identification with the sovereign people. For both women and men, sovereignty meant deliberating in section assemblies, bearing arms, sitting in a revolutionary tribunal, revoking the mandates of elected officials, and rising in insurrection. However, because laws excluded women from exercising many of the rights of sovereignty directly, their status remained ambiguous—that of citizens without the rights of citizenship.

As a consequence of this exclusion, women developed certain gender-specific practices. The leading militant women formally demanded the right to bear arms. Men bearing arms could actually enforce laws prohibiting hoarding; women, who could not bear arms, attended executions in order to have concrete proof that enemies were being punished, that the people were not being deceived. More often than men, women were carriers of rumor; they acted as fire-

brands, inciting men to action. Excluded from or silenced in regular *sans-culotte* organizations like section assemblies, women found alternative places to hear the news and to air their political views. Markets, breadlines, streets, and areas surrounding the legislature were harder for authorities to control.

Women were most fully integrated into the ranks of the sovereign people in times of popular insurrection; the roles they played were gender-specific roles. For example, during the last popular insurrection of the Revolution, Prairial Year III (1795), women dominated the action—beating the *générale*, stirring up men to go to the Convention, and confronting the deputies—but women are not noted in the records for the following day when men deliberated in illegal general assemblies and made an armed assault on the Convention. Women's gender-specific roles and responsibilities did not entail dominance and dependence; rather, they indicate areas of women's initiative and real, if limited, autonomy.

In our essay on women and revolutionary radicalization in Paris during the spring and summer of 1792 (a period of acute military/ political crisis in the capital and throughout the nation), we depict and analyze the activity of women of the popular classes who marched with men in their sections in a series of armed processions. Directed by section leaders and tolerated if not positively encouraged and protected by Girondin authorities (like Jérôme Pétion, the mayor of Paris), this armed populace, with women conspicuously in its midst, coopted key elements of the armed force and applied collective pressure on both the national legislature and the royal executive.

In the processions of April 9 and June 20, 1792, armed marchers, women and men, demonstrated the powers of the sovereign people as they took over the Legislative Assembly and the Tuileries Palace, seat of royal executive authority. In their speeches, they proclaimed the rights and powers of sovereignty, and they conspicuously displayed objects, banners, emblems, and weaponry symbolizing the armed might of the sovereign people, a militant citizenry. In these ceremonial marches, which reached insurrectionary proportions on June 20, thousands of men and women hastened the erosion of the institutions and the perceived legitimacy of the constitutional monarchy; they also contributed to the section-based forces that brought down the monarchy on August 10, 1792, and established a republic.

Both supporters and opponents of these fully mobilized democratic forces in the sections were sensitive to the strategic significance of women's involvement in these armed marches. Revolutionary leaders

exploited women's presence to create a gendered image of a national alliance of comrades in arms, mothers, sisters, and children. Authorities on both sides argued that it was extraordinarily difficult if not impossible to exercise repressive force effectively; they strongly implied that these armed families of *sectionnaires* constituted an insuperable popular force.

During these months of internal crisis and preparation for war, revolutionary activists like Pauline Léon claimed the right of women to bear arms; in an address before the Legislative Assembly on March 6, 1792, Léon formally grounded this claim in the citizen's natural rights of self-defense and resistance to oppression guaranteed in the Declaration of Rights. The following month, Pétion, supporting a petition on behalf of Reine Audu, one of the most active participants in the women's march to Versailles of October, 1789, praised the militancy of *citoyennes* and invoked Reine Audu's behavior as a model of female citizenship and civic responsibility.

Political authorities like Pétion, who honored, tolerated, or even orchestrated women's involvement in the ceremonial and insurrectionary movements of 1792, never intended to include women in their legally expanded definitions of political rights under the republic. In the autumn of the following year, Jacobin leaders who, during their struggle against the Girondins, had encouraged the organized militancy of the Society of Revolutionary Republican Women, did not hesitate to outlaw women's political clubs when women's political activism began to threaten their power base.

Nonetheless, women who participated in the armed processions of 1792—women who bore weapons, shouted slogans, displayed banners, forged ties with National Guard battalions, demonstrated their solidarity with the passive male citizenry of the sections, and identified themselves as the sovereign people in arms—all contributed to mobilizing the forces that democratized practices and principles of sovereignty and militant citizenship. Such acts were necessary to the struggle for democratization, but not sufficient to break through gendered limitations on the meaning of political democracy.

In Holland, women and especially older women, even more than men, found opportunities within the neighborhood to organize, lead, and control protests. Wayne Ph. te Brake, Rudolf Dekker, and Lotte C. van de Pol describe men's and women's roles in both phases of the Dutch Revolution, treating political activity and ideology. In the first phase, predominantly illiterate working-class women took the Organist side; one of them, Kaat Mossel, became an often-caricatured sym-

bol of Organist politics. When the pro-democratic Patriot party was formed, it did not operate through these networks. It appealed to supporters almost exclusively through newspapers and formal elite organizations, like clubs, recruiting members individually. Patriot women *did* make an impact as political writers, contributing to newspapers and authoring pamphlets that attacked aristocrats and supported female education, but they appear not to have supported political equality for women. Their writings contributed to shaping the discourse about citizenship in the Dutch Republic, a discourse that brings into relief the real if limited nature of women's awareness of the requisites of membership in the polity.

During the second phase of the Batavian Revolution, between 1795 and 1801, a few women's political clubs were created and women became more publicly visible. Both these trends produced a heightened political consciousness among women. Female writers were more influential than in the earlier period. They clearly sided with the Revolution, and they placed women's issues on the political agenda. The authors argue that revolutionary Dutch politics differed from both the American and the French precedents. Dutch politics were driven by reformist ambitions growing out of a perception of decline (more apparent than real) from seventeenth-century economic dominance and political power in a regime that had granted single women legal rights nearly equal to men's. Although women of all classes were economically marginal in the seventeenth century, aristocratic women had enjoyed political influence through birth or marriage, and lower-class women played "striking and significant" roles in popular protest and collective action, roles connected to their place in neighborhood social networks. Also, women were perceived as more naturally disorderly than men, and more likely to be treated leniently by militias and judges. On the other hand, women were considered responsible for household finances, relations with relatives, neighborhood assistance, and calls to action at the beginning of riots. The Orangist movement in the 1780s drew on these traditional gender roles; the Patriots rejected them as leading to dangerously uncontrollable rabble-rousing and street politics. Eventually, Orangist leaders came to a similar conclusion. Both parties ended up circumventing the local structures through which women had operated. The Patriots developed what the authors call "proactive democratic politics," based in revolutionary committees and militias and excluding women from full political participation. It is also true, however, that women writers, especially during the democratic revolution of the

1790s, did raise their dramatically audible political voices as publicists and champions of women's issues, setting a precedent that women would follow later, and especially in 1848.

The Belgian Revolution of 1789 was more directly an international event than the Dutch Revolution, amounting to a revolt against the Austrian Emperor, Joseph II, whom the Belgians accused of violating their ancient constitution. Janet Polasky's essay describes how a coalition of the Belgian Estates and organized democratic forces drove out the Austrians in December; the leaders of the Estates then took control over the revolutionary government and drove the democrats into exile. Women participated beside men in the overthrow of the Austrians. Of particular importance was the Comtesse d'Yves, a pamphleteer and political activist in the tradition of noble women in the Belgian Estates. D'Yves was well placed to bring together guild leaders, nobles, and democrats and could cooperate with both anti-Austrian factions; she was able to maintain the trust of both sides and to play a mediating role. Polasky's other key revolutionary woman was the mistress of the leader of the Belgian Estates; her role mirrored traditional court patronage, and she became the brunt of satirists in all camps.

Women in revolutionary crowds expanded upon their traditional roles as producers and guild members. Belgium had been industrializing since the mid-eighteenth century, and women fitted into a transitional economy in which prosperity within the framework of the guilds was fueling economic growth but also coming into conflict with entrepreneurial values and a new technology. Women's participation in power politics reflected the continuing influence of two ancient privileged Belgian institutions, guilds and Estates. By the time of the modernizing Revolution of 1830 that produced Belgian independence from the Netherlands, the traditional functions of these institutions as facilitators of women's political involvement had waned to the point where women no longer played a significant role.

In the English, French, Dutch, and Belgian cases, community provided a matrix for the political participation of working-class women and men. Several of the essays emphasize the community as a principal locus of women's political influence. Where community ties were threatened and dissolved, that base eroded, and acts that had in effect conferred a kind of citizenship on both female and male actors lost their significance as modes of community empowerment. In revolutionary Paris, however, women were able to enlarge the space of their political action and develop some influence for them-

selves within new municipal and national political institutions, especially between 1792 and 1793.

In revolutionary nations where constitutions were produced, civil rights were defined and granted only to men. Nonetheless, reformers persistently proposed recasting gendered roles and rights with the goal of realizing the full promise of democratic citizenship for women as well as for men. In his analysis of reform proposals that relate to the rights of women in 1790 and 1791, Gary Kates focuses on efforts among members of the Cercle Social to reform prevailing definitions of citizenship under the new revolutionary regime. In their writings and in speeches before the Confédération des Amis de la Vérité, men and women who were affiliated with the Cercle Social, principally Etta Palm d'Aelders and Condorcet, campaigned to expand and democratize definitions of citizenship to encompass full political equality for women, including the right to vote and the right to hold public office. Cercle Social members went further still, demanding reforms that would work a revolutionary democratization within the family, a necessary condition, they believed, for the realization of equal rights for women in the polity. Those reforms included liberal divorce legislation and legislation abolishing primogeniture and establishing an equal division of property among all male and female children. Kates presents convincing evidence to support the contention that Cercle Social members designed these reforms to produce a cultural and moral revolution. They aimed to replace the patriarchal family with the egalitarian family, a model domestic society in which women and men would have separate and equal powers and roles and a measure of autonomy and independence, all of which they considered prerequisites for working essential transformations in the mores and attitudes of the next generation that would make possible full political equality for women and men.

While their focus on the need to reform mores within the family was Rousseauan, some members of the Cercle Social—Condorcet, Brissot de Warville, Etta Palm d'Aelders, the Rolands—went beyond Rousseau's paradigms; they envisioned radical reforms of gender roles in the family, society, and political community that would replace patriarchalism with egalitarianism. In the context of French political institutions and priorities under the constitutional monarchy and especially after the massacre on the Champ de Mars, their vision was utopian. Nonetheless, they established a fundamentally important theoretical and practical link between the family and the larger political society, arguing that home and polity were the two arenas in

which any definitions of equality and the rights of citizenship for women, from the most conservative to the most radical, would have to be implemented.

Family, community, and polity were also linked to developing political consciousness in the American setting, although in more practical, less utopian ways. In his essay, Alfred Young proposes an inquiry into experiences of women in prerevolutionary Boston.

Of the four New England institutions that Young identifies as central to the formation of men's political attitudes—the Congregational meetinghouse, the town meeting, the public schools, and the militia—only the church was open to women. Church affiliation provided women with numerous opportunities for forming social networks, strengthening bonds of sisterhood, and, with the coming of the Great Awakening, experiencing the impacts of a powerful equalizing spiritual force.

In addition, women in prerevolutionary Boston participated in festivals and played a role in rituals of public punishment like executions. They took part in mob action: grain riots, raids on brothels, riots to force the return of men who had been pressed into service in the navy. They marched in funeral processions. In short, they were involved in the ceremonies and rituals of public life, rituals that communicated shared values and enforced approved conduct.

Young documents women's presence and involvement in a variety of public acts in politically charged spaces during the prerevolutionary decade. They were on the scene during the Stamp Act protests, "reinforcing community solidarity." As consumers and producers of yarn both in their homes and in public spinning bees (often church-organized), and as signers of the Solemn League and Covenant, women played a central role in assuring the success of American boycotts of British goods. They joined riots in which Bostonians targeted the homes and persons of British officials. Women were conspicuously present as mourners in funerals with political overtones, like the funeral that followed the Boston Massacre of 1770 and the annual commemorations of this massacre. While they did not participate directly in the Boston Tea Party of 1773, women did exhort the men of Boston to act, and they held firm and persevered in their resistance when British authorities closed Boston Harbor in reprisal for the Bostonians' destruction of British shipments of tea. All these roles attest to a mass prerevolutionary political mobilization of women that further strengthened and radicalized the forces of resistance and opposition in Boston.

Based on his analysis of surviving evidence, like diaries and other writings by women, Young posits a link between all these prerevolutionary political acts and women's developing political consciousness. For example, the young Ann Winslow, after participating for two weeks in spinning bees, part of the campaign to promote an anti-British boycott by substituting American-made yarn for British yarn and products, wrote in her diary that she had come to identify herself as a "Daughter of Liberty."

In the months immediately preceding the Declaration of Independence, Young concludes, some women moved beyond the political self-definitions of an Ann Winslow to reach the political consciousness of an Abigail Adams, who, in her extraordinary exchange with John Adams and Mercy Otis Warren in the spring of 1776, not only called attention to the radical inequality of women in a patriarchal society, but also dared to formulate the idea of women's collective action as a possible remedy. With the progress of the war and the intensification of experiences that promoted political optimism, economic and political empowerment, and participation in challenges to constituted authorities, many more women would "leap from political liberty to personal liberty," moving into a state of heightened political consciousness and beyond, into radical opposition to gendered inequalities of rights and power.

Young explains changing self-identifications and political consciousness that could mobilize women at the opening of the American Revolution; Linda Kerber concerns herself with the ideological aftermath of the Revolution for women in the new Republic. Kerber interprets the political discourse of women in postrevolutionary America—the claims women were making on the government, their efforts to define meanings of republicanism that would be relevant to their own experiences, their priorities, and their definitions of independence and autonomy—as historically significant responses to the "deeply gendered nature of republican ideology after the American Revolution." Kerber argues that republican ideology "was a creation of the revolutionary generation, and in its shaping we can discern the subtle ways in which it reflected the gender dynamics of the generation that created it." The men who made the American Revolution also constructed an ideology that brought into relief the individual male citizen, a proprietor enjoying the benefits of political independence in a political community that he entered voluntarily. In the dominant republican ideology and political constructs, women were eliminated or marginalized; their economic and political

dependency was perpetuated and rationalized, notwithstanding repeated denunciations of monarchical patriarchy by male revolutionaries.

Kerber focuses on several texts, including Rachel Wells's postrevolutionary petition to the Continental Congress (in which Wells claims the right to compensation from the Republic for her services and sacrifices); an anonymous pamphlet of 1787 (in which the tasks and challenges facing the Republic are recast in spiritual terms and women are assigned leadership roles in meeting them); and Judith Sargent Murray's "Gleaner" essays. Kerber makes audible the authorial voices of women who articulated their own understanding of republican ideology, molded that ideology, made it their own, and demanded autonomy and independence for themselves within matrices and frameworks appropriate to their own situations and experiences of reality. For example, Judith Sargent Murray, in her "Gleaner" essays, demanded a religious and academic education for the new republican woman to prepare her for a life of economic, psychological, and intellectual achievement, independence, and self-reliance, an education that at the same time would strengthen her ability to fulfill her primary and principal responsibilities to home and family.

In her analysis of women's petitions, religious tracts, correspondence, articles, and fiction, Kerber has singled out women's multiple claims for independence and self-sufficiency. These claims amounted to a female reading of republican politics and ideology that established bases for women's expanded demands during the nineteenth century and thereby furthered the struggle for democratization although it did not cancel out constructions of political democracy that were gendered to limit women's fields of political action.

In her conclusion, Kerber reviews limits on the possibilities open to women of the postrevolutionary generation when the potential spaces of autonomy—beginning with the family—were permeated with ambiguities arising from a prior gendering of values, principles, and laws. She argues that it would require several generations for women to develop the language and acquire the experience to renegotiate their relationships, in the family and in other arenas, and to define the conditions for their realization of full autonomy.

Laura Strumingher explores women's reworking of revolutionary legacies in another cultural setting, France in 1848. She focuses on the women activists who edited the political journal, the *Voix des femmes*, during the Revolution of 1848. Strumingher presents bio-

graphical sketches of the journal's founders, most of whom frequented Saint-Simonian circles and supported causes like midwives' associations, limitations on working hours, public education, and equal civil and political rights for women. These activists, in search of models, drew from a repertory of images of revolutionary women in action available in the interpretations of early nineteenth-century historians of the French Revolution; Strumingher believes Lamartine's *Girondins* was probably most influential. The editors of the *Voix des femmes* recast the roles of women who participated in the Revolution of 1789, bringing selected moral traits into relief, deliberately and selectively blurring both revolutionary and anti-revolutionary political beliefs, and creating out of the exploits of revolutionary women whose ideologies and political beliefs were often glaringly contradictory an empowering composite image of women's physical, moral, and political capacities. For example, Marie Antoinette, Charlotte Corday, and Mme. Roland were all lauded, portrayed as women of fortitude who showed courage under fire and loyally supported husbands and family. The editors of the *Voix des femmes* may have been drawing from a study by E. Lairtuillier which praised women's inspirational roles but disapproved of their direct political intervention as a violation of feminine virtue. Occasionally, the women of 1848 defied such conventional interpretations, as, for example, when they invoked Olympe de Gouges, author of the Declaration of the Rights of Woman, as an honor to her sex. Strumingher finds evidence that these writers drew from the moral qualities of the women of the first revolutionary generation of 1789 more than they did from their ideologies; they also eschewed altogether the example of women's collective revolutionary involvement. In general, they seemed more eager to sever connections between their own political, economic, and social claims and those of the first revolutionary generation of women than to acknowledge their indebtedness. Strumingher concludes that, in general, the women of 1848 saw their primary commitment to women's rights as fundamentally new, not much connected to an ambivalent legacy from undisciplined eighteenth-century revolutionary women, whose behavior could not be applauded or imitated without provoking onslaughts of misogynist rhetoric, and whose commitment to broad humanitarian rights had failed to change either the material or the political conditions of women.

The five political cultures discussed in this volume all experienced

social upheaval and political unrest or revolution between the 1760s and 1815. Did women in fact experience a democratic revolution? The period marked the first massive involvement of women, both individually and collectively, in the political arena and in fields of political discourse. Many of these essays find the root of women's political engagement in the roles and structures of community politics, both before and during periods of revolutionary change. Some trace the links between family structure, household economy and community politics. Fixed boundaries did not divide private concerns from public involvement. In preindustrial English towns, women alongside men were coproducers and codefenders of the family's economic security; their political interventions were defensive and reactive. Their proto-citizenship was a function of authorities' recognition of the legitimacy of their demands for stable town markets. In prerevolutionary Belgium and Holland, women had particular responsibilities in neighborhood social networks for maintaining relationships with the extended family and for providing assistance and support to family, friends, and neighbors in need.

In revolutionary settings, these community ties sometimes mobilized women for political action. In Paris, Holland, Belgium, and America, women often assumed roles as firebrands, inciting men to action, inspiring them to courageous efforts, chiding them for laziness or cowardice, and even leading them through the streets towards targets of protest. In eighteenth-century Holland, the police functions of guilds and civic guards were weakening, and family, kinship, and neighborhood ties—all mainly women's responsibilities—structured the behavior of quasi-disciplined crowds. The women cast themselves as defenders of local community interests in the face of external threats to economic security and stability.

Of the five political cultures included here, only in France were women able to move out from their community base in their neighborhoods to interact with leaders in national political institutions and to stake out a claim to a political identity as citizens—members of the sovereign nation. The eighteenth-century English riots were not linked to parliamentary politics or national issues; and women's local influence was attenuated by their exclusion from men's labor groups in rapidly developing towns. In Holland, leaders on all sides organized revolutionary institutions that in effect excluded women. Furthermore, both sides came to fear the volatility of revolutionary crowds and worked to remove them from revolutionary struggle. The women of Boston had sex-specific roles within their communities, but

were prohibited from participating in town meetings, enrolling in the militia, and attending public schools—activities that mobilized men. Women were included with men only in the Congregational churches and Quaker meetings.

Only in Paris did women intervene directly and centrally in national politics; confronting the king, filling galleries of legislatures and assemblies, disrupting and invading the national legislature, joining and forming popular societies, involving themselves in clubs and in section politics, and cultivating affiliations with the national guard. These extraordinary behaviors developed from long-standing customs: a tradition of women's interactions with neighborhood, city, and national authorities; acts of *taxation populaire;* participation in religious festivals and processions; professional and guild-related activities like verification of the legitimacy of royal births; deputations; and congratulatory delegations of fishwives and market women. A whole panoply of collective behaviors set the stage for women's inter- and extra-institutional interventions, including their involvement in the exercise of popular sovereign power.

The rapid radicalization of French revolutionary politics also accounts for the breadth and scope of women's involvement and political claims. As absolutism was replaced by constitutional monarchy and monarchy in turn by a republic, the bases of political legitimacy were reconstructed. Legitimacy by divine right gave way to legitimacy based on the will of the sovereign people. Women not only identified themselves with the popular sovereign, they also demanded and exercised rights of citizenship, including the right to bear arms—in self-defense and as an integral part of the armed might of the sovereign people. When the Jacobins passed legislation that excluded women from all forms of political participation in the fall of 1793, they preceded these decrees with speeches filled with profoundly gendered rationalizations and a questioning of women's competence in every sphere of rational human endeavor. The element of panic in Jacobin rhetoric can be explained in part by women's subversion of expected gender roles, amounting to radical claims to the rights and attributes of citizenship.

Several of these essays touch on cultural definitions of women's roles, particularly during insurrections, and explore the issue of whether these definitions affected the behavior of both insurrectionaries and policing authorities. In Holland, for example, rioters assumed that women were more naturally inclined to disobedience than men; but it was also assumed that authorities would treat women

more leniently. Therefore women often were prominent in the front-
lines in food and tax riots. Shifting our focus to authorities, we see
that in England there is no evidence that judges actually handed out
lighter sentences to riotous women. Bohstedt argues that the harsh-
ness of repression varies with the kind of riot rather than the sex of
the rioters. However, in Paris during the summer of 1792, both
Girondin radicals and more conservative officials of the Department
of Paris exploited a prevailing image of women as weak and defense-
less in order to justify their failure to control insurrectionary crowds.
In short, power—the power of revolutionary and insurrectionary
crowds as well as the power of authorities struggling to control
them—is not only an objective reality; it is a gendered representation
that all sides in these revolutionary struggles are manipulating and
exploiting. It therefore becomes imperative for us to understand the
cultural matrices and traditions in which these representations
emerge and are transformed.

The essays in this volume also explore transformations in wom-
en's self-definitions and changing meanings of citizenship—women's
place in the polity in the age of the democratic revolution. Oppor-
tunities for women's political involvement opened up that worked to
expand both their political self-awareness and their ideological for-
mulations of political identity. However, richly varied experiences
that shaped women's consciousness of their membership in the polit-
ical nation, a revolutionary political language that was universal but
at the same time universally gendered, and laws which by and large
canceled out autonomy for women in the economic and political
dimensions of their lives—all combined to render women's political
status as citizens profoundly ambiguous and problematic. The young
girl who joined spinning bees in Boston, the women members of the
Cercle Social in Paris, mobilized women of the popular classes who
marched fully armed before deputies and king in Paris—all were
learning to link their experiences to the duties and rights of citizen-
ship. At the same time the Declaration of the Rights of Man and of
the Citizen, the Bill of Rights, laws, tracts and pamphlets were written
in language that encoded gendered exclusions in the very terms that
defined prerogatives of the human race. For example, American cov-
erture law and the French decree that prohibited women's political
organizations excluded women from the enjoyment of rights guar-
anteed to citizens in declarations of revolutionary principle and in
new constitutions and laws.

The essays in this volume and discussions at the conference have

suggested future research tasks for historians concerned with gender and democratic political culture. A first task is to expand the study geographically, beginning with more explicit regional comparisons within the countries included here and more systematic comparisons of political differences between nations, such as the attitudes of authorities toward women insurrectionaries or women's roles in community politics. In addition, we need a close examination of gender and politics in other nations and areas that experienced insurrection in the eighteenth century, notably Spanish America and the Caribbean, Spain, Italy, and the Germanies. The essays in this anthology do not touch at all upon the intersection of gender with race in many nations.

A second broad task is to examine more systematically the legacies of women's political participation in the age of democratic revolution. What follows are some reflections on the nature of this legacy. In the most general terms, for men, the revolutionary period established the principle of democratic citizenship, constitutionally guaranteed rights, and collective empowerment through participation in new political, economic, and social institutions. For women, revolutionary outcomes were far more complex and confused. The collective influence that women had enjoyed for centuries in their neighborhoods and communities was dissolving under the pressures of economic development and political revolution. These personal and corporate bonds were losing political significance, leaving women marginalized and individually isolated. This was a time of unprecedented disruption for all who lived through it. Links between woman/wife/mother/citizen and between man/husband/father/citizen were thrown into question as traditional relations of authority crumbled and new claims to self-determination emerged. All these relationships had to be redefined. Who is sovereign? What is a citizen? What are the guiding values of the culture? Who embodies them? Who inculcates them? Such questions are absolutely central to human self-definition (including formulations of political autonomy), to social relations, and to the legitimacy and stability of the modern nation-state. The answers, as we are beginning to see, were complexly determined in nations affected by democratic revolution. However, it would appear that gendered ideology and cultural representations that crystallized at this critical turning point remained centrally significant in shaping meanings of citizenship, for women and men, in the modern world.

These questions suggest the need to catalog and analyze the multiple cultural constructs of gender roles in myths and representations—the myth of women as firebrands, furies, or embodiments of

purity and domestic virtue, for example; and the myth of men as paragons of strength, intelligence, courage, and civic virtue—myths that interpret the actions of men and women. These constructs partially impose meanings on roles and repertories of actions, defining which ones are to be feared, tolerated, praised and venerated, or excluded. Everywhere in the western world, women's available repertories of words and symbols were derived from a male political language. This language inevitably led women into distortions and contradictions when they attempted to use it to relate their own experience to the larger political concepts, principles, and practices of the western tradition.

In a different area, we must include counter-revolutionaries, women and men, in our analyses of gender in the democratic revolutions of the eighteenth century in order to understand better what determines their principal allegiances in revolutions, as well as changes in those allegiances. In some cases, these allegiances reflect religious affiliation and conviction. In Boston, women members of the Congregational church found a route to revolutionary political consciousness; in France, some loyal believers in the Catholic faith were mobilized to act against the Revolution to defend or restore their church. In other cases, religious belief was more complexly related to political alignment, as illustrated by the dilemmas and anguish of Catholic patriots in France.

Gender, together with race, class, ideology, and power politics, shaped revolutionary outcomes in the age of democratic revolution, both outcomes that established stability on the basis of altered power relationships while perpetuating inequalities, as well as outcomes that point toward a future of continuing challenge and struggle for the realization of political equality and autonomy, the promise of democratic citizenship. The age of democratic revolution nowhere produced political democracy that included women as citizens; nowhere did women achieve political and civil rights that middle-class white male proprietors had established for themselves. If we focus entirely on short-term outcomes of these democratic revolutions for women, then we will be recounting principally the history of women's defeats. Traditionally, women had gained what Bohstedt calls proto-citizenship through their contributions to the household economy and within neighborhood and community power structures. While industrialization, commercialization, and political revolution transformed social and economic life, proto-citizenship for women did not evolve in any sim-

ple way into democratic citizenship. In the aftermath of revolution or civil unrest in the political cultures treated here, women were excluded from modern political institutions like labor organizations, political parties, militias, and legislatures. It also seems to be the case that institutions and representations of political power became more deeply gendered. At the same time, however, self-conscious demands for the improvement of women's condition through education, welfare, extensions of civil rights, and reform of family law became an ineradicable part of the political agenda. Simultaneously, men's awareness of women's claims and of their challege to male dominance and hegemonic power brought to the surface the deepseated anxieties and ambivalence of the governing elites. As we see it, the outcomes of this age of democratic revolution signified not simply defeats and losses for women, and, above all, not a return to the status quo ante, but rather new and persisting obstacles and resistances, along with new consciousness, altered strategies, revised objectives, and a continuing struggle to define the principles of democratic citizenship and the appropriate and sufficient conditions for realizing the full promise of those principles, for women and for men.

Notes

1. R. R. Palmer, *The Age of the Democratic Revolution*, vol. 2, *The Struggle* (Princeton: Princeton University Press, 1964), 574.

The Myth of the Feminine Food Riot: Women as Proto-Citizens in English Community Politics, 1790–1810

John Bohstedt

In prerevolutionary Europe women's roles in food riots were significant, but what they signify has often been misinterpreted. Women have been depicted as appointed guardians of bread prices, the market as female terrain. However, at least in English food riots, women's roles were not so different from men's. Women's place in the family economy, together with the structure and dynamics of various community polities, interacted with gender to shape women's participation in riots, the common people's politics. In many communities women worked shoulder to shoulder with men in protoindustrial households and marched shoulder to shoulder with men to defend those households in the marketplace. Households were defended by households, not by housewives. Protoindustrial women were nearly coequal to men both as breadwinners and bread rioters.

But that status was to be undermined by industrialization. The long process of industrialization from at least 1700 to 1850 comprised many kinds of development, from the spread of manufacturing, "making by hand" in rural cottages, to the sprouting of large urban factories at one end of a spectrum of techniques.[1] The varieties of economic and social growth created different kinds of communities and a corresponding spectrum of community politics, including riots. Some forms of community evolution enhanced women's grassroots political status. But the dominant trend of urbanization diminished women's leverage in practical politics. Wayne te Brake, Rudolf Dekker, and Lotte van de Pol have suggested that in Holland the era of revolution deprived women of traditional political roles.[2] In different but parallel fashion, industrialization, urbanization, and "modern" political mobilization were to leave English plebeian women stranded

in political obsolescence. That outcome was connected with the gender division of labor that industrialization had created by about 1850. But fifty years before, many women had had much more significant power in the politics of their local communities.

In Georgian Britain it was through riots that the common people acted as constituents of the political order. Neither the riots nor the context was revolutionary. Hence women's participation in English riots provides a baseline with which to compare women's political roles in other societies that were undergoing revolution. In this age of European upheaval, a British revolution was not a lively possibility because the state was not in crisis.[3] Sound fiscal and financial systems made the state secure from the sort of crisis that shattered its global competitor France. A hybrid capitalist ruling class had decisively defeated absolutist monarchy and established itself as the political nation in the seventeenth-century revolution. The landed oligarchy formed alliances with other capitalists sufficient to postpone bourgeois pressures for radical change for another generation. Though some British leaders initially welcomed the French Revolution, their attitudes were soured by the September massacres, the execution of Louis XVI, and war. Demands for significant constitutional reform by the gentlemen of the Society for Constitutional Information or by the artisans and shopkeepers of the Corresponding Societies could be safely ignored and repressed. The would-be reformers had neither the numbers nor the political clout to press their claims. Instead, by propaganda and counterrevolutionary repression, Pitt and Melville rallied the political nation, including the Portland Whigs and, for a time, plebeian loyalists, in a united patriotic campaign against the Radicals and against the French. The English political nation was stable and secure in its exercise of political power and faced no imperative to change.

In France and America democratic revolution opened up the possibility of change in social and political structures and hence raised questions about women's status. In Britain, by contrast, political stability and reaction muffled the discussion of women's rights launched by Mary Wollstonecraft, and new women's political mobilization did not begin until after 1815. The prospects of radical political change for the masses, men and women, were bleak. Plebeian women left formal institutional politics to men. Women were absent from formal political activities, participating neither in election riots nor in the meetings, societies, and petitions that accompanied both radical agitation and loyalist opposition to it. Conventional politicians did not

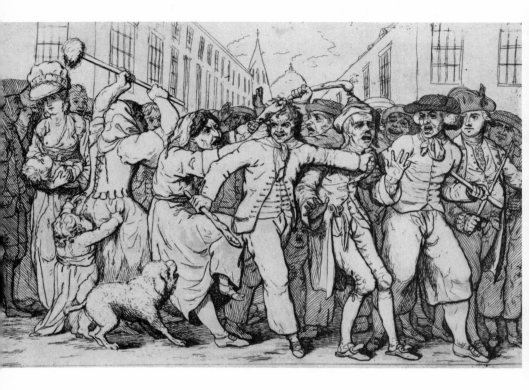

FIG. 1 *The Liberty of the Subject* [James Gillray], Published October 15, 1779, by W. Humphrey, no. 227 Strand, London. (No. 5609 in Mary Dorothy George, *Catalogue of Political and Personal Satires Preserved in the Department of Prints and Drawings in the British Museum*, 11 vols. [London, 1870–1954], vol. 5. A copy of this print is in the Department of Prints and Drawings of the British Museum in London. Courtesy of the Trustees of the British Museum.) In an east London street within sight of St. Paul's dome, sailors in a pressgang, armed with clubs, seize a tailor for impressment into the royal navy during the American Revolutionary war. The impressment is resisted by women of the common people. Such coercive recruiting for both land and naval forces was typical of this period and crowds frequently resisted it, though women were reported in such crowds very infrequently. Their presence here may suggest the popular family and community opposition to impressment, but the humorous expressions on the faces of sailors and spectators seem to interpret the conflict more as a nuisance to both sides than a matter of life and death.

perceive women as potential voters, and so women were not likely to participate in the local political parties and factions that generated election riots. The conservatives who orchestrated Loyalist riots were hardly likely to emancipate women by mobilizing them in "Church and King" mobs, nor in the organizations and Volunteer corps that sometimes underlay them. Since the radical feminist critiques of Wollstonecraft and others did not generate mass associations, women of this era participated in politics primarily via the informal community politics of riot.[4]

Riots were the plebeian branch of the constitution for they could be and often were successful. Never merely functional dialogue between the governed and their rulers, riots aimed at tangible goals, shattered local social calm, and forced the authorities to respond. Yet riots were so common as to be commonplace: more than a thousand riots took place in the period 1790–1810. Rioters typically defended their communities against "external" threats to their welfare. They pursued local and concrete objectives. They took over the food markets to stop profiteering or local export of grain in times of famine; they hounded press gangs and soldiers out of their communities; they broke machines to back up wage demands. Rioters also punished constables, witches, pickpockets, and homosexuals, as well as radicals and other political enemies. Like more conventional politics riots rested at bottom on a basis of physical coercion. But also like other politics, riots were shaped by competing interests and by public opinion and ideologies that E. P. Thompson has called "legitimizing notions."[5] Rioters were also empowered, and sometimes constrained, by the local social networks that connected common people with each other and with the authorities in the webs of community politics. A spectrum of community polities interacted with household economies and with gender to shape women's roles in riot.

In many parts of England, 1795 and 1800–1801 were years of harvest failure and soaring food prices—and food riots. A handful of examples from those years will illustrate both the range of women's actions in riots and their patterned relationship to the spectrum of community politics. At one point on that spectrum stands the constructive bargaining that was typical of stable traditional manufacturing towns. Exeter, center of Devon's decaying woolen industry, was such a town. During three days in late March, 1795, crowds seized wheat and potatoes and forced the farmers to sell them at reduced prices. The magistrates first set compromise prices between those of the crowds and the farmers, and then searched the inns and public

houses for wholesalers' shipments, which they seized and sold to the poor. Witnesses said that few of the rioters "conducted themselves with any degree of violence. . . . They used no harsh language to the magistrates, only said that if they were to suffer they might as well be hung as starved, and they would run the risk of making their situations better, for worse could not be." Only one woman was arrested. And "scarcely a man appeared among them."[6] Women had acted as effective citizens of the local polity to achieve their goals, first by direct action and secondarily by negotiation with the magistrates who took parallel actions to increase the food supply at low prices.

But women could be excluded from popular actions. Not far from Exeter was Totnes, a small, ancient, and stable market town, a parliamentary borough and center for the local woolen trade. In 1801 crowds of men went out to the farmers in the countryside and demanded they sign an agreement to market their foodstuffs at specified prices. A smaller delegation also confronted the leading corn merchant at his counting house and demanded he sign a price agreement. A popular regulating committee proclaimed by handbill that it would do its best to "protect persons and property from the least outrage," but added that, "The better to prevent confusion women are required not to attend the corn market."[7] That warning seemed to imply that women were turbulent and threatened to disrupt proceedings.

By contrast with these orderly riots in Devon's medium-sized woolen towns, the industrial boom towns of the north spawned social alienation, and women could be on the front lines of violent confrontation. Rochdale was a sprawling, rapidly-growing Lancashire woolen town in the narrow deep valleys east of Manchester. On a Monday morning in August, 1795, two magistrates were summoned to hear the complaints of an assemblage of women determined to fix the price of provisions and to demand wage raises. The magistrates assured their leaders that the town fathers had already raised a £500 subscription to provide cheap food, and told them to go home to their families. Instead the emissaries returned to their companions, who had seized a cartload of oatmeal. The magistrates stopped them from opening it up, but they marched into the market and met up with a larger party led by a woman with an iron pan and shovel, "beating to arms." She was arrested and then released but the mob increased. The magistrates called out the Volunteers, a local auxiliary militia, and to alarm the mob they openly primed and loaded their weapons. Leading citizens and magistrates urged calm and order, and

read the Riot Act proclamation, which ordered the crowd to disperse. But they only stepped up their abuse of the Volunteers, saying they "durst not fire as that they were only load with sawdust." The Volunteers charged the crowd with bayonets, but they only dispersed and reassembled. "It was now judged absolutely necessary for the protection of the men to put the law in force," and the Volunteers were ordered to fire. Half of them fired into the air and the other half into the crowd. Two old men were mortally wounded and several others were less seriously wounded. The magistrates hoped to restore order by a combination of armed patrols and food distribution.[8] The kind of bargaining between magistrates and crowds that had achieved equilibrium in Exeter did not work: the magistrates were first dismissive and then repressive, the crowd defiant. In parallel episodes at Manchester and Birmingham, troops inflicted casualties on food riot crowds when negotiations failed.[9]

Growing rural industrial villages were a third kind of community in which women and men might cooperate to control food supplies. At Aure, a village in the coal mining district of the Forest of Dean, a hungry search party challenged the sentry on a trow moored in the Severn River. When they discovered the shipment was flour they gave a loud huzza and cried out, "We have found it!" whereupon they were reinforced by a hundred men, women, and children who trooped down from the hills with horses and asses. They loaded up the wheat and flour and staggered away with it, some five hundred bushels in all, offering no recompense to the owners. According to the newspaper accounts, "the women were more riotous than the men." The magistrate rode up with a party of cavalry and dispersed the crowd, taking five coal miners into custody. Two of them were tried and hanged for stealing flour.[10]

A normally quiet agricultural village provided a fourth kind of setting for riot. A crowd of several hundred stopped a wagon load of wheat and flour at the parish of Long Hanborough between Witney, the blanket-making town, and Chipping Norton. Some of the crowd had followed the wagon from Witney, others were from the village itself. Four women distinguished themselves enough to be arrested. One of them jumped up on the wagon with a big stick and threatened to knock the carter off his horse. She helped to throw the wheat off the wagon and gave the driver a violent blow on the head when he tried to stop them. The rioters sold the grain and flour at the Bell Pub for 40 shillings a sack to purchasers from Witney and

from the village. Two women pleaded guilty and had to enter into recognizances to keep the peace for two years.[11]

These vignettes illustrate the range of actions that occurred in riots. Crowds bargained with farmers and magistrates in the disciplined manner we have come to expect of respectable English food rioters. But they also engaged in roughneck violence, bashing carters on the head and plundering food. Magistrates exhorted and negotiated but also arrested ringleaders and physically drove the crowds away. On rare occasions "order" was restored, or rather authority asserted, by firing on the crowd.[12] Punishments ranged from the taking of recognizances to moderate jail sentences to occasional and exemplary hangings.

But such anecdotes raise more questions than they settle for they cannot provide evidence for *patterns* of social behavior. Even a dozen incidents are less than two percent of the riots in this period, and selection is no substitute for counting. Indeed, selected anecdotes can be seriously misleading: that is how "the myth of the feminine food riot" has taken hold. It has often been suggested that women were the leaders par excellence of food riots. In the first serious study of food riots, the Hammonds called 1795 "the year of . . . the revolt of the housewives." They noted that in the food riots of that year a conspicuous part was taken by women, and they then gave half a dozen examples. E. P. Thompson's classic article on the moral economy states somewhat cautiously, "Initiators of the [food] riots were, very often, the women." Thompson suggests that this was because women were "those most involved in face-to-face marketing, most sensitive to price significancies, most experienced in detecting short-weight or inferior quality." Robert Southey had a different and more general explanation, one that had become a cliché among contemporary observers: "Women are more disposed to be mutinous; they stand less in fear of law, partly from ignorance, partly because they presume upon the privilege of their sex, and therefore in all public tumults they are foremost in violence and ferocity." Natalie Zemon Davis argues that in early modern Europe women were regarded as the very embodiment of disorder because of their participation in riots and because of their reputed lustfulness. Hence rioting males might even dress as females to signify the world of authority turned upside down.[13] Other studies have emphasized that women's leadership was a distinctive feature of food riots.[14] A Marxist feminist has recently concluded, "The prominence of working class women in

these class struggles of the market place derives precisely from their familial roles as executors of the wage."[15]

In the most recent review of this literature, Malcolm Thomis and Jennifer Grimmett are very skeptical about women's prominence in the history of food rioting. They note that in many food riots women are not reported but other identifiable groups are—miners, sailors, artisans, and laborers. In a survey of Scottish riots parallel to my work, Kenneth Logue concludes that women's roles in Scottish riots were not significantly different from men's. Jane Rendall has suggested that women's leadership in food riots seemed conspicuous because it contrasted with the rarity of their appearances in other forms of political action.[16] This essay will sustain these observations on the basis of a more complete analysis of statistical profiles of rioters and their behavior.

The traditional method of analyzing political behavior by compiling anecdotes may simply confirm preconceived assumptions. To comprehend a phenomenon like riot, it is necessary to make a large systematic sample of incidents and to develop a verifiable model to explain variations. I have collected a sample of all riots in England and Wales reported in four national sources between 1790 and 1810: in two national newspapers (the *Morning Chronicle* and the *Observer* of London), the *Annual Register,* and the Home Office files of local magistrates' reports about riots (H.O. 42). By a riot I mean an incident in which a crowd of fifty or more people damaged or seized property, assaulted someone, or forced a victim to perform some action. My four sources report 617 such cases of riot. That serves as a national sample of probably more than one thousand riots in these two decades.[17] For the food riots of 1795 and 1800–1801, I obtained additional information about the riots from other newspapers, manuscripts, and court records. I have coded for computer analysis various descriptive features of these riots, such as the conflict issue, rioters' identities and behavior, and authorities' actions. Town populations and rough occupational ratios come from the censuses of 1801 and 1811. One problem is that while men are often identified by their occupation, women are usually identified by their marital status, designated, for example, as "the wife of John Baker, blacksmith," or "spinster" or "widow." Their employment status must often be inferred from the shape of the local economy. But at least the political roles of women can be outlined so as to establish parameters for more detailed local studies to verify or modify. The important feature of this method is that it allows us to measure the incidence of, and

relationships among, different features of riots—the rioters' and the magistrates' behavior, the crowds' gender, the issues at stake, and the social contexts—and therefore to judge whether various elements were typical or not, rather than relying upon arbitrarily selected and possibly unrepresentative instances.

What sorts of issues did women riot over? Did they dominate food riots? Did their roles in riots differ significantly from men's? To answer these questions, I have divided the 617 riots into three groups (see table 1). The first group (columns A and B) comprises 106 riots in which women were identified. Women dominated forty of these; they appeared alone or with children, or else observers reported that the crowds were "chiefly women." In the remaining sixty-six riots, both women and men participated and/or were arrested as riot ring-leaders. In a second group of 301 riots (column C), only men were identified among the rioters, including groups from ostensibly male occupations such a colliers, tinners, and sailors. Finally, in nearly a third of the riots, some 210 (column D), the rioters' gender and occupations were not identified. Here the problem of women's "invisibility" may be a factor: observers often referred to the rioters as "the mob," "the people," or "the lower orders." When I analyze riots by gender I ignore this last group. In short, of the 407 riots for which we have some indication of the rioters' identities, women appeared in 106, or about one-fourth. Since women represented slightly more than fifty percent of the population, it appears that they were pro-portionately underrepresented in riots generally.

When women rioted it was in food riots that they appeared, but women were very far from dominating food riots. In 77 of the 106 riots in which women were identified as rioters, or nearly three-quarters of the incidents, the rioters' manifest grievance was food prices or shipment of food out of the community in times of scarcity or high prices. In nearly half of those episodes women dominated the crowds as they did at Exeter and, apparently, at Rochdale. In the other half they cooperated with men, as at Aure. In those riots in which both women and men appeared, women took the leading role about half the time. They were not simply demure followers. Indeed, women often started riots of all kinds. At Berwick women assembled on account of the high price of bread and were soon joined by men. At Northampton it was "principally women" who took the initiative to stop a shipment of flour destined for Coventry. At Carlisle "a band of women accompanied by a vast number of boys paraded the streets" and then seized grain from a merchant's house and removed it to the

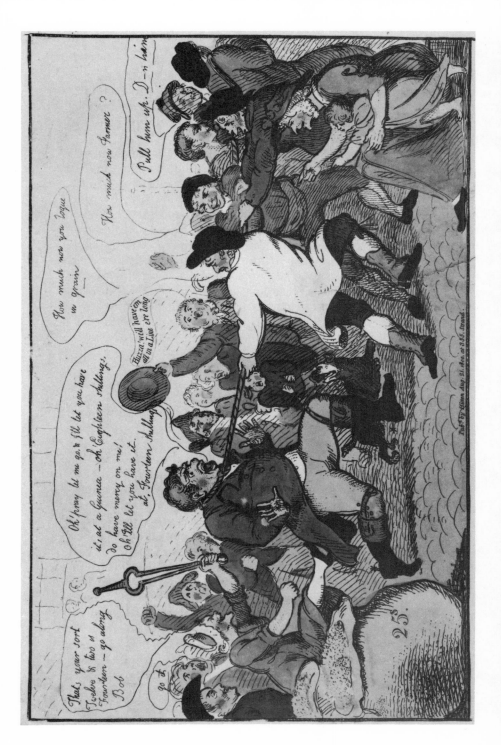

FIG. 2. *Hints to Forestallers, or a Sure Way to reduce the Price of Grain!!*[sic] [? I. Cruikshank.] Published by Hixon, August 21, 1800, at 355 Strand, London. (No. 9547 in George, *Catalogue*, vol. 7. A copy of this print is in the Department of Prints and Drawings of the British Museum in London. Courtesy of the Trustees of the British Museum.) At Bishops Clyst in Devon, near Exeter, a crowd of plebeian men and women pulls a well-to-do forestaller, a dealer or a farmer, through the marketplace. His open sacks of wheat are marked 25 shillings, about three times the normal price. The year 1800 was one of harvest failure, scarcity, and hundreds of food riots. Rioters typically sought to reduce the price to just levels, as they are doing here. Serious physical assault on their victims was rare, especially in the traditional communities of Devon, and the crowd's expressions here seem jocular and self-righteous rather than murderous. "Forestalling" was offensive to the popular moral economy because it consisted of dealers buying food before it reached the public marketplace. The women's tongs and children suggest the link between the marketplace and the household economy. Prints like this one may have contributed to serious food riots in London in September, 1800, following the posting of anonymous threatening handbills urging the people to assemble at the cornmarket and regulate the dealers. In general, London rarely had food riots.

public hall, "where it was deposited until a committee could be formed for the purpose of regulating the price etc." Magistrates tried to negotiate with crowds of women, though sometimes unsuccessfully as at Rochdale, Manchester, and Wells, Norfolk.[18] All of this suggests that qualitatively, women were nearly equal to men in the communal economy and polity. But quantitatively, women appeared in only half (77 of 158 or 49 percent) of the food riots for which we have some information about the rioters. The figure for men is much higher (123 of 158 or 78 percent).[19] Male mobs of colliers, tinners, construction workers, and militiamen were more numerous than female mobs.

Hence the feminine food riot is a myth. It is inaccurate to call food riots "the revolt of the housewives" or to suggest that the food market was a women's province when it came to defending the family economy. A food riot was a major point of intersection between the household economy and the community polity. Women and men and children all acted together in food riots because they all acted together in household production. Men were expected to defend their families' living standards as much as women. After rioting had begun at Birmingham in 1795, a printed handbill declaimed: "To arms, fellow Townsmen! . . . save your famishing familes from destruction!" One of the four male village laborers delegated to speak for protesters who had gathered at Diss, Norfolk, told the magistrate that their "wages were so small, and the price of bread so high, that they were unable to support their families." Despite its own account that *men* were the spokespeople, the *Cambridge Intelligencer*'s report

TABLE 1. **Riot Issues and Gender of Crowds, by Number of Riots**

Issue	Women Dominant (A)	Women and Men (B)	Men Only (C)	Gender Unknown (D)	Total Riots (E)
Food	35	42	81	82	240
Labor	0	6	39	1	46
Military	2	6	96	30	134
Political	0	3	25	35	63
Miscellaneous	3	9	60	62	134
Total	40	66	301	210	617

Sources: All riots that were reported in any of the following: *London Observer, Morning Chronicle, Annual Register,* Home Office files (P.R.O., H.O. 42) for 1790–1810.

Note: "Issue" includes the following: *Food:* prices and shipment; *Labor:* wages, machinery, strikes; *Military:* recruiting, mutinies, civilian-military brawls; *Political:* elections, "Church and King" riots, illuminations; *Miscellaneous:* enclosures, smuggling, theater, rescues, brawls, other.

added the editorial comment: "It is always remarked that the women are most vociferous on these occasions, but this cannot be wondered at since their feelings are more poignantly exposed to the cries of distress than those of the man, whose absence from home affords a temporary relief from the miseries under which their infant families at present labour."[20] Such a middle-class cliché was not only at odds with the newspaper's own report of the event; it was also probably distanced from the realities of plebeian household economies.

The household economy was the fundamental factor that shaped women's roles in riots. In preindustrial communities women were effective partners in the politics of riot because they were essential partners in the household economy. Women's essential role in winning the family subsistence gave them the status to join men in defending it. Women were widely employed in paid manufacturing labor. Protoindustrial production—here meaning domestic manufacture for a merchant capitalist—employed women in such places as rural industrial districts in the West Country, the whole hand-loom district centered on Manchester, and the older woolen towns of Devon with their hinterlands. By 1810 nearly half the weavers in the Manchester area were women, while "the serge trade of Devon seems indeed to have been largely in the hands of women by the end of the eighteenth century."[21] Besides the textile industries, women worked in household production, often in workshops adjacent to their cottages, in the Black Country metal trades. By the end of the eighteenth century, "nearly half the nailers [nailmakers] are women" and children. William Hutton was astonished to find blacksmith's shops on the road to Birmingham with "one or more females, stripped of their upper garments, and not overcharged with the lower, wielding the hammer with all the grace of the sex. The beauties of their faces were rather eclipsed by the smut of the anvil."[22] Women also worked as shearmen, merchants, cobblers, carpenters, joiners, barbers and periwigmakers, musicians, ropemakers, brewers, gravel-diggers, and potters.[23]

It was in such proto-industrial districts that women were most frequently found cooperating with men in food riots. Industrial employment empowered women to be publicly assertive in their community.[24] Women were most frequently found cooperating with men in riots in counties and towns with the highest ratios of nonagricultural occupations, places like the old textile districts of the West Country or the newer west midlands metals areas or the Lancashire/West

Riding textile districts. These three areas accounted for three-fifths (41 of 66) of the riots in which men and women acted together. The forcefulness of wage-earning women is nowhere better demonstrated than in the actions of five women "nailors" in food rioting at Broms-grove in the Black Country in August, 1795. "Damn you Beck," cried Hannah Phillips to Rebecca Oatley, "Come on we will have it!" And they led the crowd into a weaver's house and, exulting loudly, carried away two flitches of bacon.[25] At Bradford and Trowbridge, in the heart of the West Country woolen district, men and women assembled to visit the neighboring farmers. At Bromsgrove in the Black Country men and women gathered together to stop a wagon load of flour; a woman stepped up to the carter to speak for the crowd, and then "made signs to her companions and exclaimed there was a load of flour. . . ." Food riots by agricultural laborers were very rare, but their status as wage earners may have fortified "a large assemblage of women from the hayfields" who stopped a load of wheat near Woburn in 1795.[26] In the pastoral West Country women and men were more likely to share the same kinds of farm work than in the arable east, where division of labor by gender had begun to develop.[27] And so it was that women were the most militant participants in a protest meeting at Crediton of two hundred farm laborers on the subject of wages and food prices. Three of the "most refractory" women were arrested and taken to jail. Mary Plympsell, "single-woman," was found guilty of assault and sentenced to a week in jail, then to be whipped and discharged. Two years earlier Plympsell had been convicted with two dozen others of rescuing a man from the sheriff's bailiffs. She got the heaviest sentence, three months, while the others were fined 1 shilling, suggesting that she was either a plebeian leader or a habitual troublemaker—or perhaps both![28]

Besides giving women economic citizenship and hence standing in community politics, protoindustrial employment gave women an economic role in the family much less differentiated from men's than it was to become after industrialization.[29] Men's work and women's work were not necessarily equal, identical, and interchangeable, but women's contributions were absolutely essential to family incomes and earned commensurate respect. Women's earnings could make the difference between subsistence and destitution.[30] "We survived together" would serve as the motto of domestic economy.[31] Women's essential contribution to family incomes enfranchised them in their families and communities. The protoindustrial household economy was based on employment rather than property, on the "capital of

the working power of *both* partners."[32] Marriage was an economic partnership; women were not dependent on their husbands for their livelihoods.[33] Even the wedding ceremonies of protoindustrial communities were more nearly gender-egalitarian than those of either peasant culture or modern industrial working class culture. And so if they did not win her fully equal power, a wife's economic earnings modified patriarchal authority and raised her status.[34] The male breadwinner standard emerged only in the mid-nineteenth century when mature industrialization separated gender roles as it disengaged work and income-earning from the home.[35] The perfect lady who did not work was always more an ideal of middle-class Victorians than of the working classes.[36] Moreover, in protoindustrial households that typically produced woolen, linen, or cotton textiles or small metal goods like chains and "toys", there was relatively less division of labor by gender than in either peasant society or industrial society, in both of which work was done away from home. Hans Medick has suggested that the similarity of men's and women's protoindustrial work roles broke down gender differences in "social behavior, especially consumption and sexual relations and attitudes. . . . [creating an] 'egalitarian' role of both sexes. This was true at home as well as in the wider community. The 'plebeian sociability' of rural artisans gave frequent opportunities to both sexes to articulate their needs by drinking and smoking together," and also in acting together to defend "traditional norms of subsistence" in food riots.[37]

It is true that one sort of sexual division of labor was nearly universal: women were responsible for the care of the home and children. But this did not isolate women in a domestic sphere, for there was no sharp separation between housework and household production. Childcare included the training and supervision of children to be producers in the family household economy. Housework was doubtless subordinated to income production: "domestic chores preoccupied no one."[38] Plebeian women were income producers, not unwaged housewives confined by gender to the more modern role of homemaking.

Both in community and family politics it was women's role as producers of income, not as directors of consumption, that underwrote their place in food riots. It is an anachronistic mistake to assume that women's participation in food riots grew out of some special female role as the shopper for the family. Nowhere is there evidence for the frequent assumption that in this period women were the primary shoppers for their families.[39] Contrary to some historians'

assumptions, food riots did not usually begin as spontaneous explosions of consumers in the marketplace; more often, riots were launched by crowds foregathered for the purpose. Riots were complex assertions of shared memberships, beliefs, and obligations, not instinctive "rebellions of the belly."[40] Accordingly, men were equally or more likely than women to go in crowds to the marketplace to defend the family economy. Women were not simply housewife furies, drying their hands and heading off to the market or igniting there as a crowd of shoppers. Rather, both as breadwinners and bread rioters they should be seen as proto-citizens and constituents of the local polity and economy, nearly coequal to men in claiming their rights to affordable bread.[41]

Nor did housework isolate women from public spheres; just the reverse: it overflowed into communal cooperation. In French peasant communities women's domestic tasks brought them out of the house to socialize and cooperate with other women, in fetching water and doing laundry, for example, and the same was undoubtedly true of English small towns and industrial villages.[42] At the same time women knit the networks of neighborhood between households, networks that were forms of social regulation—by gossip, for instance—as well as crucial means for weathering crisis by mutual aid. Such aid included borrowing and lending money, helping each other in childbirth, illness, and childcare, and making arrangements for local putting-out work, for plebeian fairs and markets, and for leisure activities such as the parish wakes and games and morris dancing.[43] Medick suggests that such mutual aid functioned as a kind of insurance policy, and so the social and economic dimensions of those communal bonds are indistinguishable: "The social exchange, which was so typical an expression of plebeian culture, strengthened the bonds of kinship, of neighborhood and friendship. Thus it produced just that solidarity to which the small producers could, in times of dearth, crisis and need, most easily have recourse."[44] The capacity to act collectively (and coherently) in riots was not produced instantaneously by the fusion of *individual* interests at the critical moment; rather it was the product of preexisting bonds that united the rioters. Men's joint action in food riots seems based more on prior public collective experience in work, political clubs, militia groups, or labor combinations. In 1801, for instance, the Volunteer Corps of Devon were notorious for providing the nucleii of mobs to set prices.[45] The informal communal networks that women helped construct were a powerful

cement for the solidarity of food riot crowds and accounted for women's staunch role in them.

Female friendly societies may have served both as an institutionalization of such mutual aid and as a source of cohesion in riots. Friendly societies were clubs that provided conviviality as well as mutual insurance against sickness, unemployment, and death. Men's friendly societies were often proto-trade unions; they provided the basis for collective action in labor conflicts. Women, on the other hand, did not participate much in labor combinations.[46] For them friendly societies seemed to provide collective mutual aid to defend household security—or perhaps even to substitute for household security among employed single women. William Marshall found that the single women among the serge weavers of Tavistock in Devon had by 1796 combined to form one or more box clubs or provident societies. Sheila Lewenhak has also found scattered evidence of women's friendly society organization in the midlands, London, and the northern textile districts, just where paid employment for women was most available.[47] Female friendly societies comprised just under ten percent of the hundreds of societies enumerated in the parliamentary report of 1803–4 on the "Expense and Maintenance of the Poor." Perhaps friendly society membership contributed to collective action in riots. Very strikingly, two-thirds of the national total of some 9,000 female members were found in Devon's riotous towns and Lancashire's and Cheshire's cotton towns.[48] Those towns accounted for three of the six labor riots in which women were involved, as well as twelve food riots, mostly in Devon. Hence friendly society membership is likely to have provided an additional basis for women's solidarity in collective action, another strand in the skein of relationships between household economy, work, and community polity.

Gerald Sider has made two important points that help to connect household production, patterns of sociability and leisure, and women's role in food riots.[49] First, where families and communities controlled the relations of production in relatively undifferentiated economies, popular culture was integrally intertwined with the system of production; rituals like Christmas mumming actually helped reconstitute the relations of production. In parallel fashion, the rituals of mutual aid and popular market regulation by riot seem to have been intimately connected with the integration of production, reproduction, and consumption in the household economy, with its male and female near-parity. Second, Sider points out that it is in

such unalienated modes of production that popular culture can provide a position from which to criticize the state. The personalistic household production unit provided a basis for upholding the moral economy against the impersonality of the free capitalist market.

For in this transitional phase of proto-industrial production, the household economy stood on the frontier between the market and the moral economy, balanced between production and reproduction, public and private, exchange values and use values, mingling economic and noneconomic values. Some of the family income was obtained through use rights as well as production for the market— gleaning, poaching, reed gathering, wood gathering, and access to the commons. This emphasis on use values rather than exchange values may explain why the family economy was more sensitive to food prices than wages. The famous moral economy of the traditional food riot gave priority to the use needs of an interdependent community over an individual's profit from exchange and also over abstract property rights. Food rioters insisted that food be sold at the just price rather than the market price. They insisted upon the natural justice of use when they sold food at the prices of a previous year rather than maximizing their own profit by seizing the food without payment or by arbitrarily halving the price.[50] They no more wished to ruin the farmer or merchant than they would allow him to ruin them.

Women occupied that frontier in a cultural as well as an economic sense. Medick has argued that the household economy gave rise to a plebeian culture partly attuned to capitalist markets and partly resistant to them. Early modern plebeian culture often took symbolic and expressive modes of expression, rather than the reasoned literate, perhaps even numerate, discourse of bourgeois culture.[51] The moral economy was qualitatively as well as quantitatively at odds with the market economy. Plebeian resistance to fully developed capitalism—in this case, to the doctrine of the free market in foodstuffs—was rooted as much in distinctive cultural modes of perception and expression as in modes of production. Women may have been the residual bearers of that distinctive culture. For women's role in the family economy, though essential, was not identical to men's. Women's earnings were not separate but were usually subsumed in the family earnings.[52] Since men usually collected the family wage from the employer, women may have been somewhat shielded from regular participation in capitalist labor market exchanges. Perhaps women were more involved in use than exchange, directors of repro-

duction as well as production, perhaps more immersed in the moral, less in the market, economy. Perhaps, as later, "married working-class women . . . seem almost an internal backwater of pre-industrial values within the working-class family."[53]

That may explain why it was often women who added distinctively expressive touches of theater to food riots. They carried into action symbols of the connection between hearth and marketplace. Women marched into the marketplace at Rochdale "beating to arms" on an iron pan and shovel. At Nottingham they carried a mourning loaf draped in black through the market in 1795, and a loaf streaked with red and tied with black crepe, symbolizing "bleeding famine decked in Sackecloth," in 1812. At Gainsborough in 1795 a woman collected a large mob by beating a drum through the streets. At Newcastle under Lyme in the Potteries a mob wearing blue ribbons was headed by a woman ringing a bell. At Hastings two or three hundred women and girls paraded with bludgeons, mops, and brooms, demanding a reduction in food prices, "which after some windows belonging to a baker had been broken . . . was complied with," and they "returned to their homes in triumph." At Margate they threw a miller's effigy dubbed Guy Vaux into the sea. Women frog-marched an errant miller from Trowes to Norwich, one holding over his head a halter supported by a pole; they followed him with shrieks and groans to answer before the mayor. Near Wolverhampton, as a dairyman was carrying butter to market, he was asked the price by some women on the road. When he told them 18 pence a pound, "they immediately seized him and besmeared him all over with his butter and then rolled him in a ditch." These rituals were rooted in the kinds of expressive mentality and culture Medick claims for the preindustrial plebeian culture. Occasionally men seemed to borrow expressive license from women as Natalie Davis suggested. At Bellamarsh in Devon in 1795 a crowd broke the traditional protocol of riot by demolishing a mill's machinery and assaulting the miller. Perhaps because they waived the ordinary restraints, the rioters appeared as women: "from the great number of petticoats, it is generally supposed that several men were dressed in female attire."[54]

As a parallel to women's expressive part in food riots, Deborah Valenze has discovered the crucial neighborhood leadership roles of women in "cottage religion." In cottage religion, women developed and articulated an uninstitutionalized, *unalienated,* personal form of religion. Their neighborhood leadership integrated communities in the insecure world of cottage industry, amid dissolving social ties in

the impersonal contexts of new urban slums and mines.[55] In both riots and cottage religion, not only did women's protoindustrial work give them economic and political leverage in the community, but the nature of their place in the protoindustrial household may have shaped their qualitatively distinct contribution to public plebeian behavior and mores.

If the household economy gave women a role in riots, the nature and degree of force they used was shaped by both differences in issues and variations in community politics. The fracas at Hanborough shows that women could be as physically violent as men, if not more so. Was Southey right to suggest that female rioters were ferocious furies, sheltering behind the immunity of their sex? The anecdotal evidence points both ways. The decorous women at Exeter, who "used no harsh language to the magistrates," did their part to create the now-conventional picture of the disciplined food rioter. By contrast, a great crowd of colliers, women, and children, marched into Haverfordwest from Nook Colliery to intercept a sloop of butter bound for Bristol. They marched down the street with their "oaken Bludgeons . . . Bawling out—One & all—one & all." A physician magistrate, who waded into the crowd to confront them, observed that, "The Women were putting ye men on & were perfect Furies. I had some Strokes from some of them on my Back, but luckily for me my Servant (a stout young Fellow) happened to come into ye street & ran immediately up & kept close behind me & kept ye Women off." A fierce struggle for the bludgeons ensued and some middle-class "Ladies screechd out yt I shd be murder'd, & sent what men they cd muster to my assistance." The crowd was dispersed by the threat that the assembled militia would fire upon them, but class bitterness remained: "During ye Riot a Woman said, yt in a less Time than a Twelvemonth, she shd see ye downfall of all ye Clergy & of every Rich Person. . . . Some of ye Women said they wd have fresh Butter as well as ye Gentry, & wd live as well as ye Gentry." The Totnes popular leaders' fear that women would create confusion has already been mentioned. At the tail end of the 1808 weavers' strike at Manchester, the newspapers lapsed into a contemporary cliché: "The women are . . . more turbulent and mischievous than the men. Their insolence to the soldiers and special constables is intolerable, and they seem to be confident of deriving impunity from their sex." In food rioting at Nottingham in 1800 it was reported that "The women are the principal aggressors, and they are permitted to remain

at liberty."[56] Did these stereotypes reflect the observers' class biases rather than the rioters' behavior?

Probably not. Eyewitnesses recounted plenty of women's violence. When rioters threw down a load of flour at the Yarpole turnpike gates, their female captain told the carter, "We will not hurt you because you are a servant but if your master was here we would kill him." Few rioters were more violent than fifty-four-year-old Hannah Smith of Manchester. In the alarming Luddite year of 1812 Hannah led raids by crowds of men, women, and children on potato shops and carts. "Damn them we will have them for nothing!" she swore, and then threw down a basket of potatoes and carried off an apron-full. She later threatened to have butter and milk for nothing if the shopkeepers would not lower their prices. She exulted that she could raise a crowd in a minute. When someone mentioned a constable, she exclaimed, "I would have him to mind or he will be hanged up I know he will!" Smith served both as expiation and example in that disturbed spring: So far from being immune, she was hanged for the crime of highway robbery instead of being indicted for riot. When sentence was pronounced, the judge declared that her acts seemed "to prove that you were one of the most determined enemies to good order, and it is fit to be understood, that sex is not entitled to any mitigation of punishment, when the crime is of such a nature as to deserve it. . . . [Let others] take warning from your example."[57]

Such anecdotes are suggestive, but they cannot establish patterns. Women's fierce rhetoric about tearing people to shreds was not typically matched by violent assault. Women's riots were significantly less violent than men's, as measured by a simple violence quotient, a ratio between the number of riots involving either of two categories of violence. The more serious violence (category I in table 2) included physical assault on persons; the less serious violence (category II) involved only coercion (such as the forced sales of food in the markets) or property damage. Table 2 shows that riots in which women dominated were more likely to involve the less serious kinds of force rather than personal assault. Conversely, men, either acting alone or with women, were more likely to use violence against persons than were women. In short, the violence quotients for women's riots are strikingly lower than those for riots in which men were involved. Hence the dramatic stories of violent women are exceptions to the more general pattern. Perhaps like other features of women's participation in riots, they provoked comment just because they were exceptional.

Those significant differences in the level and kind of violence between men and women can be explained by the interaction of two factors: the tactics employed in riots over different issues and the contexts of community politics. First, rioters used different physical tactics to deal with different issues. Food riots, for example, typically involved forceful control or damage of property rather than violence against persons.[58] Personal violence was not usually necessary to control markets or food shipments. Food rioters wished to correct rather than to destroy the merchants and farmers who were often their neighbors and upon whom they depended for their food supply. Women most frequently appeared in food riots (see table 1) and so they tended to be involved in those riots that were tactically less violent than other riots.[59] Moreover, food riots were usually successful, so if practical politics is the art of the possible, one might interpret women's specialization in food riots as a form of pragmatism.

However, it is necessary to remember that food rioters applied force rather than merely polite admonition. In the last twenty years revisionist historians have emphasized the discipline of food rioters.[60] That has been an important correction of the bourgeois sociologists of the nineteenth century who depicted crowds as irrational and chaotic. But we may have made the rioters too respectable. We have already seen females stealing food in tiny Aure and carrying off potatoes in Manchester. A second measure, the disorder quotient, compares the number of disorderly food riots (in which rioters stole food or damaged it) with the number of disciplined riots (in which rioters negotiated price reductions, either selling food at just prices and returning the proceeds to the owners or forcing contracts on the

TABLE 2. Crowds' Genders and Degrees of Violence, by Number of Riots

Degree of Violence	Women Dominant (A)	Men and Women (B)	Men Only (C)	Total Women (A + B)	Total Men (B + C)
I. Personal assault, with or without coercion or property damage	10	40	170	50	210
II. Coercion and/or property damage, but not personal assault	27	26	117	53	143
Violence Quotients (I/II):	0.37	1.54	1.45	0.94	1.47

Sources: See table 1.

farmers). It turns out that between 1790 and 1810 there were somewhat more disorderly riots than disciplined food riots.[61]

So it is now time to revise the new orthodoxy of "good" riot discipline by correlating differences in behavior (measured by violence and disorder) with a spectrum of types of community. We shall find that disciplined riots tended to occur in certain kinds of communities, and disorderly riots in others. After the range of community polities has been established, the determinants of women's behavior in riots will emerge more clearly. In order to test the impact of community politics on behavior, I have created four categories of towns classified by population size (small, medium, large), rate of growth (stable, moderate, rapid), and occupational type (agricultural, mixed, industrial/commercial). Hence the four categories are as follows: (1) small agrarian villages, like Long Hanborough; (2) medium-sized, stable, nonagricultural towns, like Exeter; (3) small, rapidly-growing, semi-rural industrial villages, like Aure; and (4) big rapidly-growing industrial or commercial boom towns, like Rochdale. London, always *sui generis,* makes up a fifth category by itself.[62]

If we let physical assault on persons (violence) be the distinguishing criterion, there is a clear statistical correlation between these different kinds of towns and the degree of violence employed by the rioters, as shown in table 3. The level of violence seems to increase with the degree of social instability of the town. In small agrarian villages, for example, riots of all kinds were rare. In both stable medium-sized towns and rural industrial communities a majority of riots witnessed only minor violence (the control of property or coercion of persons, as in forced sales of food) or property damage (many times only broken windows). By contrast, in industrial boom towns and London a majority of riots witnessed more serious violence, including personal assault and significant damage to property. When only food riots are considered (see table 4), a significantly higher proportion of those in the industrial boom towns also involved personal assault.

So more violent riots typically took place in the larger cities. That is partly because of the distribution of conflict issues among the different kinds of towns. Table 5 shows that to be a significant pattern. The towns represented in table 5 witnessed 420, or two-thirds, of the whole sample of riots. Of that subset, the majority of food riots, normally less violent than other riots, took place in medium-sized towns or rural industrial parishes. At the same time, food riots comprised the majority of those towns' riots. By contrast, more violent *kinds* of

TABLE 3. Types of Towns and Degrees of Violence, All Riots

Degree of Violence	Small Agrarian Villages	Medium-Sized Stable Towns	Rural Industrial Villages	Big Industrial Boom Towns	London
I. Personal assault, with or without coercion or property damage	7	37	26	62	99
II. Coercion and/or property damage but not personal assault	12	45	34	59	19
Violence Quotients (I/II)	0.58	0.82	0.76	1.05	5.21

Sources: See table 1. For categories of towns, see note 62.

TABLE 4. Types of Towns and Degrees of Violence, Food Riots Only

Degree of Violence	Small Agrarian Villages	Medium-Sized Stable Towns	Rural Industrial Villages	Big Industrial Boom Towns	London
I. Personal assault, with or without coercion or property damage	2	14	9	16	3
II. Coercion and/or property damage but not personal assault	9	35	24	24	1
Violence Quotients (I/II)	0.22	0.40	0.38	0.67	3.00

Sources: See table 1. For categories of towns, see note 62.

conflict took place in the larger cities. The majority of all military riots took place in big industrial towns or London, partly because recruiting parties were most likely to seek their man-harvest in the biggest towns. Resistance almost always included physical assault. Some eighty percent of all political riots occurred in the big cities, including London, perhaps because they were more likely to be organized for political conflict.[63] Political riots usually included personal assaults designed to intimidate electoral opponents or Radicals. Miscellaneous riots, including brawls, rescues, and attacks on unpopular individuals, occurred primarily in London. So in part, the greater violence in the bigger towns reflects their greater preponderance of more violent kinds of riots—but only in part. Recall that a significantly higher proportion of food riots in the industrial boom towns also involved personal assault.

A full explanation of differences in rioters' behavior must locate them in the varying ecologies of community politics.[64] On the spectrum of community politics, stable medium-sized towns provided optimum conditions for disciplined bargaining by riot. The dense social milieux of small and medium-sized towns such as Exeter endowed rioters with horizontal networks derived from collective experience and vertical networks of patronage that established recip-

TABLE 5. Types of Towns and Riot Issues

Issue	Small Agrarian Villages	Medium-Sized Stable Towns	Rural Industrial Villages	Big Industrial Boom Towns	London	Total
Food	11	53	33	43	5	145
Labor	0	9	2	13	6	30
Military	4	15	16	27	30	92
Political	0	5	4	25	16	50
Miscellaneous	5	9	8	17	64	103
Total	20	91	63	125	121	420

Sources: See table 1. For categories of riots see table 1 and of towns see note 62.

rocal obligations between elites and common people.[65] In the parliamentary borough of Exeter, the Anglican corporation and the Dissenting opposition party polarized the electoral fields of force within which patrons and factions wooed voters and tried to organize them. The municipal charities for both crisis and routine occasions kept corporate patronage ties in repair. The Volunteer companies, militia auxiliaries, created another set of strong horizontal bonds among plebeian rioters, and a variety of vertical ties with their elite (and not-so-elite) commanders. Finally formal and informal trade combinations provided experience in both collective solidarity and negotiation with magistrates and employers. Devon's other small (between two and six thousand people), stable, corporate woolen towns and boroughs had similar social structures. Slow growth allowed their social networks to luxuriate and interlock without disruption. These visible institutional networks, together with the more informal networks of neighborhood mutual aid and community that women did so much to sustain, provided the framework of time-tested memberships and shared perceptions that empowered rioters both to act collectively and coherently and to bargain with magistrates with whom they had longstanding relations.

Such dense community networks made food riots more likely to succeed in controlling prices and supplies. The moral economy of food riots in both its senses—the moralizing of the marketplace and the articulation (and enforcement) of neighborly moral obligations—could really only work in small, stable face-to-face communities where farmers and merchants could be held personally responsible for local food supply both by crowds' physical control and by magistrates' official pressure. Forceful negotiation in riots was a crisis transformation of normal patronage politics with its pragmatic reciprocities.

In the more disciplined behavior typical of such places, rioters observed a protocol of riot partly in order to hold on to the moral high ground of necessity. Dartmouth rioters told a gentleman "that Government had been applied to, long enough and nothing was done for them therefore it was time they shod do something for themselves to keep their families from starving."[66] Restraint was also enforced by a calculus of consequences, sanctions only too available in communities where everyone knew everyone else. Violators of those rules of the game might be punished by loss of favor or patronage.[67] Most tangibly, the politics of justice might seek both to brand and to deter unacceptable violence with an exemplary hanging, as Hannah Smith and the condemned men at Aure illustrate.[68] So the pragmatic pro-

tocol of riot was sanctioned by the rewards and penalties of community politics.

The rural industrial communities of mining and protoindustrial areas shared part of this pattern of orderly disorder, at least the horizontal networks of close community and work groups. The small communities had the traditions of protest and "the capacity to generate such resistance and the social cohesion to be successful. . . . the unmanageable manufacturing districts [had] . . . large concentrations of independent and self-assertive workers . . . [and] little direct economic control, . . . the squire and parson had but little sway. . . ."[69] Hence there was less deterrent to disorderly riot in the form of punishment or the withdrawal of patronage. The common people and the authorities neither knew each other nor had such reciprocal obligations as in the corporate communities. Magistrates might either be absent in such industrial frontier areas or hopelessly partial, as were the clothier magistrates of the West Country who repressed the outrages of 1802.[70] We need to know much more about the community structures and dynamics of such communities. But if the food riots in the rural industrial districts of the west had been orderly in 1766, they were much less so by the end of the century, perhaps because of their rapid growth. In the more stable medium-sized communities, food rioters typically undertook disciplined price-fixing, but in the rural industrial districts disorderly damage and outright theft of food were more frequent.[71]

In the bigger cities like Manchester, Birmingham, and London, both external and internal factors did not foster the disciplined negotiation of food riots in the medium-sized corporate towns. Their ultimate food suppliers were hundreds of miles away, beyond the reach of marching crowds who would enforce the moral economy. Internally, a place like Manchester was run by efficient bourgeois management instead of patronage politics. Social relations were more anonymous. Unfamiliar rioters might escape punishment, and so were less restrained by sanctions, while authorities perceived their community as a city of strangers. In the absence of the reciprocal networks that could support bargaining between crowds and magistrates, rioters engaged in violent destruction, theft, and punitive assault on food vendors rather than disciplined market-regulation within a protocol of riot. The authorities could not negotiate with constituents, and so they used force and charity to manage the masses as faceless objects. Cavalry and soup kitchens stood in for bargaining and patronage.[72] Sanctions were starker because they were weaker.

Magistrates had to resort to judicial terror in the form of hangings to discourage the others. Riots tended to be head-on collisions instead of manipulations of community politics. In sum, different kinds of community dynamics shaped the degrees of rioters' violence and disorder.

This spectrum of community politics helps to explain women's behavior in riots. In agricultural villages and in London women were not prominent rioters. Women were more likely to be found rioting in the other three kinds of towns, where they had opportunities for industrial employment and where the structure of community politics made food riots a viable form of social conflict.[73] Food riots involving women were somewhat more likely to include personal assault in the industrial boom towns than in the medium-sized stable towns or the rural industrial communities.[74] Food riots involving women in both rural industrial districts and big industrial towns were much likelier to include damage or outright theft of food, while rioters in the medium-sized stable towns used more disciplined tactics, forcing merchants and farmers to reduce their prices or seizing and controlling food prior to bargaining with the magistrates. These patterns are reflected in the disorder quotients in table 6.

TABLE 6. Gender and Disorder in Food Riots

Disorder	Small Agrarian Villages		Medium-Sized Stable Towns		Rural Industrial Villages		Big Industrial Boom Towns		London		Total	
	W	M	W	M	W	M	W	M	W	M	W	M
I. Damage or theft of food	2	4	5	6	6	11	17	18	1	1	31	4
II. Control of food: forced sale or agreement	0	2	7	13	3	8	1	4	0	0	11	2
Total	2	6	12	19	9	19	18	22	1	1		
Disorder Quotients (1/II):												
Women's riots	∞		0.71		2.0		17.0		∞			
Men's riots		2.0		0.46		1.38		4.5		∞		

Sources: See table 1.

Note: Riots involving both men and women are counted for both genders.

Women's behavior in food riots thus seems to fall into two distinct modes, reflecting the divergent effects of industrialization on their political capacities. In the first mode, that of more cohesive traditional towns like Exeter, women and food riots were organic to community politics. Proto-industrial employment strengthened women's political status, while community structures enabled their food riots to be practical politics. Small to medium-sized stable protoindustrial towns best provided that continuity between household and marketplace discussed earlier. In these stable towns women entered the marketplace, often with men, as proto-citizens of an integrated community and observed the protocol of riot inscribed in the framework of community politics. They bargained successfully with food vendors and magistrates, perhaps forcing sales of food at reduced prices, but with little violence or disorder.

In the second mode, in the big industrial boom towns, the food riots that took place were often led by women, and these riots were often bitterly violent, like the episode at Rochdale. At Manchester in 1795, crowds composed mostly of women turned a deaf ear to the magistrates, flung potatoes about, and smashed the windows and doors of grain merchants' homes and warehouses. They were subdued only by a cavalry charge. In June, 1800, violent women again disrupted the magistrates' attempts to restore order in the potato market, abusing those who did cooperate and stealing potatoes. Mostly female crowds at Nottingham in September, 1800, broke shop windows, stole bread, scattered adulterated flour, and plundered barges and warehouses. At Birmingham during the food riot of June, 1795, an old woman selling gingerbread yelled at the soldiers in the street: "Ah you———, give us bread to eat; let the poor people alone, you———." When the soldiers laughed, she threw her stool at them and retreated, "uttering the grossest imprecations." Another woman, leaning out of a window flanked by her children, held out a sixpenny loaf and exclaimed, "Here, you———, take this to your officers, and tell them we want more bread for 6 pence. You———, you have got my husband, and me and my children are starving." At the end of that riot troops shot two members of a crowd, one fatally, when they attempted to rescue some arrested rioters. One Margaret Boulker was hanged for participating in the attack on James Pickard's steam flour mill.[75]

But in such boom towns, both women and food riots were increasingly vestigial and peripheral to changing community politics, as they had already become in London.[76] In 1800 in Manchester a

committee of organized craftsmen warned their brother workmen against the folly of food riots, "which would aggravate the evil by deterring the merchant."[77] Male workers in Manchester were already beginning to organize to defend wages rather than food prices. In the mushroom towns of the Industrial Revolution women might be empowered by industrial employment but they were also bereft of the patronage and neighborhood networks that held together the traditional towns and that might alternately reward restraint or punish excess. They were free laborers—free to sell their labor on the market, free to act, free of supporting or restraining networks. The erosion of the moral economy and its supporting social framework in the big towns made food riots obsolescent. Although women continued to lead food riots, they were left marooned in a traditional form of protest, while their brothers and fathers formed more modern political and labor associations to take up their cudgels on the frontier of the capitalist labor market. Women continued to be assertive but they were citizens of a community politics whose efficacy decayed as the alienation between elites and masses grew.

Now, finally, there is the question of repression. Were women immune on account of their sex, as Southey suggested? Did the common designation of women in court records as "Margaret, the wife of John Wilson of Methley, labourer" imply that women were not considered fully, legally responsible for their acts? The firing on the crowd at Rochdale and the hangings of Hannah Smith and Margaret Boulker suggest the contrary.

In general, magistrates were no respecters of gender. Women were not immune from repression. Indeed, women were often treated as harshly as men when it came to the repression of riots. At the scene of the riot, magistrates were somewhat more likely to negotiate peacefully with crowds that included women than they were with crowds that consisted of men only (see table 7). In part that was because women appeared most often in food riots, and the pathway towards peace was easier in food riots than in, say, impressment riots: magistrates could compromise the property rights of food merchants more easily than the requirements of the navy. However, when compromise failed, as at Manchester and Rochdale, magistrates might use military force against women. Crowds that included women were as likely to be fired upon or forcibly dispersed by troops as all-male crowds (table 7).

The most frequent form of repression was the arrest of crowd leaders. Magistrates arrested rioters as frequently in crowds that

included women as in all-male crowds (see table 7). Both the magistrates and popular opinion certainly regarded arrested women as co-leaders of the riots and hence as fit subjects for exemplary punishment. In a typical case at Dudley in the Black Country, after a riot led by colliers, "four men and a woman, the most active in the riot were apprehended." After a serious riot at Lane End in the Potteries, seven of the leaders, four men and three women, were taken prisoner and held for trial, despite an anonymous letter that demanded their release. The only one to be convicted at the summer assizes was a woman named Emma Birks, who was sentenced to be hanged but then was reprieved by the judge and transported for life instead. More work remains to be done on the politics of justice in riot cases, but my impression from the dozen or so assize circuits and quarter sessions archives I have searched is that the majority of arrested rioters brought to trial were men; perhaps that is because the majority of food rioters were male.[78] More generally the presence of women in mobs did not induce the magistrates to treat them more gently. The evenhandedness of that treatment reinforces the conclusion that, even negatively, women in riots were regarded as nearly equal to men.

What can we conclude about women in the politics of riot? Women's roles and their political leverage in riots declined as industrialization and urbanization transformed work and community politics. Such material factors had more influence on working women's political status than ideology and attitudes. Generally what enabled people to act collectively, what shaped the nature of their actions, and what determined their success (and hence the likelihood of repetition) were not simply the ideas or grievances they had in their heads. Ideologies

TABLE 7. **Gender and Repression**

Magistrates' Actions in Riots	All Women's Riots (n = 106)		All Men's Riots (n = 367)	
	No.	(Percent)	No.	(Percent)
Peaceful negotiations, no force	57	(53.7)	138	(37.6)
Arrests	62	(58.5)	202	(55.0)
Forcible dispersal or shooting	22	(20.8)	62	(16.9)

Source: See table 1.

Note: Arrests might also have been involved in these incidents, so totals add to more than 100 percent.

such as the moral economy or particular grievances over hardships or injustices were always much more widespread than the capacity to take effective collective action to remedy such problems. What was necessary for collective action was the capacity to mobilize previously forged relationships, horizontal and vertical, for political leverage.[79]

In this transitional period of industrialization, riots were the dominant mode of collective popular politics; they focused on the concrete welfare of local communities. Economic, social, and ultimately political relationships shaped women's patterns of action in the fundamental politics of riot. Enfranchised by their essential role in the family economy, women entered into this politics as determined and militant citizens, or perhaps proto-citizens, but they did so selectively. They participated almost exclusively in the central form of collective action that defended the family economy—the food riot. They entered the marketplace, beating pans and shovels or carrying a mourning loaf, or perhaps preceded by the town crier, not as housewives but as full-fledged contributors to the family income. But they were hardly alone in that defense; food riots were not markedly feminine. The household economy was defended by the whole household, not by a housewife. Repression also did not know gender. That reinforces the conclusion that women in this period were nearly equal citizens in the arena of community politics rather than having a distinctively sex-differentiated role.

Community ecology was decisive in the way gender entered into the politics of riot. If women's political standing was created initially by relatively undifferentiated work roles, it was shaped ultimately by distinctive local political contexts. The variegated process of industrialization was creating a wide spectrum of different kinds of communities with different patterns of social relations. At both ends of the spectrum of community types, women were not very active. In agrarian villages, not many riots took place. In London women rarely appeared, perhaps because food riots were rare while military and political riots were more common. It was in the other kinds of towns, but for contrasting reasons, that women acted in riots. In the stable traditional manufacturing towns women's key roles in household economies merged into membership in the community polity. Disciplined food riots reflected both empowerment and restraint by the dense network of community ties. But the first generation of rapid urbanization stripped common people of their collective social identities, of the proto-citizenship they had wielded in traditional prein-

dustrial towns. In the raw frontier boom towns of the Industrial Revolution, direct-action politics were supplemented and ultimately superceded by institutionalized protest based on associations such as reform movements and trade unions that were formed around particular interests rather than on communities of multivalent networks. From those associations women were generally absent. And so in industrial boom towns women entered the marketplace as liberated weavers or nailmakers, but without sustaining and restraining networks. Hence food riots were more desperate, violent, and disorderly. Men were beginning to depart from those very same food market crowds in favor of labor and political movements. Food riots became increasingly obsolescent politically. They tended to be left to women, who were thus stranded on the ragged frontier of class alienation that appeared in the industrial boom town. Ironically, when and where food riots did become feminine, it was a symptom of women's political weakness rather than their strength.

Notes

I am very grateful to Kathleen Emmett, James Farr, and Cathy Matson and to my colleagues at the Bellagio conference for helping me clarify the argument of this essay. I appreciate Kathryn Kidd's technical advice. A different version of this essay was first published in *Past and Present: A Journal of Historical Studies* 120 (August, 1988): 88–122. World Copyright: The Past and Present Society, 175 Banbury Road, Oxford, England. I am grateful to the editors of *Past and Present* for permission to reproduce parts of that article. I thank the Trustees of the British Museum for permission to reproduce the prints by Gillray and Cruikshank.

 1. Maxine Berg, *The Age of Manufactures: Industry, Innovation and Work in Britain, 1700–1820* (London: Fontana Press, 1985).

 2. See te Brake, Dekker, and van de Pol in this volume.

 3. Theorists of revolution such as Theda Skocpol and Lawrence Stone emphasize the necessity of a crisis of state, of a collapse of the government, in order for a radical revolution to take place. Theda Skocpol, *States and Social Revolutions: A Comparative Analysis of France, Russia, China* (Cambridge: Cambridge University Press, 1979), 24–32, chap. 2, and 285; and Lawrence Stone, "The English Revolution," in *Preconditions of Revolution in Early Modern Europe,* ed. Robert Forster and Jack P. Greene (Baltimore: Johns Hopkins University Press, 1970), 56–57, 64.

 4. Malcolm I. Thomis and Jennifer Grimmett, *Women in Protest, 1800–1850* (London: Croom Helm, 1982), 11, 109–10; John Bohstedt, *Riots and*

Community Politics in England and Wales, 1790–1810 (Cambridge, Mass.: Harvard University Press, 1983), 112–15; Jane Rendall, *The Origins of Modern Feminism: Women in Britain, France, and the United States, 1780–1860* (London: Macmillan, 1985), 55–72, 235.

5. E. P. Thompson, "The Moral Economy of the English Crowd in the Eighteenth Century," *Past and Present* 50 (February, 1971): 78.

6. University of Nottingham, Portland Papers, PwF 9847, Richard Eastcott, Jr., March 28, 1795.

7. Public Record Office, London (hereafter P.R.O.), H.O. 42/62, Thomas Kitson, May 1, 1801, and H.O. 42/62/254, Giles Welsford, miscellaneous documents, n.d. Cf. Bohstedt, *Riots and Community Politics,* 28–31.

8. *Manchester Mercury,* August 11, 1795. Thirteen years later when a weavers' strike spread across the cotton district, Rochdale experienced the most bitter and violent episode of the series: the local jail was burned to the ground. That bitterness was probably a residue from the arrogant and unnecessary killings of 1795.

9. Bohstedt, *Riots and Community Politics,* 85–95, 205.

10. *London Chronicle,* November 17–19, 1795, and P.R.O., Assize 5/116, Gloucestershire, indictment of Thomas Yemm et al., and deposition of William Woodward, Lent 1796.

11. P.R.O., Assize 5/116, Oxfordshire, indictment of Ann Cockhead et al., depositions of Thomas Higgins et al., Lent 1796.

12. Shootings by the forces of order took place in only 33 (about 6 percent) of the 617 riots in my national sample.

13. J. L. Hammond and Barbara Hammond, *The Village Labourer,* 4th ed. (London: Longmans, Green, 1927; reprint, 1966), 116–17; Thompson, "Moral Economy," 115–16; Robert Southey, *Letters From England,* 2 vols. (London, 1814 ed.), 2:47, quoted in Thompson, 116; Natalie Zemon Davis, *Society and Culture in Early Modern France* (Stanford: Stanford University Press, 1975), 124–51.

14. John Stevenson, "Food Riots in England, 1792–1818," in *Popular Protest and Public Order: Six Studies in British History, 1790–1820,* ed. R. Quinault and J. Stevenson (London: George Allen and Unwin, 1974), 49; David Jones, *Before Rebecca: Popular Protests in Wales, 1793–1835* (London: Allen Lane, 1973), 33–34.

15. Jane Humphries, "The Working Class Family, Women's Liberation, and Class Struggle: The Case of Nineteenth Century British History," *Review of Radical Political Economics* 9 (Fall 1977): 38.

16. Thomis and Grimmett, *Women in Protest, 32–34;* Kenneth Logue, *Popular Disturbances in Scotland, 1780–1815* (Edinburgh: John Donald, 1979), 199–203; Rendall, *Origins of Modern Feminism,* 201.

17. That estimate is based on the comparison of the relevant parts of my national sample with local studies based on more complete local records. See Bohstedt, *Riots and Community Politics,* 230n.6. My definition of riot, rather than the common law standard of three or more people acting together or

the Riot Act's specification of twelve, fits the way contemporaries routinely used the word "riot" in the newspapers and in correspondence I have read for this period.

18. Berwick, Northampton, and Carlisle: *London Courier*, July 23 and 28, August 5, 1795; Wells: *Norfolk Chronicle*, December 19, 1795, and P.R.O., H.O. 42/37, Marquess Townshend, December 16, 1795.

19. In ten riots at least two issues were at stake, as at Rochdale. I arbitrarily assigned them to the category of the more salient issue.

20. Birmingham: *Morning Chronicle*, June 25, 1795; Diss: *Cambridge Intelligencer*, October 24, 1795.

21. Ivy Pinchbeck, *Women Workers and the Industrial Revolution, 1750–1850* (London: George Routledge and Sons, 1930), 166.

22. W. Hutton, *History of Birmingham* (Birmingham, 1781; 1835 ed.), 192, quoted in K. D. M. Snell, *Annals of the Labouring Poor: Social Change and Agrarian England, 1660–1900* (Cambridge: Cambridge University Press, 1985), 297; Marie B. Rowlands, *Masters and Men in the West Midland Metalware Trades before the Industrial Revolution* (Manchester: Manchester University Press, 1975), 160–61; Pinchbeck, *Women Workers*, 270–81.

23. Snell, *Annals of the Labouring Poor*, 279–82, 292–93, 303; W. H. Pyne, *Microcosm: or, A Picturesque Delineation of the Arts, Agriculture, Manufactures, &c. of Great Britain* (London, 1808; reprint, Luton: Luton Museum, 1974), pls. 4, 10, 13, 17.

24. Just as their great-granddaughters in late Victorian Lancashire were the leading trade unionists and suffragists among women workers. See Jill Liddington and Jill Norris, *One Hand Tied Behind Us: The Rise of the Women's Suffrage Movement* (London: Virago, 1978).

25. They were fined only a shilling and put on their recognizances to keep the peace. P.R.O., Assize 5/116, Worcestershire, indictments, depositions, and recognizances, Lent 1796. Most of these women were identified as widows and spinsters. Did single women have a distinctive role in community politics? See Olwen Hufton, "Women without Men: Widows and Spinsters in Britain and France in the Eighteenth Century," *Journal of Family History* 9 (1984): 355–76.

26. Bradford and Trowbridge: *London Courier*, July 24, 1795; Bromsgrove: P.R.O., Assize 5/116, Worcestershire, information of John Wall, Lent 1796; Woburn: *Morning Chronicle*, July 24, 1795.

27. Snell, *Annals of the Labouring Poor*, 22, 40, 53, 57n.54, 64, 406–7, but cf. 48.

28. Devon Record Office, Exeter, 1262M/L5, Lord Clifford to Lord Fortescue [ca. April 14, 1795], and Quarter Sessions rolls, Midsummer 1795; P.R.O., Assize 24/43, Devon, Summer 1793; *London Courier*, April 22, 1795; *Exeter Flying Post*, April 16, 1795.

29. Hans Medick, "The Proto-Industrial Family Economy," in *Industrialization before Industrialization: Rural Industry in the Genesis of Capitalism*, ed. Peter Kriedte, Hans Medick, Jürgen Schlumbohm, trans. Beate Schempp (Cam-

bridge: Cambridge University Press, 1981), 38–44; Wally Seccombe, "Patriarchy Stabilized: The Construction of the Male Breadwinner Wage Norm in Nineteenth-Century Britain," *Social History* 11 (January, 1986): 53–76; David Levine, "Production, Reproduction, and the Proletarian Family in England, 1500–1851," in *Proletarianization and Family History*, ed. David Levine (Orlando: Academic Press, 1984), 97, 118; and John R. Gillis, "Peasant, Plebeian, and Proletarian Marriage in Britain, 1600–1900," in Levine, *Proletarianization*, 138, 155–56.

30. Lindsey Charles and Lorna Duffin, eds., *Women and Work in Pre-Industrial Britain* (London: Croom Helm, 1985), 17–19, 196–97, 202; David Levine, "Industrialization and the Proletarian Family in England," *Past and Present* 107 (May, 1985): 175–76; Eric Richards, "Women in the British Economy since about 1700: An Interpretation," *History* 59 (1974): 337–46; Berg, *Age of Manufactures*, 136.

31. David Vincent, *Bread, Knowledge and Freedom: A Study of Nineteenth-Century Working Class Autobiography* (London: Methuen, 1981), 55, 79–86.

32. Medick, "Proto-Industrial Family Economy," 63; Gillis, "Peasant, Plebeian, and Proletarian Marriage," 138.

33. Snell, *Annals of the Labouring Poor*, 303–5; Olwen Hufton, "Women and the Family Economy in Eighteenth-Century France," *French Historical Studies* 9 (Spring 1975): 1, 17.

34. Gillis, "Peasant, Plebeian, and Proletarian Marriage," 138, 140, 146, 150; Joan W. Scott and Louise W. Tilly, "Women's Work and the Family in Nineteenth-Century Europe," *Comparative Studies in Society and History* 17 (1975): 46, 48; Berg, *Age of Manufactures*, 155–56; Maxine Berg, Pat Hudson, and Michael Sonenscher, *Manufacture in Town and Country before the Factory* (Cambridge: Cambridge University Press, 1983), 3, 16.

35. Levine, "Industrialization and the Proletarian Family," 177–79; Seccombe, "Patriarchy Stabilized," *passim;* Richards, "Women in the British Economy," 346–51.

36. Martha Vicinus, "Introduction," in *Suffer and Be Still: Women in the Victorian Age*, ed. Martha Vicinus (Bloomington: Indiana University Press, 1972), xii.

37. Medick, "Proto-industrial Family Economy," 62–63.

38. Hufton, "Women and the Family Economy," 11; Rendall, *Origins of Modern Feminism*, 150; Caroline Davidson, *A Woman's Work Is Never Done: A History of Housework in the British Isles, 1650–1950* (London: Chatto and Windus, 1982), 185–86, 204; Berg, *Age of Manufactures*, 156–57; Medick, "Proto-Industrial Family Economy," 41.

39. Besides Thompson, "Moral Economy," see John Stevenson, *Popular Disturbances in England, 1700–1870* (London: Longman, 1979), 101. Shopping is not treated as the duty of preindustrial women in either Ann Oakley, *Women's Work: The Housewife, Past and Present* (New York: Pantheon, 1974), or Davidson, *Woman's Work.*

40. Thompson, "Moral Economy," 77; Bohstedt, *Riots and Community Politics, passim.* My own frequency counts of some four hundred mobs' start-

ing points suggest that in about three out of four cases, crowds assembled purposely to deal with the issue, rather than originating from routinely gathered groups. For food riots the proportion was nine in ten.

41. Compare riots over government bread policies in Egypt, Poland, East Germany, Venezuela, Jordan, and the Sudan in more recent times.

42. Martine Segalen, *Love and Power in the Peasant Family: Rural France in the Nineteenth Century*, trans. Sarah Matthews (Oxford: Basil Blackwell, 1983) 138–42.

43. Berg, *Age of Manufactures*, 165–67; Robert W. Malcolmson, *Popular Recreations in English Society, 1700–1850* (Cambridge: Cambridge University Press, 1973), 31, 32, 56, 86. I am grateful to my Bellagio colleagues, Rudolf M. Dekker, Lotte C. van de Pol, and Wayne Ph. te Brake, for the notion that women were the makers of informal social networks of gossip and social regulation that organized urban neighborhoods, and that such networks contributed to the solidarity of food riot crowds. See their essay in this volume, and Rudolf M. Dekker, "Women in Revolt: Popular Protest and Its Social Basis in Holland in the Seventeenth and Eighteenth Centuries," *Theory and History* 16 (1987): 349–53. Cf. Bohstedt, *Riots and Community Politics*, 40–41, 68, 93–94. It was the women in the crowd who were especially vehement in "expressing their detestation" of homosexuals arrested in Vere Street, London, in 1810. *Morning Chronicle*, July 10, 1810.

44. Hans Medick, "Plebeian Culture in the Transition to Capitalism," in *Culture, Ideology and Politics: Essays for Eric Hobsbawm*, ed. Raphael Samuel and Gareth Stedman Jones (London: Routledge and Kegan Paul, 1982), 92.

45. Bohstedt, *Riots and Community Politics*, 49–51.

46. Women do not appear among the nearly four hundred labor combinations in eighteenth-century England surveyed in C. R. Dobson, *Masters and Journeymen: A Prehistory of Industrial Relations, 1717–1800* (London: Croom Helm, 1980).

47. William Marshall, *The Rural Economy of the West of England*, 2 vols. (London, 1796), 1:29, quoted in Pinchbeck, *Women Workers*, 166; Sheila Lewenhak, *Women and Trade Unions: An Outline History of Women in the British Trade Union Movement* (London: Ernest Benn, 1977), 15–27.

48. A questionnaire of 1802–3 found 1,053 friendly societies in England and Wales with 104,776 members, among which were 89 female societies with 9,257 members. The figures for thirteen key cotton towns in Lancashire and Cheshire are as follows: 396 societies with 37,845 members; 38 female societies with 4,535 members. In twenty-eight of Devon's riotous towns were 204 societies with 16,691 members, including 22 female societies with 1,613 members. These figures show that female societies enrolled about 10 percent of friendly society members. No doubt some women were hidden as members of some of the nonfemale societies. It would be surprising if the figures collected were completely accurate or complete, but the proportions ought to be usable. The figures are from the "Abstract of Answers and Returns . . . Relative to the Expence and Maintenance of the Poor in England," *Parliamentary Papers*, 1803–4, vol. 13.

49. Gerald M. Sider, "Christmas Mumming and the New Year in Outport Newfoundland," *Past and Present* 71 (May, 1976), 124–25.

50. Bohstedt, *Riots and Community Politics,* 211; Levine, "Industrialization and the Proletarian Family," 179; Medick, "Proto-Industrial Family Economy," 41.

51. Medick, "Plebeian Culture," 85–86, 89, 93.

52. Vincent, *Bread, Knowledge, and Freedom,* 80; Levine, "Industrialization and the Proletarian Family," 176.

53. Scott and Tilly, "Women's Work," 59.

54. Nottingham, 1795: *London Courier,* July 26, 1795; Nottingham, 1812: Thompson, "Moral Economy," 135; Gainsborough: *York Courant,* July 27, 1795; Newcastle: Stevenson, *Popular Disturbances,* 105; Hastings: *London Chronicle,* May 17–19, 1796; Margate: *Morning Chronicle,* September 26, 1800; Trowes: *Cambridge Intelligencer,* April 23, 1796 and *Norfolk Chronicle,* April 23, 1796; Wolverhampton: *London Packet,* September 22, 1800; Bellamarsh: *London Chronicle,* April 18, 1795. Cf. Dekker, "Women in Revolt," 343. The evidence does not permit us to conclude that only women added such flourishes. It may be that men, however, favored military emblems like flags. Several Wolverhampton men were accused of entering the market blowing a horn and carrying a red flag and a bread roll on a spiked pole. P.R.O., Assize 5/120/4, Staffordshire, deposition of Benjamin Stokes et al., Lent 1800.

55. Deborah Valenze, "Pilgrims and Progress in Nineteenth-Century England," in Samuel and Jones, *Culture, Ideology and Politics,* 113–26; and Deborah M. Valenze, *Prophetic Sons and Daughters: Female Preaching and Popular Religion in Industrial England* (Princeton: Princeton University Press, 1986).

56. Haverfordwest: P.R.O., H.O. 42/35, John Philipps, August 24, 1795; Manchester: *Annual Register* (1808): 64; Nottingham: *London Packet,* September 3–5, 1800.

57. Yarpole: P.R.O., Assize 5/115/1, Herefordshire, indictments and depositions, Summer 1795, and H.O. 42/35, Lord Bateman, July 13, 1795; Hannah Smith: *Leeds Mercury,* June 6, 1812, quoted in Thomis and Grimmett, *Women in Protest,* 44; P.R.O., T.S. 11/3582, case against Hannah Smith.

58. Fewer than one-third of the food riots involved personal assaults. Nearly half the labor riots involved personal assaults. By contrast, more than three of every four military riots and more than two of every three political and miscellaneous riots involved personal assault. The violence quotients are 0.43, 0.91, 3.13, 2.05, and 2.18, respectively, for these five categories of riots.

59. For some discussion of why women were involved in food riots more than other kinds of riots, see John Bohstedt, "Gender, Household and Community Politics: Women in English Riots, 1790–1810," *Past and Present* 120 (August, 1988): 113–19.

60. George Rudé, *The Crowd in History: A Study in Popular Disturbances in France and England, 1730–1848* (New York: John Wiley and Sons, 1964), 252–57, and Thompson, "Moral Economy," 112–13; Stevenson, *Popular Disturbances,* 105.

61. Viz., ninety-three riots in which food was seized outright or damaged, as against eighty-three riots in which food was sold, negotiated, or controlled. (In forty-eight of the former both elements were involved.)

62. Specifically, *small agrarian villages* are defined as those with populations of up to 3,000, growth rates of up to 10 percent between 1801 and 1811, and more families employed in agriculture than in manufacturing according to the census of 1811. *Medium-sized stable towns* include populations of 1,500–10,000, growth rates of up to 10 percent, and more families in trade and manufacture than in agriculture. *Rural industrial villages* have populations up to 3,000, growth rates over 10 percent, and more families in trade and manufacture than in agriculture. *Big industrial boom towns* have populations of 10,000–100,000, growth rates of more than 10 percent, and at least twice as many families in trade and manufacture as in agriculture. *London* forms a fifth category, with a population of 900,000, a growth rate of 16.7 percent, and a heavily nonagricultural population. (The growth rate of England's and Wales' population in this period was 14 percent.) Of course many towns fall outside these categories, but towns in these categories witnessed two-thirds of the riots in the national sample. Population figures for each town or parish are taken from the enumeration sections of the censuses of 1801 and 1811, and the occupational ratios for each place compare the number of "Families Chiefly Employed in Trade, Manufactures or Handicraft" with the number of "Families Chiefly Employed in Agriculture," as given in the census of 1811.

63. See Bohstedt, *Riots and Community Politics*, chap. 5, and 204, 206.

64. Ibid., chap. 2, esp. 44–51, and chap. 4.

65. By patronage I mean the broad and multiform kinds of tangible vertical friendship discussed by Harold Perkin, *The Origins of Modern English Society, 1780–1880* (London: Routledge and Kegan Paul, 1969), 44–51.

66. Bohstedt, *Riots and Community Politics*, 37, and cf. 29, 34, 38.

67. For social control by patronage, see ibid., 48–49.

68. For the calculus of justice, see ibid., 64–65.

69. Andrew Charlesworth and Adrian J. Randall, "Comment: Morals, Markets and the English Crowd in 1766," *Past and Present* 114 (February, 1987): 205.

70. Adrian J. Randall, "The Shearmen and the Wiltshire Outrages of 1802: Trade Unionism and Industrial Violence," *Social History* 7 (October, 1982): 288.

71. For 1766; see Charlesworth and Randall, "Comment," 209–11. The disorder quotients (ratios of riots involving damage or theft of food to riots involving only control of food) for food riots in the three types of communities are as follows: medium-sized stable towns, 9/17 or 0.53; rural industrial villages, 11/9 or 1.22; and big industrial boom towns, 23/4 or 5.75. See also table 6.

72. Bohstedt, *Riots and Community Politics*, chap. 4.

73. Women appeared in three of the nine food riots (33 percent) in agrarian villages and London for which gender is reported. By contrast,

women appeared in fourteen of thirty food riots (47 percent) in the stable medium-sized towns; thirteen of twenty-seven (48 percent) in the rural industrial villages; and twenty-two of thirty-two (69 percent) in the industrial boom towns. Among eight mixed crowds in the boom towns, women dominated six.

74. Of food riots involving women in which the rioters' behavior is known, eleven of twenty (55 percent) in the industrial boom towns included physical assault on people, while only six of fourteen (43 percent) of the riots in medium-sized stable towns did. Four of thirteen (31 percent) of women's riots in rural industrial villages included personal assaults.

75. Manchester: *Manchester Mercury,* August 4, 1795, and June 3, 17, and July 29, 1800, and P.R.O., H.O. 42/35, Nathan Crompton, July 30, 1795; Nottingham: Bohstedt, *Riots and Community Politics,* 206; Birmingham: *Morning Chronicle,* June 25, 1795, and *Birmingham Gazette,* August 10, 17, 1795.

76. London witnessed only five food riots among 121 of all kinds. Bohstedt, *Riots and Community Politics,* 208.

77. *Manchester Gazette,* December 14, 1799. In sociological terms, men had moved from communal to associational forms of solidarity for collective action. For that typology, see Charles Tilly, "Collective Violence in European Perspective," in *Violence in America: Historical and Comparative Perspectives,* rev. ed., ed. Hugh Davis Graham and Ted Robert Gurr (Beverly Hills: Sage Publications, 1979), 107–8.

78. Dudley: *Birmingham Gazette,* September 21, 1795; Lane End: *London Packet,* May 9–12, 1800. *Birmingham Gazette,* May 5, August 25, 1800, and P.R.O., Assize 5/120/5, Staffordshire, indictments, Summer 1800. In Devon, for instance, of fifty-four rioters committed for trial in 1795 and 1801, only seven were women. Bohstedt, *Riots and Community Politics,* 38. But at Manchester, nine women were among twelve people charged for riots of July, 1795. Lancashire Record Office, Preston, Quarter Sessions rolls, indictments of George Potts et al., and Ann Prestwick et al., October, 1795.

79. Many sociologists have begun to explain social movements in terms of the organizational resources that enable disgruntled people to *act* instead of emphasizing solely the mental states of protestors (including motivations, interests, relative deprivation, social psychology, and ideology). See John D. McCarthy and Mayer N. Zald, "Resource Mobilization and Social Movements: A Partial Theory," *American Journal of Sociology* 82 (May, 1977): 1212–41; Charles Tilly, *From Mobilization to Revolution* (Menlo Park, California: Addison-Wesley, 1978); and Bohstedt, *Riots and Community Politics,* 40–51, 202–3, 222–23.

Masculine and Feminine Political Practice during the French Revolution, 1793–Year III

Dominique Godineau

The thoughts presented here are based on a book about women of the popular classes in revolutionary Paris.[1] In that larger work, I analyzed the influence of the Revolution on women's everyday lives with their families and at work. This study of women of the people promotes a better understanding of their role in the revolutionary movement, including their political, social, and economic aspirations, which often were determined by their status as women. Only a few women claimed the right to vote during the Revolution. Nevertheless, the question of their citizenship always faces the historian because a problem keeps recurring: how was it possible to be a *citoyenne,* how was it possible for women to become involved in political life, without acquiring all the attributes of citizenship?

An important women's movement, for too long forgotten in the historiography, existed at the heart of the revolutionary movement. During certain periods, nothing distinguished this women's movement from the whole of the popular movement in Paris; at other times it stood out. One such moment was October, 1789, when women marched to Versailles and returned with the King; another was the spring and summer of 1793, when groups of militant women were very strong and a minority of *sans-culottes* went so far as to argue that women as well as men could participate in politics. Finally, the great insurrection of Prairial (May 20–23, 1795) represented the apogee of this feminine revolutionary movement; the failure of this insurrection marked the end of women's interventions in the Revolution. During these three revolutionary moments, women of the people left their mark in the documentation, either because they turned up suddenly in police reports or in remarks under the category "women," or because their numbers rose in the arrest records. This emergence of women as a group reflects the specific interven-

tions of women of the popular classes in the revolutionary process. Their intervention can be viewed chronologically, but also in terms of certain defining characteristics, which I will analyze here as part of the history of the popular movement during the French Revolution, and which allow us to grasp that movement in its entirety.

The popular movement was composed of both men and women. However, while the distinction between active and passive citizens was abolished on August 10, 1792, giving all men the right to vote and to bear arms (attributes inherent in citizenship as it was defined during the Revolution by participants in the popular movement), women were legally excluded from these two fundamental rights. Nonetheless they behaved as citizens. Under such circumstances, how did women participate when they possessed an incomplete citizenship? To what extent were their interventions in the Revolution determined either by the idea of citizenship or by women's traditional status as mothers and nurturers? Did militant *citoyennes* act out of political consciousness, or were they acting as mothers of families whose behavior was socially and culturally programmed?

The Declaration of the Rights of Man and of the Citizen created a new political space. Were women, who did not enjoy political rights, integrated into this political space, and if so, how?[2] Did their incomplete citizenship lead women to develop an original practice of politics? If so, did this practice influence the course of the Revolution?

At the outset, I want to identify the women in question here; all women did not have the same interests or engage in the same behaviors during the Revolution. The findings presented here concern only women of the popular classes in Paris. The majority were working women: seamstresses and laundresses, but also skilled artisans (polishers, book binders, etc.), merchants or domestics who enjoyed an extremely full social existence that was related to their political participation and which linked them with men within the popular movement. In itself, this social factor neither accounts for all aspects of women's participation nor avoids the contradictions that arise when one studies "women" without being more precise about the use of the term. When the revolutionaries used the generic term "women," they were not referring always to the same women. Unless we try to identify these women politically, we might just as plausibly say that women were on the side of the most advanced revolutionaries as that they were allied with the counter-revolutionaries. We can leave aside the

counterrevolutionaries; if we place any credence in arrest records, counterrevolutionaries were in the minority among women of the popular classes in Paris, who reveal themselves essentially through their attachment to the Revolution. I should add that not all Parisian women of the popular classes demonstrated the same degree of revolutionary involvement; furthermore, the motives behind their interventions could differ. Therefore I have identified three overlapping groups of women participants: prominent militant women (*militantes marquantes*), militant women who formed the base of this group (*militantes de base*), and the popular masses of women (*masses populaires féminines*).

In revolutionary historiography, the term militant is generally applied to lists of those present in the general assemblies of the sections. This criterion is not operative for women, who did not vote. Figures of revolutionary women activists nonetheless stand out strikingly. I therefore have designated as militants those women who meet different criteria. The first and classic criterion is membership in popular societies. I have enlarged this group to include women habitually in attendance in the galleries of the revolutionary assemblies (*habituées des tribunes*). Participation in at least two insurrectionary *journées* is another criterion. Additional indicators are terrorist remarks of a political character, and the practice of denunciations when these acts are accompanied by other elements characteristic of *sans-culotte* mentality. The militant woman is therefore one who has a more or less sustained involvement in politics, and whose presence in the archival records is not simply the result of passing anger provoked by counterrevolutionary remarks, high prices, or scarcity.

From these militant women a minority of *citoyennes* emerges, women who were particularly active and self-consciously aware and who met all the various criteria mentioned. They went nightly to the galleries of the clubs (the Jacobins or the Cordeliers) or the section assemblies and intervened in all areas of life in their sections, where they were known for energetically propagating their Jacobin opinions. They possessed a solid political culture and used revolutionary concepts without much difficulty. Their presence is striking in the historical documentation; they can be traced in various archives and during different time periods. These were individual women who did not really comprise a group; their involvement hardly differed from that of men taken individually. However, their ages were different;

the militant *sans-culotte* was a young "father of a family,"[3] while the militant woman was either past the age of needing to spend time with several young children or not yet a mother.

Other women met only one or two of these criteria. They were the militant women who constituted the base of the group (*militantes de base*). Although they were not regulars in the galleries (*habituées des tribunes*), they listened to debate in the societies and assemblies when they had time, when the subject seemed interesting to them, or, as in the summer of 1793, when popular mobilization was particularly strong. During Year III, after the fall of the Robespierrists, they stirred up a constant opposition in the galleries of the Convention; they formed groups in the streets, where they took up the defense of the Jacobins and of the regime of Year II. Although they are anonymous in the police reports, a certain number appear by name in other documents, figures glimpsed fleetingly before receding into the shadows. Their presence suggests that among Parisian women of the people, a certain proportion whose importance is not in question demonstrated a more or less sustained political interest, were conscious of what was at stake in the Revolution, and formed part of the mass base of the democratic revolution with which the Jacobins identified.

Prominant militant women and militant women who formed the base of the movement constitute a category of *sans-culotte* women, a fluid but important group whose practices and reactions often reflected women's social and political status.

Not all women of the people who intervened in the Revolution were militant. Large numbers of Parisian women, not prominently involved, were nonetheless strongly attached to the Revolution, adhered to its ideals, and shared *sans-culotte* aspirations and *mentalité*: the right to existence, egalitarianism, political and economic terror, and commitment to the sovereignty, dignity, and happiness of the people.[4] In this sense, they supported the Convention in Year II when the Montagnards attempted to realize a politics favorable to the popular masses, but they also opposed the whole body of deputies (without distinguishing among them) when the majority abandoned popular objectives in Year III (1795). They took an interest in political life, even from a distance, and sometimes participated, notably during riots or insurrections. Such women have a less marked political coloration than the category of *sans-culotte* women. Misery and real famine during Year III pushed these popular masses of women into the foreground; their demonstrations constituted the opening

acts of the insurrections of Germinal and Prairial, Year III (April and May, 1795).[5]

The delineation of these three groups facilitates the analysis of certain aspects of women's intervention in the Revolution, notably the link between women and subsistence. In effect, in all periods of food crisis, women of the people passed into the front ranks, and many historians have concluded that women invervened in the Revolution only when this problem surfaced, leaving strictly political questions to their male companions. A special connection between women and subsistence does exist, based on women's social function of nurturer, but it must not blind us. If women of the people did not occupy center stage when the subsistence question was secondary, that does not in any sense signal their absence. They simply merged into the larger whole of the popular masses; they were present not as collectivities of women, but rather as individuals of the feminine sex. Moreover, women were not guided solely by subsistence, as we can see from their demands at Versailles on October 5, 1789: "Bread, but not at the price of liberty."[6] I cite also the failures of counter-revolutionary campaigns against women during grave subsistence crises . . . and the *mot d'ordre* of the insurgent women of Prairial: "Bread and the Constitution of 1793." Militant women were not primarily mobilized by subsistence; the Parisian women's club of Revolutionary Republican Citizens (*Citoyennes Républicaines Révolutionnaires*, May 10–October 30, 1793), relegated subsistence questions to a secondary position.[7]

The chronology of Year III points up links between the subsistence question and the three groups of women identified here. The prominent militant women, called "the *habituées* of the galleries of the Jacobins," supported the Jacobin Club from the end of Year II and during the autumn of Year III (1794); for some militants, that support can be traced to Thermidor, a period when the food situation was clearly not yet a cause for despair. In the sections, they sided with the *sans-culottes* against the offensive launched by the moderates; at the time of Carrier's trial, they defended the accused (for them a symbol of Year II) against those who wanted "to put the Revolution on trial." In this instance, it is for uniquely political reasons that some women individually opposed the new government. During the winter of Year III (1795), due to the effects of the social crisis, this small group increased to include the *sans-culotte* women collectively, and no longer as individuals. The subsistence crisis mobilized them, but the expressions of their anger continued to take on a political resonance.

Finally, beginning with Germinal (April 1795) in a time of famine, popular masses of women forcefully distinguished themselves by stirring up constant opposition. From here on it was only for militant women that this opposition was primarily a political one. Famine is the reason why women became so important during the spring of 1795; women were the essential component of the insurrectionary crowds of the 7th and 12th of Germinal, and the first of Prairial, Year III (March 27, April 1, May 20, 1795). The food question was the dominant motive of these demonstrations by women, although they still have political significance. In the name of the right to existence, women as a whole rose up against members of the Convention who, they declared, had betrayed their mandate by not assuring the people's well-being.[8]

During this insurrection, the militant woman put political demands first (the Constitution of 1793, the liberation of imprisoned Montagnard deputies, the formation of a new Commune, etc.), while the ordinary woman rioter gave priority to economic demands (bread).

These connections between women and subsistence are considered here as a possible motive for women's intervention in the Revolution and as a determinant of the extent of their political involvement. The connections were clearly visible during Year III, but are not unique to this year. I cannot discuss all episodes of the Revolution here, but, at least for the years 1793–1795, there are three types of links between women and subsistence, corresponding to the three subgroups of women discussed above. First, there is individual action, in which women engage not as a group but as individuals within the popular movement. This category includes acts by the most politically conscious militant women, acts that are independent of the subsistence question (9 Thermidor, Year II; autumn 1794). Second, there are pressures applied by *sans-culotte* women against the background of subsistence crises but related to political matters (spring, 1793, during the Girondin-Mountain conflict; spring, Year II, during the trial of the Cordeliers; winter, Year III). Finally, there are mass movements of women within the popular movement, directly linked to the problem of subsistence as the participants' primary concern (spring, Year III).

Chronologically, the subsistence question surfaced at the beginning of the women's movement and gave it a distinctive character within the larger popular movement. This issue also marked specific aspects of women's intervention within the popular movement as a whole: for example, hostility (initially on the part of women) in

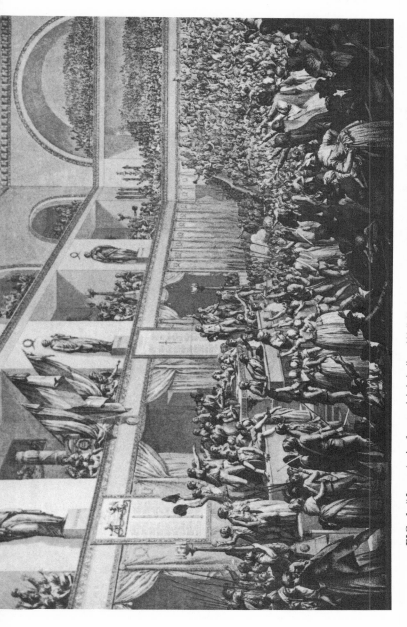

FIG. 1. "*Journée du 1er prairial de l'an III.*" Engraving by Helmon, after Monnet. Musée Historique de la Ville de Montreuil.

Women and men in the Convention Hall of the first of Prairial, Year III. In the morning, Parisian women marched on the Convention, followed by men bearing arms; in the afternoon they joined the men in the crowd inside the Convention.

encounters with commissioners in the section who policed bread distributions during Year III and who became one of the principal targets of popular rage.

But the originality of women's political practices seems to me to rest far more on the importance of the idea of popular sovereignty than on the subsistence question. The *sans-culottes*, men as well as women, had a very concrete idea of this concept: the Sovereign People deliberating in its section assemblies, bearing arms, sitting on the Revolutionary Tribunal. From the inalienable and undelegatable nature of popular sovereignty, they derived the right of controlling and recalling elected representatives, their "mandatories," as well as the right of "Holy Insurrection" on occasions when the Sovereign People was betrayed by its mandatories or divested of its rights.[9] Women of the people identified themselves as belonging to the Sovereign,[10] and no one thought of denying that the Sovereign People was composed both of citizens and *citoyennes*. But women were legally excluded from the body politic and possessed none of the attributes of sovereignty (voting rights, the right to deliberate in the general assemblies of the sections, the right to organize in an armed body and sit on the Revolutionary Tribunal, etc.). Their status was ambiguous—that of *citoyennes* without citizenship. On the other hand, in case of popular insurrection, when the Sovereign People made its voice audible to mandatories whom it judged unfaithful, women constituted an integral portion of the Sovereign—although such insurrection was not included within the structures of *sans-culotte* organization.[11] In this paradoxical situation, women were fully recognized as members of the Sovereign only in times of insurrection, when the people attempted to reclaim its rights, rights that women, as women, did not enjoy. The insurrection of Prairial, Year III (May 20–23, 1795) provides an excellent illustration of these ambiguous relationships. Women's acts dominated the first of Prairial (May 20). In the sections, women sounded the call to arms; they stirred up the men whom they dragged with them to the Convention where they mounted the first assault. The *journée* of the second of Prairial was marked by the people's deliberating in illegal general assemblies and marching, armed, on the Convention; in the documents pertaining to this day, women are partly eclipsed.

This incomplete citizenship had its effect on women's practice of politics. Sharing with their companions the consciousness of belonging to the Sovereign People, as well as an active notion of sovereignty, they, unlike their men, could not actuate this consciousness by enjoy-

ing attributes of popular sovereignty. In addition, women attempted to compensate for this exclusion by developing certain behaviors and certain practices.

First, one finds among the militant women a will to assert themselves as full members of the Sovereign. They expressed this will in a claim to rights that were attached to sovereignty and that constituted the basis of citizenship: the right to sanction laws by vote and the right to bear arms. Until the fall of 1793, the demand for the organized arming of women was one of the essential and constant demands of *sans-culotte* women. On March 6, 1792, Pauline Léon, a future founder of the club of Revolutionary Republican *Citoyennes*, presented to the legislature a petition signed by approximately 300 Parisian women who demanded permission to organize themselves into a women's national guard. On July 31, 1792, the inhabitants of the Hôtel de Ville section demanded in turn that "true *citoyennes*" be armed for the defense of the capital.[12] In 1793, the Revolutionary Republican *Citoyennes* returned several times to this demand. Article One of their regulations even stipulated that the Society had "for its objective arming itself in order to unite for the defense of the *Patrie*."[13] This was the only public demand by members of the women's club for equality of rights between the two sexes. If we take into account the importance of popular sovereignty during the Revolution, we can give a feminist meaning—the demand for citizenship— to an act that, on first view, was simply patriotic.

The right to vote was reclaimed by only an extremely small number of *citoyennes*. But during the summer of 1793, when the Constitution was being accepted by the people, large numbers of women, both from Paris and the provinces, wrote to the Convention that "although the law deprives them of the precious right of voting for the acceptance of the Constitution," they adhere to it.[14] These women declared before the Convention that they approved the constitutional act, and that they had met to vote their acceptance of it. This wave of formal addresses not only reflected their political involvement and their support of the Montagnards; it also marked their will to integrate themselves into the Sovereign, to exercise popular sovereignty in spite of their legal exclusion from the electoral body. By this very gesture, they were engaging in an act of citizenship; they were appropriating a right that they did not have.

Notwithstanding these different petitions from militant women, during normal times women were partially excluded from rights derived from popular sovereignty. Along with these conscious

maneuvers, one comes across actions that, it seems to me, we can better understand in view of women's truncated role within the Sovereign. Thus, during Year II, many contemporaries remarked upon the strong presence of women at the foot of the guillotine. They attributed this behavior to ferocity. Historians have often seen it as a reflection of masculine mentalities that associated the image of women with softness, and were shocked by the presence of women at the foot of the scaffold.[15] Of course, one must take into acount the apparent exaggeration of male sources; it is true, nonetheless, that women's cult of the "Holy Guillotine" left a strong mark on the popular movement. To inquire whether women were more or less ferocious than men is to pursue a false issue; it is not ferocity that impelled revolutionary women to take up their places before the guillotine.[16] The real question is to understand why the majority of spectators at executions were women. This behavior seems to me to be related to the exclusion of *citoyennes* from armed organizations (the National Guard, the Revolutionary Army). In effect, men armed with the "Holy Pike," symbol of popular power, could verify on the spot, by site visits to the homes of merchants or arrests of suspects, that measures enforcing economic regulation were applied or that plots were thwarted. Such a possibility did not exist for women; their presence at an execution was a concrete and visual way of assuring themselves that enemies were punished, that the people were not deceived, and that they were still invincible.

Women could not take up arms to carry out acts of vigilance and surveillance, two of the principle revolutionary virtues in the eyes of the *sans-culottes*. Vigilance and surveillance did inspire women to attend the galleries of the Revolutionary Tribunal (their presence struck all contemporaries), and to act in other ways that produced the numerous denunciations of women found in the archives.[17] Unquestionably, sitting in the galleries was not a passive act, but rather one aspect of exercising control over representatives, and an expression of the people's conception of sovereignty. A male citizen in the Year II was proud that his wife returned every other day to the Revolutionary Tribunal, since "the tribunal always needed good patriots to impress their will on the judges."[18]

Certain particular aspects of the political behavior of women derive from the will—conscious or unconscious—actually to exercise a portion of sovereignty themselves, even if indirectly.

Large numbers of women crowded into the galleries of clubs, general section assemblies, or popular societies. They received their political education there, but did not legally have a deliberative voice.

If, in times of crisis (notably during the summer of 1793), they were able to leave the galleries of the sections and mingle with male citizens and sometimes even vote with them, in the end they were asked to return to their places. In the last analysis, they were not considered full members of the general assembly, itself an emanation of the Sovereign People. A large number of insurrectionary events reminds us of this (May 31, 1793; 9 Thermidor, Year II; 2 Prairial, Year III). The most active militant women tried to compensate for this restricted place accorded to them in *sans-culotte* institutions by organizing themselves into women's clubs, but such clubs were prohibited in the autumn of 1793. Furthermore, even if women continued to attend the galleries of section assemblies as active spectators able to influence the course of debates on occasion, *sans-culotte* institutions were not the only frameworks for their political practices. Since they could not make themselves fully heard in section assemblies, they formed the habit of speaking out in the markets, on bread lines, in the street, in groups, and in front of the Convention. And they found other places to regroup: the galleries of the Convention or the Tuileries Gardens. This amounted to a diffuse and scarcely structured "organization," to be sure (if it can be called that at all), but one that offered the advantage of being harder to control and to dismantle. It would be wrong to consider this nonassociative political sociability as marginal and without impact on the course of the Revolution. On the contrary, it gained its full importance in the Year III. Since the moderates were at that time in control of the general assemblies and the *sans-culottes* had been chased out, an important part of the political life of the popular classes found expression in other places. These other places included the galleries of the Convention, a veritable center of anti-government resistance where women and patriots met, or the groups that were always forming in the streets. At that time, new attention was given to a political practice that, at least in part, women had engaged in since the beginnings of the Revolution, a practice placing them in the front rank of popular resistance in the winter of Year III (1794–95). It was at the end of Ventôse (March 13, 1795) that an insurrectionary poster, *"People awaken: the time has come,"* called upon the wives of *sans-culottes* to occupy the galleries of the Convention continuously in order to counteract the counter-revolutionary efforts of certain deputies. After the failure of the Prairial insurrection, the members of the Convention prohibited women from gathering in the street in groups of more than five, thus underscoring the central importance of these groups of women whose members had been preaching insurrection for many months in the name of

the rights of the Sovereign People, and who had played a key role in working up anger and launching the revolts of spring 1795.[19]

Thus far, we have looked at the keys to certain original aspects of women's behaviors in the popular movement. Men's and women's roles were not different, but the originality of women's actions developed out of the increasing frequency of certain practices common to both men and women. Lines of gender division nevertheless crisscrossed the popular movement.

There are two indications of these divisions. One, which can be labeled static, is the formation of distinct groups of men and women within the popular movement. Thus a male citizen could propose in December, 1792, "to assassinate all the nobles and all the priests (and) to arm the wives of patriots so they in their turn could cut the throats of wives of aristocrats."[20] Men did not intervene in any way other than as arbiters in certain brawls between groups of women—and this because of their prestige or authority. For example, on May 15, 1793, Marat became involved in the conflict between the Revolutionary Republican *Citoyennes* and Théroigne de Méricourt. The armed forces and section authorities became involved in the "cockade war" in September, 1793. Authorities intervened in the tumultuous session of the Club of Revolutionary Republican *Citoyennes* on 7 Brumaire, Year II (October 28, 1793), when market women clashed with members of the club. "Women's battles, simultaneously within and outside of men's Revolution," writes Michel Vovelle.[21] In this way, women figure in descriptions that, we must not forget, were written by deliberately scornful men. If, for example, we confine ourselves to police reports concerning the confrontations of September, 1793, between those women demanding the obligatory wearing of the cockade and those refusing to wear it, this episode falls "outside of men's Revolution"; but the attention it received in the section assemblies places it back inside the Revolution and in fact makes it one of the victorious stages of the larger popular movement.

This gender division resulted in part from a certain male disdain for stories about women. Reprimanded for the counter-revolutionary opinions of his servant, a male citizen responded that "quarrels of women did not concern him." Another gave the same answer to a similar reproach concerning his wife. As for a third, "he paid little attention to what a woman could say about (political) affairs."[22] A group of accused men demanded their liberty by arguing that the accusations against them were based on nothing other than "women's prattling."[23]

But this phenomenon of gender division results from more than scorn. It is also the direct consequence of the independence of married women of the popular classes. *Citoyennes* who attended the sessions of clubs preferred to go there with their female friends rather than with their husbands. Likewise, to avoid having to approach a paid scribe who would cost her money, one Despavaux, a linen worker, begged her husband to make her several copies of a denunciation she intended to make, but she forbade him to sign it because, in her own words, "it didn't concern him." It was her own affair; her husband might save her a few pennies, but he was not to interfere.[24] In the ranks of the popular classes there was a very rich social life among fellow female workers or neighbors, in which men did not intervene. Lines of gender division that cut across the popular movement were repercussions of social distinctions between worlds of women and men, "parallel" worlds, which both sexes respected. Men would not think of intervening in a quarrel between two women neighbors any more than they would consider intervening in a quarrel between women "*jacobines*" and market women, for that "didn't concern them"; moreover, they probably would have been given a very poor reception. Not that they withdrew in amused neutrality, but they let women manage their affairs among themselves and remained free to testify later against one party or the other. These are the attitudes we find at the level of political life.

This line of gender demarcation is paralleled by behavioral differences between the roles of men and women. Describing the discursive event, "The Death of Marat," Jacques Guilhaumou writes: "women are the principal vectors of rumor, and of related incitements to action."[25] Incitements to action are a recurrent female activity in the revolutionary movement. On July 14, 1789, Pauline Léon "incited cowards to leave their houses";[26] in May, 1793, during the conflict between the Girodins and the Jacobins, militant women called for insurrection just outside the convention, calling men cowards and dastards.[27] In the spring of Year III, women's calls for insurrection took on a particular cast. Famine was prevalent in Paris. Bread rations were cut until they fell to 60 grams per person per day; and every day, several hundred Parisians had to do without. Moreover, after the abolition of economic controls, prices of other necessities soared beyond the reach of the popular masses. Every day, groups of women disrupted the galleries of the Convention and blocked bakers' doorways. "Women above all" became a common expression among police observers: in groups, "women above all" "appeared angrier"

(25 Germinal), "appeared to play the principal role" (7 Floréal), "burst out with the most absurd and menacing propositions" (8 Floréal), "permitted themselves the most violent as well as the most seditious speeches" (18 Floréal), "appeared to be very discontented" (3 Floréal), etc.[28]

In militant couples, it was the wife who played the role of "the apostle of insurrection." After the defeat of the insurrection of Prairial, the wife of the Jacobin Gillet de Coudray was accused of having carried Jacobin principles "into (certain social) circles, into workshops, into groups" and of having preached pillage and insurrection to workers.[29] This propaganda role for women rested upon their special connections with life in the streets and with the groups that formed there. Women called men to action, and nearly every day police reports describe the same scene with a singular monotony:

—"women say that men are assholes (*des jean-foutre*) to let themselves be led in such a fashion" (24 Germinal).

—"women call men 'assholes' for not going to the Convention to demand an account of grain (supplies)" (25 Germinal).

—"women say that men are fainthearted for accepting such a modest ration" of bread and speak of "their cowardly husbands" (26 Germinal).

—"women . . . spread about the most incendiary propositions, provoking men to insurrection . . . by calling them cowards" (5 Floréal).

—"women . . . harangue men, treating them as cowards . . ., a great number of the women want to rise up in insurrection" (7 Floréal).

—women say "men are cowards if they don't turn out" (8 Floréal).

—women tell men "that they are all cowards for letting themselves be led about in this way, seeing that the intention is to make people die of hunger" (19 Floréal).

—women "provoke men to rebellion and to pillage by uttering insults" (22 Floréal).

—"women . . . cry out against the Convention, saying that men are stuck pigs (*couillons*) to endure hunger" (30 Floréal).[30]

"We cannot kid ourselves; in the stormy moments which have troubled this city, women have played the role of firebrands," wrote the *Comité civil* of the *section du Nord* after the insurrection of Prairial.[31]

Women's calls for insurrection were addressed to men. To the extent that women were ready for revolt, they did not go out to preach it to themselves; rather, they addressed themselves to those whom it was necessary to persuade. This evidence is only half satisfactory. What did the woman say who was arrested on 17 Floréal (May 6, 1795) near the Pont Neuf? "Men must march against the Convention, center of all crimes."[32] Did she mean that men had to take charge of the insurrection? These examples of exhortation show that women considered a revolt by a crowd of women to be incomplete. Let us recall this fundamental rule about uprisings: men had the arms, and notably the cannon that were capable of overturning everything.

Women made it their work to jolt masculine apathy. They took on the role of "firebrands": "if they began the dance, the men would follow"; "we would have been followed by a lot of other sections, which were waiting for us, and not only by women, but also by men whom we supported," they assured one another on 2 and 17 Floréal (April 21 and May 6, 1795).[33] This detonating function of women was confirmed particularly forcefully in Year III, but we can find it at other times. A police reporter wrote on May 13, 1793, during the confrontation between Girondins and Montagnards: "women are continuing to press for the withdrawal of 22 deputies (Girondins) . . . They even hope that they'll be seconded by men." Five days later, a deputy spelled it out for the Convention: "Women will begin the movement . . ., men will come to the support of the women."[34]

But who would be seconding whom? The comments of women on 2 and 17 Floréal, Year III expose the underlying pattern of the insurrections of spring, Year III (1795): women rose up, men followed, and women in their turn supported men. This pendulum-like motion circumscribed the appropriate action for each gender. Certainly, women ended up effacing themselves voluntarily (but not disappearing). Most important, this allocation of roles made for a fundamental reciprocity between men and women. That was what women were calling for in Germinal and Floréal Year III—and to a somewhat lesser extent in May, 1793—by their incessant expressions of disdain and exhortations to their companions. As a last recourse, they sometimes proposed to carry out the insurrection by themselves, but that was absolutely unsatisfactory. The desperate and repeated insults shouted out by women on these occasions seem to me to be indicative of their disarray as they obstinately sought to reinvoke in a time of insurrection gender roles that in fact could no longer be activated.

This role of firebrand also illuminates a pattern that became very obvious in Year III in the popular movement: male or female militants addressed themselves first to women of the popular masses, who in turn initiated masculine action. Thus, on the first of Prairial, militant men asked women to spread the slogan "Bread and the Constitution of 1793." On 3 Prairial, as the rumor spread that the troops were marching on the insurgent Faubourg Saint-Antoine, a male citizen asked a group of women to beat the *générale* and sound the tocsin, "because then, men would follow."[35] That evening it was again women who addressed themselves to men and women who wanted to rescue the condemned Tinel, accused of having carried on the tip of a pike the head of the deputy Féraud, killed by the insurgents on the first of Prairial.[36] "It is mainly the women who are stirred up, women who in their turn communicate all their frenzy to men, heating them up with their seditious propositions and stimulating the most violent effervescence," wrote a police inspector on 3 Prairial; it could hardly have been put more clearly.[37]

The distinctive role of women in the popular movement, a role that they assumed fully and that the entire society recognized, was that of firebrands, those who use words to incite action. Even in the heat of action, their words retained their full meaning, as the incitement and support of action. Limiting ourselves to two famous examples, we see on July 14, 1789, Pauline Léon "stirring up (male) citizens against the partisans of tyranny," and on August 10, 1792, Claire Lacombe "rallying (male) citizens who were being routed by continuous gunfire," while other women "encouraged their husbands, their children, their brothers."[38]

Must we conclude that women of the people issued a call to action, but that men took the action? That women spoke, but men acted? It might appear that this is the way things were; and it was very clear in the months preceding Prairial Year III that *citoyennes* incited male citizens to action because the men controlled the armed force. However, this explanation would be very reductionist. First, women physically participated in action, just as men did. On July 14, 1789, Pauline Léon also barricaded the streets; on August 10, 1792, Claire Lacombe "fought the henchmen of a treacherous court."[39] In that same cause, Pauline Léon was armed with a pike, but she had to relinquish it to a man upon the demands of her fellow citizens. On the first of Prairial, Year III (May 20, 1795), a crowd of women put to rout the guards surrounding the Convention and broke down the door of the meeting hall of the Assembly, smashing it with logs; a few

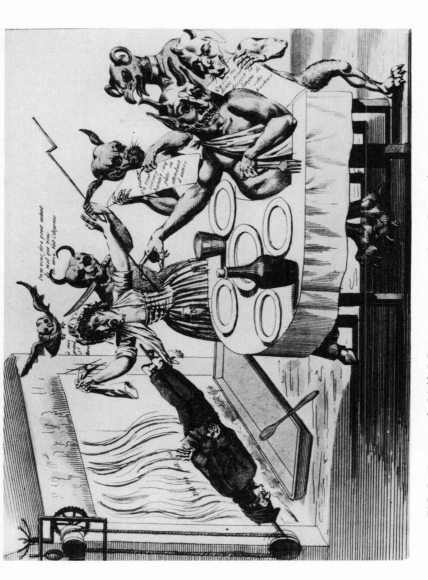

FIG. 2. "*Le souper du Diable*." Gravure anonyme. Musée Carnavalet. Agence photographique Edimedia.
This anonymous and satirical picture (about 1795 or 1796) reflects the importance of women's words in the popular movement: the Devil is saying that he wants to eat "the tongue of this *tricoteuse*" for dessert.

hours later some women took part in the assassination of the deputy Féraud.

Moreover, to the pithy formula "women spoke," we must in any case add, "What did they say, and what were the consequences of their words?" In that case the question can be considered from a different angle. The word of women, often a prelude to the act of insurrection, procreator of action, thus became one of the elements of action, a specifically feminine element. Numerous documents convince us that the word as an element of action was one of the original features of women's participation in the revolutionary process.

In conclusion, we can stress that two important points that appear in revolutionary Paris are also found in studies of other countries. We note that in Holland and the United States, and in quite a different way in England,[40] women, who gave proof of a very central involvement in the course of events, are partially excluded from them, or at least lose their importance once organizational structures under men's control come back into play. Examples of such structures include National Guards in Holland and in France (especially on 2 Prairial, Year III); section organizations in France; and municipal, political, or work associations for the United States or England. Even so, in these three nations we find women repeatedly issuing calls to action. These very important comparisons encourage us to study women's political manifestations not simply in terms of their mobilization, but in all cases to emphasize the exclusion of women from certain institutions as a limit on their involvement. Finally, taking into consideration diverse contexts and cultural, political, social, and economic differences among different countries, we must measure how and why French women were able to bypass the limits imposed upon them from outside in order to enter fully into these different movements, whereas English and American women could not.

Notes

1. Dominique Godineau, *Citoyennes Tricoteuses: Les femmes du peuple à Paris pendant la Révolution française* (Aix-en-Provence: Editions Alinéa, 1988).

2. On women and the Declaration of the Rights of Man and of the Citizen, see Godineau, *Citoyennes Tricoteuses*, 271–84, and "Quels droits naturels pour les femmes d'un peuple libre?" in *Les Droits de l'Homme et la Conquête des Libertés: Acts of the Conference at Grenoble-Vizille, 1986* (Grenoble: Presses universitaires de Grenoble, 1988), 181–87.

3. Michel Vovelle, *La mentalité révolutionnaire: Société et mentalités sous la Révolution française* (Paris: Messidor, 1985), 117.

4. Concerning *sans-culotte* mentality, see Albert Soboul, *Les sans-culottes parisiens en l'an II: Mouvement populaire et gouvernement révolutionnaire (2 juin 1793–9 thermidor an II)* (Paris: Clavreuil, 1958), 400–680.

5. Concerning these insurrections, see Godineau, *Citoyennes Tricoteuses,* 297–305, 319–33.

6. This phrase cited by the editor of the *Révolutions de Paris.*

7. Concerning this club, see Godineau, *Citoyennes Tricoteuses,* 129–79, 364–66.

8. See the reports of police observers for the period in question, Archives nationales (hereafter A.N.) F[IC] III Seine 14, 15, 16. There is a major contrast here with the English case; see, in this volume, John Bohstedt, "The Myth of the Feminine Food Riot: Women as Proto-Citizens in English Community Politics, 1790–1810." On the one hand, women's involvement is limited to subsistence riots; on the other hand, the political aspect—demanding bread in the name of a right that authorities have violated—is less clear than in the English case. The contrast seems to me to bring into relief the political space created by the French Revolution. The language of the Revolution was political; it was impossible for women to escape it. In addition, even if they were given only a limited role, women were present in revolutionary assemblies (sections, clubs, Commune, Convention) where they acquired a political education by following debates from the galleries, sometimes participating in debates, especially at the section level, and by listening to public readings of journals.

9. Albert Soboul, *Les Sans-culottes parisiens.*

10. This consciousness was marked by affirmations (found in numerous documents) of women who asserted, whether during an insurrection or not, "We are the Sovereign."

11. In effect, when the general assemblies of the sections directed an action, women were partly rejected. For example, on May 31, 1793, when the Revolutionary Republican *Citoyennes,* whose role in precipitating the insurrection is generally recognized, asked to sit on the insurrectionary committee, they were told that they could not because it was not a club that was involved, but a gathering of deputies of the forty-eight sections, an emanation of the Sovereign People. See *Le Moniteur* 16:527. See also the *journée* of 2 Prairial, Year III.

12. A.N., AE II 1252 C I 90 (March 6, 1792) and C 154 d. 292 bis, 1 (July 31, 1792). In this volume, see Darline G. Levy and Harriet B. Applewhite, "Women, Radicalization, and the Fall of the French Monarchy." If, as Levy and Applewhite show, women armed on their own initiative in the course of various revolutionary events, it is also true that never, except in rare and exceptional individual instances, were they part of the organized National Guard. The various events described by Levy and Applewhite show women sometimes armed and mixed in with the National Guard, but never permitted to be members of the National Guard. Similarly, there is a difference between claiming citizenship via the right to bear arms and obtaining this right. The events analyzed by these two authors seem to me to correspond to my earlier point about women who were members of the Sovereign

during the preparation of insurrections. Once the distinction between passive and active citizens was abolished in fact (although not in law), the concept of citizenship was more fluid and therefore more open to women than after the insurrection of August 10, 1792.

13. Bibliothèque Historique de la Ville de Paris, 9589.

14. See, for example, *Archives parlementaires*, 1st ser. (Paris, 1868–92), 68: 139, 251, 254, 283, 286, 314, 381; and A.N., C 280, d. 765, 12; C 262, d. 583, 8; C 266, d. 629, 13; C 267, d. 631, 19, d. 635, 10.

15. L. Devance, "Le féminisme pendant la Révolution française," *Annales historiques de la Révolution française*, no. 229 (1977): 351–76.

16. Godineau, *Citoyennes Tricoteuses*, 227–33; and Arlette Farge, *La vie fragile: Violence, pouvoirs et solidarités à Paris au XVIIIe siècle* (Paris: Hachette, 1986), 210–20.

17. See, for example, the reports of Nivôse 1, 21, Year II: A.N., F (7) 3688 (3).

18. Police report of Ventôse 7, Year II: A.N., W 112.

19. Bibliothèque nationale, 8 Lb (41) 1708 (*Peuple, réveille-toi*); and *Le Moniteur* 24:519.

20. A.N., F (7) 4774 (32), d. Mallais.

21. Vovelle, *La mentalité révolutionnaire*, 241.

22. Archives de la Préfecture de Police, Paris (A.P.P.), AA 176, July 6, 1793; and A.N., F (7) 4774 (90), d. Rantais; F (7) 4722, d. Gerigny.

23. See, for example, A.N., F (7) 4774 (39), d. Maurice.

24. A.P.P., AA 77 f. 195 and ss.

25. Jacques Guilhaumou, "Description d'un événement discursif: la mort de Marat à Paris (13–16 July 1793)," in *La mort de Marat*, ed. Jean-Claude Bonnet (Paris: Hachette, 1988).

26. A.N., F (7) 4774 (9), d. Leclerc.

27. See, for example, the police report of May 4, 1793: A. N., AF (IV) 1470.

28. A.N., Flc III Seine 16.

29. A.N., F (7) 4724, d. Gillet de Coudray.

30. A.N., Flc III Seine 16. See also F (7) 4597, d. Bertrand; F (7) 4665, d. Deffaut.

31. A.N., F (7) 4584, d. Baillet.

32. A.N., Flc III Seine 16.

33. A.N., F (7) 4775 (46), d. Vilembre; Archives départementales de la Seine, VD* Register 794, 32.

34. A.N., F (7) 3688 (3) and *Le Moniteur* 16:414, 420, 421.

35. A.N., W 548 nos. 71 and 74.

36. See especially A.N., W 547, no. 61; F (7) 4662, d. Dauphinot; F (7) 4775 (18), d. Sergent.

37. A.N.. Flc III Seine 16.

38. A.N., F (7) 4774 (9), d. Leclerc (P. Léon); T1001 (1–3) (C. Lacombe); and *Le Moniteur* 13:538 (letter from a witness to the tenth of August).

39. Ibid.

40. See the essays on these nations in this volume.

Women, Radicalization, and the Fall of the French Monarchy

Darline G. Levy and Harriet B. Applewhite

During the spring and summer of 1792, women participated in a movement of political radicalization in revolutionary Paris. Radicalization involved transformations in the principles and practices of sovereignty and citizenship, the development of new measures of political legitimacy, a mobilization of insurrectionary forces, and, eventually, the fall of the monarchy and the establishment of the First French Republic. The massive presence of women, their words and acts, made a historically significant difference in the dynamics and outcome of events. Women dramatically increased the numbers of those challenging the political status quo. They engaged in decisive collective demonstrations of force and acts of violence; they were key actors in the cooptation of the armed force available to authorities who supported the constitutional monarchy. These acts, in combination with women's discourse—everything from shouts and slogans denouncing tyrants, proclaiming liberty, and validating the *sans-culottes* to formal addresses before the Legislative Assembly demanding women's right to bear arms—contributed to the delegitimation of constitutional monarchy, a reformulation of rights and responsibilities of citizenship, and a redefinition of sovereignty as the will and power of the people. The constant, often programmed presence of women among the civilian and military forces of a popular opposition dramatized the power of the powerless—to the point where revolutionary authorities of all political sympathies and persuasions acknowledged that this combined physical and symbolic democratic force could not be resisted.

This transitional period between constitutional monarchy and republic is a moment of extraordinary indeterminacy and openness in the political history of the Revolution, the moment of a surge of

women's individual and collective political participation. It is true that under the Constitution of 1791, women had been denied the political rights of citizenship. In addition, key terms in a revolutionary political lexicon derived largely from Rousseauan and classical political philosophy—laws and rights of nature, citizenship, virtue and civic virtue—were gendered to define and legitimate public and political roles for male citizens and exclusively domestic, private roles for women. A body of recent scholarship interprets revolutionary political opportunities and outcomes for women as largely determined by this political language and by the male-dominated hegemonies it supported and reflected.[1] Our documentation suggests a more complex and indeterminate patterning. In the period between 1789 and the fall of 1793 (when the Jacobin leadership outlawed their organized political activity), women's individual and collective political acts (often grounded in solid traditions sanctioning or even prescribing their involvement in public and political affairs), the competing languages in which these acts were narrated and interpreted, and the political claims and counterclaims with which they were associated—all had the effect of multiplying repertories of political action and political discourse.[2]

Our interpretation of women's participation in ceremonial, institutional, and insurrectionary politics during the spring and summer of 1792 cautions against reading back into the ever-shifting ideological constellations and power struggles in which women of all socioeconomic categories were caught up between 1789 and 1793, a repressive linguistic-political-military hegemony that the Jacobins established only in the fall of 1793, and even then, only incompletely.

From the middle of the eighteenth century, the monarchy in France had been strained and weakened by the explosion of Enlightenment ideas, by Jansenist-Jesuit controversies, by the maneuvers of Parlementary magistrates, and most especially by reactions to reforms that royal administrators themselves had initiated. Nonetheless, Louis XVI still ruled by hereditary right. His actions were not limited by written constitution; his will was enforced by a strong standing army and by regiments of foreign mercenaries.

Between June, 1789, and September, 1791, the National Assembly instated a constitutional monarchy to replace a monarchy absolute by divine right. In the spring and summer of 1792, a predominantly "passive" citizenry in the politicized sections of Paris, aided and abetted by Girondin and Jacobin radicals, undermined this political sys-

tem. They challenged the principle of delegated sovereignty divided between an indirectly elected national legislature and a hereditary monarchy. They dissolved the distinctions that excluded "passive citizens" from voting, serving in the National Guard, and standing for election to political assemblies. And they exploited a collapse of trust in the King to challenge the legitimacy of constitutional monarchy and to claim that the determination of legitimacy rested exclusively with the sovereign nation.

Women of the popular classes from the sections of Paris and a handful of bourgeois women were directly in the center of forces that brought about this second revolution of 1792. Revolutionary leaders and radicals often encouraged, when they did not actually program, women's integration into the political nation in arms. Women were conspicuously present in ceremonial/insurrectionary dramatizations of democratic citizenship, popular sovereignty, and legitimacy as the expression of the will and might of the sovereign nation—for example, in ceremonies such as the series of armed processions of the spring and summer of 1792 that are the subject of this essay.

The actual collapse of the constitutional monarchy on August 10, 1792 resulted from a military confrontation in the courtyard of the Tuileries Palace between the King's guard, on one side, and the armed force of the Paris sections and the Departments of France, on the other. However, this change of regime was prepared by a progressive buildup of revolutionary forces and a weakening of resistance in the King's camp and in the national legislature. The principal developments were the King's defection from the Constitution of 1791 and the public's growing attraction to republicanism. On February 4, 1790, Louis XVI appeared before the National Assembly and committed himself to supporting the Constitution. In June, 1791, the King attempted to flee the country. He was apprehended at Varennes and forced to return to Paris. The National Assembly provisionally suspended him from his functions. The King's flight and its aftermath furthered a rapid growth of republican sentiment and the escalation of political activity in the Jacobin club, the Cordelier club, the section-based clubs and popular societies, and the radical press. However, the National Assembly, committed to the principles of a constitutional monarchy, refused to honor petitions that originated in the sections and expressed demands for a national referendum on the nature of executive authority in the new Constitution. On July 17, 1791, Lafayette's National Guard, supported by the mayor of

Paris, Bailly, opened fire on thousands of men and women who had gathered on the Champ de Mars to sign one of these petitions. The repression following the *journée* of July 17th temporarily silenced republican polemicists, but it did not abort the pro-republican movement. The declaration of war in mid-April 1792 generated insecurity in the capital and intensified public concern over the King's suspicious behavior, especially his veto of two decrees voted by the Legislative Assembly in its effort to counter internal and foreign threats to national security. All these developments widened the breach between the King and his opposition, chiefly Brissotins, Robespierrists, and members of the Cordelier club, and also shaped the confrontation between constituted authorities, who continued to operate within constitutional limits, and fully mobilized insurgents in the sections who claimed an all-legitimating constituent authority and who were led or encouraged by Cordelier activists.

In order to analyze selected elements in the mobilization of that popular force during the spring and summer of 1792, we investigated six armed processions through the halls of the Legislative Assembly that involved thousands of men, women, and children, principally "passive citizenry" from the sections and environs of Paris. These processions took place on April 9, April 29, May 29, June 4, June 19, and June 20. In each case, we found the participants demanding recognition of their legitimacy and power and receiving that recognition from the national legislature. Second, in the accompanying speeches and through signs, exclamations, gestures, images, symbols, and line of march, the participants, both women and men, built a symbolic significance into their behavior that linked it to radical definitions of citizenship, sovereignty, and legitimacy. Finally, they conspicuously paraded weapons, which carried the threat that armed force would be used. This display of military force, in combination with concrete demands and symbolic representations, in fact coalesced the transformative forces of a second revolution.

We are focusing on two armed processions: the April 9th procession through the Legislative Assembly of soldiers from the regiment of Châteauvieux, armed battalions of National Guardsmen, and armed men, women, and children from the sections of Paris; and the June 20th armed procession through the Legislative Assembly and the Tuileries Palace of men, women, and children from the Faubourgs Saint-Antoine and Saint-Marcel.

On April 9, 1792, several deputies from the city of Brest submitted a letter to the Legislative Assembly requesting that forty sol-

FIG. 1. [July 17, 1791]. The National Guard firing on petitioners on the Champ de Mars. The French text calls this "the terrible day of July 17, 1791," and states that "men, women, and children have been massacred upon the Altar of the Fatherland at the Champ de la Fédération." (Louis-Marie Prudhomme, ed., *Révolutions de Paris*, vol. 9, no. 106, July 16–23, 1791, from Bibliothèque nationale, Cabinet des Estampes, B23621.)

diers from the Swiss Regiment of Châteauvieux be granted permission to appear before the bar of the Assembly.[3] This was a politically charged request. In August, 1790, the Châteauvieux regiment had participated in a rebellion pitting civilian patriots in Nancy and regiment soldiers against the forces of the regional commander, the marquis de Bouillé, who in this affair was acting on orders issued from Paris by his cousin, Lafayette, Commander-General of the National Guard. In the bloody repression that followed Bouillé's reconquest of Nancy, thirty-three soldiers of the Swiss regiment were hanged or broken on the wheel and forty more were condemned to the galleys off Brest.[4] In December, 1791, the Legislative Assembly granted an amnesty to these forty soldiers. Between their sentencing and their pardon, public confidence in Lafayette had ebbed and mistrust of National Guard battalions overtly loyal to him was running

high, particularly after the *journée* of July 17, 1791. In March, 1792, as debate intensified in the Legislative Assembly over a motion to declare war against Austria, preparations began for a popular festival to honor the insurrectionary soldiers of Châteauvieux. In a petition addressed to the General Council of the Commune of Paris on March 24, 1792, a delegation that included the patriot and militant Théroigne de Méricourt urged municipal officers to join in honoring the people's martyrs who, "even in chains, have preserved their internal liberty and no king on earth has succeeded in taking it from them. The fatherland has engraved on their chains the formal oath: live free or die. It has done the same on sabres and pikes. This oath will remain engraved in our hearts as well and in the hearts of true Frenchmen."[5]

On April 9th, not long after they had completed a triumphal march from Brest to Paris, the forty soldiers with their escort of National Guardsmen and armed civilians—men, women, and children—arrived at the Assembly. Following a heated debate, the Assembly voted unanimously to admit the Châteauvieux soldiers and, notwithstanding further maneuvering by deputies on the right, they were accorded the honors of the session by a narrow vote and granted permission to march through the hall accompanied by the National Guard. The soldiers' spokesman, Collot d'Herbois, setting the tone for what was to follow, recalled the oath they had sworn earlier in the Revolution to die in defense of the nation, "and they renew it before you. (All the soldiers of Châteauvieux): We swear it!" Collot concluded his speech: "May the chains which the soldiers of Châteauvieux bore and which you have broken, be the last which despotism uses to enchain the most ardent, the most determined defenders of liberty." In his reply the President attempted to limit the impact of Collot's discourse on the Assembly and the galleries. He recalled that the Assembly had voted the soldiers an amnesty and were adding to this "kindness" a permission for them to appear before the bar, so that the Assembly might receive "the testimony of your gratitude." He then cautioned: "Enjoy its kindness" [that of the Assembly]; "Love your duties, obey the laws." Having delivered himself of this admonition, he accorded the soldiers of Châteauvieux the honors of the session.

At this point, the National Guardsmen who had accompanied the Châteauvieux soldiers paraded through the Assembly, about one hundred strong, marching in order, sabres drawn, and to drumbeat, amid shouts from deputies on the left and spectators in the galleries: "Vive la Nation!" "Vive l'Assemblée Nationale!" "Vive les soldats de

Châteauvieux!" "Vive la liberté!" In their midst marched a citizen named Gonchon, a spokesman for the Faubourg Saint-Antoine (the faubourg of the vainqueurs de la Bastille). He carried a pike, surmounted by a red cap of liberty that was decorated with laurel leaves and tricolor ribbons. Mingling with this formation were veterans, Swiss Guards in uniform, sappers, and cannoneers of the National Guard. As the procession passed before the President, Gonchon entered the bar and stood there, pike in hand, while troops and civilians paraded past, superimposing their figures on a living emblem of militant citizenship. There followed "a large procession of men, women, children, carrying tricolor flags, pikes, and other emblems of liberty." On the tip of one of their pikes was a set of detailed instructions for the upcoming fête of April 15th in honor of the Châteauvieux soldiers and a letter from Jérôme Pétion, the mayor of Paris, vigorously supporting it. The march closed with a procession of citizens representing the various popular societies of Paris and Versailles and carrying the tricolor flags that departmental authorities had presented to the Châteauvieux soldiers to honor them during their march from Brest to Paris.

As the procession concluded, Gonchon, speaking for the citizens of the Faubourg Saint-Antoine, announced that his faubourg was manufacturing ten thousand pikes, like the one he was carrying. "They always will be forged for the support of liberty [and] the Constitution, and for our defense." Gonchon and his party were accorded the honors of the session. The Assembly decreed the printing of Collot d'Herbois' speech, but not the speech of the President of the Assembly. The session ended with the approval of a motion that called attention to the fact that the flags given to the Châteauvieux soldiers by various departmental authorities had passed through the space of the Assembly.[6]

This armed procession through the Legislative Assembly by Châteauvieux soldiers, National Guardsmen, and armed men, women, and children can be read from several perspectives. First, the Assembly, seconded by the enthusiastic galleries, repeatedly sanctioned this extraordinary demonstration and everything it signified. Initially, the Assembly voted to receive the Châteauvieux soldiers and granted permission to their supporters to march armed through the Assembly. Then, after their spokesman defined their cause as the struggle of liberty against despotism, the Assembly further underscored its approval of the demonstration and its legitimation of a radical reading of the right and responsibility of the citizen to resist oppression and to die in defense of liberty. It voted to print Collot's speech; it

refused to print the speech of its own President, in effect repudiating his discourse, which had reduced the soldiers to the status of supplicants grateful for the Assembly's vote of amnesty. The motion noting that tricolor flags from the departments had passed through the political space of the legislature added still another dimension of legitimacy to the processsion and carried the message of a bond of solidarity uniting the rehabilitated soldiers with National Guardsmen, armed civilians, and all sections of the political nation. All these approvals can be read as a de facto legitimation of the right of popular insurrectionary resistance.

Second, as the procession, marching to drumbeat, took over the space of the Legislative Assembly, the marchers filled that space with politically charged signs of a militant citizenry. The liberty cap on a pike, for example, linked the citizen's right to liberty, his right of self-defense, his right to resist oppression, and his possession of the weapons with which to enforce all three. Furthermore, this processional ritual worked to recast the separate identities of the marchers into a collective identity. They all enacted a drama in which insurrectionary soldiers were reidentified as heroic citizens and reconciled with National Guardsmen, veterans, armed women, and armed children. The whole was represented as the reunion of a great national family, the other face of which was a united nation in arms. What this procession dramatized most palpably and concretely was the message that the entire passive citizenry of France was being integrated into a national force—men, women, and children "carrying tricolor flags, pikes and other emblems of liberty," each one marching past the spokesman from the Faubourg Saint-Antoine, forming a *tableau vivant* of militant *sans-culotte* citizenship.

While accounts mention armed women, they do not focus special attention on them. We propose to stop the moving picture of this procession in order to magnify and analyze female militancy as one element in a larger dramatic depiction of the national family, on the march, pikes in hand.

In an article, "Des Piques," appearing in the February 11–18, 1792, number of his *Révolutions de Paris,* the radical journalist Prudhomme called attention to the symbolic and military significance of the pike, a weapon already being produced in large numbers in the Paris sections as an alarmed population began to calculate the consequences of a declaration of war. "[U]niversally accessible, available to the poorest citizen," the pike was an emblem of independence, equality under arms, vigilance, and the recovery of liberty: "A pike

in the hand of every citizen is terrifying for malevolent persons, in that it announces an armed nation's continual surveillance." "The pikes of the people are the columns of French liberty." Prudhomme proposed that every citizen, even the poorest, be armed with two pikes, "one for the repose of his household, the other for the safety of the republic." At the same time, he conspicuously eliminated half the nation's potential pike bearers by denying the right of women to bear these arms. Dismissing what he described as a proposal by Théroigne de Méricourt to organize and lead a phalanx of Amazons, Prudhomme cautioned: "Let pikes be prohibited for women; dressed in white and girded with the national sash, let them content themselves with being simple spectators."[7]

On March 6th, less than a month after this article appeared, a delegation of "citoyennes de la ville de Paris," led by Pauline Léon, an outspoken revolutionary activist, presented to the National Assembly a petition with more than 300 signatures concerning the right of women to bear arms. The petitioners grounded their claim in an appeal to the right to defend one's own life and liberty and to resist oppression—rights guaranteed in article two of the Declaration of the Rights of Man and of the Citizen. "You cannot refuse us and society cannot remove from us this right which nature gives us, unless it is alleged that the Declaration of Rights does not apply to women and that they must allow their throats to be slit, like sheep, without the right to defend themselves. . . ." They also claimed for women the political/moral attributes of revolutionary citizenship, including civic virtue, and they based that claim partly on the evidence of recent revolutionary history. They represented their participation in the *journée* of the fifth and sixth of October, the women's march to Versailles and their return to Paris with the King in tow, as the act marking their political transformation into militant patriots whom tyrants and enemies would not fail to identify: "No, no, they will remember the fifth and sixth of October. . . ." They renewed the oaths they had sworn earlier in the Revolution to live free or die. They requested permission to arm themselves with pikes, pistols, sabres, and rifles; to assemble periodically on the Champ de Mars or in other places; and to engage in military maneuvers under the direction of the former French Guards.

The Assembly's response to the petition was ambiguous. The President invited the delegation to attend the session. A deputy expressed his fear that if the petition were honored, "the order of nature would be inverted." The delicate hands of women "were not

made for manipulating iron or brandishing homicidal pikes." As serious motions crossed with parody—the petition should be sent to the Military Committee, no! to the Committee of Liquidation!—the Assembly decreed a printing of the petition, and honorable mention in the *procès-verbal*, and promptly passed to the order of the day.[8]

A conservative journalist remarked, commenting on the inconclusiveness of the Assembly's action and on the precedent that might be set by it: "Perhaps in interpreting this decree, women will arm themselves nonetheless"; to avoid a dangerous confusion the Assembly ought to have declared that there was no cause to deliberate on the matter in the first place.[9]

While the Assembly hesitated between "liquidating" and tolerating women's demands for the right to bear arms, the General Council of the Paris Commune and the mayor, Jérôme Pétion, took action to honor women's militancy publicly, reward it officially, and instate it as a model of female citizenship—all this just four days before the armed procession through the Assembly to honor the Châteauvieux soldiers. In a speech to the Commune on April 5th, Pétion supported a petition on behalf of Reine Audu, one of the few participants in the October days to have been arrested and imprisoned. Pétion argued that while French mores generally kept women out of combat, it was also true that "in the moment of danger, when the fatherland is in peril," women "do not feel any the less that they are *citoyennes*." "We are not adequately sensitized to the importance of forming *citoyennes*." He noted that until now it has seemed as though men have wanted only to subjugate women. He praised Reine Audu "for having escaped the slavery of your sex's education. You have shown great energy; you have rendered important services." The Council of the Commune, acting on the petition, decreed a ceremony in which the mayor of Paris would present and decorate "this *citoyenne*" with a sword as "an authentic testimony to her bravery and her patriotism."[10]

This evidence strongly suggests that in the weeks preceding the April 9th procession, a concept of female citizenship was emerging. This concept dissolved distinctions between active/passive, male/female citizens and the public/domestic spaces where citizenship could be acted upon; combined women's right of self defense with their civil obligation to protect and defend the *patrie;* and placed these rights and duties directly in the center of a general definition of the rights and responsibilities of citizenship. Thus, the armed women who marched on April 9th as participants in an imposing, section-based procession representing a united national family in arms, at the

same time embodied a driving force of radicalization, the principle and practice of militant citizenship.

This picture of an armed national family is the clean, sharp inverse of the radical journalists' earlier depictions of unarmed families brutally gunned down by Lafayette's troops as they gathered on the Champ de Mars in July, 1791, to sign the petition on the fate of the monarchical executive under the new Constitution. In the days and weeks following the *journée* of July 17th, the incendiary journalist Jean-Paul Marat filled the pages of his *Ami du peuple* with provocative word pictures of "poor old men, pregnant women, with infants at their breast!", massacred in cold blood.[11] "The blood of old men, women, children, massacred around the altar of the fatherland is still warm, it cries out for vengeance. . . ."[12] The arming of passive citizens, including women, in the spring of 1792, turned upside down Marat's provocative picture of the world of the weak; activated an involuntarily pacific (because legally "passive") citizenry; and placed the mobilization of half the population behind the radical leadership's escalating estimates of the strength of the national family in arms.

The armed marchers of the *journée* of June 20, 1792, started out from the Faubourgs Saint-Antoine and Saint-Marcel. They converged in the Faubourg Saint-Antoine, moved through the streets and avenues of the right bank of Paris, into the halls of the Legislative Assembly, across the Tuileries Gardens, and then through the residence of the King in the Tuileries Palace, symbolically reclaiming these spaces for the people and reconsecrating them to the work of executing the general will of the sovereign people.

On June 16, a delegation from the sections of these two working class faubourgs had informed municipal authorities of their plans. Their purpose was to plant a liberty tree in the Tuileries Gardens to commemorate the third anniversary of the Tennis Court Oath and to present petitions to the Legislative Assembly and the King "relative to the circumstances." They asked for authorization to dress in the uniforms and carry the arms they had used in 1789. The key to the circumstances to which the delegation alluded was a collapse of the King's credibility, entraining a new crisis of confidence in the constitutional monarchy. The crisis was prepared in a generalized climate of fear, uncertainty, and mistrust as the nation suffered its first defeats in the war declared on April 20th. It was precipitated by the King's dismissal of his liberal Girondin ministry following his veto of legislation that, in the interest of national security, decreed harsh

sanctions against the refractory clergy and authorized the preparation of a camp beneath the walls of Paris to receive 20,000 troops from the departments.

The Council of the Commune refused to authorize the armed procession announced on June 16: ". . . considering that the law forbids all armed assemblies not a part of the legally required public defense, [the Council] passes to the order of the day."[13] This action had no impact on the organizers and participants who continued with their preparations from bases in the general assemblies, clubs, and popular societies of their sections. A section meeting convoked on the night of June 19th in the church of the Enfants-Trouvés, in the Faubourg Saint-Antoine, was attended by more than a thousand citizens, men and women, who were repeatedly and strenuously urged to march, armed, on the 20th. Several other sections held all-night meetings to hear speeches, fraternize, and secure the participation of local National Guard commanders.[14]

This same night, Pétion, informed by faubourg leaders that nothing could stop the march, developed a strategy of placing all armed marchers under the flags of National Guard battalions in their sections and under the authority of battalion commanders, thereby legitimating an extraordinary armed force composed of National Guardsmen and all citizens, passive along with active, women and children along with men. During the night of June 19–20, the royalist Department of Paris vetoed Pétion's scheme; and the following morning, Pétion, who appeared ready to comply with departmental policy, dispatched municipal authorities to the faubourgs with orders to prevent or disperse the procession.[15]

When these municipal officials arrived in the sections of the two faubourgs, they were met by thousands of fully mobilized citizens—National Guardsmen, men, women, and children, ranged in formation, armed, and preparing to march. An officer dispatched to the Faubourg Saint-Marcel reported a portion of its battalion already in marching formation, fully armed, with the battalion's cannon at the head of its line of march. "This gathering was all the more numerous as it was increased by a large number of citizens and women, each one armed after his [her] fashion, with rifles, pikes, sabres, swords, sticks, etc." After attempting to reason with them the officer and his colleagues concluded that there was no way to persuade these "volunteer soldiers, citizens, and the women who are with them" to "lay down their arms and return their cannon to the *corps de garde*. . . ." They were going to march armed because, as they put it, they feared

being repulsed by force—especially at the Tuileries Palace.[16] A second detachment of officers also dispatched to the Faubourg Saint-Marcel reported coming upon a troop of men armed and in uniform, with horse-drawn cannon at their head, and accompanied by "a tremendous number of persons of all ages and both sexes, armed and unarmed, and a very large number of them in uniform—grenadiers, fusiliers, light infantrymen, carrying their flags." They refused to lay down their arms or abandon their march: ". . . nothing could prevent them from marching." They argued that they knew what the law was as well as anyone else; they were armed only to assure that it was respected and observed. They also argued that there were legitimizing precedents for armed processions of this kind, "several others having come armed to the National Assembly, which gave them a good reception." Finally, the marchers made it clear that they were armed to repel force with force, if necessary: "if anyone had any idea about dispatching cannon against them, then we [the authorities] would see that they also had [cannon]. . . ." In the end the marchers closed all discussion by taking action: "So the whole troop of them, giving way to their impatience, began to cry out: that's quite enough of all this; forward march, *Monsieur le commandant,* forward march!"[17]

At the very moment when officers in the field were meeting with insuperable resistance to their efforts to stop the march, Pétion and the Municipality of Paris confronted the necessity of relegitimating it. Notwithstanding explicit instructions to the contrary from the Department, the Municipality decreed that the Commander-General of the National Guard issue all necessary orders "to assemble under the flag citizens in all kinds of uniforms, with all kinds of arms, who will march thus assembled under the command of the officers of the battalions."[18]

Starting out from the two faubourgs, the armed marchers joined forces on the right bank, marched together through the streets and principal sections of the capital, and having arrived at the Tuileries Gardens, planted a commemorative liberty tree and regrouped outside the meeting hall of the Legislative Assembly.[19] Meanwhile, inside, the deputies engaged in a tense debate over whether and under what conditions these petitioners should be admitted: with arms? without arms? in a delegation? all eight thousand (one deputy's estimate of the number assembled and clamoring at the doors)? Vergniaud, a deputy on the left, warned that if the law against armed demonstrations was applied, a massacre would result, a replay of "the bloody scene on the Champ de Mars" when men, women, and children were

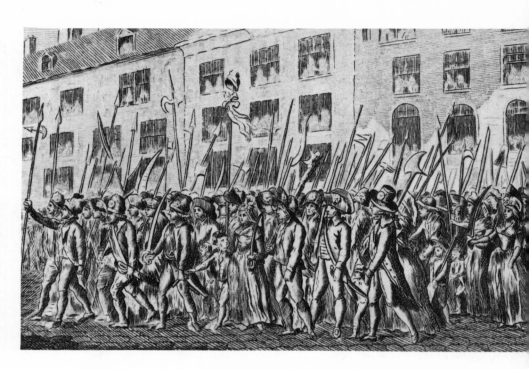

This anonymous engraving from the *Révolutions de Paris* is titled "Famous journée of 20 June 1792." The accompanying caption reads: "Reunion of Citizens from the Faubourgs St. Antoine and St. Marceau en route to the National Assembly to present a petition, followed by another [petition] to the king." A mobilized armed population of men, women and children from the sections and faubourgs is depicted marching alongside members of the National Guard and carrying a revolutionary emblem of liberty and popular sovereignty, a *bonnet de liberté* mounted on the tip of a pike. (Louis-Marie Prudhomme, ed., *Révolutions de Paris*, vol. 12, no. 154, June 6–23, 1792.)

shot down. Finally, under mounting pressure from the tumultuous galleries and from the pressing multitude outside, the vote was taken: a delegation would be received.[20]

The delegation's address to the Assembly, read by a citizen from the Faubourg Saint-Antoine, Huguenin, established the marchers' claims and linked them to a second revolutionary ideology in the making, a republican ideology rooted in principles of popular sov-

ereignty, militant citizenship, and political legitimacy as an expression of the will of the sovereign people. First, the orator established an identity between the marchers and the French people: "The French people is here today to make known to you its fears and its anxieties." This people comes "in the name of the nation which has its eyes fixed on this city." The orator later expanded this explosive claim: the marchers are the people and the people is the sovereign. "The people is present, it awaits in silence an answer worthy of its sovereignty. . . ." In his conclusion, the speaker returned to the most immediate reality—the real strength of the force actually concentrated behind the doors of the Assembly. "This is the petition not only of the inhabitants of the Faubourg Saint-Antoine but of all the sections of the capital and the vicinity of Paris."[21] "[A]nd of the entire realm," a deputy added, completing the orator's extraordinary representation of this procession as a mobilized sovereign people, on alert, standing in tense silence at the doors of the Legislative Assembly.[22]

Second, the orator underscored a matter of fact of which the Assembly was already only too aware: this sovereign people was fully mobilized; it was an armed force. "We come to assure you that the people is on alert [*le peuple est debout*] and worthy of the circumstances [*à la hauteur des circonstances*] and prepared to take extreme measures to avenge the majesty of the outraged people." He justified a recourse to armed might—insurrection—by an appeal to natural right, the right to resist oppression, which was guaranteed in Article Two of the Declaration of Rights.

Third, the orator proclaimed that the armed sovereign was the supreme authority, and its will was insuperable. No other willpower could prevail against it: "this head [that of the people] is the genealogical tree of the nation and before this robust oak, the weak reed must bend." And again: "A single man must not influence the will of a nation of twenty-five million souls." The orator reread the constitutional crisis between the King and the Assembly as a confrontation of wills: the will of the sovereign people against that of traitorous Catalines in the Assembly, a veto-wielding despot on the throne, and pusillanimous judges in the courts. Implicit in the warnings and claims expressed through this discourse was the doctrine that the will of the sovereign people, expressed most forcefully in the insurrection, stood before and behind all constitutions, institutions, and laws as the source, expression, and ultimate measure of their legitimacy. In one such double-faced message, the orator professed respect for the Constitution, then immediately appealed beyond it to the force of the armed sovereign: "We do not want to adopt any position other than

that which will be in accordance with the Constitution." But in the passage immediately following, he added: "Would the enemies of the fatherland imagine that the men of the fourteenth of July are asleep? If they appeared to them to be [asleep], their awakening is terrible."[23]

The President of the Assembly tried to parry the thrust of these declarations with a lecture on the respect owed to the laws. Several deputies recalled the law prohibiting the introduction of arms into the Assembly, but to no avail. The Assembly voted to allow the armed procession to parade through the hall.[24]

In the hour and a half that followed, thousands of marchers, 8,000, 20,000, 40,000, 50,000 (the estimates vary from observer to observer)[25]—armed men, women, and children—enacted concepts of militant citizenship and popular sovereignty and dramatized the principle that the will of the people is the source and measure of political legitimacy. Their barely ceremonial behavior, veering between processional performance and insurrection, undercut and threatened to dissolve prevailing constitutional arrangements. In this sense the procession of June 20th previewed the new republican order in the making.

The marchers played out a political self-definition that their spokesman had articulated in his speech. They represented themselves as the sovereign people in arms. As they paraded through the hall, indeed took it over, observers identified detachments of National Guardsmen, light infantrymen, grenadiers, and troops of the line, interspersed with children, women—"*dames et femmes du peuple*"—and men—porters, charcoal burners, priests with swords and guns, and veterans. A sympathetic enthusiastic eyewitness, Mme. Jullien, described the marchers as "all intermingled in the true spirit of equality and fraternal union." "[A]ll the people were on alert [*debout*]. The real sovereign knew how to deploy a true majesty." The following weapons were reported: long pikes, guns, axes, knives and paring knives, scythes, pitchforks, sticks, bayonnets, large daggers, clubs, and great saws. Armed women were described separately as wearing liberty caps and carrying sabres and the heads of iron weapons. In the engraving, "Famous *journée* of 20 June 1792 . . . ," the women were depicted carrying pikes and swords. Notwithstanding the immense numbers, the staggering variety of costumes and arms, the mélange of civilians and trained military, and the combinations of all ages and both sexes, a kind of order, unity, discipline, and hence additional power was created and sustained by the line and rhythm of a march to drumbeat, martial music, and refrains of "Ça ira."[26]

Exclamations, cries, emblems, signs, and speeches linked the marchers as a palpable, forceful physical presence to the principles

and powers of popular sovereignty. A torn pair of black culottes was carried through the hall, inpaled on a pike, surrounded by cocardes, and bearing the inscription: "Long live the *sans-culottes!*"[27] An eyewitness called attention to an additional inscription: *A bas le véto!*"[28] A calf's heart, stuck onto the tip of a pike with the inscription, "Heart of an Aristocrat," was paraded about until, as the *Archives parlementaires* reported, the bearer was asked to leave the hall and he complied.[29] A banner read: "Tyrants, you dare to drive out our pikes, return to the law or tremble!" Another, carried by a woman marcher, proclaimed on one side, "Liberty! Tyrants, tremble. The French are armed!" and on the other, "Equality. Reunion of the Flags, Saint-Antoine and Saint-Marceau." A third bore the inscription on one side, "When their country is in danger, all the *sans-culottes* are alert," and on the other side, "Tremble tyrants, your reign approaches its end."[30] A placard bore the message, "Warning [*avis*] to Louis XVI: The people is tired of suffering, liberty or death."[31] In the middle of the procession a marcher delivered a speech in which he equated the avenging force present on the floor of the Assembly with the power of millions: "It is not two thousand men, it is twenty million men whom we come to offer, it is an entire nation which must arm itself to combat tyrants, [the nation's] enemies, and yours."[32]

Symbolic trophies of victory—the enemy's knee breeches, his heart—placards, and banners filled with ultimata and death warnings to tyrants and aristocrats all carried the message that an invincible sovereign, a people twenty million strong, was capable of piercing its enemies full of holes, tearing out their hearts—in short, physically eliminating them from the political system, constitutional guarantees notwithstanding. When the marchers targeted aristocrats and tyrants as enemies of the sovereign people, they explicitly named Louis XVI, whose double veto they read as the chief obstacle to the execution of their sovereign will. At the same time, their placards proclaimed their loyalty to the Constitution of 1791, which explicitly authorized the monarchical executive's exercise of a suspensive veto power. When the marchers paraded through the Assembly, their cries, "Long live the law!" "Long live our representatives!" mingled with their shouts of "Long live the patriots!" "Long live the *sans-culottes!*" "Long live liberty!" "Down with the Veto!"[33] One of their banners bore the inscription, "The Constitution! Live free or die! The Constitution or death!"[34] They meant what they said; they were loyal to the Constitution. However, as they understood the matter, the Constitution, along with all constituted authorities, was only the instrument of the will of an armed, sovereign citizenry, the supreme constituent authority and ultimate source of the system's legitimacy.

These new meanings of citizenship, sovereignty, and legitimacy played out in the ceremonial framework of an armed procession symbolically inverted the constitutional arrangements of 1791, which had located delegated powers of national sovereignty in a monarchical executive and a national legislature. Having traversed the Legislative Assembly, the marchers exited into the Tuileries Gardens. They broke through the gates of the royal palace and charged up the staircase armed with sabres, pikes, sticks, and rifles (and dragging a cannon, at least to the top of the stairs). They literally cornered the King and the royal family in their private quarters and repeated the earlier procession, but with greatly increased numbers and more threatening gestures, including episodic breakthroughs of regicidal impulses. The marchers' invasion of the King's space turned it into a battleground of wills: the King's will against the will of the sovereign people. They concretized the recalcitrant will of the King in his veto power and attempted to bend that will into an expression of the popular will. The King's consent to withdraw his vetoes would be the only acceptable sign of conversion and anything less only further evidence of tyrannical governance. As they marched under the palace windows or filed past the King in his quarters, they practiced a politics of persuasion through threats, insults, verbal and physical displays of force, the exhibition of symbolic trophies, offerings of transformative patriotic emblems, self-acclamations, and pledges of allegiance and solidarity to one another: "Long live the Nation!" "Long live the *sans-culottes!*" "Down with Monsieur Veto!" "Down with Madame Veto!" "Down with the King!" "Down with the Queen!"[35] They paraded two hearts impaled on pikes. One was made of wood or painted carton and bore the inscription, "Heart of M. Veto"; the other was a bloody animal heart with a similar inscription,[36] signifying now *not* the impaled heart of aristocrats but that of Monsieur Veto himself, the King. One marcher filed past the King and held out to him a liberty cap that he had placed on the end of a long stick. The King took it. He put it on his head. Applause and shouts rang out: "Vive la Nation!" "Vive le Roi!" "Vive la liberté!" The liberty cap, alas, did not transform the will of the King who wore it into an expression of popular will. A woman held out her sword, decorated with flowers and a cocarde—a striking emblem of joyful force, the people's festive harmonization of wills through the application of armed might. The King took it and brandished it and joined the crowd in shouts of "Vive la nation!" Then he reiterated his refusal to retract his vetoes, proclaiming his fidelity to the principles of the Constitution.[37]

In the end, neither side scored a clear victory in a battle of wills that strained ceremonial ritual to the breaking point. After the siege

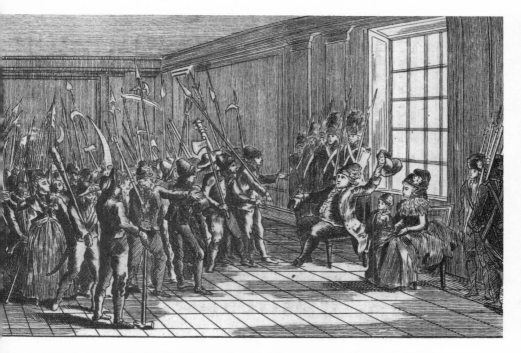

FIG. 3. [June 20, 1792]. The caption in this anonymous engraving from the *Révolutions de Paris* reads: "Citizens from the Faubourg Saint-Antoine and Saint-Marcel in the residence of the King, present him with a petition. Louis XVI takes a *bonnet rouge* and places it on his head, exclaiming "*Vive la* nation!" and drinking to the health of the *sans-culottes*. (From Louis-Marie Prudhomme, ed., *Révolutions de Paris*, vol. 12, no. 154, June 16–23, 1792.)

had lasted more than six hours, the mayor and municipal authorities finally moved the demonstrators out of the palace and gardens. However, two guards reported overhearing the section chief, Santerre, comment as he left the château, "The King has been hard to move today. We will return tomorrow; we will make him give in"[38]—an unambiguous expression of this collective determination to break the King's will and incorporate it into the will of the people.

Witnesses on the scene were quick to seize the larger import of the day's events. The American diplomat Gouverneur Morris wrote in his diary: "His Majesty has put on the Bonnet rouge but he persists in refusing to sanction the Decrees. . . . The Constitution has this day I think given its last groan."[39]

P. L. Roederer, the Procurator-General of the Department of

Paris, commented in his *Chronique de Cinquante Jours*: "The throne was still standing but the people were seated on it, took the measure of it; and its steps seemed to have been lowered to the level of the paving stones of Paris."[40]

On June 21, 1792, the Legislative Assembly decreed that under no circumstances would "any armed gathering of citizens be admitted to its bar for purposes of parading through its meeting hall or presenting itself before any constituted authority without prior legal authorization."[41] The legislation came too late. The armed processions, repeatedly legitimized by the deputies' votes to receive and honor them, had functioned successfully as ceremonial demonstrations of the breadth, scope, and strength of a fully mobilized democratic force in the revolutionary capital. The day the legislators passed their decree, a police commissioner reported that in the incendiary Faubourg Saint-Antoine he had heard it said that ". . . the people is the only sovereign, it must make the law WITHOUT CONSTITUTION AND WITHOUT SANCTION."[42]

Women were at the center of a mass-based political and military movement in Paris that gathered force and momentum through the spring and summer of 1792 and culminated on August 10, 1792, in a military victory of the armed sections, the flight of the King into the Legislative Assembly, and the collapse of the constitutional monarchy. We have analyzed one ceremonial and insurrectionary expression of this movement of revolutionary radicalization and democratization, armed processions through the Legislative Assembly involving men, women, and children from the sections of Paris. Months before the constitutional monarchy fell and a republican system was established, these armed processions mediated a collective expression of the principles and practices of popular sovereignty, militant citizenship, and political legitimacy defined as the expression of the popular will. We have called attention to the contribution of women like Pauline Léon, who reformulated, democratized, and claimed for women fundamental political principles and rights that later were enacted in the armed processions, like the right to bear arms both in self-defense and as a patriotic act. We have emphasized the numbers and visibility of women in ceremonial demonstrations of collective strength, which previewed and prepared the events of August 10, 1792.

One might ask nonetheless: What historical difference did the presence of women really make? Did women's active participation change any outcomes? Are the historians missing much when they

leave women out of their depictions and analyses of revolutionary radicalization or when they include women, if at all, only to add local color? We want to speak to these questions.

Three days after the events of June 20th, the Procurator-General of the Department of Paris, P. L. Roederer, forwarded to the mayor and municipal officers a letter he had received from a Parisian cloth merchant named Mouton. Mouton reported overhearing the conversation of three poorly dressed men as they watched his wife working behind the counter: "There's a young strong woman; this one will make a good marcher [*ça marchera bien*]. . . . we must put her on our list." Mouton linked these remarks to what he called a well-known strategy "of forcing peaceful *citoyennes* to march in the middle of tumultuous crowds in order to paralyze the force responsible for disciplining them." Pétion reported back to the Department that he had forwarded the two letters to the municipal police and had ordered them to take appropriate precautionary measures.[43]

As he wrote these orders, Pétion himself was under attack for having failed to use force to prevent or to disperse the armed procession of June 20th. Pétion rushed into print with a self-defense: *Conduite tenue par M. le Maire de Paris à l'occasion des événements du 20 juin 1792.* His answer to his critics was that neither he nor anyone else could have commanded the force capable of halting the march of "such an immense crowd of citizens." "Where was the repressive force capable of stopping the torrent? I say it did not exist." All battalions from the two faubourgs were marching with cannon and arms, followed by large numbers of armed citizens and a multitude of unarmed citizens, Pétion argued. Any force mobilized against the marchers could only have been composed of National Guardsmen. In that case, the Guardsmen would have been opposing fellow Guardsmen, combating citizens armed with pikes, opposing unarmed men, confronting women, battling with children. ". . . who could have answered for the lives of these persons who are the most precious to the nation [and] whom it is most important to preserve?" On whom, and where, would this attacking force have fired? "The very idea of this carnage makes one tremble"; "[a]nd to whom would this bloody battlefield have been left?" Three-quarters of the National Guard would have refused to fire on their fellow citizens, given that they all shared the marchers' motives, given that the Legislative Assembly already had set precedents when it tolerated earlier processions.[44] Other observers,[45] and notably officials in the Department of Paris who suspended Pétion from office, acknowledged that he was right about June 20—there was no way to oppose this popular force with

force—although they blamed Pétion for issuing the order that incorporated all these people into the National Guard. "An *attroupement*, without subordination or discipline," they wrote, "armed with forks, pikes, sticks with iron points, containing an admixture of women and children, not only brought disorder into the ranks of the National Guard; it also placed public force out of the state of maneuvering and making moves which [otherwise] would have been commanded."[46]

In short, authorities of all convictions who would have had to give the orders perceived that the participants in the insurrectionary processions of June 20 (precisely this particular combination of National Guardsmen and their commanders marching with armed and unarmed male and female citizens and children, their relatives, friends, and neighbors) had shaped themselves into a new symbolic, political, and military force and represented themselves as a national family in arms that could not be vanquished. On August 10, 1792, that turned out to be the case; on June 20, it already was considered by authorities to be the case, in part because of the presence of women.

We suggest that radicalization in revolutionary Paris involved a coalescing of the democratic aspirations, strategies, energies, beliefs, and ideals of individuals and groups into a force that was perceived as invincible by authorities well before it scored the costly military victory at the Tuileries that brought down the monarchy. Women participated in the armed processions that shaped that force; added their numbers to its mass; contributed to formulating and communicating its fighting principles and demonstrating its strength. Women's solidarity with that force, coupled with the symbolic representation of all these armed marchers as a national patriotic family in arms, convinced the authorities that the power of these crowds of predominantly passive citizens who identified themselves as the sovereign people was, in any event, irrepressible.

We are not able to reconstruct all the pressures, interests, and convictions that motivated these political actors; but we suggest that the experience of involvement in ceremonies, deputations, and insurrections during the spring and summer of 1792 furthered the development of political consciousness. For example, the petition bearing more than three hundred signatures that Pauline Léon and a delegation of women brought to the Legislative Assembly on March 6, 1792, clearly attests to the women's understanding of their entitlement to the rights and responsibilities of citizenship. Léon insisted on women's natural right to self-defense: ". . . society cannot deny

the right nature gives us unless you pretend the Declaration of Rights does not apply to women and that they should let their throats be cut like lambs. . . ." She also claimed for women attributes of civic virtue that, in both neoclassical and Rousseauan variants of the "male language of virtue," were reserved exclusively for men. "We are *citoyennes* and we cannot be indifferent to the fate of the fatherland."[47] In the case of the processions of April 9th and June 20th, the leaders armed women, handed them political placards, flags, "and other emblems of liberty," and led them through the national legislature and the Tuileries Palace. They also dissolved prevalent distinctions between the domestic roles and private virtues of women and the political roles and civic virtues of men. They empowered the powerless and hailed their militancy as formidable demonstrations of popular sovereignty. These processional and insurrectionary performances were symbolically charged acts. Notwithstanding efforts to control and direct such acts, they retained a subversive potential to blur or invert gender roles and, beyond that, to dramatize radically new political identities for women as members of a militant, sovereign citizenry.

The breadth, scope, and impact of women's engagement in the events of 1792 are remarkable. Radicalization meant in part a collective application of force that opened up the possibility for an expanded legal and constitutional definiton of the rights and status of citizenship. Women's acts of power in the Revolution were very real. Women enlarged the demographic base of the democratic revolution; by the summer of 1792, the presence of women in a crowd, in a procession, intermingled with battalions of National Guardsmen—even when they were armed—made the use of countervailing force problematic, if not impossible. Their participation in revolutionary dramaturgy strengthened the psychological and political bonds linking the individual and the nation. Their most radical discourse linked their roles as militants to fundamental principles and rights of citizenship, like the right to bear arms. Male radicals remained profoundly ambivalent about the political implications of women's involvement. Nonetheless, they recognized women's weight as political actors; they tolerated and even orchestrated women's participation in the ceremonies and demonstrations of armed force that contributed to democratizing the process of legitimation and practices of sovereignty and citizenship.

Our focus on the crisis of 1792 has brought into relief neglected aspects of women's central involvement in the dynamics of revolution-

ary radicalization. It also reveals that women's political status, claims, strategies, and opportunities remained relatively open and fluid at this critical historical juncture. Following the events of August, 1792, this indeterminacy favored women's escalating struggles for political identity in the new revolutionary system and their efforts to shape and transform the language of politics to express and legitimate their claims. Eventually, a victorious republican leadership encoded legal and constitutional definitions of citizenship that democratized, universalized—for men—rights of political citizenship, access to political office, the suffrage, and the right to bear arms in the National Guard and other armed forces, while underscoring women's continued political passivity and further validating the gendered models of nature, citizenship, and virtue that rationalized it. But in 1792, and for more than another year, until the Jacobin repression of women's organized political activity in October, 1793,[48] these definitions did not have a decisive impact on women's escalating militancy, their progressively more radical and militant counterdefinitions, claims, and practices of citizenship through institutional and insurrectionary political interventions. At all levels, a shifting republican leadership persevered in its uneasy toleration and episodic exploitation of women's de facto but not de jure political status without, however, resolving the issues of gender and citizenship that this double-faced politics had exposed.

Notes

1. See, for example, Joan Landes, *Women in the Public Sphere in the Age of the French Revolution* (Ithaca, N.Y.: Cornell University Press, 1988); Dorinda Outram, *"Le Langage Mâle de la Vertu*: Women and the Discourse of the French Revolution," in *The Social History of Language,* ed. Peter Burke, Roy Porter (Cambridge: Cambridge University Press, 1987), 120–35.

2. For a more fully developed interpretation of women and revolutionary politics during this entire period, see Darline Gay Levy and Harriet Branson Applewhite, "Women and Political Revolution in Paris," in *Becoming Visible,* 2d ed., ed. Renate Bridenthal, Claudia Koonz, and Susan Stuard (Boston: Houghton Mifflin Company, 1987), 279–306.

3. For the procès-verbal of this *fête,* which is the basis for our discussion, see *Archives parlementaires de 1787 à 1860,* 1st ser., 171 vols. (Paris, 1879–1908), 41:387–91 (April 9, 1792).

4. Michel Vovelle, *La Chute de la Monarchie, 1787–1792* (Paris: Editions de Seuil, 1972), 149.

5. Otto Ernst, *Théroigne de Méricourt, D'après des documents inédits tirés des Archives secrètes de la Maison d'Autriche* (Paris: Payot, 1935), 257–58, cited by Ernst without reference.

6. *Archives parlementaires*, 1st ser., 41:387–91 (April 9, 1792).

7. "Des Piques," *Révolutions de Paris*, ed. Prudhomme, February 11–18, 1792.

8. *Archives parlementaires*, 1st ser., 39:423, 424 (March 6, 1792). In this context, see also a speech by Théroigne de Méricourt on March 29, 1792, as she presented a tricolor flag to the citizens of the Faubourg Saint-Antoine. The speech is cited without reference in Ernst, *Théroigne de Méricourt*, 252. The speech, as cited, begins: "Let us arm! We have the right by nature and under the law. Let us arm to show men that we are not inferior to them either in virtue or courage. Let us show Europe that French women, conscious of their rights, are worthy of a century of enlightenment like the eighteenth. . . ."

9. Montjoye, *Ami du Roi*, no. LVIII, Thursday, March 8, 1792, 270, reporting on a session of the Legislative Assembly, Tuesday evening, March 6, 1792.

10. *Extrait du registre des délibérations du Conseil général de la Commune de Paris, du vendredi 5 avril 1792, l'an 4 de la liberté* (Paris, 1792).

11. Jean-Paul Marat, *Ami du peuple*, no. 529, Wednesday, August 10, 1791, 1–2.

12. Jean-Paul Marat, *Ami du peuple*, no. 524, July 20, 1791, 2.

13. Laura Pfeiffer, "The Uprising of June 20, 1792," *University Studies*, (University of Nebraska) 12, no. 3 (July, 1912): 39.

14. Pfeiffer, "Uprising of June 20, 1792," 45–46. For a discussion of women's attendance at this meeting, see Report of Desmousseaux, Municipal Officer, June 29, 1792, in Archives nationales, BB 30 17. See also "Procès-verbal de la séance du 19 juin de la Section des Quinze-Vingts," *Journal Des débats et décrets*, no. 273 (1792): 359–60.

15. Pfeiffer, "Uprising of June 20, 1792," 50ff. See also Directory of Department of Paris to Mayor of Paris and Police administrators, June 20, 1792, in *Revue Rétrospective*, 2d ser., 1 (1835); copy of letter from Pétion and municipal officers to Directory of Department of Paris, June 20, 1792, midnight, in *Pièces relatives à l'événement du 20 juin 1792*, in Archives nationales, BB 30 17.

16. Pfeiffer, "Uprising of June 20, 1792," 48–60. Report by Perron, Administrator at the Department of Police of the Municipality of Paris, June 20, 1792; Report of MM. Mouchet, Guiard, Thomas, municipal officers of Paris—both in *Revue Rétrospective*, 2d ser., 1 (1835) 170–72, 172–75.

17. Procès-verbal drawn up by MM. Mouchet, Guiard Thomas, municipal officers, in *Revue Rétrospective*, 2d ser., 1 (1835): 172–75.

18. Pfeiffer, "Uprising of June 20, 1792," 61. Extract from the register of the deliberations of the Municipal body of Paris, June 20, 1792, in *Revue Rétrospective*, 2d ser., 1 (1835): 168.

19. Pfeiffer, "Uprising of June 20, 1792," 69ff.

20. *Archives parlementaires*, 1st ser., 45:411–16 (June 20, 1792).

21. For the text of this speech, see *Archives parlementaires*, 1st ser., 45:416–17 (June 20, 1792). See also Huguenin, "rédacteur, citoyen du Faubourg Saint-Antoine," *Pétition et adresse présentés à l'Assemblée nationale & au roi, le mercredi vingt juin, l'an quatre de la liberté, par les citoyens des Faubourgs Saint-Antoine et Saint Marceau, des différentes sections de la capitale, et municipalités des environs* (Paris, 1792).

22. Montjoye, *Ami du Roi*, no. CLXXIII, Thursday, June 21, 1792, 690–91, reporting on session of Tuesday evening, June 19 [*sic*, for 20], 1792.

23. *Archives parlementaires*, 1st ser., 45:417 (June 20, 1792).

24. *Archives parlementaires*, 1st ser., 45:417–18 (June 20, 1792).

25. Edouard Lockroy, ed., *Journal d'une bourgeoise pendant la Révolution, 1791–1793* (Paris: Calmann-Lévy, 1881), 137, 138; Jean-Paul Marat, *Ami du peuple*, July 16, 1792, 1; P. L. Roederer, *Chronique de Cinquante Jours, du 20 juin jusqu'au 10 août 1792, redigée sur pièces authentiques* (Paris, 1832), 25ff.

26. The preceding description is based upon material in the following sources: *Archives parlementaires*, 1st ser., 45:419 (June 20, 1792); Mme. Rosalie Jullien, letter dated June 19–20, 1792, in Lockroy, *Journal d'une bourgeoise*, 137–39; *Mercure de France*, no. 26, June 30, 1792, 306–7 (report on legislative session of June 20, 1792); *Le Mercure universel*, June 21, 1792, as cited in Pfeiffer, "Uprising of June 20, 1792," 84. The reference to "*dames et femmes du peuple*" is taken from Mme. Jullien's account, June 19–20, 1792, 137, 138. The description of women wearing liberty caps and carrying sabres and blades is taken from the procès-verbal in *Archives parlementaires*, 1st ser., 45:419 (June 20, 1792). The engraving mentioned, "Famous *journée* of 20 June 1792 . . . , réunion of citizens from the Faubourgs Saint-Antoine and Saint-Marceau," is reproduced here from Prudhomme, ed., *Révolutions de Paris*, vol. 12, no. 154, June 16–23, 1792.

27. *Archives parlementaires*, 1st ser., 45:419 (June 20, 1792); for the inscription "long live the sans-culottes," see *Mercure de France*, no. 26, June 30, 1792, 307.

28. Roederer, *Chronique de Cinquante Jours*, 34.

29. *Archives parlementaires*, 1st ser., 45:419 (June 20, 1792).

30. *Le Mercure universel*, June 21, 1792, as cited in Pfeiffer, "Uprising of June 20, 1792," 84.

31. *Archives parlementaires*, 1st ser., 45:419 (June 20, 1792).

32. Ibid.

33. Ibid.

34. *Le Mercure universel*, June 21, 1792, as cited in Pfeiffer, "Uprising of June 20, 1792," 84.

35. Declaration of J. J. Leroux on the events of June 20 through June 24, in Bibliothèque nationale, MSS fr., 2667, fols. 87–89v.

36. Declaration of J. J. Leroux, in Bibliothèque nationale, MSS fr., 2667, fol. 76. See also report to the Council of the Department of Paris, by Garnier,

Leveillard, and Demantort, all three commissioners, noting three hearts, in *Revue rétrospective*, 2d ser., 1 (1835): 236.

37. *Procès-verbal dressé le 20 juin 1792 par MM. Mouchet et Boucher St. Sauveur, officiers municipaux. Réimprimé par ordre du corps municipal* (Paris, 1792), 23, in Bibliothèque nationale, N.A. fr., 2667.

38. Pfeiffer, "Uprising of June 20, 1792," 122 and n. 303. One National Guardsman, Bidault, a grenadier with the Battalion St. Opportune, reported overhearing the following remark as the King put on the liberty cap: "il a f . . . bien fait de le mettre car nous aurons vu ce qu'il serait arrivé et f . . . s'il ne sanctionne pas le décret sur les prêtres réfractaires et sur le camp de 20,000 hommes, nous reviendrons tous les jours et c'est par là que nous le lasserons et que nous saurons nous faire craindre." A Copy of Bidault's declaration on the event of June 20, 1792, is in Archives nationales, BB 30 17.

39. Gouverneur Morris to Lord George Gordon, Paris, Wednesday, June 20, 1792, in Gouverneur Morris, *A Diary of the French Revolution*, 2 vols., ed. B.C. Davenport (Boston: Houghton Mifflin, 1939), 2:453.

40. Roederer, *Chronique de Cinquante Jours*, 64.

41. Louis-Mortimer Ternaux, *Histoire de la Terreur, 1792–1794, d'après des documents authentiques et inédits*, 2d ed., 8 vols. (Paris, 1863–1881), 1:234.

42. Report of Dumont, commissaire de police, Section de la Rue Montreuil, to the Directory of the Department of Paris, June 21, 1792, in "Journée du vingt juin 1792," *Revue rétrospective*, 2d ser., 1 (1835): 180, 181.

43. P. L. Roederer to the mayor of Paris and the municipal officers in the Department of Police, Paris, June 23, 1792, with enclosed letter from M. Mouton, cloth merchant, Rue de Bussy, n.d., and letter from Pétion to Roederer, Paris, June 24, 1792; reprinted in "Journée du 20 août 1792," *Revue rétrospective*, 2d ser., 1 (1835): 193, 194.

44. Jérôme Pétion, "Conduite tenue par M. le maire de Paris à l'occasion des événements du 20 juin," *Revue rétrospective*, 2d ser., 1 (1835): 221–34.

45. See Pellenc to Lamarek, Paris, June 24, 1792, in Hans Glagau, *Die Französische Legislative und der Ursprung der Revolutions Kriege, 1791–1792* (Berlin, 1896), 336–38.

46. *Extrait des Registres des Délibérations du Conseil du Département de Paris, 6 juillet 1792* (Paris, 1792).

47. Darline Gay Levy, Harriet Branson Applewhite, and Mary Durham Johnson, eds., *Women in Revolutionary Paris, 1789–1795* (Urbana, Ill.: University of Illinois Press, 1979), 72, 73. The speech is misdated March 6, 1791, both in the printed copy and in our anthology. The term "the male language of virtue" is taken from Dorinda Outram, "*Le Langage Mâle de la Vertu*: Women and the Discourse of the French Revolution."

48. Levy, Applewhite, and Johnson, eds., *Women in Revolutionary Paris*, 213–20.

Women and Political Culture
in the Dutch Revolutions

Wayne Ph. te Brake, Rudolf M. Dekker, and Lotte C. van de Pol

Democratic revolution came to the Dutch Republic in two distinct phases in the last quarter of the eighteenth century.[1] In the 1780s the self-styled Patriot movement challenged the Dutch republican regime at its base in the chartered towns and in the countryside of the seven United Provinces, whose representatives made up the Estates General. In the decentralized Republic, this early phase of the revolutionary conflict had a checkered, piecemeal quality that reflected the provincial and local diversity of Dutch politics. Yet the movement was strong and successful enough to provoke a determined counter-revolution sponsored by English funds and Prussian military intervention that restored the Prince of Orange and the old-regime oligarchy in the fall of 1787. Some seven years later, in January 1795, the northward march of French revolutionary armies unleashed a second wave of revolutionary conflict that decisively ended the old regime and established the Batavian Republic. In this second phase, provincial and local autonomies were replaced by a centralized, unitary state along French lines. French fraternity under the Directory gave way, however, to French domination under the Consulate, and finally between 1810 and 1813 the Dutch provinces were annexed to Napoleon's Empire.

In the course of these two revolutions—the Patriot and the Batavian—extending over two of the most turbulent decades of European history, the political culture of the northern Netherlands was dramatically transformed. In the first place, the corporative, aristocratic pattern of old-regime politics was broken open; politics became the ongoing public concern and activity of a broad range of citizens engaged in elections, political clubs, and militias. At the same time, the old-regime language of political privilege rooted in history was

forced to make room for the more radical language of political equality rooted in natural rights. These shifts in Dutch political culture, though clear and decisive, were not immediately expressed in lasting constitutional victories as the revolutionaries had originally hoped, but neither did the Orangist restoration of 1787 or the expulsion of the French in 1813 serve simply to undo the changes that had occurred. By 1848, the transformation of Dutch politics begun by the Patriots in the 1780s was consummated by the adoption of a liberal constitution for the Kingdom of the Netherlands.[2]

Within the context of this broad revolution in political culture, it is also possible to discern important changes in gender relations. In the first place, women gradually lost their influential old-regime political roles as leaders of crowds and wives of important political figures; the politics of the new active citizen became an essentially male preserve. At the same time, however, the traditional language of female subservience was countered for the first time by the language of gender equality and feminism. These shifts in gender roles and ideology, by contrast with the larger transformations in political culture noted above, are seriously understudied and little understood in Dutch historiography.[3] Thus, it is our goal in this essay to explore the political dimensions of the shift in gender relations during the revolutionary period, to account for this shift in light of Dutch history—especially the history of women and of popular politics—and, in conclusion, to suggest its importance for the development of modern Dutch politics.

Women and Revolutionary Conflict in the 1780s

At first glance, the Dutch Patriot Revolution looks like an essentially male-dominated affair. Most of the leaders of the revolutionary movement, for example, were regents, public officials, and educated professionals who were almost by definition male. What's more, the Patriots' characteristic mechanism for popular mobilization—the revolutionary militia—excluded women from full membership.[4] This is not, however, to say that women were not involved in the political conflicts of the 1780s. Many women played indirect and supportive roles on both sides of the conflict, while others were more directly involved, like Betje Wolff, as revolutionary Patriot publicists or, like Kaat Mossel and Wilhelmina van Pruisen, as leaders of the Orangist counter-revolution. But before we examine more closely the roles

these women played, we must survey the general course of events during this remarkable decade, when the Dutch staged the first major democratic revolution on the European continent.[5]

The Patriot movement was born of the political and social crisis that resulted from Dutch involvement in the American Revolutionary War.[6] The Dutch were dragged willy-nilly into the war at the end of 1780 when the English learned of trade negotiations between the colonies and representatives of the city of Amsterdam. For the Dutch, the Fourth English War (1780–1784) was an unmitigated military and economic disaster, and it immediately set loose a torrent of internal bickering and mutual recrimination. On one side, the so-called Patriots attacked the Stadhouder, Prince William V of Orange, for his pro-English proclivities and his conduct of the war as commander of both the army and the navy. On the other side, the so-called Orangists attacked the traditional opponents of the Prince—the regents of Holland and the city of Amsterdam in particular—for provoking an unnecessary war with the Republic's natural ally, England.

In the fall of 1781, this internal debate was crystallized and transformed by a remarkable pamphlet entitled *Aan het Volk van Nederland* (To the People of the Netherlands).[7] In this long-winded pamphlet, J. D. van der Capellen, a dissident nobleman from Overijssel, managed to link the disastrous course of the war with a whole range of regional and local domestic political issues, claiming throughout that the current malaise in the Republic was all the result of the tyrannical and pro-English policies of William V. The chief conclusion that Van der Capellen drew from all this history was that the people of the Netherlands, like the people of America, had to organize and arm themselves and to seize control of their own affairs. Though *Aan het Volk van Nederland* can hardly be considered a blueprint for the Patriot Revolution, it nevertheless was instrumental in shifting the terms of the debate and laying the practical foundations for a popular political movement.[8]

The war with England was not officially ended until 1784, but issues of foreign policy quickly gave way to local and regional political problems. In particular, the Patriots seized on the alleged abuses of the elaborate patronage system through which William (as Stadhouder, he was technically only an appointee of the provinces separately) exercised considerable influence in the politics of the Republic.[9] Gladly and to loud popular acclaim, many members of the old-regime oligarchy chipped away at the enormous influence of the

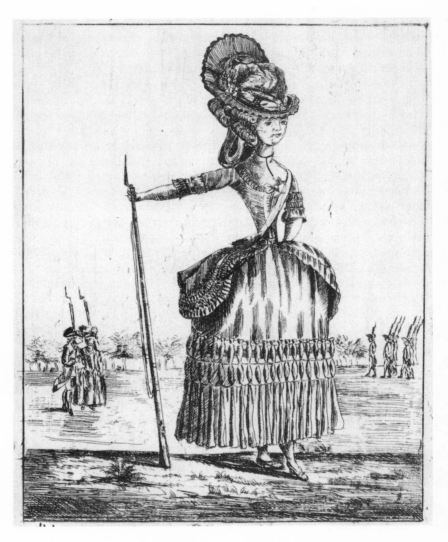

FIG. 1. Orangist caricature of a female supporter of the Patriots (1787): 'Armed heroine or present-day benefactor'. (Foto: Rijksprentenkabinet Collection F. Muller 4897, Rijksmuseum Amsterdam.)

Prince's so-called lieutenants—that is to say, the local power brokers who in fact controlled access to political office. Eventually this encroachment on the prerogatives of the Stadhouder extended as well to the Prince's control of the system of military justice and even to his command of the military. By 1785, after he had been relieved of his command of the important garrison at The Hague, a very discouraged William abandoned his residence there and retreated to his estates in the province of Gelderland.

This early, anti-Orange phase of the Patriot movement was rooted in a broad range of regional and local grievances; it allied, however tentatively, disgruntled oligarchs with an increasingly organized and confident popular movement. As success was piled on success, however, the Patriots were faced with the more difficult and divisive issue of who and what would fill the political void left by the diminution of the Stadhouder's authority; and the enormous periodical and pamphlet literature of the period resounds with the cacophonous discussions of this central issue and the grievances that fed it. In this rhetorical battleground, Patriot publicists easily maintained the upper hand, drowning out the learned but lonesome voices of conservative writers like Adriaan Kluit, Rijkloff Michael van Goens, and Elie Lusac.[10]

In the generally familiar eighteenth-century fashion, many Patriot writers argued that in order to make up for the mistakes of the past, government would henceforth have to be seen to proceed from the "sovereignty of the people," *het Volk*. Whereas in the earlier stadhouderless periods of Dutch history the "tyranny" of the Stadhouder had been replaced by the "true liberty" of the self-perpetuating regent oligarchy, the Patriots now demanded that the *burgerij*, the citizenry, be able to choose its own representatives so that the dependence of the regents or magistrates on the people could be institutionalized. After a hesitant start, the Patriots made considerable progress in creating new institutional arrangements at the local level, within more or less sovereign municipalities, where the principles of representative democracy could be most immediately realized.[11] The first of these municipal revolutions was achieved at Utrecht in 1786 and was followed by a rapid series of Patriot coups in the many cities of the provinces of Overijssel and Holland in the course of 1787. When outside intervention cut this revolutionary process short in September, 1787, the Patriots were in control of three provincial governments and had created revolutionary governments alongside conservative originals in two others. Orangists were in control of just two of the seven provinces.

Within this broad pattern of conflict, the most immediately striking participation of women was on the side of Orangist counterrevolution. Indeed, two Orangist women are among the most famous actors in the revolutionary drama. At one end of the social scale, probably the most colorful and infamous figure of the whole Patriot period was Catherina Mulder, known generally as Kaat Mossel.[12] A seller and official inspector of mussels, she was a well-known figure in the Achterklooster district of Rotterdam, a poor neighborhood known for its enthusiastic demonstrations of support for the House of Orange. In the beginning of 1784, Rotterdam was the scene of serious political unrest. After the government reluctantly gave permission for Orangist celebrations of the Prince's birthday, Orangists molested Patriots who refused to contribute money. Moreover, after the Patriots' militia unit was incorporated into the official Civic Guard (*schutterij*), this so-called Black Company—named for its black cocardes, a popular Patriot symbol—was harassed by Orangist crowds every time it kept the watch. On one such occasion in 1784, the Captain panicked and the men of his unit opened fire on the crowd, killing four people and wounding many others. An investigatory commission immediately arrested Kaat Mossel, accusing her both of bribing participants in the Orangist crowd and of leading the crowd herself.

Kaat Mossel's public life was not ended, however, by her arrest and imprisonment. Her legal defense, led by the young and brilliant Orangist lawyer William Bilderdijk, kept her in the public eye, and for her own part, Kaat Mossel managed to celebrate loudly and publicly the Prince's birthday even while in her cell. Finally, when in 1787 all Orangist political prisoners were given amnesty following the restoration, she refused to leave the prison, demanding that she be acquitted in an official trial and that she be given financial compensation. She actually got both, and when she was at last freed, a military honor guard accompanied her from The Hague to Rotterdam.

At the other end of the social spectrum was Wilhelmina van Pruisen, the wife of Stadhouder William V.[13] In 1787, when the province of Holland was falling into radical Patriot hands, the province of Gelderland where the Prince and his family sought refuge was firmly under Orangist control as a result of William's military repression of Patriot dissent. The Republic seemed to be on the brink of civil war, and at this point Wilhelmina forced the issue. Following a plan of her own making, unknown to the Prince's principal advisors and against the opposition of the Prince, she traveled at the end of June toward Holland with the express purpose of provoking an Orangist revolt upon her return to The Hague. At the border of Patriot territory, she was stopped by Patriot militiamen, arrested, held

captive for one night, and then sent back to Gelderland. In the process, she was treated as a commoner, without special deference to her social position, and when her brother, the King of Prussia, heard of this offense, he demanded satisfaction from the province of Holland. Receiving none, he sent 20,000 Prussian troops to restore the Orangist regime everywhere in the Dutch Republic in September, 1787. In the end, then, Wilhelmina's decision to travel to The Hague turned out to be a critical moment in the Patriot Revolution.

As a result of their actions, Kaat Mossel and Princess Wilhelmina became important symbols of Orangist politics and objects of Patriot scorn. Numerous caricatures and political cartoons depicted Kaat Mossel as the Orangist rabble-rouser,[14] par excellence, while Patriot pamphleteers typically attacked Princess Wilhelmina even more viciously than her husband.[15] Both are outstanding examples of the roles women played in the counterrevolutionary movement, but neither stood alone. On the local level, for example, the Vrouw van Almelo, too, was a leading defender of the old regime; and, in her home province of Overijssel, she was an important object of Patriot derision.[16] Likewise, in the city of Deventer, a 44-year-old woman was condemned to an exemplary six years in prison for leading and provoking an Orangist crowd in much the same way as Kaat Mossel.[17] That the revolutionary governments took the political actions of Orangist women seriously is further indicated by the occasional overreactions of Magistrates to servant girls wearing orange flowers or waitresses decorating tables with a few pieces of orange ribbon.[18]

By comparison with the prominent leadership roles of women on the Orangist side, the Patriot movement afforded women relatively limited secondary roles. In some exceptional cases, women signed the Patriots' many political petitions;[19] in others, they became "extraordinary members" and "donatrices" or sewed ceremonial banners for the Patriot militias.[20] The Patriot women, especially the donatrices, were taken seriously enough to be mocked repeatedly in Orangist pamphlets and caricatures.[21] Their actions, however, were largely indirect, and they were clearly subordinate to the large numbers of males whom the Patriots brought deliberately and directly into the political arena. In order to see evidence of more direct involvement on the Patriot side, we need to look at the contribution of female writers to the voluminous Patriot literature. Since, as we have already noted, the Patriots' battle against the old regime was fought out in the pages of pamphlets and newspapers as well as in the streets of its many cities and towns, it is significant that women appeared as the authors of articles and pamphlets supporting the Patriot cause.

Undoubtedly the most prominent example of a female author

who publicly supported the Patriot Revolution is Betje Wolff, whose wit and sharp pen had attracted many readers and caused many a controversy long before the politicization of the 1780s. She had taken part in several public controversies about church discipline, education, and the like, and in a work published in 1765, she argued specifically for better education for girls, which she saw as a necessary precondition for further emancipation for women.[22] Though Betje Wolff had always insisted that politics was not an appropriate activity for women, by 1786, when the escalating conflict allowed little room for neutrality, she was induced to side openly with the Patriots' political cause in a series of pamphlets.[23] In these pamphlets, her primary concern was to praise the Patriot leadership and its political objectives while attacking the "aristocrats" whom she held responsible for the alleged tyranny of the old regime. Typically, her concern for female education and emancipation notwithstanding, she did not during the Patriot Revolution raise women's issues explicitly, nor did she advocate specific rights for women within the new democratic constitutions.

It is extremely difficult to assess the role of female publicists during the Patriot Revolution, though it is clear that Betje Wolff was not a singular example. Most political writing was anonymous, so that even in Betje Wolff's case we are not certain how much political writing she actually did. In any case, it seems to be true that women were visible as only a small minority in a large pool of writers. For example, in the *Republikein aan de Maas,* a Patriot weekly published in Rotterdam from 1785 to 1787, just one of forty-six letters to the editor was signed by a woman.[24] In this case, "the wife of a Patriot shopkeeper" advocated that all good Patriots should boycott Orangist shopkeepers—a tactic reminiscent of the not insignificant, but essentially secondary, role played by women in the American Revolution. We can find no evidence whatsoever of demands for direct engagement by women in the participatory and democratic politics of the Patriots.

Like thousands of other Patriots, Betje Wolff and her longtime associate Aagje Deken left the Dutch Republic for exile in France following the Orangist restoration in the fall of 1787.[25] Unlike many of their compatriots, Wolff and Deken were not fleeing for their lives, but it is nevertheless clear that for them, as for the Patriots generally, the disillusionment caused by the Patriots' failure was deep and enduring. Many Patriot refugees settled with French support in St. Omer or in Paris where they witnessed and were inevitably caught up in the collapse of the French monarchy and the ensuing struggles

for control of France's political future. If it is generally true that the French Revolution served to alter the very meaning of the word "revolution," it is not surprising that when the northward march of the French revolutionary armies precipitated the collapse of the Orangist regime, the Dutch revolution, too, should take on different forms and exhibit a different tone, not least of all with regard to women.

Radicalism and Emancipation in the 1790s

The Batavian Revolution of 1795 began, in a profound sense, where the Patriot Revolution had left off in 1787—in the cities and towns of the sovereign provinces that constituted the old Republic.[26] Revolutionary governments at the local level dispatched delegates to create revolutionary governments at the provincial level, and thereby laid the groundwork for a transformation of the institutions of central government that clustered around the Estates General in The Hague.[27] Very quickly, however, it was clear that the Batavian Revolution would be a very different political process, in part because the Orangists, in sharp contrast to 1786 and 1787, were immediately and decisively driven from the field. Stadhouder William V fled with his family and courtly entourage to England shortly after the French invasion began. Thereafter, except for an ill-fated plan for an Orangist uprising and invasion in 1799, the kind of organized and active counter-revolutionary agitation that had confronted the Patriots at every turn in the 1780s was conspicuously absent in the 1790s.

To say that the Batavian revolutionaries were quickly and decisively victorious is not, of course, to say that theirs was a revolution without struggle. Under the banner of liberty, equality, and fraternity, the revolutionary leaders of 1795 moved quickly to replace the last vestiges of old-regime political privilege with local and provincial institutions of representative democracy of the sort that had been advocated in the 1780s. Before 1795 was out, a popularly elected National Assembly had been called as well. As the Assembly moved to design a new constitution of national government, however, the delegates quickly divided into factions.[28] Some of the formerly exiled Patriots now favored the creation of a centralized, unitary state to replace the venerable particularisms of the old regime; but their opponents, the so-called federalists who favored a more decentralized regime, prevailed in the constitution-writing committee of the National Assembly. After long and frustrating deliberation and national debate, a clearly federalist constitution was soundly defeated

by the electorate in 1797. New elections did little to change the composition of the National Assembly, however, and amid sharpening divisions and conflicts, the future shape of the Dutch state remained in doubt. Finally a radical, French-sponsored *coup d'état* in January 1798 created a unitary national state that was quickly ratified by the electorate.

Though the radicals themselves were removed by a counter-coup six months later, the unitary state that they had created with French help remained a constant feature of the political landscape through the succession of regimes that followed. The moderate democratic regime of June, 1798, was eventually replaced in 1801, again with French help, by a far more conservative regime called the *Staatsbewind* that was, in turn, replaced by the Kingdom of Louis Napoleon in 1806. Even Louis Napoleon proved to be too resistant to French demands on Dutch resources, however, and finally in 1810, the provinces of the northern Netherlands were annexed to Napoleon's Empire. As the Napoleonic Empire was crumbling in 1813, the Dutch at last drove out the French as oppressors, but they retained the essential features of the newly centralized state under the new Kingdom of the Netherlands with William V's son ruling as King William I.[29]

During the Batavian Revolution, there was a decisive change in the visibility of women and the prominence of specifically women's issues within the revolutionary movement.[30] This change was clearly signaled by a letter published in May, 1795, in the *Oprechte Nationaale Courant*. Though the letter was unsigned, it was probably written by Etta Palm d'Aelders who, Dutch by birth, had risen to international prominence as a feminist voice in the French Revolution but had been forced to leave France under the Directory.[31] Speaking of her experiences in the women's clubs in France and apologizing for her poor use of the Dutch language after so many years abroad,[32] Palm d'Aelders argued for the creation of women's political clubs on the French model; she defended the exclusion of men because they would surely dominate, while women, no matter how intelligent, would be too timid to speak.[33] Before the month was out, Etta Palm d'Aelders had been confined as a political prisoner by the Batavian authorities— not, to be sure, because of her feminism, but because she was suspected of being an Orangist spy. In any case, she was by no means the only activist of this sort. Though few archival records remain, there were, indeed, women's clubs created during the Batavian period.[34] One of the principal activities of these clubs was the planting

of liberty trees, which, given the numerous revolutionary ceremonies of the day, could amount to a prominent role for women. In March, 1795, for example, revolutionary periodicals published the names of dozens of "Bataafse Meisjens" (Batavian Maidens), who dressed in festive clothing, danced, and sang as part of a revolutionary celebration.[35] In Haarlem, where the records of a women's club have survived, there was also a patriotic theater group with a woman as the dynamic force.[36] Though women were not in this way directly involved in politics, these activities clearly promoted a greater political consciousness among women.

Equally striking during the Batavian Revolution is the appearance of specifically women's political issues as part of the political debate. In 1795, for example, someone signing with the initials "P. B. v. W." published a pamphlet entitled *A demonstration that women should take part in the governance of the nation*.[37] Apparently unaware of Condorcet's famous plea for women's rights in 1789, the author argued that precisely because women had not been enfranchised in France, the Netherlands could serve as a good example for the French. France, the land of revolution, he wrote, might then cry out: "Holland, we broke the chains, but you, you establish liberty on her throne." The well-known Patriot IJsbrand van Hemelsveld also pleaded for women's rights in his periodical, the *Revolutionaire Vraagal.* And in 1795 he published an article entitled "Why should women not also be able to rule the nation?"—which was signed in the name of "our women's council."[38] A year later, he also translated Mary Wollstonecraft's *Vindication of the Rights of Women* into Dutch.

Two other well-known radicals also publicly championed women's political emancipation in the 1790s. Lieuwe van Ollefen, a professional publicist and a great admirer of Betje Wolff in his youth, not only published the letter from Etta Palm d'Aelders noted above, but wrote a play called *The Revolutionary Household.* In the play, a father teaches his six daughters occupations that are typically male; the father boasts, as a result, that he is revolutionary not only in his politics but also in his personal life.[39] Meanwhile, Gerrit Paape called on his contemporaries not to do just half the job in their revolution. In his political testament from 1798, with the subtitle *Revolutionary Dream,* he describes how the ideal society will look in 1998. Men and women will then, according to Paape, be entirely equal.[40]

In the 1790s, there was also an increasing number of women who openly published in political periodicals. In 1795, for example, Maria Paape, the wife of Gerrit Paape, wrote the "Republican Prayer

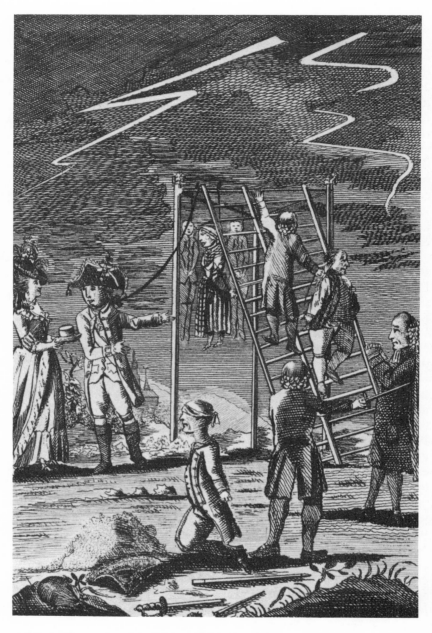

FIG. 2. Illustration for the pamphlet Heuglyk vooruitzicht of
vaderlandsche droom ('Happy prospect or Patriotic dream'), a Patriotic
pamphlet. Kaat Mossel is hanged together with other Orangist leaders.
(Algemeen Rijksarchief Den Haag, Hof van Holland 5527.)

of a Patriotic Woman."[41] The *Nationaale Bataafsche Courant* published five pieces by women in 1797; the *Oprechte Nationaale Courant* published no less than sixteen in 1798. These and other revolutionary periodicals are only incompletely preserved, so these are minimal numbers from a limited sample. But among the many female authors, two stand out as especially interesting: Petronella Moens and Catherina Heybeek. Petronella Moens was born blind, but as a successful author she dictated her work to a secretary.[42] Together with her friend, the radical Patriot Bernard Bosch, she helped to establish a number of political periodicals in the revolutionary period, and in 1792, they had jointly produced a commentary on the new French constitution. In 1798 and 1799, she directed a periodical called *De Vriendin van het Vaderland* (The [Female] Friend of the Fatherland) in which she touched on a broad range of general political topics. With regard to the position of women in particular, Petronella Moens echoed the ideas of Betje Wolff: better training and education is the beginning of further emancipation.

Catherina Heybeek was, without a doubt, one of the most exceptional and colorful characters of the Batavian Revolution. Originally a wool spinster, she is reminiscent of the French *sans-culottes* whose radicalism and passion she easily matched. Lieuwe van Ollefen, with whom she lived, called her a "girl of exceptional talents" and predicted that she would become a "brilliant star . . . in the array of fine literature."[43] Together Van Ollefen and Heybeek directed the *Nationaale Bataafsche Courant* to which Catherina regularly contributed articles. She wrote, for example, a distinctly critical account of a visit to the National Assembly;[44] but perhaps her most inflammatory work was a dialogue, published in August, 1797, between a "clubist" and his revolutionary wife, Kaatje, on the subject of the proposed federalist constitution.[45] Noting that her husband is wearing his best pants, Kaatje suspects that he is once again going off to his political club. Kaatje immediately protests, but changes her mind when she learns that the radicals hope to vote down the proposed federalist constitution: "Bravo, young man . . . even if I got you back without your head, it wouldn't matter; for every Orangist whose neck you break, you'll get a shot [of gin] from me." When she and Van Ollefen were arrested by the authorities and accused of sedition, Heybeek defended herself saying that she had written the dialogue for the education of the "less discerning citizens" and was justified by the "state of revolution in which the Fatherland presently finds itself."[46] Undeterred by the arrest, she wrote another dialogue a month later in which Kaatje tells her husband: "You must admit women to the clubs."[47]

Though the voices of female political writers and the arguments in favor of the political emancipation of women were clear, distinct, and generally on the side of the Batavian revolutionaries during the 1790s, there were still other avenues, distinctly reminiscent of the 1780s, for women's involvement in the revolutionary process. On the side of counter-revolution, for example, the Freule van Dorth tot Holthuisen recalls the leadership role of Princess Wilhelmina.[48] In 1799, an Orangist revolt in the east of the country was serious enough that French troops were required to put it down. In the aftermath, the Freule van Dorth tot Holthuisen (in the absence of her brother, the head of her aristocratic family) was one of two leaders who were sentenced to death for their part in the revolt and, by extension, one of only a few people who were executed for their political activities in the entire revolutionary period. Similarly, research in the judicial archives of Amsterdam indicates that, in the streets, women like Kaat Mossel could still be identified and arrested as leaders of popular Orangism.[49] But these cases were exceptional during the 1790s, for on the whole Orangism remained weak—largely limited to sporadic street brawls—and, consistent with that trend, the role of Orangist women was nearly invisible, especially by comparison with the 1780s.

In the end, then, we can observe a decisive shift in the political roles played by women during the Batavian Revolution. On the revolutionary side, the role of female political writers, evident but weak and secondary during the 1780s, became clear and distinct on the side of the revolutionaries during the 1790s; simultaneously, specifically women's issues for the first time emerged as part of the political discourse. Women writers and feminist issues were, to be sure, never dominant during this period. Indeed, these developments can be associated especially with a few prominent couples—teams like Catherina Heybeek and Lieuwe van Ollefen, Maria and Gerrit Paape, and Petronella Moens and Bernard Bosch—who were closely identified with the radicals who seized power only briefly during 1798. On the counter-revolutionary side, the leadership of Orangist women, so prominent and important during the 1780s, all but disappeared during the 1790s. To be sure, the execution of the Freule van Dorth tot Holthuisen and the prosecution of Orangist women for street disturbances suggest that the Batavian authorities still took Orangist women seriously, but during the Batavian Revolution, Orangist counter-revolution—whether male or female—was more spectral than real.

Viewed in a broader comparative context, these Dutch patterns are striking and problematic in several ways. The essentially secondary and supportive role of women in the Patriot movement of the 1780s is reminiscent of the role women played earlier in the American

Revolution; but the emergence of more strident, feminist voices in the Batavian period goes well beyond the American model and echoes, instead, the radicalism of the early years of the first French Republic. Though foreign examples—both contemporary and historical—undoubtedly played a role in the development of all the eighteenth-century revolutions, the distinctively Dutch shift in women's political roles we have suggested here needs to be understood in light of the peculiarities of Dutch history both during the old regime and in the course of the two democratic revolutions.

Gender and Politics under the Old Regime

The eighteenth century has long been associated in Dutch history with decline—cultural, political, economic, and social. For a time in the seventeenth century, during the Dutch "golden age," the Amsterdam market was the center of the expanding international economy of Europe; Dutch ships dominated the seas; Dutch artists and intellectuals set new cultural standards; and Dutch armies repeatedly fended off the attacks of Louis XIV and various allies. Clearly the miracle could not last, and the next stage of Dutch development was sure to disappoint. Foreign competition supported by aggressive state action in France and England ate away at Dutch commercial advantages; the waves of religious refugees, who had so enriched Dutch economic and cultural life, subsided; and the enormous financial burden of almost continual warfare took its inevitable toll. In comparison with the seventeenth century, the eighteenth century seemed like an unmitigated disaster: the Republic's policy of strict neutrality in international affairs belied a much diminished military capacity; the refined manners of the political elites betrayed the self-interest and corruption of the urban oligarchies; and the increasing burden of poor relief seemed the unmistakable token of economic decline.

Modern research has shown the Dutch Republic's eighteenth-century decline to be much more relative than absolute—relative especially to the expansion and maturation of the British and French imperial economies in the course of the eighteenth century.[50] Still, the contemporary perception of decline is important and gives a special flavor not only to the historical literature on the period but to the political conflicts that emerged at the end of the century. Indeed, the perceived problem of decline—in various moral, political, and economic guises—was especially characteristic of the literature of the Dutch Enlightenment, which grafted a new vision of national rejuvenation onto the older traditions of Christian sociability and human-

ist scholarship.[51] At the same time, a spate of new organizations such as literary, reading, and reforming societies engaged remarkably diverse segments of the Dutch population in this search for the renewal of the Fatherland. The result was that virtually everyone—Patriots and Orangists, Calvinists and dissenters, merchants and manufacturers, aristocrats and peasants—could agree that reform of some sort was necessary. The difficult question that had eventually to be confronted was, of course, what kind of reform?

Female writers were part of this wide-ranging discussion, which included the issue of gender roles; but like the Dutch Enlightenment as a whole, the writers were not politicized and the issues were not terribly divisive.[52] Most of the literature stressed separate roles for men and women, and especially the so-called spectator literature promulgated an essentially bourgeois, domestic model for women as wives and mothers. To be sure, there were important eighteenth-century debates and disagreements between, for example, orthodox Calvinists and natural law philosophers; but women authors, like Betje Wolff, did not stake out strikingly different or radical positions with regard to women.[53] Wolff, among others, pleaded for better education and training for women. As we have seen, however, she was herself reluctant to stake out a direct role for women in politics, and she did not develop aggressive demands for equal rights once she entered the political fray.[54]

On the face of it, it would seem that eighteenth-century Dutch women had little motivation to agitate specifically for civil and political rights, for according to contemporaries, nowhere did women enjoy greater freedom than in the Dutch Republic. Indeed, some of women's gender-specific demands that emerged in the French Revolution were well-established rights in parts of the northern Netherlands. Already in the sixteenth and seventeenth centuries, foreigners were amazed at the independence of Dutch women: they engaged in trade, made distant business trips, managed shops, and were permitted to visit theaters and inns without accompaniment.[55] Still, we cannot speak of the rights of women, as such. The Republic was, after all, a country where the rights of citizens could vary greatly, depending on social class and place of residence; moreover, there was no clear distinction between private and public law. Thus, a woman who had come of age could not marry without the consent of her parents in the province of Overijssel but could do so in the province of Holland.[56]

In general, the legal position of the mature unmarried or wid-

owed woman differed very little from that of men.[57] She could enter into contracts, assume an inheritance, make labor agreements as either employer or employee, engage a notary, initiate legal proceedings, serve as a witness in criminal law, and so forth. The position of the married woman was different because she was considered to be under the custody of her husband. Still, she could retain a great deal of independence. If she were married according to the provisions of a marriage contract, she managed her own property; in addition, as a merchant she could enter into commercial contracts, incur debts or extend loans, and stand as a guarantor. Also, if her husband were absent for an extended period, a woman generally managed the joint property. Finally, in this officially Protestant state, she could divorce her husband on grounds of adultery or desertion.

The economic position of women during the old regime is more difficult to determine.[58] In general, we can say that a large number of occupations were performed by both men and women, though we find few women in socially prestigious and well-paid positions. In Amsterdam, for example, where notarial archives for the first decade of the eighteenth century can serve as a guide,[59] some 416 primary occupations were listed, of which 21 were practiced exclusively by women—retail flower merchants or knife sharpeners, for instance. Another 115 occupations were practiced by both men and women, while the remaining 280 were exclusively male. These figures do not indicate the proportions of women to men, but they do suggest that the possibilities for women were relatively diverse, including skilled occupations like bakers, beer brewers, printers, bookkeepers, cashiers, midwives, and metalworkers, as well as a number of marginal occupations like street singer or prostitute.

In many parts of the Dutch Republic, guilds remained important economic institutions with control over critical labor markets; most cities had 20 to 30 such organizations. Though some guilds excluded women from participation altogether, most guilds at least allowed a widow to continue her husband's trade on the condition she hired a master craftsman.[60] Some guilds allowed women to be full members; others allowed them to be *gildekopers*—that is, to purchase the right to sell an article controlled by the guild. Besides these, there were some guilds that consisted entirely of women, such as (in Haarlem) wool seamstresses, barrelers of peat, and sellers of discarded or used clothing. Only in this sort of guild could women have leadership functions.

Although a large number of occupations were, thus, open to

women, only a few women were able to take advantage of the opportunities. Notarial archives in Rotterdam, for example, suggest only minimal participation by women in economic activities: just three to five percent of those listed as having an occupation were women.[61] This impression of the economic marginality of women is confirmed by two additional considerations. Among the upper classes, there were many more women living as rentiers than men, and at the lower levels of society many more women than men were eligible for and depended on poor relief. Thus, at both social extremes, Dutch society made it relatively easy for women to withdraw from active participation in economic affairs. It is also possible that the independent economic activity of women declined in the course of the eighteenth century, especially as the woman as independent entrepreneur disappeared because of structural shifts in the economy. In Rotterdam in the first half of the eighteenth century, for example, there were several dozen breweries, a number of which were run by women. By the end of the century, however, only a few large breweries remained, all of them run by men. This trend, which is evident in Haarlem as well, would be consistent with what is often suggested for other European countries; a gradual withdrawal of women from direct participation in economic life between the sixteenth and the eighteenth centuries.

The old regime nevertheless provided Dutch women with two major avenues to political power, active influence in political affairs, and involvement in the political process. One was by birth and marriage. Since feudal law was quite favorable to women, aristocratic women could wield considerable power by inheriting noble or seigneurial rights.[62] In the Netherlands, some fiefs, specifically manorial estates, could be inherited by women, and the seigneurial rights of a village or manor could consist, among others, of the appointment of sheriffs, village magistrates, and even preachers. A lady of the manor thus had considerable power at the local level and was permitted, remarkably, to appoint men to positions women could not hold. Since in the eighteenth century, many manorial rights were purchased by wealthy burghers, affluent women who were not of noble birth could also have such prerogatives at their disposal. Being married to a man with an important position could also give considerable informal influence to women, especially in the days of patronage, informal political bargains, and family networks. It is well known, for example, that several prominent regents were strongly influenced by their wives. Thus, among the political elites—in the circles of the Stad-

houder's court or within the landed nobility and the urban patriciates—the political influence of women could be great, both formally and informally.

Outside the political aristocracy, the formal prerogatives and rights of women rapidly diminished. Roturier women could obtain the citizenship rights of a city, but these were devoid of political meaning. Municipal governing functions and offices were, meanwhile, exclusively the prerogative of men. A second avenue to political involvement did open up, however, as lower-class women were nevertheless able to become involved in the political processes of the Dutch Republic through their informal leadership of urban neighborhoods and, by extension, through their organization and leadership of traditional collective protest. To be sure, the traditional historical wisdom often suggests that the Dutch Republic was an oasis of domestic tranquility in the seventeenth and eighteenth centuries, but this view needs to be revised. Here we will focus on the special roles played by women within the overall patterns of popular protest and collective action.

Throughout the history of the Republic, there were, with a certain regularity, popular protests and disturbances of various kinds.[63] In general, the patterns of popular protest in the Dutch Republic did not differ greatly from the general European pattern, and the repertoire of Dutch collective political action includes the now familiar range of elements—from petitions expressing collective grievances to the plundering of houses and *taxation populaire*. In the late sixteenth and early seventeenth centuries, religious conflicts, especially, entailed popular mobilization, while in the later seventeenth and eighteenth centuries tax protests and food riots were more common, particularly in the urban and commercial western provinces. What is more, during the Republic's most important political crises around 1617, 1672, 1702, and 1747, a variety of popular protests dovetailed with serious divisions within the ruling aristocracy. The result, in various parts of the Republic, was fundamental changes in the oligarchic regime—changes not only in the personnel of local governments but also in the rules under which the regents governed.[64]

Within this rich and extensive history of popular protest and collective action, the role of women is striking and significant.[65] Of the hundreds of popular protests and upheavals in the province of Holland during the seventeenth and eighteenth centuries, there were no less than 50 demonstrations and 26 larger riots that involved

women exclusively; in addition, where both men and women partic-
ipated, women sometimes acted as a separate group. More specifi-
cally, of the twelve food riots for which we have information about
the participants, ten were the work chiefly of women; of the 38 tax
riots for which information on participation exists, women played
leading roles in ten. But perhaps most impressive is the participation
of women in collective action revolving around explicitly political
demands, especially in the three waves of Orangist demonstrations
and riots in 1653, 1672, and 1747. In 1672, for example, women
were at the forefront of major riots in The Hague, Alkmaar, Hoorn,
and Rotterdam, while eleven of seventeen lesser crowd demonstra-
tions on behalf of Prince William III either predominantly or exclu-
sively involved women.

During these riots and demonstrations in Holland, women gen-
erally had quite specific tasks. Frequently they were initiators and
leaders; they beat drums and waved banners. Screaming above the
tumult, they often communicated the grievances that animated the
crowd. The actual violence of plundering or stone-throwing was usu-
ally left to the younger males who were nevertheless urged on by
female leaders. Compared with their male counterparts, the women
in Dutch crowds were relatively old, generally between 30 and 50
years of age, but sometimes even older. Often the leaders were
women who were well-known because of their highly visible occu-
pations, typically in fish and fruit marketing.

The prominence of women in the history of popular protest in
the Dutch Republic can be explained in a variety of ways. In the food
and tax riots—especially those involving the heavy excises of Hol-
land—the role of women as housekeepers undoubtedly was impor-
tant. They were the first to be confronted with high prices and scar-
city, and thus they were naturally the first to take action. In addition,
one may point to the contemporary view of the character of women:
women were often seen as naturally inclined to rebellion and disobe-
dience; riotous conduct flowed from their very nature. Moreover, it
was a common opinion that the authorities would be less aggressive
in dealing with women than with men; women could count on less
severe repression and on more lenient treatment from judges.
Thus, it was a more or less accepted fact that women stood in the
front line of riots.

All of these considerations may have played a role, but the most
important factor seems to be that women stood at the center of the
social networks of urban neighborhoods and rural villages because

most Dutch riots appear not to have been rooted in formal organizational structures, such as guilds and civic guards (*schutterijen*). In the late Middle Ages, especially in the southern Netherlands, guilds had been important in mobilizing the middle groups of urban populations for concerted action against local elites; but from the sixteenth century onward, in the province of Holland especially, authorities had been able to prevent or reduce the independence of guilds. Thus, only in a few cities—for example, Dordrecht in Holland or Deventer in Overijssel—did guilds retain sufficient autonomy to play an important role in the organization of popular protest during the Republic. Similarly, the civic guards, which in principle mobilized all able-bodied adult males in the maintenance of public order, either had fallen into disuse or were controlled sufficiently by local authorities to prevent them from directly challenging the established order. In exceptional circumstances, such as 1672 and 1747, they did threaten the municipal regents by demanding, in some cities, popular election of militia officers or refusing to follow orders to repress crowds. Even so, few *schutters* show up as crowd participants.

But if formal structures were not generally at the root of popular mobilization, even relatively spontaneous tax and food riots required a certain amount of preparation. Collective grumbling about taxes in the marketplace or political discussions in cafés could, in some cases, lead to protest demonstrations and even collective violence. Still, for the mustering of a large number of people—a crowd—a minimum of organization was always necessary. People often organized impromptu parades with improvised banners and wooden barrels used as drums. Indeed, within such crowds there often emerged a structure that imitated the military or the civic guard—the leaders were often called captains, their comrades were called officers, and there were always drummers and standard-bearers. The social-organizational foundations of this kind of action can best be seen, as Craig Calhoun argues, in traditional communities.[66] Within established communities, neighborhood and kinship networks offered lines of communication and allegiance and helped to recruit individuals for collective action.

The networks of kinship and friendship that facilitated popular mobilization in Holland were strongest at the neighborhood level in cities and at the village level in the countryside. In 1747, for example, a tax protest involving several villages appears to have been organized by a single family; in other cases, we find the participation of four or five members of a family. But neighborhood networks were undoubt-

edly more important in the many cities of Holland. In some lower-class neighborhoods in the larger cities—for example, the Jordaan and Kattenburg districts in Amsterdam and the Achterklooster in Rotterdam—we can even see the development of traditions of popular protest and collective action that lasted from the seventeenth century well into the twentieth.

What is critical for our purposes is the fact, generally accepted by contemporaries, that Dutch neighborhood and village life was very much influenced by women. In moralistic tracts, for example, clergymen impressed upon the population that maintenance of the community was the special familial responsibility of women. Men and women had separate spheres of existence, and the management of household finances and relations with relatives and neighbors were the exclusive domain of women. Women also organized neighborhood assistance, passed on oral traditions, and, especially in the cities, dominated the social education of the laboring classes. Thus, when a community's interests were threatened, women were in the best position to mobilize the population in the short term. As the first to be mobilized, women were particularly active in the beginning of riots, bringing the crowds together as did two women in Delft in 1616: With one beating on a kettle and the other on a box, they proceeded through the city, assembling a crowd of women and boys, one of whom carried a banner made from a blue apron. We must also remember that women often dominated the public spaces of Dutch communities, hawking fish, vegetables, fruit, and many other types of merchandise. These women in particular could count on the solidarity of a city quarter or village, mobilize its inhabitants, and channel collective dissatisfaction into a demonstration or riot; they were the bearers of traditions of popular protest and collective action.

Popular Mobilization, Democratic Revolution, and Gender Roles

Returning, then, to the revolutionary era, we can see that the prominent leadership of women on the side of the Orangist movement is an obvious extension of typically old-regime political patterns. Princess Wilhelmina, by virtue of her marriage to William V and her family ties to the kings of Prussia, was in a unique position to take bold, decisive action on behalf of the Orangist cause. Likewise, the Vrouw van Almelo could be an influential force in Overijssel politics as a consequence of her inherited seigneurial rights. Meanwhile, Kaat Mossel serves as an especially vivid example of old-regime crowd

leadership by virtue of her position within the Achterklooster district of Rotterdam. Indeed, her indictment and trial records provide invaluable inside information: on how old-regime crowds were mobilized; how news was passed secretively but quickly through the neighborhood; how women came to be on the front lines of the demonstrations against the Patriot militia; and how, in this case, Kaat Mossel's leadership was rooted in her special connections with Orangists outside the neighborhood. These connections allowed her freely to provide songbooks, pamphlets, decorative Orangist symbols, and even, as the authorities charged, bribes to young men who executed the violence that led to the panicky response of the Patriot militiamen in 1784.[67]

On the other side of the revolutionary political divide, we might, in principle, expect that such a rich tradition of popular protest and collective action would be of great comfort to the leaders of a political movement that sought to institutionalize the principle of popular sovereignty. Such was not, however, the case with the Dutch Patriots of the 1780s. On the contrary, the political discourse of the Patriots exhibits a strong undercurrent of fear and suspicion of that tradition. This is most clearly evident in the language of *het grauw* and *het gepeupel*—both collective nouns with obviously pejorative connotations, roughly equivalent to the English "rabble" or "mob"—that was frequently used by Patriot writers, including Betje Wolff, to describe their political enemies.[68] Given the fact that this kind of pejorative language to describe popular collective action most often proceeds from the mouths of established authorities, it is indeed striking that it was present in the popular literature of the Patriots long before they seized power anywhere.[69]

To some extent, the Patriots' obvious fear of *het grauw* may reflect the fact that disgruntled oligarchs were an important part of the Patriots' revolutionary coalition, but it more clearly represents the important and not unreasonable lessons that the Dutch Patriots had learned from their own history. In particular, the recent history of the crisis of 1747–50 taught them that crowds were a very imperfect instrument of popular sovereignty, for in that fateful period *het grauw* had, in the name of political reform, launched the House of Orange into an unprecedented position of hereditary power.[70] Yet the crowds had eventually disappeared, and the Prince of Orange very quickly made his peace with the oligarchy. Thus, the political reforms that the crowds had demanded were never implemented, and in the end, *het grauw* had shown itself to be undisciplined and ephemeral.

Against the backdrop of this reading of Dutch history, the mobilization of the Patriot movement in the 1780s can be seen as a series of attempts to reform popular politics as well as aristocratic politics—as a deliberate attempt to replace the essentially defensive or reactive politics of the crowd with a new kind of aggressive or proactive politics invested in revolutionary committees and militias. These objectives had clear and profound implications for gender roles in the politics of the future. As early as 1782, the Patriots transformed the venerable tradition of humble petition for redress of grievances into an aggressive tactic to pressure reluctant (and largely defenseless) Magistrates into favorable action on important political issues.[71] In order to draft petitions and organize petition campaigns, the Patriots often created citizens' committees (*burgercommissies*), modeled on the American committees of correspondence, which were especially useful in the larger cities. The citizens' committees also had great symbolic value because they offered the opportunity to thrust political outsiders, like religious dissenters who were specifically excluded from holding public office, onto the center of the political stage.[72]

In the end, however, the preferred mechanism by which the Patriots mobilized their popular movement was the voluntary militia—what they usually called the *vrijcorps*, the *exercitie genootschap*, or the *genootschap van wapenhandel*.[73] Once again seizing the American example, the Patriots sought to create a permanent political vigilance among an activist citizenry by creating voluntary associations with the explicit purpose of defending against both foreign and domestic tyranny. Unlike the old-regime civic guard (*schutterij*), the independent *vrijcorps* could be deliberately tolerant and inclusive of everyone regardless of religion or social position; still, it would be uniform and harmonious in that presumably only those good citizens who truly supported the Patriots' cause would join. Indeed, as J. D. van der Capellen suggested, the voluntary militia could be considered an experiment in self-government, a microcosm of the new democratic ideal: Free and equal individuals would join together, draw up a mutually acceptable compact to govern their affairs, elect their leadership; but in the end be orderly, disciplined, and obedient to the decisions of their chosen officers.[74]

It is, of course, generally true that the stated intentions of revolutionaries can be considered only a very imperfect guide to the reality of revolutionary situations. Still, the apparent determination of the leadership of the Patriot movement both to democratize the oligarchy and to organize and discipline popular politics is reflected

in the general characteristics of the revolutionary conflict that developed in the 1780s. Thus, to a remarkable extent the popular Patriot movement followed the prescriptions of the new proactive democratic model, while the popular Orangism of the 1780s reflected the generally reactive characteristics of the older political tradition. It was equally evident, however, that these differences tended to diminish in the course of two decades of political conflict.

However much the leaders of the Patriot movement might have considered theirs an entirely new sort of mobilization, it is nevertheless clear that they had to rely on typically old-regime solidarities in order to put together a viable revolutionary coalition. In cities like Deventer and Zwolle, the elders of relatively independent guilds organized the most successful petition campaigns, and when the Patriots created new citizens' committees there, they explicitly incorporated the leaders of the guilds.[75] In Utrecht, the *burgerhoplieden*—neighborhood or district officers—remained important leaders alongside the citizens' committee and the voluntary militia; in Rotterdam, Amsterdam, and Dordrecht, the Patriots built with variable success on the traditional *schutterijen*.[76] In the countryside, of course, the patterns were different, but the structures of the old regime were nevertheless visible in the mobilization of the Patriot movement. In Bathmen (Overijssel), for example, the Patriots built on local resistance to land enclosures within the communal *mark* organization to mobilize a clear majority of the adult males in a voluntary militia.[77] By contrast, in Friesland, where there were no less than 48 militia units in the countryside, the powerful officials of the *grietenijen* (rural districts) were apparently able to use their clientele networks either to promote or to obstruct the Patriot movement.[78]

Likewise, however much the Patriot leadership might have wished to avoid the tumult of *het grauw*, they discovered from bitter experience that crowd actions were virtually indispensable in their rise to power. In the city of Utrecht, during the first of their municipal revolutions, the Patriots demonstrated remarkable reluctance, even timidity, in the use of force; but in the end they repeatedly organized massive demonstrations, during which terrified Magistrates were not allowed to leave the Stadhuis, in order to remove Orangist regents and to implement their new electoral system.[79] In Zwolle, too, the Patriots eventually mobilized angry crowds to seize control of the municipality.[80] By the time the Patriots came to power in Holland, all reluctance to use force had been abandoned, for in Amsterdam Patriot crowds not only forced the removal of Orangist

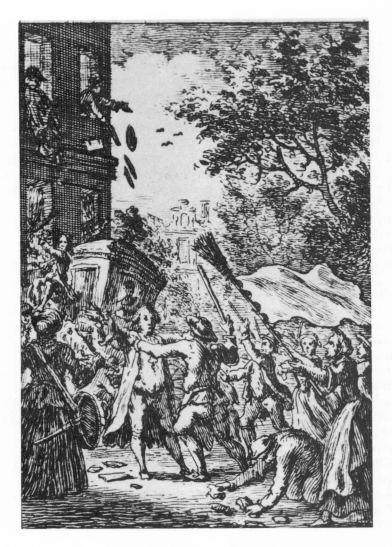

FIG. 3. Konstalmanak 1781. Depicted is a riot in Groningen in 1748, with women waving a banner and beating a drum. (Universiteitsbibliotheek Amsterdam)

regents, but systematically plundered the Kattenburg district where their popular opposition was most clearly concentrated.[81]

In reality, then, the Patriots found that they could not do away with the past entirely. Indeed, the old regime provided them with powerful, even indispensable, resources with which they could bring in the new. Yet as the struggle developed, the new creations—the specifically political, voluntary organizations—increasingly set the tone and provided the leadership of the movement. Especially the Patriots' militias, coming together in provincial and national associations, bound an otherwise diverse and localized movement into something like a national whole. The increasing importance of the *vrijcorps* was facilitated as well by the escalation of the level of the conflict in 1786 and 1787; local political initiatives finally gave way, of necessity, to broader provincial and national military strategies.[82] Thus by 1787, when it is necessary to speak of an emerging civil war within the Republic, the deliberately new, proactive elements of the Patriots' mobilization were overshadowing the essentially reactive remnants of the older, popular political traditions.

But to a certain extent, the same could be said of the Orangist or counter-revolutionary coalition as it developed in the course of the 1780s. Although the first signs of popular Orangism looked to the Patriots like simply a rehash of 1748, as the conflict intensified the Orangists came to look more and more like their antagonists. First, on the feast of St. Nicholas in 1782 and thereafter regularly on March 8, William V's birthday, there were rowdy Orangist demonstrations, the most famous of which occurred in Den Haag, Rotterdam, and Leiden. Essentially reactive to the sudden explosion of the Patriot movement, these demonstrations bore all the earmarks of traditional crowd protests in Holland, and the pointed reminders of the Orangist victories of 1747 were by no means lost on the Patriots.[83] Recounting the demonstration in Rotterdam in March, 1783, for example, an influential Patriot weekly remarked that these "riotous excesses and seditious impudences" were started and perpetuated "with the very same signs, symbols and slogans by which in former times the Fatherland was brought into the most violent upheaval."[84]

After the initial shock, however, it became obvious that the Patriots could use their political influence to forbid the public display of Orangist symbols; more important, they could use their militias to defeat the less-disciplined Orangist crowds in the streets. Thus, the leaders of the Orangist movement found that they had to adapt their strategy to the radically changed circumstances in which *het grauw* was being out-organized and out-hustled by "the respectable citizenry," which the Patriots claimed rhetorically to represent. Indeed, spurred on by an enormous infusion of British cash, a small but well-con-

nected group of Orangists began a concerted attempt to beat the Patriots at their own political game—creating Orangist clubs, organizing mass petition campaigns, electing citizens' committees, and, where possible, arming Orangist militias.[85] At all costs, these Orangist leaders wished to avoid the undisciplined tumult of the crowd that had merely become, in many places, an excuse the Patriots gladly used to discredit and repress the Orangist movement.

In the end, then, the Patriots were remarkably successful in transforming the nature of popular politics in the Dutch Republic. Though it was not the only means by which Patriots mobilized their popular movement, the voluntary militia nevertheless became the most common and effective weapon in the Patriots' arsenal. With regard to gender roles, the implications of this tendency toward the military organization of the popular movement are obvious: women were, ipso facto, excluded from full political participation. Clearly, as we have already seen, women were not shunned entirely; rather, they were encouraged to take up honorary, albeit peripheral, roles as "donatrices" to the militias. On the other side, the Orangist movement visibly embraced the leadership of women like Kaat Mossel, not as a matter of positive principle, but as a proven expedient. Consequently, as the Dutch political process was transformed by the infusion of a constantly vigilant, disciplined, and armed Patriot movement, the Orangist leaders, too, were ready to abandon the tactics of the old-regime crowd.

At the same time, the Patriots took some important steps toward the institutionalization of some form of representational democracy to replace the oligarchical structures of the old regime. Like so many other eighteenth-century revolutionaries, the Dutch Patriots found that the concrete realization of the principle of popular sovereignty was no easy task; but in both the pamphlet literature and in the actual construction of electoral systems within specific communities it seems clear that they were generally moving toward individualist and essentially male notions of active citizenship.[86] Patriot publicists and constitution-writers, like the Americans before them, often linked active citizenship with the right and obligation to bear arms, which was considered an exclusively male affair. Likewise, only those burghers who paid a minimum amount of direct taxation would be considered active, that is, enfranchised citizens. This clearly implied the political disenfranchisement of both collectivities, like self-perpetuating town councils and guilds, and those who were considered to be dependent persons, like servants, children, convicts, and, of course, women. To be sure, the exclusion of women was not explicitly a matter of public discussion; rather, it seems to have been assumed that women, gen-

erally dependent on fathers and husbands, would not play an active political role in the future, just as in the past only men had been formally admitted to the ranks of the municipal oligarchies.

Under the Orangist restoration, the Patriots' militias were abolished, houses of leading Patriots were plundered, magistracies were purged, and, not surprisingly, it was Patriot rather than Orangist women who were arrested for political offenses in the streets. But neither the political processes that had been set in motion nor the political education of those who had participated in the struggle could be so easily undone. In Amsterdam, for example, the explicitly political *vrijcorps* gave way to more subtly political *leesgezelschappen* (reading societies), where mobilized citizens could continue to discuss issues of mutual and public concern.[87] Likewise, the popular press was bridled and censored under the restoration regime, but it continued to be political nevertheless under the cover of transparent literary conventions and imaginary worlds.[88] Meanwhile, those groups that, in the thick of the revolutionary struggle, had been recruited and organized to bolster the Orangist cause did not necessarily vanish immediately from the political stage like the old-regime crowds. In Deventer, for example, guildsmen who had abandoned the Patriot coalition to form the basis of a popular Orangist movement continued to agitate for a more thoroughgoing counter-revolution and a more permanent place in the political life of the community;[89] in Gouda, members of the newly created Orangist club not only continued to attack old Patriot enemies, but rallied numerous protests against the restoration regime in the hope of securing the political rewards they thought their due.[90] In neither case, however, did the agitation of the Orangist faithful have its desired effect, for like his father in the crisis of 1747, William V finally chose the regent oligarchy, not the popular movement.

Gender and the Genesis of Modern Dutch Politics

The resumption of the revolutionary process with the Batavian victory of 1795 had, as we have already seen, a distinctly different outcome; but it is clear that, in a profound sense, the Batavian Revolution merely completed the reform and transformation of popular politics that the Patriots had begun in the 1780s. The explicitly political voluntary associations—committees, clubs, societies—that were uprooted by the Orangist restoration sprouted in even greater numbers after 1795. Meanwhile, a national militia to defend the principles of liberty, equality, and fraternity took up where the Patriots' inde-

pendent *vrijcorps* had left off. A new feature of the democratic restructuring during the Batavian Revolution was the creation (even before the centralization of the state) of a system of *wijk* or *grondvergaderingen* (neighborhood assemblies), similar to the French *sections*, which served further to regularize and channel popular politics at the local level.[91] As a result of these changes, the crowd, which, just 25 years earlier, had been the hallmark of popular politics, largely disappeared from the political stage. Simultaneously, the destruction of old-regime privilege and patronage resulted in the formalization and bureaucratization of Dutch government as never before.

As was the case with the Patriots' program in the 1780s, one obvious result of these Batavian reforms was that women were willy-nilly excluded from direct political participation. The rejection of the politics of the crowd entailed, of course, the elimination of the important roles that women had played as organizers of and participants in the popular politics of the old regime. The rejection of old-regime privilege entailed as well the elimination of the kinds of formal authority and informal influence that aristocratic women had achieved through inheritance or marriage. And to the extent that the structure of the Batavian state remained even after the expulsion of the French in 1813, these developments clearly implied that in the future Dutch women would have a good deal less space in which they could be actively and directly engaged in political action. This is not to suggest, however, that women became politically invisible. On the contrary, as we have seen, some Dutch women were able to develop a new kind of political voice that was well-adapted to the political culture of the new regime.

In the torrent of words that was so characteristic of the revolutionary era, it is not at all surprising that women should join the rhetorical fray as journalists and pamphleteers. In the last pre-revolutionary decades of the Dutch Republic—which was surely one of the most literate countries in early modern Europe—several Dutch women already had distinguished themselves as gifted writers. Though the exclusively male Society for Netherlandic Literature (founded in 1766) would not admit them to membership, authors like Betje Wolff, Aagje Deken, and Belle van Zuylen (Madame de Charrière) attained not only considerable immediate popularity but lasting literary reputations.[92] As we have already seen, Betje Wolff first had to overcome her reservations about direct political involvement for women, but by 1786 she clearly had chosen the side of Patriots in a series of political pamphlets. Indeed, as the conflicts intensified, it became difficult for anyone, male or female, to remain

politically neutral. Still, because so much of the political writing was anonymous or pseudonymous, it is difficult to measure the extent of female participation in the Patriots' battle for the rhetorical high ground in the 1780s.

In any case, during the 1790s female publicists became more visible. Thus, while the crowd politics of Kaat Mossel might overshadow Betje Wolff's support of the Patriot Revolution, the radical politics of a journalist like Catherina Heybeek can be considered more characteristic of the Batavian Revolution than the occasional street slogans that were shouted in support of the House of Orange. Paired with the increased visibility of female authors was the emergence of specifically women's issues in the political debate. As had been the case earlier in France, a fluid and unpredictable revolutionary situation in the Netherlands provided a unique opportunity for radical publicists, whether male or female, to develop a critique of the trend toward exclusively male politics that was visible under the Batavian regime.

By the turn of the century, however, the tide had once again turned. The women's clubs had disappeared along with most of the female publicists. Catherina Heybeek stopped publishing in 1798; Aagje Deken and Betje Wolff died in the same year; Etta Palm d'Aelders died in 1799, three months after she was released from prison; Petronella Moens involved herself exclusively with domestic and educational issues after 1799. A notable exception was Aletta Hulshoff, who was involved in the publication of anti-Orangist pamphlets in 1804.[93] She was arrested, and though she denied being the author, she was sentenced to two years in prison. In 1809 she published another seditious pamphlet attacking Napoleon and was again arrested. This time she escaped from prison and fled via England to New York where she continued her career as a publicist and translated the French constitution of 1793 into English. Finally, in 1817 Aletta Hulshoff returned to the Netherlands, but like so many others, male and female, she turned away from direct political involvement.

On balance, then, the transformation of Dutch political culture under the aegis of democratic revolution brought no lasting political reward for Dutch women. On the contrary, the shift in the political roles that women played during the two Dutch revolutions highlights the fact that the modernization of the Dutch state and the transformation of popular politics that attended it effectively eliminated the paths by which women had come to exercise political power and influence in the past. Meanwhile, the new centralized and rationalized political structures afforded women no comparable or compensating

political space. Revolutionary publicists, to be sure, had developed a new kind of political voice and urged the creation of new political opportunities for women, but the radical democratic experiments of the 1790s turned out to be as ephemeral as the old-regime crowds. As a final reprise in 1813, Dutch women again played an important role in the anti-French crowds that attended the collapse of the Napoleonic regime in the Netherlands; but in this essentially reactive role, they were unable either to reverse·the political processes of the last decades or to carve out new political opportunities for the future. Only toward the end of the nineteenth century, with the liberal constitutional monarchy setting the framework for modern democratic politics, did Dutch women collectively reenter the political arena, making forceful proactive claims for the new kind of political equality and opportunity that the radicals had first anticipated in the 1790s.

Notes

The authors wish to thank Lesbeth Sassen for assistance with the research. This collaboration was made possible by joint funding from the Netherlands-America Commission for Educational Exchange and the Nederlandse Organisatie voor Zuiver-Wetenschappelijk Onderzoek.

1. The best survey of the entire period is Simon Schama, *Patriots and Liberators: Revolution in the Netherlands, 1780–1813* (New York, 1977). For a critical review of the literature since 1945, see E. O. G. Haitsma Mulier, "De geschiedschrijving over de Patriottentijd en de Bataafse Tijd," in *Kantelend Geschiedbeeld*, ed. W. W. Mijnhardt (Utrecht/Antwerpen, 1983).

2. The most forceful statement of the thesis of continuity from the Patriots of the 1780s to the liberals of 1848 is C. H. E. de Wit, *De strijd tussen aristocratie en democratie in Nederland, 1780–1848* (Heerlen, 1965); cf. E. H. Kossmann, *The Low Countries, 1780–1940* (Oxford, 1978).

3. An important exception is an unpublished paper by Dini Helmers and Marja Koster, "Idee en werkelijkheid: Speurtocht naar veranderingen in de ideeen over de maatschappelijke positie van de vrouw in de Republiek aan het einde van de 18e eeuw" (Amsterdam, 1985). See also Anke Pouw, "De 'waare verlichting' van de vrouw," *Comenius*, September, 1986; H. E. van Gelder, "Feministische Bataven," in *Fragmenten Vrouwengeschiedenis*, ed. W. Fritschy, 2 vols. (Den Haag, 1980), 1:69–84.

4. Cf. Wayne Ph. te Brake, "Popular Politics and the Dutch Patriot Revolution," *Theory and Society* 14 (1985): 199–222.

5. On the broader context of the Patriot Revolution, see R. R. Palmer, *The Age of the Democratic Revolution* (Princeton, 1959), vol. 1, *The Challenge*.

6. On the Republic's international military and diplomatic position, see

A. C. Carter, *Neutrality or Commitment: The Evolution of Dutch Foreign Policy 1667–1795* (London, 1975); on the layers of connection with North America, J. W. Schulte Nordholt, *The Dutch Republic and American Independence* (Chapel Hill, N.C., 1982).

7. First edition: Ostende, 1781; cf. the modern Dutch edition with an introduction by W. F. Wertheim and A. H. Wertheim-Gijse Weenink (Amsterdam, 1981).

8. Cf. Wayne Ph. te Brake, "Van der Capellen en de Patriottische Revolutie in Overijssel," in *De Wekker van de Nederlandse Natie: Joan Derk van der Capellen, 1741–1784,* ed. E. A. van Dijk, et al. (Zwolle, 1984).

9. On the history of the peculiarly Dutch office of Stadhouder, see H. H. Rowen, "Neither Fish nor Fowl: The Stadholderate in the Dutch Republic," in *Political Ideas and Institutions in the Dutch Republic* (Los Angeles, 1985), 3–31; on the political significance of the Stadhouder's patronage system in the 1780s, see Wayne Ph. te Brake, "Provincial Histories and National Revolution: The Dutch Republic in the 1780's" (Paper presented at the symposium "Decline, Enlightenment, and Revolution: The Dutch Republic in the Eighteenth Century," Washington, D.C., March, 1987; forthcoming in the proceedings of the conference).

10. N. C. F. van Sas, "The Patriot Revolution: New Perspectives" (Paper presented at the symposium "Decline, Enlightenment, and Revolution: The Dutch Republic in the Eighteenth Century," Washington, D.C., March, 1987; forthcoming in the proceedings of the conference).

11. Te Brake, "Popular Politics."

12. G. van Rijn, "Kaat Mossel," *Rotterdams Jaarboekje,* 1890, 159–231.

13. C. A. Tamse, ed., *Nassau en Oranje in de Nederlandse geschiedenis* (Alphen aan de Rijn, 1979), 202–28.

14. See, for example, the print entitled "Heuglijk vooruitzicht of vaderlandsche droom" in which Kaat Mossel is pictured hanging from the gallows (Algemeen Rijksarchief, Den Haag, Hof van Holland, 5527); see also the play entitled *Kaat Mossel voor den throon van Belzebub* (Utrecht, n.d.), Universiteits Bibliotheek Amsterdam (UBA), 691 C 108. See also the gossip about one "Moeder Trago," an Orangist leader in Leiden: *Politieke Kruyer,* 7:747–48.

15. See, for example, the thinly veiled attack on Princess Wilhelmina in J. A. Schasz, *Het land der willekeurigen* (Amsterdam, 1789); this work indicates how easily these attacks on particular Orangist women could shade into a more general antifemale prejudice, since in Schasz's "land of despots" it is women who rule. Cf. Peter Bakker, "Literair-politieke pamfletten tussen 1787 en 1795: Een tereinverkenning," unpublished thesis, Instituut voor Neerlandistiek, Amsterdam, no. 2911.

16. See, for example, *Blaadje zonder titel voor Burger en Boer in Overijssel,* no. 7 (October, 1985): 49–54.

17. Gemeentearchief Deventer, Rechterlijk Archief, no. 60, vol. 1, 657–59. For other examples, see P. M. Verhoofstad, *Geschiedenis van Purmerend*

(Permerend, 1957), 280; H. A. Wertheim-Gijse Weenink, *Democratische beweg-ingen in Gelderland, 1672–1795* (Amsterdam, 1973).

18. Cf. Schama, *Patriots and Liberators,* 105.

19. See, for example, a massive petition in Deventer in the fall of 1782: Gemeentearchief Deventer, Republiek II, no. 133.

20. See, for example, P. Schotel, "De Dordrechtse Schuttersgilden in de Patriotttentijd, 1782–1787," *Kwartaal en Teken van Dordrecht* 10 (1984): 24; *Post van den Neder-Rhijn* 3:198, 309–10; *Politieke Kruyer* 7:108, 458–59, and 8:58, 512.

21. See, for example, *Hartloper van Staat,* no. 1 (1784): 26; *Nieuwe naam-lijst der notabele en veel vermogende Keezen en Keezinnen . . . in 's Gravenhage* (n.p., n.d.), Koninklijke Bibliotheek (KB), no. 21676.

22. P. J. Buijnsters, *Wolff en Deken, een biographie* (Leiden, 1984), 58ff.

23. Ibid., 234–43.

24. Similarly, in the long-running *Post van den Neder-Rhijn,* 12 vols. (1780–87), there were just six letters and four poems signed by women; in the *Politieke Kruyer* (9 vols., 1781–87), there were seven letters and three poems by women.

25. Buijnsters, *Wolff en Deken*; R. van Gelder, "Patriotten in balling-schap," *Speigel Historiael* 14 (1979): 80–87.

26. For what follows generally on the Batavian Revolution, see Schama, *Patriots and Liberators*; Kossmann, *The Low Countries,* 82–102; R. R. Palmer, "Much in Little: The Dutch Revolution of 1795," *Journal of Modern History* 26 (1954): 15–35.

27. For examples of the sequential character of the reforms, see R. E. de Bruin, *Burgers op het kussen: Volkssoevereiniteit en bestuurssamenstelling in de stad Utrecht, 1795–1813* (Zutphen, 1986); J. Theunisz, *Overijssel in 1795* (Amster-dam, 1943).

28. Cf. P. Geyl, *Geschiedenis der Nederlandse stam,* vol. 6 (Amsterdam/ Antwerpen, 1962).

29. On the transformation of the Dutch state in this period, in addition to Schama, *Patriots and Liberators,* see J. Verrips and T. Zwaan, "De mannen van het groene laken," *Symposion* 1 (1979): 28–69; L. J. G. Rogier, "Uit ver-deeldheid tot eenhied," in *Terugblik en Uitzicht* (Hilversum, 1964), 248–61.

30. For the purposes of this analysis, we have dated the Batavian Rev-olution from the beginning of 1795 to the end of 1800 on the grounds that in 1801 the *Staatsbewind* brought the end of radical democratic or republican experiments and a concomitant decline in popular mobilization and collective action, at least on the national level. In *Burgers op het kussen,* a local study of Utrecht, R. E. de Bruin argues for the vitality of democratic processes at the local level through 1803.

31. H. Hardenberg, *Etta Palm, een hollandse parisienne, 1743–1799* (Assen, 1962); Judith Vega, "Feminist Republicanism: Etta Palm d'Aelders on Justice, Virtue and Men," *History of European Ideas* 10, no. 3 (1989): 333–51.

32. The same apology for her awkward Dutch appears in a petition signed by Etta Palm in 1795 shortly after her return from France.

33. *Oprechte Nationaale Courant,* May 6, 1795; it was signed "Vriendinne van de waarheid." She published another letter the next week: ibid., May 13, 1795.

34. W. P. J. Overmeer, "Het aandeel der vrouwen aan de omwenteling van 1795 te Haarlem," *De Navorscher* 54 (1904): 356–57.

35. See, for example, *Oprechte Nationaale Courant,* March 13, 16, and 25, 1795.

36. J. N. de Boer, " 't Vermaakelijk Nut," *Jaarboek Haarlem,* 1983, 74–93.

37. *Ten betooge dat de vrouwen behooren deel te nemen aan de regeering van het land* (Harlingen, 1795), KB, no. 22558. This text has been edited with an introduction: Judith Vega, "Het Beeld der Vrijheid; Is het niet uwe Zuster?" *Socialistisch-Feministische Texten* 11 (1989): 89–111.

38. *De revolutionaire vraagal, of de zwaager van den politieken blixem,* no. 14 (1795); cf. Helmers and Koster, "Idee en werkelijkheid," 32–34.

39. Lieuwe van Ollefen, *Het revolutionaire huishouden* (Amsterdam, 1798). Cf. Helmers and Koster, "Idee en Werkelijkheid," 30–32; *Nieuwe Nederlandsch Biographisch Woordenboek* (NNBW), 8, cols. 1236–37.

40. Gerrit Paape, *De Bataafse Republiek, zoals zij behoord to zijn en zoals zij wezen kan, of revolutionaire droom in 1798 wegens toekomstige gebeurtenissen tot 1998, Vrolijk en Ernstig* (n.p., 1798), KB, no. 23006. Cf. Helmers and Koster, "Idee en Werkelijkheid," 29–30; NNBW, 5, cols. 413–17.

41. Maria Paape, *Republikeins gebed van eene vaderlandsche vrouw* (n.p., 1795). Cf. A. J. van der Aa, ed., *Biographisch Woordenboek der Nederlanden* (Haarlem, 1872), 15:6.

42. Helmers and Koster, "Idee en werkelijkheid," 51–63; Bernardus Bosch, "Levenschets," in *Gedichten* (Leiden, 1803), 269–332.

43. *Nationaale Bataafsche Courant,* July 25, 1797. Heybeek is also mentioned in H. T. Colenbrander, ed., *Gedenkstukken der Algemeene Geschiedenis van Nederland van 1795 tot 1840* ('s Gravenhage, 1906), vol. 2, *Vestiging van den eenheidstaat, 1795–1798,* 737–85.

44. *Nationaale Bataafsche Courant,* July 6, 1797.

45. Ibid., August 5, 1797.

46. Gemeentearchief Amsterdam, Rechterlijk Archief, 480, Confessieboek 1797.

47. *Nationaale Bataafsche Courant,* September 30, 1797.

48. Theodor Jorissen, *Historische Studien,* 2d ed. (Haarlem, 1893), 4:27–49; J. A. F. Wassink, "Contrarevolutionaire oranjebeweegingen in Oost-Gelderland, september 1797," *Speigel Historiael* 20 (1985): 184–90.

49. I. van Manen and K. Vermeulen, "Het lagere volk in de politieke geschiedenis van Amsterdam van 1780 tot 1800, Oranjegezinden en patriotten," unpublished thesis (Amsterdam, 1975), Appendix A.

50. Johan de Vries, *De economische achteruitgang der Republiek in de achtteinde eeuw* (Amsterdam 1959); James C. Riley, "The Dutch Economy after 1650: Decline or Growth?" *Journal of European Economic History* 13 (1984): 521–69. At a recent conference on eighteenth-century Dutch history at the Folger Library in Washington, D.C., the notion of decline was all but discarded by the participants.

51. W. W. Mijnhardt, "De Nederlandse Verlichting: een terreinverkenning," in *Figuren en Figuraties: Acht opstellen aangeboden aan J. C. Boogman* (Groningen, 1979); idem, "The Dutch Enlightenment: Humanism, Nationalism and Decline" (Paper presented at the symposium "Decline, Enlightenment, and Revolution: The Dutch Republic in the Eighteenth Century," Washington, D.C., March, 1987; forthcoming in the proceedings of the conference). Cf. Simon Schama, "The Dutch Enlightenment," in *The Enlightenment in National Context*, ed. R. Porter and M. Teich (Cambridge, 1981).

52. Mijnhardt, "The Dutch Enlightenment," and the literature cited there.

53. Buijnsters, *Wolff en Deken*. Compare Jane Randall, *The Origins of Modern Feminism: Women in Britain, France, and the United States, 1780–1800* (London, 1985).

54. Cf. *De advocaat der vrouwelijke kunnen en wel voornaamentlijk der jonge dochteren en weduwvrouwen met artikelen van bezwaar . . .* (n.p., n.d.), UBA, Broch. CLXXVII, 9, which not only advocates better education, as did Betje Wolff, but argues that women should be allowed to be members of learned societies. The only exceptions to this moderate rule seem to be two aristocratic women with international connections: German-born Charlotte-Sophie Bentinck, who was married to William Bentinck, and Belle van Zuylen, who as Madame de Charriere became an important francophone author. Cf. Joanne Boeijen, et al., "Nostre misere est generale: Gedachten van Charlotte-Sophie Bentinck over de positie van de vrouw," *Documentatieblad Werkgroep Achtiende Eeuw*, no. 44 (1979): 3–29; C. H. E. de Wit, "De historische realiteit van Belle van Zuylen ten aanzien van de Republiek in 1787," *Documentatieblad Werkgroep Achtiende Eeuw*, nos. 27–29 (1975): 51–61.

55. See, for example, J. N. Jacobsen Jensen, ed., "Moryson's reis door en zijn karakteristiek van de Nederlanden," *Bijdragen en Mededeelingen van het Historisch Genootschap*, 39 (1918): 214–306; Alice Clark, *Working Life of Women in the Seventeenth Century*, 2d ed. (London, 1982), 35–38.

56. Florence W. J. Koorn, "Illegitimiteit en eergevoel: Ongehuwde moeders in Twenthe in de 18e eeuw," *Jaarboek Vrouwengeschiedenis* (1987).

57. Hugo de Groot, *Inleidinge tot de Hollandse rechts-geleerdheid*, 2 vols. (Gouda, 1939), 1:9; Cornelis Overvoorde, *De ontwikkeling van den rechtstoestand der vrouw volgens het oud-germaansche en oud-nederlandsche recht* (Rotterdam, 1891); William Robert Veder, *Historisch kenschets van den privaatrechtelijken toestand der vrouw in ons burgerlijk wetboek* (Leiden, 1882); W. van Iterson, "Vrouwenvoogdij," *Tijdschrift voor Rechtsgeschiedenis* 14 (1936): 421–52, and 15 (1937): 78–96, 175–90, 287–387.

58. The literature on this subject is sparse. See E. Tas, "De vrouw in het economisch leven van Amsterdam tot 1700," unpublished thesis (Amsterdam, 1938); Leonie van Nierop, "Het kohier van de personele quotisatie te Amsterdam over het jaar 1742 en de Amsterdamse vrouw," *Jaarboek Amstelodamum* 43 (1949): 80–102; Marjolein van den Boogaard. "Maria Jacoba Daemen, 1658–1733, koopvrouw te Amsterdam," unpublished thesis (Amsterdam, 1979). On women's wages, see L. Noordegraaf, *Daglonen in Alkmaar 1500–1850* (n.p., 1980), 72–73.

59. Gemeentearchief Amsterdam, Index Notariele Archieven.

60. Jenneke Quast, "Vrouwenarbeid omstreeks 1500 in enkele Nederlandsche steden," *Jaarboek Vrouwengeschiedenis* 1 (1980): 46–65; idem., "Vrouwen in gilden in Den Bosch, Utrecht, and Leiden van de 14e tot en met de 16e eeuw," in *Fragmenten Vrouwengeschiedenis* 1:27–38.

61. Unpublished research results from a working group in the Department of Social History, Erasmus University Rotterdam.

62. J. J. A. Wijs, *Bijdrage tot de kennis van de leenstelsel in de Republiek* ('s Gravenhage, 1939), 9–11.

63. R. M. Dekker, *Holland in beroering, oproeren in de 17e en 18e eeuw* (Baarn, 1982).

64. Cf. Te Brake, "Provincial Histories."

65. What follows is drawn from Rudolf Dekker, "Women in Revolt: Collective Protest and its Social Setting in Holland in the Seventeenth and Eighteenth Centuries," *Theory and Society* 16 (1987): 337–62; cf. R. M. Dekker, "De rol van vrouwen in oproeren in de Republiek in de 17e en 18e eeuw," *Tijdschrift voor sociale geschiedenis*, no. 12 (1978): 305–16.

66. C. J. Calhoun, "The Radicalism of Tradition: Community Strength or Venerable Disguise and Borrowed Language," *American Journal of Sociology* 88 (1983): 866–915.

67. Cf. Van Rijn, "Kaat Mossel."

68. Buijnsters, *Wolff en Deken*, 240–41; cf. Wayne Ph. te Brake, "Rhetoric and Reality in the Patriot Revolution" (Paper presented at the universities of Amsterdam and Rotterdam in 1985 and the University of Michigan in 1986).

69. The contrast with the rhetoric of the American Revolution, in the early days of which crowds were often glorified as the "people out of doors," is striking. On the shifting attitudes toward crowds in the American Revolution, see, for example, Gordon Wood, *The Creation of the American Republic, 1776–1787* (Chapel Hill, N.C., 1969). See also Colin Lucas, "The Crowd and Politics between *Ancien Regime* and Revolution in France," *Journal of Modern History* 60 (1988): 421–57.

70. See, for example, *De Friessche Patriot* 1 (1786): 397. On 1748–50, see also J. A. F. de Jongste, *Onrust aan he Spaarne* ('s Gravenhage, 1984); P. Geyl, *Revolutiedagen te Amsterdam* ('s Gravenhage, 1936).

71. Cf. Wayne Ph. te Brake, "On the Importance of a Failed Revolution," in *Papers from the First Interdisciplinary Conference on Netherlandic Studies*, ed. W. H. Fletcher (New York, 1985), 147–54.

72. Te Brake, "Popular Politics," 206–7.

73. Ibid., 209–10.

74. *Post van den Neder-Rhijn* 5:589–96.

75. Te Brake, "Popular Politics," 207–8.

76. On Utrecht, see A. van Hulsen, *Utrecht in de Patriottentijd* (Zaltbommel, 1966); on Rotterdam, H. C. Hazewinkel, *Geschiedenis van Rotterdam*, vol. 1 (reprint, Zaltbommel, 1974); on Amsterdam, H. T. Colenbrander, *De Patriottentijd*, vol. 3 ('s Gravenhage, 1899); on Dordrecht, Schotel, "De Dordrechtse Schuttersgilden."

77. Wayne Ph. te Brake, "Revolution and the Rural Community in the Eastern Netherlands," in *Class Conflict and Collective Action*, ed. Louise Tilly and Charles Tilly (Beverly Hills/London, 1981).

78. J. de Boer, "De verhouding tussen aristocraten en democraten in Friesland en de opstand te Franeker, 1782–1787," unpublished thesis (Leeuwarden, n.d.).

79. Van Hulsen, *Utrecht in de Patriottentijd*; Schama, *Patriots and Liberators*, 88–100.

80. W. Ph. te Brake, *Regents and Rebels: The Revolutionary World of an Eighteenth-Century Dutch City* (Oxford and Cambridge, Mass., 1989), 57–59.

81. P. Geyl, *De Patriottenbeweging, 1780–1787* (Amsterdam, 1947), 96ff; Schama, *Patriots and Liberators*, 110–21; I. van Manen and K. Vermeulen, "Het lagere volk van Amsterdam in de strijd tussen Patriotten en Oranjegezinden 1780–1800," *Tijdschrift voor sociale geschiedenis*, part I, 20 (1980): 331–57, and part II, 21 (1981): 3–43.

82. W. Ph. te Brake, "Violence in the Dutch Patriot Revolution," *Comparative Studies in Society and History* 30 (1988): 143–63.

83. W. W. van der Meulen, "De betekenis van de Haagsche opstootjes in den Patriottentijd," *Die Haghe* 1909: 79–112; *Post van den Neder-Rhijn* 5:833–39.

84. *Post van den Neder-Rhijn* 3:1080.

85. Colenbrander, *Patriottentijd* 3:192–204; R. A. M. ter Bogt, "De Oranjesocieteit in Gouda," unpublished thesis (Leiden, 1985). Cf. C. H. E. de Wit, *De Nederlandse revolutie van de achttiende eeuw* (Oirsbeek, 1974) and Alfred Cobban, *Ambassadors and Secret Agents: The Diplomacy of the First Earl of Malmsbury at The Hague* (London, 1954).

86. Cf. E. J. van Himbergen, "Grondwettig Herstelling," in *Figuren en Figuraties*, 27–39.

87. Van Manen and Vermeulen, "Het lagere volk," part II, 27.

88. Cf. Bakker, "Literair-politieke pamphletten."

89. Te Brake, *Regents and Rebels*, 171–73.

90. Ter Bogt, "Oranjesocieteit in Gouda," 45–46.

91. Schama, *Patriots and Liberators*, 226–29.

92. Helmers and Koster, "Idee en werkelijkheid," 39.

93. Hanna Stouten, "Maria Aletta Hulshoff (1781–1846), dweepster of idealiste?" *Literatuur* 2 (1984): 72–79; NNBW, II, col. 620.

Women in Revolutionary Brussels: "The Source of Our Greatest Strength"

Janet Polasky

Together with their sons, their fathers, and their husbands, the women of Brussels revolted against their Austrian rulers in 1789 to establish an independent Belgian republic. They drafted political treatises, coordinated clandestine meetings, led processions, and heaved stones from their housetops onto the retreating Austrian armies below. The participation of countesses, a political mistress, and female artisans in this Brabant Revolution was apparently expected as well as accepted.

In 1787 in a dramatic break from the practices of his mother from whom he had inherited the Austrian throne and its territories, Joseph II announced his scheme for reforming the religious, judicial, and administrative institutions of his newly inherited Austrian Netherlands.[1] The three Brabant Estates met in Brussels to protest against innovations that violated their privileges. For centuries, the Belgians had enjoyed the protection of foreign rulers who had governed according to the terms of the medieval Brabant Constitution, the Joyeuse Entrée. The Austrian Emperor persisted in his attempts to enlighten his Belgian subjects. Just as stubbornly, the Brabant Estates refused to vote the Emperor his tax subsidies. Finally, to break the stalemate, in June, 1789, Joseph barred the doors of the meeting rooms of the Estates.

A group of lawyers, wholesale merchants, and members of the liberal professions had quietly observed the Estates' ineffective struggles throughout the spring of 1789. This group of democrats organized a secret revolutionary society, Pro Aris et Focis, in Brussels. They distributed guns, ammunition, and pamphlets throughout the provinces. Noting the recent victories of the French Third Estate, they explained: "We are situated a hundred times more advantageously

for recovering our liberty . . . since in contrast to the French who began their revolution without a written constitution, we already have a fixed and permanent constitution."[2] The French had struggled to establish a new form of constitutional rule; the Belgians had but to regain theirs.

Throughout the summer the two groups—the leaders of the Estates who had followed the Brussels lawyer Henri Van der Noot into exile across the Dutch border and the democrats who were gathering arms and ammunition for Pro Aris et Focis—alternately cooperated with each other and complained about the futility of the other group's revolutionary strategy.

The two groups finally coalesced in October, 1789, wrote a manifesto of independence, organized an army, and launched their attack on the Austrians. Much to the surprise of the rest of Europe, this so-called "army of the moon" succeeded in driving the Austrian troops from the Belgian provinces. Henri Van der Noot proclaimed Belgian independence from the Austrians in December, 1789, reestablishing the sovereignty of the provincial Estates. The democrats, who were scattered throughout the provinces at the head of the Belgian troops, were outmaneuvered and excluded from the government of the new Belgian republic. After several months of petitioning against the Estates' usurpation of the people's sovereignty and of being chased through alleys and down drainpipes by mobs of angry artisans, most of the democrats fled the Belgian provinces for exile in Lille.

Just as the Brabant Revolution, with its dominant traditionalist leadership, diverged in course from the more radical French Revolution, so too Brussels women pursued roles markedly different from those of their Parisian counterparts. In contrast to the neighboring French, Belgian women shared actively in every phase of the Brabant Revolution. As members of the Second Estate, noble women met freely with the other revolutionary leaders, wrote pamphlets, and loaned their families' arms to the revolutionary cause. The wives and widows of artisans and shopkeepers dropped stones, presented cannons, and joined in the political debates. Political mistresses conveyed revolutionary correspondence, wrote poetry, and distributed handbills. All of these Brussels women participated actively in the Revolution within the traditions established and maintained by their ancestors. They all continued to share in the public life of the Ancien Regime. Unlike the French Revolution, the Brabant Revolution did not topple either the corporate economic structure or the political

institutions that had allowed independent countesses, mistresses, and artisanal women a voice in Belgian political life for centuries.

Henri Van der Noot's traditionalists dominated the Brabant Revolution and the independent Etats Belgiques Unis. The three privileged orders of Brussels—the nobility, the clergy, and the artisans—coalesced to defend the independence of the Catholic Church, the guilds' monopoly of the marketplace, and noble representation for the countryside. Their impassioned defense of the old regime was based on a corporative argument. "Everyone lives happily in the midst of prosperity," one traditionalist pamphleteer explained. "The farmer, the artisan, the clergy, the nobility are all just one family attached to the Estates."[3] Because they all shared common interests, it was to the benefit of all the Belgian people, peasants as well as nobles, that "the natural aristocracy" continue to rule. Besides, other pamphleteers concluded, God himself had imposed the hierarchy on human society. Mere mortals should not tamper with divine design.[4] Not surprisingly, women figured prominently among the lists of noble and artisanal followers of Van der Noot.

The lawyers and professionals of Pro Aris et Focis contended that the nobility and the clergy, who had dominated medieval society and politics, no longer performed any essential services in exchange for their privileged positions.[5] These two privileged orders no longer represented or understood the divergent interests of the people of the cities and the countryside. And the guilds spoke only for their particular commercial interests; they no longer deserved to serve as exclusive spokesmen for the entire Third Estate. The useful classes—the lawyers, the businessmen, as well as the peasants who fed the nation—deserved their own individual representation, the Belgian democrats explained.[6] Few women enlisted in their campaign for the destruction of feudal privilege and the corporate institutions of the Ancien Regime.

One revolutionary pamphlet—"Precis historique sur les anciennes Belges"—heralded a centuries-old tradition of feminine involvement in Belgian public life.[7] The author of the pamphlet explained that "the Belgians, the first free people, have maintained their liberty throughout the centuries because women no less than men have worked continuously to guard it."[8] Thirty-three pages of examples of women who had intervened throughout Belgian history to guide governments in wars and revolutions formed the body of the pamphlet. In the Belgian provinces, the pamphlet concluded,

"Women have always been the source of the greatest strength."[9] The author dedicated the pamphlet to the Comtesse d'Yves, a renowned participant in the Brabant Revolution.

Anne Thérèse Philippine d'Yves, the fifty-two-year-old unmarried daughter of an ennobled vicomte, lived in Brussels throughout the Brabant Revolution.[10] Soon thereafter, she emigrated to Paris, living at the Hotel de Suède under the name Citoyenne Maréchal.[11] She corresponded freely with the leaders of the Brabant Revolution, learning daily of the activities of the volunteers and of the crowds, as well as the decisions of the revolutionary committees, the Estates of the various provinces, the Congress, and especially the War Department.[12] Based on her comprehensive information-gathering network as well as her own sense of political and military strategy, she in turn offered advice to her correspondents on matters ranging from troop movements to treaty negotiations.

In addition to collecting one of the most extensive sets of revolutionary brochures, she was a respected pamphleteer herself. In her widely distributed writings, she incorporated the traditionalist respect for medieval privilege with the democratic appeal to the philosophes' natural rights theories. She integrated what historians and political theorists have since categorized as separate and opposed ideas. She began her argument by insisting that the Brabant Constitution be preserved because it had served the people so well in the past. Belgium, she explained, was widely recognized as "the model of the universe."[13] However, like the democrats, she then called on the common people of Belgium to fight for their sovereignty and their natural rights. Protesting Joseph's violations of the provisions of the Joyeuse Entrée, the Comtesse d'Yves warned that if the Belgian people surrendered their centuries-old constitutional rights, they would not soon regain them. "In this century when sovereigns force their subjects to submit to the yoke of despotism," she told her compatriots, it was imperative that they fight to maintain the liberty secured for them by their ancestors.[14]

In addition to her own writing, the Comtesse d'Yves also distributed traditionalist pamphlets to the democrats and vice versa. She never hesitated to criticize them before she forwarded them. Marginal notes suggest that her correspondents often took her comments more seriously than they did the original pamphlets.[15]

The house that she shared with her mother served as a gathering place for Brussels revolutionaries of all classes and political factions. Guild leaders met there with members of the nobility; Brussels dem-

ocrats discussed plans with emissaries from the traditionalists. By all reports, she ran an informal Brussels equivalent of a Paris salon.[16] When the Austrians arrested a number of suspected revolutionary leaders in 1788, the mayor of Brussels, who visited her almost daily, warned her to be more circumspect. Her ideas were being discussed publicly on every street corner of Brussels, he suggested.[17] She refused to heed his advice and continued to rally the leaders of the Estates and Pro Aris et Focis, supplying them with the latest pamphlets and pressing them to persevere in their defense of the rights of the Belgian people.

The Comtesse d'Yves was one of the very few revolutionaries who cooperated with both political factions. Both Jan François Vonck, the leader of Pro Aris et Focis, and Van der Noot relied on her to intervene with the other side on their behalf and to arrange confidential meetings.[18] Several other nobles tried to work with both political factions in 1789, but only the Comtesse d'Yves continued to be trusted by both traditionalists and democrats throughout the Revolution. That faith was not entirely deserved, however. By March, 1790, she had come to fear General Vandermeersch and his followers among the Flemish democrats. She worried that the democrats' plans to reform the Estates would undermine the crucial efforts of the young Belgian nation to win recognition from the other countries of Europe. The Brabant revolutionaries had ousted the Emperor for violating the terms of their constitution. What would other European sovereigns think if the newly independent Belgians then changed the constitution themselves?[19] Her attacks on the "cabale des démocrates" became more ardent as their threat increased. When she also complained about Van der Noot's "stupidity" as well, a correspondent replied that if only she were not a woman, she herself could have led the revolutionaries along a more sensible and moderate course.[20]

Only once did the Comtesse d'Yves allude to women as a separate political category. In one letter she explained that if the Belgian democrats really were serious about granting the vote to propertyless villagers, nothing would prevent them from concluding that because "women comprise at least half of the population, out of equity they too deserve their own representatives."[21] The propertyless villagers, like the women, were already represented in the Brabant Estates; they had no need for individual representation. Her reference to women's political rights as individuals in this instance only served to buttress her corporate argument. Nothing else in her writing distinguished it from that of her male counterparts.

Joining the Comtesse d'Yves as revolutionary participants were the female members of the two highest noble families of the Austrian Netherlands. Their husbands had given their support to the democratic committee, before fleeing for safety. In contrast to the majority of nobles who supported the Estates, these democrats enjoyed substantial wealth. The Duc d'Arenberg and the Duc d'Ursel, for example, received an annual revenue of 400,000 florins as opposed to the median Brabant noble income of 12,000 florins.[22] They corresponded with French philosophes, held military positions in the Austrian Army, invested in mining and banking operations, and processed at the head of the honorary guild volunteer units in Brussels celebrations. The Duchesse d'Ursel and the Duchesse d'Arenberg remained in the Belgian provinces throughout the Revolution, although both their husbands had left. The two women lent their assistance and family cannons to the revolutionary armies.[23] The Duchesse d'Ursel had driven her own horses to the gates of Brussels to welcome Van der Noot on his triumphal return to the capital in December, 1789. The Austrian commander despaired of the courage and tenacity "of this party of Amazons."[24]

The names of several other noble women appear periodically on the lists of revolutionary groups, both as supporters of the Estates and of Pro Aris et Focis, but there is little information on the extent of their revolutionary participation.[25]

As the "Précis historique sur les Anciennes belges" suggests, this participation of noble women in Belgian political life was the continuation of a long established practice. Records from the Ancien Regime suggest that noble women had been sitting in the Brabant Estates as well as sharing informally in governing circles for four hundred years. The unmarried Comtesse d'Yves was not a rare feature in the political realm of the Ancien Regime. The correspondence between revolutionary leaders never alluded to the fact that she was in any way different from the other nobles who joined the two revolutionary factions, nor did her gender appear to limit the range of her participation.

More notorious than the Comtesse was Jeanne de Bellem, the mistress of the revolutionary leader, Henri Van der Noot. Before her liaison with Van der Noot, she had been a domestic servant and a prostitute.[26] Her participation in the Brabant Revolution was reminiscent of the court patronage of the Ancien Regime, or at least a lower bourgeois parody of it. While Van der Noot's court was privileged, it was certainly not noble.

When Van der Noot became involved in the Revolution, writing the protest petitions for the Brabant Estates, Bellem joined in the political cause. Between 1787 and 1790 she wrote scores of pamphlets in verse that she distributed with her daughter Marianne in the shops and streets of Brussels, often right under the noses of unsuspecting Austrian soldiers. In one early rhyming verse, for example, she urged the Belgians to look to the American example: "Belgian People, Tyrannical Court, Do like America." ("Peuple Belgique/cour tyranique/faisons comme l'Amérique.")[27] Perhaps more importantly, she served as a link in a chain of secretive political conversations among the revolutionaries. Because her relationship with Van der Noot appeared to Austrian authorities to be personal, she could relay information to him from Brussels guild leaders who dared not be seen conversing too frequently with the known leader of the Belgian resistance.

After Van der Noot fled to exile in London in the summer of 1788, Austrian soldiers arrested Madame de Bellem. She continued to send political reports to him from her Brussels prison through an increasingly intricate network of couriers. When the first two Estates seemed about ready to give in to the Emperor's demands in 1788, she wrote despairingly to Van der Noot that they "both resembled the Gods of the Gentiles. They have eyes, ears and mouths, but they no longer see, hear or speak. They also have hands and feet, but they use them only to visit the Austrian minister."[28] When her beloved Henri failed to write for several weeks while she was imprisoned, she complained characteristically: "I wrote you that I had been sick, not that I had died."[29] He answered somewhat unsympathetically that with so much work it was all he could do to sustain himself on the ghastly English vegetables and weak beer. Liberated at last after a long and well-publicized trial, Madame de Bellem accompanied Van der Noot on his triumphal return to Brussels in December, 1789.[30] Together they paraded through Brussels in an open carriage and attended the pageant at the Théâtre de la Monnaie celebrating the Belgian victory.[31]

Pamphleteers and cartoonists, enraged at Van der Noot's domineering, though unofficial, control of the Estates General of the newly independent Belgian republic, soon singled out his liaison with Madame de Bellem for attack. The cartoonists portrayed Bellem rocking a cradle full of sleeping guild leaders, powering a steam engine on which the revolutionary leaders were riding, and concealing plotting traditionalists under her skirts. In the pamphlets, the

FIG. 1. Madame de Bellem rocking the revolutionary leaders in their cradle. A caricature from the Brabant Revolution. (Source: Bibliothèque Royale Albert 1st, Brussels [Cabinet des Estampes].)

democrats attacked her unofficial leadership of the party of "feminothéocrates."[32]

The author of two of the more vicious satires, "Vie amoreuse de Jeanne de Bell—m, dite la Pin..u. [*sic*], Maîtresse en Titre d'un des célèbres Personnages du Brabant" and "Histoire secrète de la Révolution," charged that when Van der Noot declared himself duke of the Belgian provinces, Madame de Bellem had taken the title of the duchess for herself.[33] Neither had legitimate claim to their assumed positions. The author further accused Madame de Bellem of inspiring the coterie of followers surrounding Van der Noot, all allegedly her lovers, to horrifying acts of terror against the democrats. According to the "Histoire secrète," for example, the evening after the leaders of the Brussels guilds had refused to swear allegiance to Van der Noot, Madame de Bellem muttered vengefully, "Well then,

we will have to exterminate them all tonight."[34] Other pamphleteers, realizing the futility of their previously moderate critique of Van der Noot's regime, joined in the offensive.[35] Their ribald tales resembled the attacks written throughout early modern Europe against other political mistresses who allegedly took advantage of their informal access to power. In form and content, they repeated the charges made against the French court.

Madame de Bellem also attracted her share of admirers. One of the leading publicists, for example, wrote that he wished he could be planted as a tulip in her garden so as to observe her all day long.[36] She apparently encouraged such adulation. In her letters to her male correspondents, she apologized continuously for her handwriting, which she said resembled the scrawls of a cat, and the mediocrity of her ideas. She deferred demurely to one revolutionary correspondent, "I am only a woman after all."[37]

Once the Austrians returned to power in the autumn of 1790, Van der Noot fled again to the Netherlands. His letters continued to appear periodically, addressed to former leaders of the Revolution as well as to Austrian and then French government officials. Observers reported sightings of Madame de Bellem in lodgings near his in the Netherlands, but for all intents and purposes, she disappeared from the political records after 1790.

A multitude of other Brussels women participated in the revolutionary crowds. Unfortunately, the Austrian spies, our most reliable source of information on the large multitudes that gathered daily in the Grand' Place, worried only about the revolutionary leaders. No information on the other participants was included in their reports. However, women were clearly depicted in the drawings of the crowds in the Grand' Place and surrounding the Cathedral. Their participation was consistent with their continued active role in the guilds that mobilized the crowds throughout the Revolution.

Also, many of the political pamphlets written in the form of dialogues depicted women as well as men discussing political grievances, plotting the rebellion, and planning the republic.[38] While these sources are anecdotal, it is significant that both the written and pictoral representations of the Revolution showed women from the artisanal mainstream of Brussels alongside their male counterparts. Women were depicted realistically, rather than allegorically. They were full political participants.

In the midst of the Revolution, Austrian military leaders bemoaned the guerrilla tactics of artisan women who dropped stones

from housetops onto the heads of the Austrian soldiers below. After the Belgian victory, official Belgian records listed the daily cavalcades of women who presented the Congress with cannons, ammunition, and arms to defend the new republic.[39] This ceremonial presence paralleled that of their French neighbors.

One pamphlet suggested that the exceptional Belgian woman may also have joined the Belgian army in disguise. "Les femmes belges" told the story of a young girl who resolved to join her fiancé in the revolutionary army.[40] her mother applauded her determination, exclaiming in a statement that is reminiscent of the hommage to the Comtesse d'Yves, "I am so happy to see you developing that time-honored courage that is the distinctive character of our Belgian women."[41] She then summoned a priest to marry the young couple before they departed for battle. When the priest questioned the wisdom of sending her only daughter to the front, the mother replied that perhaps because he was a foreigner he did not understand that Belgian women differed from other European women. "They are no less susceptible to glory than to the daily pleasures," she explained.[42] In the last scene, Isabelle, armed with her father's sword and gun, departed for battle. Although other pamphleteers recounted similar tales, there is little substantive evidence of any significant feminine military participation.

Traditionalist support for the Revolution was mobilized through the Ancien Regime corporate institutions in which Belgian women had always participated. Women had customarily shared the political as well as economic power that came with membership in the Belgian nobility and the Brussels guilds. As John Bohstedt has explained in his study of English riots, women participated in the Brabant Revolution as household producers. Not until the enforcement of free-trade decrees and the loss of noble privilege under the French Occupation at the end of the 1790s did Belgian women lose this significant power base.

In contrast to the neighboring French, Belgian women shared actively in every phase of the Brabant Revolution. They were never excluded. But they were not noticed as distinct from their male counterparts, nor did they participate in female-dominated food riots as in France. These Belgian women had no significant history of bread or food riots on which to draw. The Belgian provinces had enjoyed relative agricultural prosperity, especially in comparison with neighboring France.

Amidst the hundreds of volumes of pamphlets written during

the Brabant Revolution, two appeals for women's political rights alone survive—"Réclamation des citoyennes de Bruxelles tant Démocrates qu'Aristocrates" and its double, "Réclamation des Citoyennes de Liège tant Démocrates qu'Aristocrates."[43] These two pamphlets predicted that the storm of revolutions sweeping both sides of the Atlantic at the end of the eighteenth century would finally bring an end to the "seventeen centuries of masculine abuse" endured by women.[44] Contending that they "had carefully studied the principles of natural law," the pamphleteers demanded "the reform of all existing laws that limit our right to enjoy our property and our liberty."[45] More specifically, the authors called for the creation of a Belgian National Assembly to replace the provincial Estates. Three hundred of the six hundred delegates were to be women. If the Belgian revolutionary leaders ignored their demands, the pamphleteers threatened in conclusion that women would withdraw from society, leading to the imminent extinction of the Belgian race. The authors demanded further that men become the property of the women to whom they were bound by love. These two pamphlets, however, are the sole examples of the genre so common in neighboring France.

Probably, in fact, the pamphlets were written in France, or at least were intended as satires of the outspoken Parisian women to whom the author frequently alludes. The contrast between these two pamphlets and the myriad of other Belgian pamphlets that heralded the courage of revolutionary men and women together demonstrates the striking differences in the treatment of gender in the two political cultures.

Belgian women participated alongside men throughout the Brabant Revolution in part at least because the Belgian revolutionaries never dismantled the Ancien Regime institutions that had always allowed them a role in the economic activities and a place in the political community. As R. R. Palmer explained in his *The Age of the Democratic Revolution,* the dominant traditionalists of the Brabant Revolution reestablished and reinforced the authority of the "privileged, closed, or self-recruiting groups of men."[46] In the Belgian case, however, Palmer's "men" should be replaced with "men and women." Belgian custom and law granted the artisanal and noble women privileges alongside their husbands, fathers, and sons. The Belgian women revolutionaries of 1789 were the inheritors of a long, proud, and perhaps unique tradition of strong feminine political and economic involvement.

Also, unlike the other democratic revolutions that occurred one

after another on both sides of the Atlantic at the end of the eighteenth century, the Brabant Revolution was fought within a prosperous, industrializing society. Belgian industrialization had begun in the second half of the eighteenth century, decades ahead of neighbors on the European continent.[47] Between 1750 and 1784, bourgeois and noble entrepreneurs began to concentrate production under one roof and under one central direction, drawing upon substantial capital investment in their expansion. As the Comtesse d'Yves herself frequently observed, these entrepreneurs and their lawyers formed the memberships of the Belgian democratic committees.

In contrast to their French Girondin counterparts, the Belgian democrats enjoyed little feminine support. That may be because the Belgian democrats so closely joined together their revolutionary politics to their economic aspirations. The democratic entrepreneurs, most of whom employed at least fifty workers and traded throughout Europe, made explicit their arguments for free trade and individual representation. They joined the lawyers of Pro Aris et Focis in their contention that "the most learned, clever, and dignified have contributed the most to the well-being of the nation."[48] Neither the nobles nor the guilds deserved their exclusive privilege of representation on the Estates, they charged. The frequent court battles in the two decades preceding the Revolution attest to the conflict of economic interests between the entrepreneurs and the artisans in the Belgian provinces. Perhaps the Belgian women who were so actively engaged in the traditional society saw more clearly than their French counterparts the exclusion of women inherent in the laissez-faire, liberal society idealized by the democrats.

The uncharacteristically unself-conscious sharing of Belgian women in the revolutionary community of the traditionalists reflected the strength of the two privileged orders in the prosperous, industrializing society. By 1830 when the Belgian democrats led the second and ultimately successful revolution for Belgian independence, women stayed home and were ignored in the new definition of the political rights of the individual. They no longer shared in the economic or political community that mobilized the Revolution.

Notes

Portions of the essay are reprinted from "Women in Revolutionary Belgium: From Stonethrower to Hearthtenders," *History Workshop Journal* 21 (Spring, 1986): 87–104.

1. For more information on the Brabant Revolution see: Janet Polasky, "Traditionalists, Democrats, and Jacobins in Revolutionary Brussels," *Journal of Modern History* 56, no. 2 (June, 1984): 227–64; and Janet Polasky, *Revolution in Brussels, 1787–1793* (Brussels: Académie Royale de Belgique, and Hanover, New Hampshire: University Press of New England, 1986).

2. Trompette anti-autrichienne," *Révolution belge,* vol. 102, pamphlet 21, Bibliothèque Royale, Brussels.

3. George Talker, "Quelques réflexions politicopratiques ou adieux à Bruxelles," Acquisitions récentes, 4/13, Archives Générales du Royaume, Brussels. See also: "Les Trois frères, allégorie historique aux Belges," *Brochures 1790,* vol. 2, Université libre de Bruxelles, Brussels; "Dialogue familière entre un royaliste belgique fugitif et un patriote brabançon ambulant," *Révolution belge,* vol. 125, pamphlet 7, Bibliothèque Royale, Brussels; and "Het groot ligt door den Waeren Brabander," *Brochures 1790,* Université libre de Bruxelles, Brussels.

4. "Manifeste," Ms. 20373, Bibliothèque Royale, Brussels; "Lettre patriotique aux Belges delivrés du joug de la Maison de Lorraine-Autriche" (Brussels, 1790), *Révolution belge,* vol. 108, pamphlet 20, Bibliothèque Royale, Brussels; *Ami des Belges* (May 28, 1790); A. D. J. de Braeckenier, "Contrepoison," *Révolution belge,* vol. 11, pamphlet 8, Bibliothèque Royale, Brussels; "Les Sept Psaumes pénitentiaux des Vonckistes," *Révolution belge,* vol. 12, pamphlet 29, Bibliothèque Royale, Brussels; "Die Boerkens van Maesel, *Révolution belge,* vol. 17, pamphlet 6, Bibliothèque Royale, Brussels; Van Eupen, *Journal générale de l'Europe* (December 30, 1789).

5. J. B. C. Verlooy, "Projet raisonné d'union des Provinces-Belgiques," *Révolution belge,* vol. 108, pamphlet 10, Bibliothèque Royale, Brussels; "Les Belges affranchis ou réflexions d'une société des citoyens" (1789), *Révolution belge,* vol. 81, pamphlet 26, Bibliothèque Royale, Brussels; "Relation d'un député du comité de la lune . . . ," *Révolution belge,* vol. 51, pamphlet 23, Bibliothèque Royale, Brussels; and "Adresse aux Etats Généraux par un Solitaire," *Révolution belge,* vol. 52, pamphlet 26, Bibliothèque Royale, Brussels.

6. J. F. Vonck, "Vervolg van Staetkundige onderrigtingen voor het Brabantse volk," Lille, 1792, Ms. 20474, Bibliothèque Royale, Brussels.

7. "Précis historique sur les anciennes Belges," Bibliothèque 813/2, Archives de la Ville de Bruxelles, Brussels.

8. Ibid.

9. Ibid.

10. I would like to thank Claudine Lemaire for sharing her extensive knowledge of the Comtesse d'Yves with me. Her article on the library of the Comtesse d'Yves is forthcoming.

11. Comtesse d'Yves du Bavay, Correspondance avec Comte d'Hane de Steenhage, G 12329, Rijksuniversiteit Gent, Ghent.

12. Ibid.

13. Comtesse d'Yves, "A la nation" (November 10, 1788), Goethals 210, Bibliothèque Royale, Brussels.

14. Ibid.

15. See, for example: Goethals 210, Bibliothèque Royale, Brussels; Duras to Yves, Etats Belgiques Unis 195, Archives Générales du Royaume, Brussels. Her correspondence is collected in the Archives des Etats Belgiques Unis 195 to 197, Archives Générales du Royaume, Brussels.

16. Actes du comité secret au Conseil du gouvernement, Conseil du gouvernement général 2573, Archives Générales du Royaume, Brussels.

17. Beeckmans to Yves, December 17, 1788, Etats Belgiques Unis 195, Archives Générales du Royaume, Brussels.

18. See for example: Van der Noot to Yves, December 26, 1789, and March 5, 1789, Etats Belgiques Unis 197, Archives Générales du Royaume, Brussels.

19. Comtesse d'Yves to Comte de Steenhage, February 7, 1790, G 12329, Rijksuniversiteit Gent, Ghent.

20. Comtesse d'Yves to Comte de Steenhage, March 19, 1790, G 12329, Rijksuniversiteit, Gent, Ghent; and Baron d'Hove to Comtesse d'Yves, October 16, 1790, Archives des Etats Belgique Unis 194, Archives Générales du Royaume, Brussels.

21. Comtesse d'Yves, Goethals 210, Bibliothèque Royale, Brussels.

22. Contribution de cinq millions 70/1–5, Archives de la Ville de Bruxelles, Brussels.

23. C. Terlinden, ed., *Souvenirs d'un Vonckiste: Les Aventures de J. B. Van der Linden ou détails circonstanciés sur la Révolution de Brabant* (Brussels, 1932).

24. Hop, October and November, 1789, Brussels, Staten Generaal 7460, Rijksarchief, The Hague.

25. See Polasky, *Revolution in Brussels.*

26. Frans Van Kalken, *Madame de Bellem* (Brussels: Office de Publicité, 1923).

27. Madame de Bellem, Préliminaires de la Révolution 1787–1789, Etats Belgiques Unis 1, Archives Générales du Royaume, Brussels.

28. Mme de Bellem, Goethals 210, Bibliothèque Royale, Brussels.

29. Jeanne de Bellem to Henri Van der Noot, November 7, 1788, Etats Belgiques Unis 180, Archives Générales du Royaume, Brussels. Other letters can be found in Office fiscal 1002, Archives Générales du Royaume, Brussels; and Goethals 210, Bibliothèque Royale, Brussels.

30. Trial records are in Office fiscal 1326, pp.71–103, Archives Générales du Royaume, Brussels.

31. Galesloot, "Chronique des événements les plus remarquables arrivés à Bruxelles de 1780 à 1827," Bibliothèque Royale, Brussels; and Hop, December 21, 1789, Staten Generaal 7460 Rijksarchief, The Hague.

32. "Maleficos Non Pateris Vivere, Derniers adieux des Aristo-Théocrates brabançons," Ms. 19648, Bibliothèque Royale, Brussels; "Die Boerkens van Maesel, *Révolution Belge*, vol. 17, pamphlet 6, Bibliothèque Royale, Brussels; Van Eupen to De Rode, February 6, 1790, Brussels, Etats Belgiques Unis 189, Archives Générales du Royaume, Brussels; Gérard, *Rapédius de Berg*

(January 6, 1790) (Brussels: Imprimérie de Demanet, 1842–43), 1:48–51, Ms. G573, Bibliothèque Royale, Brussels; and E. J. Dinne, *Mémoire historique et pièces justificatives pour M. Van der Mersch* (Lille, 1791).

33. [Robineau], "vie amoureuse de Jeanne de Bellm [*sic*], dite la Pin...u, Maîtresse en Titre d'un des plus célèbres Personnages du Brabant," Bibliothèque Royale, Brussels; and "Histoire secrète et anecdotique de l'insurrection Belgique," Rijksuniversiteit Gent, Ghent.

34. Ibid.

35. See: "Observations sur la Révolution belgique," *Varia Belgica* N²/ 397m Bibliotheek voor Godgeleerdheid, Katholiek Universiteit, Leuven; "Chanson Favorite de Madame Pineau," Staatskanzlei IV DD B Fasz 183 C (876) Haus-Hof und Staatsarchief, Vienna; "Lettre écrite par Madame Du Buisson" (May 4, 1790), Rijksuniversiteit Gent, Ghent; "Le Retour de la Liberté Brabançonne" (October 26, 1790), Acquisitions récentes, E-257, Archives Générales du Royaume, Brussels; "Humble requête présentée à Son Excellence Madame de Pauni, Par son très obéissant serviteur, le baron de Thunderhaghen Bergenopomhamburg . . ." Acquisitions récentes, E-228, Archives Générales du Royaume, Brussels; "Les deux Paillards de l'armée de Schoenfeld en bonne fortune & propos variés avec la fausse DUCHESSE DE BRABANT & son Adulterine," Acquisitions récentes, E-264, Archives Générales du Royaume, Brussels; and "Recueil," Acquisitions récentes, E-263, Archives Générales du Royaume, Brussels.

36. Dupont to Madame Pinaut (July 30, 1787), Goethals 210, Bibliothèque Royale, Brussels.

37. Jeanne de Bellem, Goethals 210, Bibliothèque Royale, Brussels.

38. See, for example: "Dialogue entre Franchette, bruxelloise, Josephine, namuroise, Thérèse, gantoise, Catherine, montoise, Tranche-Montagne Soldat, Patriote, Merveilleux, Colporteur Brabançon," *Ecrits politiques* 27:56–173, Archives Générales du Royaume, Brussels.

39. See, for example: "Vers recités à Messeigneurs les Etats Généraux des Provinces Unies par Mlle. Van Mons," *Pamfletten*, Rijksuniversiteit Gent, Ghent; "Compliment adressé aux Etats due Brabant à l'occasion de remise de deux canons par Cecile Niçoise, au nom des dames et demoiselles de la Monnoye, Grand Marché, Marché aux Poulets et ses environs à Bruxelles," *Pamfletten*, Rijksuniversiteit, Ghent; and "Description du Cortège qui a accompagné le canon, donné par les dames de la Montagne du Congrès et bonnes voisines," *Ecrits politiques* 58:203–9, Archives Générales du Royaume, Brussels.

40. "Les femmes belges," Archives de la Ville, Brussels.

41. Ibid.

42. Ibid.

43. "Réclamations des citoyennes de Bruxelles tant Démocrates qu'Aristocrates," *Révolution belge*, vol. 97, pamphlet 8, Bibliothèque Royale, Brussels; and "Réclamations des citoyennes de Liège tant Démocrates qu'Aristocrates," *Révolution belge*, vol. 3, pamphlet 33, Bibliothèque Royale, Brussels. For a discussion of these pamphlets, see Etienne Hélin, "Un man-

ifeste féministe Liège en 1790," *Bulletin de la société royale Le vieux Liège* 9 (1976): 77–83.

44. "Réclamations des citoyennes de Bruxelles."

45. Ibid.

46. R. R. Palmer, *The Age of the Democratic Revolution* (Princeton: Princeton University Press, 1959), 1:4.

47. Jan Craeybeckx, "The Brabant Revolution: A Conservative Revolution in a Backward Country?" *Acta Historica Neerlandica* 4 (1970): 62; and J. Polasky, "Revolution, Industrialization, and the Brussels Commercial Bourgeoisie 1780–1793," *Revue belge d'histoire contemporaine* 1–2 (1980): 203–35. See also: H. Coppejans Desmedt, "Economische Opbloei in de Zuidelijke Nederlanden," in *Algemene Geschiedenis der Nederlanden* (Amsterdam, 1955), 8:273–80; J. Van der Wee, *De industriele revolutie in Belgie* (Antwerp, 1972); and R. Devleeshouwer, "Le Consulat et l'Empire: Période de Take-off pour l'économie belge," *Revue d'histoire Moderne et Contemporaine* 42 (1970): 610–19.

48. J. F. Vonck, "Vervolg van staetkundige onderrigtingen voor het Brabantse volk" (Lille 1792), Ms. 20474, Bibliothèque Royale, Brussels.

"The Powers of Husband and Wife Must Be Equal and Separate": The Cercle Social and the Rights of Women, 1790–91

Gary Kates

On a Friday evening in December, 1790, the four thousand members of the Cercle Social's Confédération des Amis de la Vérité witnessed an unprecedented event in the activities of Parisian revolutionary clubs: a woman—the Dutch baroness Etta Palm d'Aelders—delivered a major speech to the group. Until the autumn of 1790 women did not usually participate in revolutionary clubs. For example, the Jacobins, the Cordeliers, and the Monarchiens did not grant membership to women on a regular basis. When the Cercle Social founded its Confédération des Amis de la Vérité in October, 1790, it became the first club to formally admit women as members. While it is impossible to estimate the number of female members, it is clear that by December the Confédération had become one of the largest and most progressive clubs in Paris.[1]

In her speech, Palm d'Aelders urged the leaders of the Revolution to apply to women the values articulated in the Declaration of the Rights of Man and of the Citizen: if each individual has rights, what prevents a woman from exercising them on an equal footing with a man? Palm d'Aelders recognized that granting women their full rights would require something more than a political revolution. First, there would have to be a transformation in customs, habits, and morals among French men and women in order to "regenerate *les moeurs*."[2]

During the 1970s historians generally described Palm d'Aelders' ideas in comparison with other pioneering feminists, such as Olympe de Gouges and Pauline Léon, though the extent to which they knew one another—much less acted together—is still not clear. But for Etta Palm d'Aelders, at least, this stress on the content of her work rather

163

than on her political behavior has minimized the role played by political groups such as the Cercle Social. Because the National Assembly rarely discussed female emancipation, and never granted women the right to vote, historians tended to view the campaign for female civic rights as a failure, "the preserve of crackpots," lying only on the periphery of the Revolution's main concerns. "A minority movement," French Revolutionary feminism was seen as politically isolated, noteworthy primarily because it foreshadows late nineteenth-century suffragette movements and helps reveal misogynist tendencies of male French revolutionaries.[3]

But recent work by Darline Levy, Harriet Applewhite, Joan Landes, Dominique Godineau, and others has demonstrated that the women's rights movement was not the preserve of extremists.[4] It is a mistake to treat early feminists like Etta Palm d'Aelders in isolation when their speeches and writings reached thousands of influential activists. Before this movement for women's rights is dismissed as a failure, historians should investigate what links it to other ideological and political dimensions of the French Revolution. It is in this sense that the Cercle Social's role in the women's rights movement becomes important. Through their club and publishing company, the Cercle Social disseminated the works of Etta Palm d'Aelders and other feminists, such as Condorcet, and was a meeting place for large numbers of women activists, such as Madame Roland. Although a male-led group, the Cercle Social lobbied for ways to bring about sexual equality in the new political order. Hardly peripheral figures, the leaders of the Cercle Social included several prominent Paris journalists and politicians. The Cercle Social became one of the most important centers where an embryonic campaign for women's rights was launched during the early years of the French Revolution.

Cercle Social feminism has been ignored largely because the Cercle Social itself has been misunderstood. Since at least the 1830s, when Buchez and Roux devoted more than twenty pages to the group in their monumental *Histoire parlementaire de la Révolution française*, historians have described the Cercle Social as a group of mystical and abstract thinkers who had close ties to European Freemasonry, but who had little connection with the political realities of revolutionary Paris.[5]

This description is somewhat accurate. There is no doubt that the Cercle Social was at the forefront of a movement whose adherents hoped to transcend the limits of a political revolution and transform

French society and culture itself. In its influential writings, the Cercle Social developed proposals for establishing public education, reorganizing the Catholic Church, restructuring the press and the intelligentsia, distributing land and wealth more equitably, and establishing popular clubs throughout Europe to spread the new gospel. The movement to gain rights for women must be seen as part of this cultural revolution, a revolution in *moeurs,* as Etta Palm d'Aelders called it.[6] In this sense the Cercle Social reflected the mood of the very early years of the Revolution, when political activists and writers believed that the unprecedented events of the spring and summer of 1789 heralded an entirely new epoch for the world. "Here we are," declared one president of the Cercle Social at a meeting in December, 1790,

> all new seeds which will decorate the earth and procure for it a never-ending stream of the most sacred, virtuous, and sublime truths. This is the way that the entire world will be transformed into one great city by the principal generators of the *patrie.*[7]

But if the rhetoric of the Cercle Social was utopian, its leading members were anything but "the preserve of crackpots." The Cercle Social began not as some mystical society, but as a group of shrewd Paris politicians who sought to extend their influence in municipal and national affairs. Its main activists included Nicolas Bonneville, Claude Fauchet, Jacques-Pierre Brissot, Jacques Godard, François Lanthenas, Henri Bancal, Jean-Philippe Garran-Coulon, and Condorcet. At the beginning of 1790 they came together in the Paris Communal Assembly to start a small club and newspaper (*Cercle Social*) that became the embryo of a loosely organized political faction whose members advocated a democratic constitution for the municipality. They were soundly defeated in the municipal elections of August, 1790, and six weeks later they reconstituted their group as a public club, the Confédération des Amis de la Vérité. Attracting crowds well into the thousands, it immediately became one of the most popular clubs in France. When Manon and Jean-Marie Roland moved to Paris during the spring of 1791, they regularly attended its meetings.

The Confédération met weekly at the Palais Royal until July, 1791, when it was suppressed by the Paris authorities following the Massacre on the Champ de Mars. Between July, 1791, and June, 1793, the same people who had been active in the Cercle Social emerged on the national scene as the core of the Girondins, and the Cercle Social's publishing company, the Imprimerie du Cercle Social,

became the largest and most effective center for Girondin propaganda. The Cercle Social and the Girondins thus became linked, and the Cercle Social finally came to an end when the Girondins were overthrown in June, 1793.

The Cercle Social's vision of a democratic France included women. We usually think of the suffrage question as the primary criterion for determining the extent of commitment to women's rights before the mid-twentieth century. But Cercle Social writings and the minutes of Cercle Social meetings reveal that the suffrage question is at best an incomplete measure of commitment to improving the status of women. To be sure, there were a few activists in the Cercle Social who believed that women should have the vote and the right to run for political office. But Cercle Social feminists also discovered more immediate ways to integrate women into the new social order on a more egalitarian basis. Specifically, they called upon the new government to pass a liberal divorce law and major reforms in inheritance law that would assure a woman's freedom and independence. In their eyes a French revolutionary feminist was someone who believed that women could obtain civic equality only when they had attained an equal right to dissolve an unhappy marriage and an equal right to own and inherit property.

In an early issue of the journal *Cercle Social*, a woman from Marseilles named Seline wrote that the best way to improve the status of women was by lobbying for the legalization of divorce. She told the Cercle Social about her own marriage. For ten years her relationship with her husband had been loving and fulfilling. But slowly they grew apart. He became cold and distant, and the relationship deteriorated into a formal and unhappy union, without affection. She began to suspect him of having affairs with other women. Legally and financially dependent upon a husband who no longer cared for her, Seline felt trapped and embittered by her situation. A divorce law, she believed, would help her and other women in similar situations to regain "our liberty and our happiness."[8]

Letters like this one were raised to a theoretical level by the Cercle Social's founder and chief editor, Nicolas Bonneville. "I will prove," he claimed, "that the indissolubility of marriage is contrary to good politics . . . [and that it] is very harmful and even deadly to society." Bonneville's argument stressed the reasons that nations legalized conjugal unions in the first place. He claimed that marriage was simply the most practical way that civilized societies made sure that fathers carried out their paternal duties. The identity of a mother

is obvious to the community; marriage made the father's identity equally obvious. This was in the state's interest, because "without family ties demarcating clear lines of inheritance as precisely as possible, there would be no way to bind people to each other." For Bonneville, marriage was not a sacrament, but simply a device for holding fathers accountable to their children. But if husband and wife were no longer having sexual relations, Bonneville saw no reason that they should not be permitted to divorce. In Bonneville's view, forcing a couple to remain married after their relationship had deteriorated was in the interests of neither the couple nor the state.[9]

Cercle Social writers were neither the first nor the only advocates of matrimonial reform during the early years of the Revolution. The call for legalization of divorce came from many groups.[10] But the centrality of divorce in Cercle Social ideology is connected to the group's view of divorce as primarily a feminist issue. They argued that without divorce, wives were forced into a life-long dependence upon husbands, trapped in a kind of bondage in which escape was at least legally impossible. This meant that marriages without the possiblity of divorce robbed women of their natural right to freedom. "Will you make slaves of those who have zealously contributed to making you free," Etta Palm d'Aelders rhetorically asked the members of the Constituent Assembly in a Cercle Social pamphlet,

> No. No. . . . The powers of husband and wife must be equal and separate. The laws cannot establish any difference between these two authorities; they must give equal protection to, and maintain a perpetual balance between, the two married people.[11]

The state should view marriage as a civic and contractual arrangement. A liberal divorce law was seen as a prerequisite for developing women into dignified citizens. In short, the Cercle Social interpreted divorce as a feminist issue because it believed that its ultimate goal of female political equality first required wives to become free and independent.

Recent research by social historians has underscored the importance of divorce for the women who lived during the French Revolution. Roderick Phillips, for example, studied those couples who made use of divorce when it became legal in 1792. His findings indicate that women petitioned for divorce more than two-and-a-half times as frequently as men; more important, the most common reason women cited for divorce was wife-beating.[12] This lends credence

to the Cercle Social view that divorce was a feminist issue. In this case Cercle Social writers were not engaging simply in utopian rhetoric, but they were responding to the grim realities of eighteenth-century marriage.

A second major theme in Cercle Social feminism was the call for an end to primogeniture and the passage of inheritance law reform that would divide property equally between all children, regardless of age or sex. During the early days of the Revolution the campaign for these reforms was led by one of the most important Cercle Social publicists, the future Girondin Conventionnel, François Lanthenas. In 1789 Lanthenas published a comprehensive book attacking primogeniture, which was highly praised in the revolutionary press. The book's thesis was that primogeniture led to a growing cleavage between rich and poor, which fueled social inequality. The result was the opposite of what Rousseau had advocated: instead of an egalitarian society in which everyone had moderate assets, primogeniture gave everything to one member of the family and nothing to his siblings.[13] By encouraging inequality, Lanthenas believed that primogeniture had wrecked the economy of the Old Regime and had undermined the stability of the family. "Our inheritance law," he wrote, "was born from the corruption of the feudal system, and it was the nourishment rather than the cure for the anarchy which followed."[14]

Despite its obvious relevance to women, there was nothing in Lanthenas's book that specifically made inheritance law reform a woman's issue. That link was explicitly made in a lengthy review of the book published in the *Courrier de Lyon* immediately after the book had appeared. After praising the work and urging readers to study its ideas, the reviewer noted that women had the most to gain from Lanthenas's proposals: "One of the most harmful effects of primogeniture is that it regularly exposes a mother of a family to the contempt and vexations of her husband and the sons preferred by him."[15] Where Lanthenas emphasized the effects primogeniture had had upon French society, the reviewer noted how its evils began by destroying the natural affection among members of a family and imposing a harmful kind of inequality that transformed the family into a microcosmic despotism. Although this review was anonymous, it was very likely written by Madame Roland. She was close friends with both Lanthenas's and Courrier's editor, Champagneux, and had already taken a great interest in inheritance law reform.[16]

At the beginning of 1790, Lanthenas, Henri Bancal, and future

Girondin chief Jacques-Pierre Brissot all helped to found the Société de 89. But when it became clear that their ideas were too radical for the other members of this fairly moderate political club, they deserted it, and in the summer of 1790, Lanthenas founded the Société des Amis de l'Union et de l'Egalité dans les Familles, specifically to lobby for more democratic inheritance laws. The club included many members of the Cercle Social, such as Brissot, Bancal, Bonneville, and the well-known writer Louis-Sebastien Mercier. In August, 1790, Lanthenas spoke on behalf of the Société des Amis de l'Union et de l'Egalité dans les Familles to the National Assembly. He attacked primogeniture as an example of feudal exploitation of the poor. In its place he asked "that equality of distribution among children be reestablished by a constitutional decree."[17]

After his address to the National Assembly, Lanthenas returned to Lyon for several months, and the Société des Amis de l'Union et de l'Egalité dans les Familles was absorbed into the Cercle Social's new club, the Confédération des Amis de la Vérité. In one of the first issues of the club's newspaper, the *Bouche de fer,* an author identified as a woman from Lyon approached primogeniture in an autobiographical fashion:

> I am a woman and a victim of this arbitrary law. [I was] born into an arrogant system that permitted unequal division . . . between children whom nature had given the same rights; a system that facilitated the acquisition of immense wealth in . . . a state that rewarded neither virtue nor talent, and in which ignorance and hypocrisy seemed to be given special prerogatives.[18]

She went on to describe how her younger brother, a man with enormous talents and virtues, was forced into a career in the church, while the eldest sibling allowed his wife to squander the family fortune until they were badly in debt. She reiterated her belief that the Old Regime thus rewarded laziness and discriminated against merit, and she called on the new government to enact an inheritance law that would give "brothers and sisters equal portions of their father's estate."[19]

Again, internal evidence indicates that the author of this article was Madame Roland. Certainly her closest friends were among the club's founders, and when she and her husband moved from Lyon to Paris in 1791, they regularly attended its meetings. This may seem odd considering Madame Roland's reputation as an antifeminist. "She was following," one biographer recently wrote, "uncritically and

FIG. 1. Madame Roland, from an engraving by François Bonneville
(Bibliothèque Nationale, Paris)., One of the most remarkable activists of the
French Revolution, Marie-Jeanne Phlipon worked through her older and
austere husband, Jean-Marie Roland, to hold together the Girondins, a
political faction that dominated French politics between 1791 and 1793.

perhaps unwittingly, Rousseau's own brand of anti-feminism."[20] But
this dismissal of Madame Roland's views is unfair. What unites her to
Etta Palm d'Aelders is the determination to change the status of wom-
en in areas like primogeniture and divorce.

Madame Roland's attitude toward female participation in politics
is complex, but best illustrated in a letter of April 5, 1791, to Henri
Bancal, where she discussed why women should not take a leading
role in the Cercle Social.

> As to the Cercle Social, I could not spend two days without there
> being some sort of letter that would concern you and it. I have

written to it, in another circumstance, without ever naming myself, because I do not think that our *moeurs* yet allow women to show themselves. They must inspire and nourish goodness, and enflame all patriotic feelings for the country, but not appear active in the world of politics. They cannot participate openly until all Frenchmen merit the name of free men. Until then, our superstitions, our bad *moeurs* may seem ridiculous to those women who would make something of themselves, and in so doing, annihilate any advantage which, otherwise, they might be able to get.[21]

One can see in this rich passage that at the very least Madame Roland was concerned about the role that women played in the new regime. And while she realized that women could not be effective politicians at this time in France, she looked forward to a day when women would participate with men in political affairs. But that day would come only after a cultural revolution, when the "bad *moeurs*" of Frenchmen were changed. What France needed immediately, therefore, was new legislation in areas like divorce law and inheritance law that could help bring about this kind of regeneration. Serious discussion of suffrage and direct political participation for women would be appropriate only after women had reached parity with men within the family.

Like Madame Roland, even Etta Palm d'Aelders, the Cercle Social's best-known feminist, understood that women's suffrage was not the first goal of a French Revolutionary feminist. In her first speech to the Confédération des Amis de la Vérité, where she spoke about rights for women, she was predominantly concerned with overcoming domestic violence. "Be just toward us, Messieurs," she began. "Nature created you with superior physical strengths."[22] She argued that the inherent physical weakness of women required laws that protected them against their stronger fathers and husbands. But the oppressive laws of the Old Regime had only exploited their frailty, burdening them with an "inferior existence in society" that "often has forced us into the humiliating situation of being rudely conquered by man's ferocious character." A few months later, Palm d'Aelders described the condition of women during the Old Regime: "Deprived of a civil existence, subjected to the arbitrary will of their companions . . . daughters at the will of their parents, wives at the whim of their husbands, women vegetated in a kind of slavery."[23] The way to correct this deplorable situation was for the new regime to transform the family into a compassionate, egalitarian unit. "We are your compan-

ions and not your slaves," Palm d'Aelders declared in supporting matrimonial and inheritance law reform.[24]

Of course, there were some Cercle Social feminists who went on to argue that women should also participate in the new political institutions on an equal footing with men. In his essay "On the Admission of Women to the Rights of Citizenship," Condorcet may have been the first French revolutionary to call for female political equality. While he admitted that "women are superior to men in the gentle and domestic virtues," he claimed that this was no reason to exclude them from political participation. Men had political rights because they had been endowed with the capacity "of acquiring moral ideas and of reasoning concerning those ideas." Because women were also endowed with these abilities, "either no individual of the human race has any true rights or all have the same." Condorcet urged the National Assembly to rise above its prejudices and grant women the same political rights as men.[25]

Condorcet's article was first published during the summer of 1790 in the journal of the Société de 89. When it collapsed Condorcet became an officer of the Cercle Social, and his call for women's rights was echoed throughout the club. "Woman, be a Citoyenne! Until now you have only been a mother," cried club member Charles-Louis Rousseau, who argued that any system of primary national education depended upon raising the status of women. A similar point was also made by another club member and a close friend of Jean-Marie Roland, the former classics professor Athanase Auger, who called upon the National Assembly to establish elementary schools for women, which would be "absolutely the same as those for men. We will teach them in the same school and in the same manner."[26]

The Cercle Social's commitment to the rights of women was demonstrated most explicitly in March, 1791, when the club established an exclusively female section, the Confédération des Amies de la Vérité. This group was to have three functions. First, it would devise "a way to prove that they [women] are deserving of justice"; that is, it would lobby for the elimination of primogeniture, protection against wife-beating, a liberal divorce law, and other forms of civic equality for women. Second, it would "be charged to supervise the establishment of nurseries" for the children of young women from the countryside who often found themselves pregnant and desperate in Paris. Finally, the female Confédération would also establish free medical clinics for these women and try to find work for them.[27]

The Confédération des Amies de la Vérité is the only known

example in the French Revolution of a male-led club establishing a female section in order to further the rights of women. The Cercle Social allowed the female group to use its headquarters (#4, rue du Théâtre Français) for its meeting place. More important, the Cercle Social allowed the new group full access to its presses. Feminist ideas, club announcements, and minutes of its meetings were featured in the club's journal, the *Bouche de fer*.

The first meeting of the female Confédération, held on March 25, 1791, took on the aura of a celebration, since the Constituent Assembly had just passed a bill abolishing primogeniture. "We express our gratitude," declared one member, "for the decree which allows women to an equal share of estates." In contrast to the more formal style of the male group, a twelve-year-old boy (a member's son) was allowed to give a speech on the National Assembly's new law. "I have always shared with my brothers and sisters," he announced, "and I am glad that the National Assembly has made this so for the whole world." The new club unanimously elected Etta Palm d'Aelders its first president, and the Cercle Social sent a male delegation that called upon all feminists "to rectify, by their personal sacrifices, the cruel inequalities that creep into the best governments."[28]

After this first meeting, the Confédération des Amies de la Vérité developed an organizational structure and launched a membership drive. Any woman could become a member of the group by contributing three *livres* per month, a prohibitive sum for all but those women from the comfortable classes. Clearly, with a focus upon inheritance law reform and a stiff dues structure, Palm d'Aelders' Confédération des Amies de la Vérité was aimed exclusively at bourgeois women. Throughout the spring of 1791 charter members wrote letters to their friends and acquaintances inviting them to join the club. These letters provide further evidence that the women's club was composed of wealthy women who felt a deep sense of *noblesse oblige* toward their downtrodden sisters.[29] Announcements were also sent to several journalists, but radical Cordelier publicists like Desmoulins and Prudhomme were not sympathetic. Only Brissot consented to publicize the new organization in his popular newspaper, *Le Patriote français*.[30] To what extent this membership drive was successful is difficult to determine. Nonetheless a few provincial towns like Creil, Alais, and Bordeaux followed Palm d'Aelders' lead and organized their own female clubs.[31]

Thus during the spring of 1791 the Confédération des Amies de

la Vérité was both a charitable organization run by wealthy women to aid their indigent sisters, and a political club that lobbied for female equality and liberty. For the first few months political activities were subordinate to the club's charitable functions. But during the summer of 1791 the group was drawn into direct criticism of the Constituent Assembly when its Constitutional Committee recommended a bill stipulating that "the charge of adultery can be pursued only by the husband" and further stipulating that if a woman was convicted of adultery, her husband would gain control of her dowry "no matter what clauses are contained in the marriage ceremony."[32]

In response, Etta Palm d'Aelders wrote a highly charged polemic against the bill on behalf of the Cercle Social. She lashed out at the Constitutional Committee for surpassing "the most unjust thing done in barbarous centuries; this is a refinement of despotism." She warned the Constituent Assembly that the constitution it was writing would be meaningless unless it assured freedom and civic equality to all women.[33]

When Louis XVI signaled his aversion to the Revolution by his flight to Varennes in June, 1791, the Cercle Social helped galvanize the movement for a democratic republic, which threw the capital into a period of militant political activity for several weeks. The government expressed its hatred for democracy when it shot at crowds of peaceful demonstrators during the massacre on the Champ de Mars. There followed a more general repression of radical activists. On July 19, Etta Palm d'Aelders was arrested for her subversive political behavior. The club's newspaper interpreted this act as an attempt by the government to intimidate the entire Cercle Social.[34] If this was the government's intention, the move succeeded. Within days Bonneville announced the closing of the Confédération des Amis de la Vérité, and Palm d'Aelders' Confédération des Amies de la Vérité also seems to have closed at this time.[35]

The Cercle Social's emphasis on divorce and inheritance law reform demonstrates the intimate connection it saw between politics and the family. This was hardly new. One of the cornerstones of early modern political thought was its insistence on the family as the primary, natural, social institution. A well-ordered society should have the same values regulating social relations both in public and in domestic institutions. During the seventeenth century this kind of formula had been used by patriarchal theorists such as Robert Filmer, who tried

to justify patriarchal authority as a model for both monarchy and family.[36]

Cercle Social members' concern for women's rights constituted a repudiation of this extreme version of patriarchal authority. Cercle Social feminists believed that egalitarian families must be the only basis for democratic political institutions. In their view, if France was to become a democratic republic, the new regime had to be nurtured and fostered by a family that was itself a microcosmic democratic republic: egalitarian, affective, voluntary, and consensual. They believed that this kind of a family was a prerequisite to founding viable democratic political institutions. Divorce and inheritance law reform were important steps toward this end.

Lawrence Stone has suggested that the early modern family developed from a patriarchal model to one based on "affective individualism"; that is, from a hierarchical and authoritarian arrangement in which the husband ruled his family like a king, to a more egalitarian family where love formed the basis of conjugal and parental relationships.[37] Cercle Social ideology fits well into Stone's model. In one early Cercle Social journal, for example, an "amie des enfants" wrote "to the good mother of the Cercle Social" advocating progressive ways of child rearing, popularizing many of the ideas found in Rousseau's *Emile*. Later, in 1792, Bonneville proposed a law requiring spouses to vow to remain friends as well as husband and wife during the marriage ceremony.[38]

> . . . the marriage will be contracted by a declaration made in a loud voice, in these terms:
>
> I declare, as a free man and as a good citizen, to take _____ for my friend and my wife.
>
> I declare, as a free woman and as a good citizen, to take ____ for my friend and husband.

Cercle Social thinkers believed that love served the same function in the family that virtue served in civil society, an idea they may have acquired from Rousseau's *Discourse on the Origin of Inequality*.

In several important respects, Cercle Social members saw themselves as disciples of Rousseau. Like other French revolutionaries, they were under the spell of his ideas. More important, the Confédération des Amis de la Vérité organized its meetings around his *Social Contract*. Each meeting was highlighted by a major speech that took a

chapter from the *Social Contract* for its theme. These speeches stand as the most important commentaries on Rousseau made during the Revolution.[39] Given Rousseau's modern reputation as an antifeminist, it seems paradoxical that the most outspoken feminist group in the Revolution would also include Rousseau's most fervent disciples.[40] However bizarre this stance may seem today, it was indeed the case. While Cercle Social feminists endorsed Rousseau's political and pedagogical notions, they did not address themselves to the great master's attitudes on women. Unlike Mary Wollstonecraft, who sharply criticized Rousseau in her famous *Vindication of the Rights of Woman*, Cercle Social feminists simply ignored Rousseau's attitudes regarding the status of women in civil society. Rather, they learned in their reading of Rousseau that no political revolution would be successful without a corresponding transformation in family life, because the family was where a people's manners, morals, and habits—i. e., *moeurs*—were first nourished.[41]

The Cercle Social's campaign for women's rights was not a prefabricated set of tenets, nor did each member of the organization agree upon any specific party platform. The group's feminist debates evolved without any coherent political strategy, in reaction to what was happening in the Constituent Assembly and in the streets of Paris. Nonetheless, when the various aspects of Cercle Social feminism are brought together, it becomes clear that the Cercle Social constituted the most significant center for women's rights during the early years of the French Revolution. It welcomed women as regular members, established a separate women's section when Palm d'Aelders and her followers asked for it, published writings that attacked patriarchy, and provided an arena in which members of a reforming elite, such as Condorcet, Brissot, Palm d'Aelders, and the Rolands, could meet together in an atmosphere charged with remarkable optimism.

Of course, wives did not become equal with their husbands during the French Revolution, and they still have far to go. But the significance of the Cercle Social is not that it failed, but rather that it existed at all. The early years of the French Revolution, between the taking of the Bastille and the Massacre on the Champ de Mars (July, 1789–July, 1791) constituted an extraordinary period when, for a brief moment, ambitious politicians and news-hungry journalists saw that a new world was imminent. In their view, the French Revolution

would somehow transform everything it touched, and within a few years, nothing would be left of the Ancien Regime.

Nevertheless, many of these Cercle Social leaders failed to push their feminist agenda when they later emerged as Girondin deputies in the Legislative Assembly and Convention. More research on the Girondins' gender politics is needed before we can reach any definitive conclusions about their attitudes toward women's rights during this later period. But it seems fairly clear that from the spring of 1792 the Girondins were overwhelmed with more pressing issues of survival. A treasonous monarchy, a recalcitrant church, colonial revolt, currency instability, serious grain shortages, and especially a disastrous war meant that the Girondins became much more politically myopic. In the process their campaign for women's rights was postponed indefinitely.

Notes

Research for this article was supported by a Trinity University Faculty Development Committee Summer Stipend. I wish to thank Judi Lipsett, John Martin, Char Miller, Sharon Farmer, Paula Cooey, Elaine Kruse, Darline Gay Levy, and Harriet Applewhite for their helpful criticism. Some of the material in this article is drawn from my book, *The Cercle Social, the Girondins, and the French Revolution* (Princeton: Princeton University Press, 1985).

1. *Mercure national et Révolutions de l'Europe,* November 2, 1790, 1273–80; Isabelle Bourdin, *Les Sociétés populaires à Paris pendant la Révolution* (Paris: Recueil Sirely, 1937).

2. *Bouche de fer* (hereafter cited as *Bdf*), January 3, 1791, 4–11; reprinted in Etta Palm d'Aelders, *Appel aux françoises sur la régénération des moeurs et la nécessité de l'influence des femmes dans un gouvernement libre* (Paris: Imprimerie du Cercle Social, 1791), 1–9.

3. The phrases quoted are from Jane Abray, "Feminism in the French Revolution," *American Historical Review* 80 (1975): 62. See also Paule Marie Duhet, *Les Femmes et la Révolution, 1789–1794* (Paris: Gallimard, 1971); Lenora Cohen Rosenfield, "The Rights of Women in the French Revolution," *Studies in Eighteenth-Century Culture* 7 (1976): 117–37; R. B. Rose, "Women in the French Revolution: The Political Activity of Parisian Women 1789–1794," *University of Tasmania Occasional Papers,* no. 5 (1976). The first serious article on this topic was A. Aulard, "Le Féminisme pendant la Révolution française," *Revue bleue* 9 (1898): 361–66.

4. Darline Gay Levy and Harriet Branson Applewhite, "Women and Political Revolution in Paris," in *Becoming Visible: Women in European History,*

2d ed., ed. Renate Bridenthal, Claudia Koonz, and Susan Stuard (Boston: Houghton Mifflin Co., 1987), 279–306; Joan Landes, *Women and the Public Sphere in the Age of the French Revolution* (Ithaca: Cornell University Press, 1988); and Dominique Godineau, *Citoyennes Tricoteuses: Les Femmes du peuple à Paris pendant la Révolution française* (Paris: Alinea, 1988).

5. J. B. Buchez and P. L. Roux, *Histoire parlementaire de la Révolution française . . .* , 40 vols. (Paris: Paulin, 1834–38), 7:447–67.

6. On the importance of *moeurs* during the eighteenth century, see Jean-Jacques Rousseau, *Politics and the Arts: Letter to M. d'Alembert on the Theatre*, trans. Allan Bloom (Ithaca: Cornell University Press, 1960).

7. *Bdf*, no. 34 (December, 1790): 532.

8. *Cercle Social*, letter 11, 107–12.

9. Ibid., letter 60, 424–30, and letter 66, 465–77.

10. Dominique Dessertine, *Divorcer à Lyon sous la Révolution et l'Empire* (Lyon: Presse universitaire de Lyon, 1982), 33–35.

11. Cited in Darline Gay Levy, Harriet B. Applewhite, and Mary D. Johnson, eds., *Women in Revolutionary Paris, 1789–1795* (Urbana: University of Illinois Press, 1979), 76; originally published in Palm d'Aelders, *Appel*, 37–40.

12. Roderick Phillips, *Family Breakdown in Late Eighteenth-Century France: Divorces in Rouen, 1792–1803* (Oxford: Oxford University Press, 1982), 108–24. See also Dessertine, *Divorcer à Lyon*, 159–74; and Elaine Marie Kruse, "Divorce in Paris, 1792–1804: Window of a Society In Crisis" (Ph. D. diss., University of Iowa, 1984).

13. François Lanthenas, *Inconvéniens du droit d'aînesse . . .* (Paris: Visse, [1789]), reviewed in *Journal d'état et du citoyen*, September 17, 1789, 120, *Chronique de Paris*, October 14, 1789, 205, and *Patriote français*, August 20, 1789, 4, and November 3, 1789, 41; Claude Perroud, "A Propos de l'abolition du droit d'aînesse," *Révolution français* 54 (1908): 193–202.

14. Lanthenas, *Inconvéniens*, 116. Many of Lanthenas's ideas came from his friend and Cercle Social member Garran-Coulon's scholarly research published during the 1780s (see "Parage," *Encyclopédie méthodique. Jurisprudence . . .* , 10 vols. [Paris: Panckoucke, 1782–91], 6 [1786]: 365–73). Garran found that despite its biblical origins primogeniture was a relatively late phenomenon in the development of feudal law and was introduced only in the eleventh and twelfth centuries. Garran further argued that primogeniture was imposed by wealthy landowners who hoped to keep their estates united after their deaths. Such research gave Lanthenas and his friends the ammunition to argue that primogeniture demonstrated the despotism of the French aristocracy. For an overview of these issues in revolutionary France see André Dejace, *Les règles de la dévolution successorale sous la Révolution (1789–1794)* (Paris: n. p., 1957).

15. *Courrier de Lyon*, October 14, 1789, 313–16, and October 15, 1789, 320–24.

16. Gita May, *Madame Roland and the Age of Revolution* (New York: Colum-

bia University Press, 1970), 123–24; *Lettres de Madame Roland,* vol. 2, ed. Claude Perroud (Paris: Bibliothèque Nationale, 1902).

17. "Adresse de Lanthenas, Président de la Société des amis de l'union et d'égalité dans les familles," in *Recueil de documents sur l'abolition du régime seigneurial,* ed. P. Sagnac and Pierre Caron (Paris: Imprimerie Nationale, 1907), 643–45; Perroud, "A Propos de l'abolition du droit d'aînesse."

18. "Sur les successions," *Bdf,* no. 6 (October, 1790): 90–92; see also no. 16 (November, 1790): 250.

19. *Bdf,* no. 6 (October, 1790): 92.

20. May, *Madame Roland,* 115–17; Abray, "Feminism," 60.

21. *Lettres de Madame Roland* 2:258.

22. *Bdf,* January 3, 1791, 6. The following quote also comes from this page.

23. Palm d'Aelders, *Appel,* 41–42.

24. *Bdf,* January 3, 1791, 7.

25. Condorcet, *Selected Writings,* ed. Keith Michael Baker (Indianapolis: Bobbs Merrill, 1976), 97–104.

26. *Bdf,* no. 2 (November, 1790): 306–15, and January 6, 1791, 31; Charles-Louis Rousseau, *Essai sur l'éducation et l'existence civile des femmes* (Paris: Girouard, 1790); Athanase Auger, ed., *Organisation des écoles nationales* (Paris: Imprimerie National, 1791), 39.

27. *Bdf,* March 23, 1791, 539–43. See also *Prospectus pour le Cercle patriotique des Amies de la Vérité* (Paris: Imprimerie du Cercle Social, 1791). On indigent women in Paris see Olwen Hufton, "Women in the French Revolution," *Past and Present* 53 (1971): 90–108.

28. *Bdf,* March 29, 1791, 570–75. On Madame Roland's interest in the new bill see *Lettres de Madame Roland* 2:217. This bill was actually more limited and conservative than is apparent from these Cercle Social documents. For an analysis of how the new law affected one southern French town, see Margaret H. Darrow, "French Families and the Revolution in Inheritance Law: Montauban, 1775–1825" (Ph. D. diss., Rutgers University, 1981), particularly p. 28.

29. Bibliothèque historique de la ville de Paris, Ms. 777, nos. 72–75.

30. Ibid.; *Patriote français,* May 2, 1791, 477.

31. *Bdf,* March 23, 1791, 539.

32. *Women in Revolutionary Paris,* 76n.

33. This speech is reproduced in ibid., 75–77, and was originally printed in Palm d'Aelders, *Appel,* 37–40. Palm d'Aelders' reaction to this bill was part of a more general criticism of the Constituent Assembly that swept the Cercle Social between May and July, 1791. Until the spring of 1791, Cercle Social leaders sincerely believed that the Constituent Assembly would formulate a constitution providing for an egalitarian, free, and democratic society. But during the spring of 1791 radicals like Bonneville and Brissot became convinced that the Assembly wanted to establish a constitutional monarchy that was liberal but antidemocratic. Madame Roland "has been to the National

Assembly," Lanthenas wrote about his close friend. "She has become convinced that liberty and the constitution will not belong to, and actually do not belong to those, who have given the most to the Revolution." (*Lettres de Madame Roland* 2:240).

34. *Bdf*, July 25, 1791, 4–5.

35. *Bdf*, July 28, 1791, 6–8.

36. Gordon Schochet, *Patriarchalism and Political Thought* (New York: Basic Books, 1975); Jean Bethke Elshtain, ed., *The Family in Political Thought* (Amherst: University of Massachusetts Press, 1982). For France see Robert Muchembled, *Popular Culture and Elite Culture in France 1400–1750*, trans. Lydia Cochrane (Baton Rouge: Louisiana State University Press, 1985), 227–30; and Jeffrey Merrick, "Royal Bees: The Gender Politics of the Beehive in Early Modern Europe," *Studies in Eighteenth-Century Culture* 18 (1988): 7–37.

37. Lawrence Stone, *The Family, Sex, and Marriage in England, 1500–1800* (New York: Harper and Row, 1977).

38. *Cercle Social,* letter 23, 149–55; Nicolas Bonneville, *Le Nouveau code conjugal* (Paris: Imprimerie de Cercle Social, 1792), 31–32.

39. Roger Barny, "Jean-Jacques Rousseau dans la Révolution," *Dix-Huitième siècle* 6 (1974): 59–98.

40. Victor G. Wexler, "Made for Man's Delight: Rousseau as Anti-Feminist," *American Historical Review* 81 (1976): 266–91; Ruth Graham, "Rousseau's Sexism Revolutionized," in *Women in the Eighteenth Century and Other Essays*, ed. Paul Fritz and Richard Morton (Toronto: University of Toronto Press, 1976); Carol Blum, *Rousseau and the Republic of Virtue: The Language of Politics in the French Revolution* (Ithaca: Cornell University Press, 1986), 204–15; Joel Schwartz, *The Sexual Politics of Jean-Jacques Rousseau* (Chicago: University of Chicago Press, 1984).

41. Richard Brooks, "Rousseau's Antifeminism in the *Lettre à d'Alembert* and *Emile*," in *Literature and History in the Age of Ideas*, ed. Charles G. S. Williams (Columbus: Ohio State University Press, 1975).

The Women of Boston: "Persons of Consequence" in the Making of the American Revolution, 1765–76

Alfred F. Young

On March 31, 1776, three months before the Continental Congress adopted the Declaration of Independence, Abigail Adams, writing from the family farm she was managing in Braintree, Massachusetts, to her husband, John, a delegate to the Congress in Philadelphia, closed her long report on local affairs with a comment that has won a deserved notoriety as the opening manifesto of American feminism. "I long to hear that you have declared an independency—and by the way in the new Code of Laws which I suppose it will be necessary for you to make I desire you would Remember the Ladies, and be more generous and favourable to them than your ancestors. Do not put such unlimited power into the hands of the Husbands. Remember all Men would be tyrants if they could." Half-joking, as if to cushion the radical thrust of her demands, she added, "If perticular care and attention is not paid to the Ladies we are determined to foment a Rebelion, and will not hold ourselves bound by any Laws in which we have no voice or Representation."[1]

In a prompt reply, John Adams put down his wife. "As to your extraordinary Code of Laws, I cannot but laugh"—and he immediately made clear that the "Spirit of '76" included an upsurge of insubordination he was determined to suppress as much as it included a sentiment for independence he welcomed. "We have been told that our Struggle has loosened the bands of Government every where. That Children and Apprentices were disobedient—that schools and Colledges were grown turbulent—that Indians slighted their Guardians and Negroes grew insolent to their Masters. But your Letter was the first intimation that another Tribe more numerous and powerfull than all the rest were grown discontented."[2]

Abigail was serious enough about her proposal to turn for support to her friend Mercy Otis Warren, who had already won eminence for her public writings in the patriot cause. Petulant because John "is very sausy to me in return for a List of Female Grievances," she thought "I will get you to join me in a petition to Congress," thus defining the form that "fomenting a Rebelion" would take. Summarizing her letter and his reply, she clearly thought of her action as speaking for more than herself: "So I have help'd the Sex abundantly."[3]

A week later she closed the issue with John for the time being. "I cannot say I think you very generous to the Ladies for whilst you are proclaiming peace and good will to Men, Emancipating all Nations, you insist upon retaining an absolute power over Wives." She had lost, but she issued a defiant warning, "Arbitrary power is like most other things which are very hard, very liable to be broken." Then she retreated, falling back on the perennial male claim for ultimate female power: "notwithstanding all your wise Laws and Maxims, we have it in our power not only to free ourselves but to subdue our Masters, and without violence throw both your natural and legal authority at our feet—

Charm by accepting, by submitting sway
Yet have our Humour most when we obey.[4]

This was a remarkable exchange, actually the first of several, the implications of which scholars of feminism and the American Revolution have only begun to probe.[5] What prompted so extravagant and passionate a threat? What made Abigail Adams think, even half-seriously, that it was possible in the spring of 1776 to "foment a Rebelion" among women? What activities had women engaged in during the momentous decade since the Stamp Act protests of 1765? What roles had they played? What was the relative importance of these activities? And, finally, had these led, in any way, to a change in women's consciousness? Did others have a "List of Female Grievances"?

To answer these questions, we will focus on the women of Boston from 1765 to 1776, first, because Boston was indisputably one of the most important centers of the political resistance to Britain, and, second, because the activities of the women of Boston are recoverable. The evidence, however fragmentary and frustrating, permits us to track in bold outlines women's activities and to speculate about their consciousness.[6]

Abigail Adams knew Boston well. Since her marriage in 1764, she had lived in Braintree, a town close enough to Boston for her to watch the Battle of Bunker Hill in 1776 from the town's highest hilltop. But she had also lived in Boston for three years, from the spring of 1768 through the spring of 1771, at a time when patriot activity—female as well as male—was at its height. And what she did not know from her own acute observations, she learned from the reports her husband and friends shared with her. John Adams absorbed every nuance of popular activity as he traveled on legal or political business in and out of Boston and through eastern New England.[7]

We direct our attention first to the status and conditions of women in Boston on the eve of the Revolution, second, to the institutions and traditions Bostonians, male and female, drew upon as resources, and third, to the character of the revolutionary movement in Boston. Next we turn to the activities of women within that movement from 1765 through 1775, and finally to the question of consciousness among women, returning to the special moment at which Abigail Adams threatened to "foment a Rebelion" in the spring of 1776.

I

No scholar as yet has attempted to construct a social profile of the women of Boston, but the broad outlines have been suggested by recent analysis of the social structure as a whole, especially by Gary Nash. At this stage in our knowledge this much can be said of the women of Boston at the end of the colonial era: There was a disproportionate number of women compared to other cities; they included a very large number of widows, most of whom were poor; the range of occupations open to women, whether single, widows, or spinsters, was narrow; and women lived in a society in which inequality was the norm and a large proportion of the town was either impoverished or bordered on the brink of poverty.[8]

Women outnumbered men in Boston by 700 or more. In a population of 15,220 counted in 1765, there were 3,612 adult white females and 2,941 males. Among white children under 16, the distribution of males and females was approximately equal—4,109 and 4,010, respectively. The town had a large number of widows: 1,200 in 1742; 1,153 in 1751; perhaps 700 in 1765. All seaport cities had

more widows than inland country towns; a large number of men made their living by the sea and the sea took its toll. But Boston's widows were primarily the heritage of the wars England fought against Spain and France from 1740 to 1763 in which Massachusetts men—and Boston men in particular—did a disproportionate share of the fighting and the dying.[9] Boston was also a magnet for the "strolling poor" of eastern Massachusetts, a good number of whom were single women.[10]

The number of female-headed households in Boston was large, perhaps a fourth, or about 500 of the 2,069 families in the 1765 census. As may be surmised, most of these female heads of household were poor. Of 1,153 widows counted by the tax assessors in 1748, one-half were called "very poor." Of 1,200 widows estimated in 1751, 1,000 were "in low circumstances." Only a fraction of women heads of households were taxpayers. The 1771 tax list, an incomplete list that was the only one to survive, enumerates 186 women out of 2,106 taxpayers, only 9 percent of the total. Data from the wills of probate from 1685 to 1775 examined by Nash point to the same conclusion. Of 2,767 wills, 334 (12.08 percent) were left by widows and 93 (3.365 percent) by spinsters. For the late colonial period, 1775, 53.2 percent of all widows died with less than £50 worth of property, which made them poor; only 2.8 percent held over £400; and another 10.1 percent held from £201 to £400, which made them well-to-do. There were few rich widows in Boston.[11]

How did women make a living—whether they were widows or spinsters who were heads of households, or housewives and daughters in male-headed households of the laboring classes? The range of occupations open to women was narrow. Boston was a seaport and capital city, a commercial entrepôt where prosperity depended on the export-import trade and where wealth lay in ships, wharves, warehouses, inventories, and real estate. Manufacturing was in the artisan stage. The major branches of trade were the maritime trades, building and outfitting ships, the building trades, and trades catering to the local consumer's market. In 1765, moreover, Boston's once prosperous economy had been ailing for over a generation. Alone among the major cities, its population declined in the middle decades of the eighteenth century.[12]

A handful of women were in male trades, but, as elsewhere, only as wives or daughters who had taken over after a husband's or father's death. In those trades that were worked at out of a shop at home, women often were "meet help"—helpmates—to their husbands. But

this clearly was not possible for the wives of men in the maritime or building trades. The newspaper advertisements, which in Philadelphia demonstrate widows succeeding their husbands in a rich variety of crafts, are sparse for Boston.[13] Craftswomen in Boston seem clustered in exclusively female trades, in particular in the needle trades where they worked as seamstresses, mantua makers (i.e., fine clothing), milliners, and glovers. The occupations of spinster and weaver were rare in the cities; unlike their rural counterparts, city women did not normally engage in household production of textiles. Women were numerous in the nurturing professions, working as nurses, midwives, wet nurses, and school mistresses and running "dame" schools in their homes in which preschool boys and girls learned their ABCs. A fairly large number of women sold goods and services. They were shopkeepers, petty retailers who could set up shop in their own homes with small capital and inventories, keepers of inns and taverns licensed by the town, and hucksters who either worked in market stalls or hawked their wares about town. At the bottom of the female occupational ladder were household servants, laundresses, and common laborers. With only 300 female slaves in the town and almost no indentured servants, the largest number of household servants probably were daughters of the poor. Beyond the pale of respectability were prostitutes who grew in number when their regular seafaring and apprentice clientele of the port was swelled by the presence of several regiments of British troops.[14]

A large number of Boston families survived, as Nash points out, only by taking in boarders. The number of people living in single household units in Boston was 50 percent higher than in New York or Philadelphia. Boston had 9.26 persons per household (1765), compared to 6.26 for Philadelphia (1760) and 6.52 for New York (1753). Many women would have echoed the comments of Sarah Osborn, a school mistress, that the only "means that Holds up our Heads above water at all is a couple of boarders."[15]

Few self-employed females achieved "a competence" or the "independency" to which male artisans, shopkeepers, and merchants aspired. Patricia Cleary, who has tracked down the "she-merchants" of Boston—the retailers who ran shops selling a variety of commodities that were imported from England and purchased on credit from British or American wholesale merchants—has identified 41 between 1745 and 1759 and 64 from 1760 to the Revolution. Doubtless there were more. Most were widows and many were successful, in business for more than ten years.[16] But even among these, probably only a

handful could write, as did Elizabeth Murray, the most prosperous among them, that she was able "to live & act as I please."

Elizabeth Murray was a self-made woman. A Scottish immigrant who migrated with a stock of dry goods, she became successful as a retailer in Boston, married a merchant/sea captain, was soon widowed, and entered her second marriage with a rare pre-nuptial agreement; this agreement guaranteed her both the right to manage the property she brought to the marriage and a large settlement instead of the customary dower rights. On this basis she achieved a small fortune. John Copley's portrait of her in the silk and velvet finery of her class portrays her as a young woman remembered her, with a "stately air and manner," "vigorous mind," and "high spirit."[17]

Murray helped other women to achieve independence. She set up Anne and Betsy Cummings, two young orphaned women, in a small retail shop. They were effusive in their thanks to their "kind advisor" who had "made us independent of evry one but your self." She helped Jannette Day Barclay, born illegitimately, to set up a school. "Helpless Friendless almost reduced to want," Barclay wrote, "so Sunk in my Opinion" that "I had nothing to support me," Murray's act "seemed to give me a Merit in my own Eyes, and in those of the World." Childless herself, Murray mother-henned her nieces, promoting "an usefull education." "I prefer a usefull member of society to all the fine delecate creatures of the age." If writing and accountancy were indispensable in trade, "how many families are ruined by the women not understanding accounts"? A niece thanked her for "that spirit of independence you cherished in me [which] is not yet extinct." Few women, single or widowed in Boston, could make that claim.[18]

In stark contrast was the dependence of probably the vast majority of female heads of households on poor relief. The numbers of poor, male and female, requiring relief had long staggered the town fathers. In 1757, the Overseers of the Poor reported that "the Poor supported either wholly or in part by the Town in the Almshouse and out of it will amount to the number of about 1000. . . ." Admissions to the Almshouse—indoor relief originally intended for the sick and the aged and crippled—climbed from 93 per year from 1759 to 1763 to 149 a year from 1770 to 1775 (with a winter total near 275–300). Most of the poor on relief—and most of the women—lived at home and received out-relief. The records of one Overseer for 1769 to 1772 show that about 15 percent of the householders in two wards

were on relief, which projected for the city as a whole would mean 500 to 600 families.[19]

What is remarkable about these numerous poor dependent women of Boston is their dogged resistance to forms of poor relief that would degrade them. Impoverished women had a clear notion that relief at home was a right. A visitor to Boston caught the values that underlay resistance: the Overseers of the Poor were "very tender of exposing those that had lived in a handsome manner and therefore give them good relief in so private a manner, that it is seldom known to any of their neighbors." Women in general held to the conviction that they should not have to work either in a workhouse or a manufactory for relief. A large brick workhouse, opened in 1739, in which adults and children were employed in picking oakum, carding, and spinning under a strict regime, never had more than 50 inmates. A manufactory to produce linen set up by a company of private investors early in the 1750s fared only a little better. The sponsoring society had to set up spinning schools to teach the skill. In 1753 they staged a spinning exhibition on the Boston Common at which "Near 300 spinsters, some of them 7 or 8 years old and several of them Daughters of the best families among us . . . made a Handsome appearance." The sponsors imported male weavers from abroad and built a large brick building. By 1758, the operation was over, a failure. Why? "Much of the answer," Gary Nash writes, "lies with the majority of women and children [who] were reluctant to toil in the manufactory. They would spin at home . . . but removal to an institutional setting, even for daytime labor, involved a new kind of labor discipline and separation of productive and reproductive responsibilities that challenged deeply rooted values."[20] Thus on the eve of resistance to Great Britain there was a large class of women in Boston who, dependent as they may have been, held fast to values of a moral economy and to aspirations for personal independence.

II

John Adams boasted of the institutions that made New England distinctive: the town meeting, the Congregational meetinghouse, the militia, and the public schools.[21] And well he might, for romanticized as they may have become, these institutions became the basis of the male resistance movement that made the Revolution in Boston no

less than in the small country towns. Save in Boston, one could add, resistance was also built on traditions of collective crowd action that John Adams cared not to boast about, traditions that gave Boston the reputation of being the most "mobbish" town in America.

Women who participated in activities that ended in Revolution could draw on only one of these institutions: the church. But they could also draw on roles that were by custom theirs in the domestic sphere, their roles as consumers and producers in the household economy, and on rituals of the life cycle, such as the funeral procession and rituals of community punishment and shaming. And, they were heirs to traditions of war.

Political institutions in Boston were the most democratic of the large colonial cities. All men with a certain amount of property were qualified to vote in the town meeting, take part in its deliberations, and elect the selectmen who administered the laws and chose delegates to the provincial assembly. In the 1760s, out of about 3,000 adult males, 600 to 700 men usually voted; the highest turnout at a hotly contested election was 1,100.[22] Perhaps 50 percent of the adult males qualified to vote; Fanueil Hall, the usual site for the town meeting, seated 1,500. After 1770 patriot leaders called meetings of "the whole Body of the People" at which property qualifications were let down and poor artisans, journeymen, apprentices, and seamen appeared; such meetings, ranging from 3,000 to 5,000 men, had to be adjourned to the largest church in the city, the capacity of which was about 5,000.[23] The rulers of the town meeting, on the other hand, the Selectmen and Overseers of the Poor, were drawn from the well-to-do classes, and the 150 or so petty officeholders from the middling sort.[24] Women neither attended, voted for, nor held office in the town meeting.

Nor were they part of the associated male network of associations: the political caucuses for the three parts of town (north, south, central) that prearranged town meeting affairs; a merchant's chamber of commerce; three Masonic lodges; or the array of eating and social and fire-fighting clubs.[25] Artisans sustained no permanent organizations, although specific trades met on an ad hoc basis to deal with the business of the trade—house carpenters to set prices, bakers to deal with the Selectmen on the assize of bread, and tanners and a dozen others to petition the colonial government—all male trades.[26]

Boston's much vaunted public schools were also exclusively male. The town supported five schools: three writing schools (north, south, and central) and two grammar schools (north and south). For boys

only, they educated no more than half of the 2,000 or so school-age boys. Girls, like boys, were sent to "dame" schools to learn their ABCs, but after that, parents had to pay private tutors.[27] In 1773, "Clio" contended "but few of the Fair Sex have been sufficiently instructed in their own language to write it with propriety and elegance," and a decade later a would-be reformer claimed that in all of Boston so few women could keep accounts, there were only "about a dozen capable of being shopkeepers."[28]

Notwithstanding this gap in formal education, the women of Boston were more literate than country women, and the proportion of literate among them seems to have been rising.[29] Women helped sustain the city's bookstores (there were 31 in all between 1761 and 1776). Some read newspapers—there were five in the 1760s—even though they ran little by, for, or about women. There were no magazines aimed at female readers, as there would be after the war. Yet, there are many signs of the growth of a female reading public: the popularity of imported English novels, steady sellers in a religious vein, and cheap books and broadside ballads aimed at readers at lower levels of literacy.[30]

The church very likely was the most important institution to the women of late colonial Boston. There were seventeen churches in Boston to which, in 1761, one minister estimated 2,000 families belonged, all save a quarter of the town's families. There were eleven Congregational meetinghouses, two Baptist and one Presbyterian (these fourteen "dissenting" churches with about 1,500 families among them), and three Anglican Episcopal churches (with from 350 to 500 families altogether). The five largest Congregational churches had from 150 to 350 families, the smaller ones 100 and fewer. They were distributed throughout the city, which meant that for most families attendance was probably on a neighborhood basis.[31] In social class, the Congregationalist churches were mixed: the Brattle Street meetinghouse on the fashionable west side had the men of "more Weight and Consequence," John Adams observed, while others in the north end of town had more of an artisan flavor.[32] At the lower extreme was the First Baptist Church, a small congregation, which drew poorer artisans, Negroes, and sailors to its services.[33] The parishioners of the Anglican churches ranged from the very rich to the poor. Anglican priests were Loyalist, while the Congregationalist ministers by and large were what the Loyalist Peter Oliver called them: a "black regiment" supporting "pulpits of sedition."[34]

The dissenting churches clearly were centers for women. By mid-

century, twice as many women as men were being admitted to membership; in most congregations they very likely formed a majority.[35] Men governed, as ministers, deacons, elders, and vestrymen. But for women, the congregation provided a natural form of association with their sisters. It was here, of course, that the sacraments of the life cycle were performed. It was to the church that women brought their babies to be christened, their sons and daughters to be married, and where they began the funeral processions in which all mourners walked to the burial ground behind the coffin. Funerals were ceremonies in which women, apparently of all classes, wore expensive mourning clothes—long the subject of unsuccessful regulation.

Women attended services—often twice on Sunday—and went to midweek lectures. Women were members of church choirs that flourished in the 1770s under the inspiration of Boston's William Billings, hymnist of the Revolution, a tanner-turned-choir-leader whose vigorous hymns expressed an enthusiastic religion.[36] Women read the Bible at home, sometimes aloud to each other. Women formed informal networks. The letters exchanged between Sarah Prince of Boston and Esther Edwards Burr testify to this. Sarah belonged to a female prayer group, and she humorously called her circle of woman friends a "Freemasons Club." Esther referred frequently to "the Sisterhood" she had known in Boston, a term rich with connotations.[37] And for Boston's poor widows, the churches of all denominations were a source of charity as well as sisterhood.

Women's participation in the churches had been invigorated by the evangelical preaching of the Great Awakening that in Boston began in the 1740s. George Whitfield, foremost among the itinerants, visited Boston not only in the first Great Awakening in 1740, but again in 1745, 1754, 1765, and before his death in 1770. In no major city, Nash observes, "was the awakening experienced as strongly, as enduringly, or as messianically as in Boston."[38] Nor as much by women. Whitfield "generally moved the passions of the younger people, and the Females among them," Rev. Charles Chauncy wrote. In 1745, when Whitfield lectured regularly at 6 A.M. (to reach working people before they began their day), he was overjoyed to see "so many hundreds of both sexes, neatly dressed, walking or riding so early along the streets to get food for their souls."[39] Boston was his favorite American city.

The effects of evangelism on women were striking. More women than men were among the converts, consistent with the pattern established years before. The first wave of enthusiasm had the effect of

"encouraging WOMEN, yea GIRLS to speak in the assemblies for religious worship"; "for men, women, children, servants are now become as they phrase it exhorters." Critics also complained of "censoriousness" by which they meant "Husbands [condemning] their Wives, and Wives Their Husbands, Masters their Servants and Servants their Masters."[40]

Whitfield's thirty-year affair with Boston, even after the ministers tamed such enthusiasms, undoubtedly had an equalitarian impact on women. Whitfield preached a salvation open to all without regard to station, race, or gender. He was clearly Boston's most popular cultural hero of the prerevolutionary era; when he died in 1770 at nearby Newburyport, Boston printers issued at least 14 commemorative broadsides, more than for any other person in the eighteenth century.[41] The full measure of his impact is yet to be taken.

The revolutionary movement for men and women also drew on traditions of public ritual. In holiday rituals men were the active participants and women the spectators. The Puritans had suppressed the traditional Catholic calendar holidays; the colony's official holidays were "training day," in which the militia paraded and each town celebrated; "election day," at which the members of the legislature were installed in Boston amidst pomp and ceremony; and Harvard commencement at nearby Cambridge, a popular carnival-like festivity reduced to a genteel affair by the 1750s. In the countryside, young women took an equal part in such fall harvest festivals as cornhusking; in the city, there was no holiday in which women participated as more than spectators.[42]

Pope's Day, Boston's "red-letter day" for young people in the laboring classes, was predominantly but not exclusively male. Celebrated in England as Guy Fawkes' Day, in Boston, for at least twenty-five years before the Revolution, every November 5 was a raucous ritual of reversal in which apprentices, young journeymen, and poorer artisans took over the town. In the daytime, boys and girls of all ages begged for money from householders, while two male "companies" paraded giant effigies of the Pope, the Devil, and the Pretender on large wagons. In the evening, the two "companies" representing the North End and the South End of town engaged in a bone-breaking battle to destroy the other's effigies. Women were spectators throughout the day and very likely at night, egging on their heroes. The first resistance to England, the Stamp Act riots, drew heavily on the leaders and rituals of the Pope's Day "companies."[43]

Women took a more active and equal part in rituals of public punishment. Boston, capital of the county and province, was at intervals the scene of public hangings of criminals. These followed a ritualized procedure organized by minister and magistrate: Broadsides were hawked through the streets with the "True Confessions and Dying Warnings" of the convicted; there was a procession of the criminal to the gallows on Boston neck at the outskirts of town; and at the gallows a sermon was delivered to the victim before concourses that often numbered in the thousands and that included men and women of all ages and conditions, who as often as not pelted or jeered the victim. In 1773, for example, Levi Ames, a young man convicted of murder, on several Sabbaths was "carried through the streets with chains about his ankles and handcuffs . . . attended by innumerable companies of boys, women, and men."[44] There are also hints of women in Boston taking part in rough music, known in New England as skimmingtons—community organized rituals punishing male adulterers. Tar and feathering would draw on these rituals of public and private punishment.[45]

Women were also heirs to Boston's rich mob traditions. Boston fits the pattern Eric Hobsbawm found for the "classical" mob of the pre-industrial city that "did not merely riot as a protest but because it expected to achieve something by its riot."[46] In Boston there were grain riots (1709, 1713, 1729, and 1741) directed against merchants who exported corn for profit in time of dearth. There were market riots and actions pulling down buildings for public purposes (1734, 1737, and 1743). At intervals, brothels were pulled down and prostitutes ceremoniously driven out of town. Women, it is safe to say, sanctioned all such riots but so far as we know participated infrequently. In 1747 they very likely took part in the massive Knowles riot, the largest crowd action up to then in which the "lower orders" held the town for three days to secure the return of men pressed into the navy.[47]

In time of war, there was in Boston, as for time immemorial, a tradition of women as exhorters of men to patriotism and as shamers of soldiers who were cowards. New England's frequent wars against the Indians and the four wars against the French gave full play to this tradition.[48] We see women, for example, in a striking female mob action in Queen Anne's war in 1707, when Boston's soldiers returned from a stunning defeat that inhabitants assumed to be of their own making. A contemporary described the shaming ritual vividly:[49]

They [the soldiers] landed at Scarlet's wharfe, where they were met by severall women, who saluted ym after his manner: 'Welcome, souldiers!' & presented ym a great wooden sword & said with all 'Fie, for shame! pull off those iron spits wch hang by yor sides; for wooden ones is all ye fashion now'. At wchy one of ye officers said, 'Peace, sille woman, etc.' wch irritated ye female tribe so much ye more, yt they cal'd out to one another as they past along the streets, 'Is yor piss-pot charg'd neighbor? Is yor piss-pot charg'd neighbor? So-ho, souse ye cowards. Salute Port-Royal. Holloo, neighbor, holloww'; with a drove of children & servants with wooden swords in their hands, following ym with ye repeated salutations 'Port-Royal! Port-Royal.'

Thus on the eve of the public resistance to Britain the women of Boston were heirs to some traditions they shared with men in the public sphere: attending evangelistic mass meetings, walking in funeral processions, and shaming criminals in execution rituals. As Bostonians, they were hardly strangers to mob action or to exhorting men in time of war. By custom they had a role as decision makers in the domestic sphere as consumers and household producers. From 1765 to 1775 decisions that were personal and private would become political and public.

III

As one looks anew on the famous events of Boston that have assumed a near epic quality in the memory of the making of the American Revolution—the Stamp Act Riots (1765), the Boston Massacre (1770), the Boston Tea Party (1773), and the Seige of Boston (1775–76)—they are like scenes from an old familiar movie. But if one freezes the frames or, more accurately, if one focuses the camera more sharply and shifts it to unphotographed scenes, it is possible not only to detect women as faces in the crowd, but to see large numbers of them in motion on a scale that has been little appreciated.

The percentage of Loyalists in Boston was the smallest of any in the major seaboard cities, perhaps 10 percent of the total population and 15 percent of the merchants. But patriots were themselves divided. Moderate patriots drew their strength from the merchants; the popular leaders (called by some historians the radicals), who were themselves of the middling sort, opened the doors to groups unqual-

ified to participate in the normal body politic. Or perhaps one should say that the hitherto excluded groups pushed open the doors, inviting themselves into the process. The result was a tug-of-war for control of the resistance.

The male patriot movement in Boston drew from all classes: merchants, doctors, lawyers, and ministers (the "better sort"); artisans and shopkeepers (the "middling sort"); and journeymen, apprentices, sailors, and laborers (the "meaner sort"). There were leaders on each level and distinct, if sometimes shadowy, organizations: the Chamber of Commerce for the merchants; the political caucuses and an ad hoc directing caucus, "The Loyal Nine," at the middling level; and the Pope's Day "companies" at the lower level. Ministers preached from their pulpits, and printers spread the word in newspapers, pamphlets, and broadsides.[50]

As one searches for women in this picture, they can be found from 1765 to 1774 in several distinct (although overlapping) roles: (1) as spectators, (2) as enforcers of consumer boycotts, (3) as manufacturers, (4) as rioters, (5) as mourners in politicized funeral processions and memorial meetings, and (6) as exhorters of men to direct action. Then, in 1775 and 1776, as resistance turned to armed rebellion, women can be found (7) as military supporters and (8) as political refugees. The trend of women's activities is from the genteel to the militant, from small private decisions to large-scale public activities, and from the more moderate to the more radical.

Women as Spectators

In the first wave of resistance to Britain—the Stamp Act protests of 1765–66—all patriot elements united in coordinated activities. Popular resistance was built on the cooperation of the upper- and middle-class leaders with the two Pope's Day "companies" who overcame their rivalry and converted the rituals of Pope's Day to patriotic use. There were seven major actions: a ritual hanging of the effigies of British ministers followed by the destruction of the stamp collector's office (August 14); the gutting of Lieutenant Governor Thomas Hutchinson's house (August 26); two massive military-like parades on the day the Stamp Act was to go into effect (November 1) and on the annual Pope's Day (November 5); a forced public renunciation of his commission by Andrew Oliver, the Stamp Act commissioner-designate (December 1765); and a mock public trial of the Stamp Act (February 1766), followed by a massive community celebration of the act's repeal (May 1766).[51]

Women were a presence at most of these events, primarily as spectators sought by male patriots to demonstrate the solidarity of the community. They observed the hanging and processions of August 14; they did not take part in the physical assault on the Lieutenant Governor's house, which patriot leaders repudiated, but the week before "a great number of inhabitants of both sexes surrounded his honor's dwelling house at the N. end with loud acclamations for Liberty and Property."[52] "Multitudes of Gentlemen and Ladies" joined the celebration of repeal and at each subsequent anniversary of the resistance of August 14, "the windows of the neighbouring houses" near the Liberty Tree, as a newspaper put it, "were adorned with a brilliant appearance of the fair Daughters of Liberty who testified their Approbation by Smiles of satisfaction."[53]

In attacking the Stamp Act, patriot leaders harped on a theme they would pick up again: the alleged effect of the act on widows. The British law required stamped duties on legal papers as well as on newspapers and all printed matter. In the doggerel verse forecasting the horrors of the act, the bonds and writs "spoke"—[54]

The probate papers next, with many a sigh
Must we be st—pt?: with tender accent cry:
We who our life and breath, freely spend,
The fatherless and widow to defend.

Then in the mock trial the motto on the stamped paper was "For the oppression of the WIDOW and the FATHERLESS."[55] While the intent of such a claim may have been to dramatize the effects of the act for a male audience, its appeal to women, married or widowed, was obvious.

Women as Boycotters

In the second phase of resistance, from 1767 through 1774, women were central to the key patriot tactic: the boycott of imports from Great Britain and the manufacture of American textiles as a substitute.

In Boston the bulk of the merchants signed a nonimportation agreement. Patriot committees policed nonconforming retailers— some of whom were women. For the first time male patriots appealed directly to women not to patronize shopkeepers who violated the agreement: "It is desired that the Sons and Daughters of LIBERTY refuse to buy from William Jackson," read one broadside that was

posted prominently throughout the town and also reprinted in the newspapers.[56]

The town government appealed to the citizenry to boycott a long list of British-manufactured goods and to buy the same from Americans. Women as well as men were asked to sign agreements to this effect. Late in 1767 women took action of their own, pledging non-consumption—the first exclusively female action of the decade. The *Boston News-Letter* reported this as: "in a large circle of very agreeable ladies in this town, it was unanimously agreed" not to use "ribbons & c & c," implying a meeting, discussion, and a resolution.[57] In 1770 tea became a major target. "Philagius" issued a call to "the ladies" in the *Boston Evening Post* to abstain from imported tea. In response to such appeals "upwards of 300 mistresses of Families, in which Number the Ladies of the highest rank and influence that could be waited upon in so short a time are included . . ." signed a petition pledging "we join with the very respectable body of Merchants and other inhabitants of this town who met in Fanueil Hall . . . totally to abstain from the Use of Tea."[58] The *Boston Gazette* reported a second, separate action of "upwards of one hundred ladies at the north part of town"—the artisan center—who "have of their own free will and accord come into and signed an agreement." This "young ladies" agreement began: "We the daughters of those patriots who have and do now appear for the public interest."[59]

In general the boycotts were effective. At the same time it is not surprising that there was opposition from some female shopkeepers, who with small capital and small inventories, could hardly ride out a boycott as easily as large-scale wholesale importers. Anne and Betsy Cummings, the shopkeepers set up by Elizabeth Murray, refused to go along and were the only females publicly listed with seven males as "Enemies to their country." "We have never antred into eney agrement," Betsy told the merchant's committee; their business was "verry trifling" and she was furious they would "try to inger two industrious Girls who ware striving in an honest way to Get there bread." They assured Mrs. Murray that being listed "has not hurt us at all in our Business," because it "Spirits up our Friends to purchas from us" and therefore "we have mor custom then before."[60]

Women as Manufacturers

Using American-made manufactures—the other side of the coin of boycotting British imports—made the cooperation of women as household manufacturers indispensable. A doggerel verse set to a

popular tune from *The Beggar's Opera* made an explicit "Address to the Ladies":[61]

> Young ladies in town, and those that live round,
> Let a friend at this season advise you:
> Since money's so scarce, and times growing worse
> Strange things may soon hap and surprize you:
> First then, throw aside your high top knots of pride
> Wear none but your own country linnen;
> Of Oeconomy boast, let your pride be the most
> To show cloaths of your own make and spinning.

By late 1768 in the rural areas where spinning for household consumption was normal, although not universal, patriots were able to boast "almost every house in the country is now a manufactory; some towns have more *looms* therein than *houses*."[62] But in the commercial cities where spinning by women was the exception rather than the rule, spinning would have had to be taught.

Patriots sponsored spinning activities in Boston at two distinct class levels: middle and lower. The activities among the former followed the pattern that Laurel Thatcher Ulrich has found elsewhere. Of the 46 spinning meetings in New England that she could identify for 1768–70, 31 were in the homes of ministers. Usually about 50 women met for the day, reported in the papers as "young ladies," "the fair sex," and occasionally as "The Daughters of Liberty." Each woman sat at a wheel spinning wool; sometimes there was a sermon, occasionally there were songs. The skeins of wool were then donated to the minister, putting the event in the tradition of charitable work by the women of the congregation. These spinning bees were occasional, not continuous, although there is evidence that the volume of spinning by individual women picked up during these years. In Boston, Ulrich identified six such meetings: one in 1768, five in 1770. Four took place in ministers' homes, two were under lay auspices, one at the home of a known patriot. Perhaps 200 to 300 women in all were involved.[63]

For women of the laboring classes, on the other hand, spinning activities were sponsored by the town via a radical patriot entrepreneur, William Molineaux. In late 1767, the town government was seized again with its perennial problem of employment for the poor. A plan to manufacture sail cloth was abortive. Early in 1769, the town proposed to set aside money to hire school mistresses to reach spinning to women and children. Molineaux, the organizer, was a mer-

chant in the Samuel Adams group and one of their two principal crowd leaders. Investing his own money as well as the town's, he had artisans build 400 spinning wheels, and within a year claimed to have 300 women and children spinning on a putting-out basis in their own homes. The popular leaders clearly had learned a lesson from the experience of the 1750s: Boston women could not be forced to work for relief within the walls of a manufactory. To finish the textiles, Molineaux organized a "manufacturing house" that included weaving, pressing, and dying operations and that employed skilled male laborers recently arrived from England. The operation survived an effort by the British Army to take over the building, and spinning among the poor was sustained through 1775.[64]

Women as Rioters

Boston's crowd actions from 1765 to 1774 were predominantly male events in which women assumed a role in certain kinds of actions.

The history of the crowd in Boston cannot be reduced to a single pattern. In 1765–1766, the merchant and middle-class popular leaders worked hand in hand with the artisan leaders of the annual Pope's Day celebrations. But Ebenezer McIntosh, the shoemaker captain of the South End Pope's Day company who became "Captain General of the Liberty Tree," raised a spectre of "Massanielo" to popular as well as conservative patriot leaders. "Massanielo," as Thomas Anielo, the fisherman who led a revolt in Naples in 1647, was known, was the archetype of disorder in revolution. After 1766, the official, Samuel Adams leadership always put forward one of their own, either Dr. Thomas Young, a physician, or Molineaux, the entrepreneur, as a street leader, shunting McIntosh to the sidelines. Through 1775, they were as much concerned with controlling the mob as in protesting British measures. "No violence or you will hurt the cause" was literally their motto.[65]

After 1766, crowd actions in Boston were of three types. One type was sponsored by the popular leaders, whose targets usually were retailers in violation of the nonimportation agreements and later the tea merchants. Second, there were spontaneous actions, led from within, that were composed overwhelmingly of men from the laboring classes, such as the riot against the combined seizure of John Hancock's ship, "Liberty," and the threat of naval impressment in 1768. It was especially characteristic of the tar and feathering mobs who punished customs informers. Third, there were crowd actions that got out of hand, beginning one way and ending another, with

unplanned violence and large-scale participation, like the Lillie-Richardson affair and the Boston Massacre, both early in 1770.

Women were not invited to take part in crowd actions sponsored by the self-appointed male popular leaders. They were more likely to appear at a spontaneous event like a tar and feathering or at an unauthorized event. Early in 1768, for example, one such action was directed at the customs commissioners. Effigies hung in the Liberty Tree were cut down by members of the "Loyal Nine," the Samuel Adams group. In the evening, nonetheless, 800 people paraded through the town to the house of a commissioner, "Drums beating and colours flying." Adams, whose political interest dictated disassociation, dismissed the crowd as "a few disorderly persons, mostly boys," but Governor Francis Bernard, whose self-interest dictated accuracy, reported the event to London as "the assembling of a great number of people of all kinds sexes and ages, many of which showed a great disposition to the utmost disorder."[66]

After mid-1768, the presence of soldiers in Boston politicized many women as well as men. To enforce their unpopular customs laws, the British stationed at the height 4,000 troops, which, even when reduced by half, meant a lot of soldiers for a town of 15,000. They were a daily source of abrasive incidents. Patriot leaders exploited every incident in their zeal to oust the "standing army"; yet, it is likely from the allegations of some 21 cases of rape and assault that women had their own gender-based grievances against the soldiers.[67] Women of the "better sort" at first took part in dancing assemblies with the officers, but later they withdrew. Among artisans, a special grievance was the practice of soldiers moonlighting, depriving them of jobs in hard times. The catalyst of the massacre in March, 1770, was a fight in a ropewalk where an off-duty soldier sought work, and a brawl ensued in which soldiers were defeated by the workers and vowed vengeance. Seven women later gave depositions about violent threats they heard from soldiers in the days before the shooting. Some women responded in kind. When the wife of a British officer told Susanne Cathcart that "many of their arses would be laid low before morning," she retorted, "I hope your husband will be killed."[68]

On the night of the massacre, when apprentices precipitated the calling of a squad of soldiers by taunting a sentry, a few women were present in the small crowd confronting the soldiers, one widow, we know, trying to get her son from harm's way. After the soldiers fired pellmell into the unarmed crowd, killing five and wounding six others, several thousand men and women poured out of their homes

into the square. A second disaster was narrowly averted when patriot leaders, rushing to an event they had not planned, negotiated successfully for the withdrawal of the troops.

Women as Mourners

Women played a major role in the massive rituals of community mourning for the victims of the British. In February, 1770, two weeks before the massacre, there was another chilling event in which a customs official killed an eleven-year-old boy, Christopher Seider. The occasion was the peaceful picketing of the shop of T. Lillie, an importer, by a group of about 150 "boys" organized by the popular leaders. "Boys" was a term that could apply either to children or to sturdy apprentices, aged 14 to 21; in this case, it meant school-age, pre-teenage boys, which suggests they had the approval of their mothers or fathers. The picketing was uneventful until the appearance of Ebenezer Richardson, an employee of the customs service with an odious reputation as an informer. Richardson tried to break up the crowd, then retreated to the second floor of his house next door and fired wildly into the crowd below, killing Seider. The funeral for the martyr was "the largest perhaps ever known in America." Beginning at the Liberty Tree, from 400 to 500 "lads and children" marched in front of the coffin carried by six boys; 2,000 men and women followed on foot, followed by the "better sort" in 30 carriages. "My eyes never beheld such a funeral," wrote John Adams.[69]

After the massacre, less than three weeks later, the funeral for the victims of the soldiers—four young single men of the laboring classes and one Crispus Attucks, an older black sailor—outdid this. "Such a concourse of people I never saw Before," a merchant recorded in his diary, "I believe ten or twelve thousand." Church bells tolled, ships flew their flags at half-mast, shops closed, and virtually the entire town—women included—marched six abreast. "The distress and sorrow visible in every countenance . . . the peculiar solemnity . . . surpass description."[70]

In the contemporary patriot iconography of both events, women were central figures. Paul Revere's engraving of the massacre placed a woman in black widow's weeds in the center of the crowd of hapless civilian victims of the soldiers, their red blood streaming across the cobble stones.[71] Isaiah Thomas's broadside on the Seider killing featured a crude, dramatic engraving with a distraught woman in the center of the street scene: in her arm, a pitchfork; at her feet, a dead

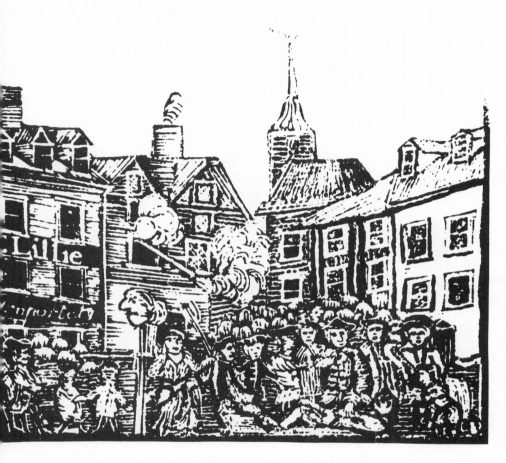

FIG. 1. A distraught mother is the central figure in this crude cut on a broadside depicting an incident in Boston in February, 1770. Boys, organized by the Sons of Liberty leaders, were picketing the store of a merchant, T. Lillie, who was violating the anti-importation agreement. A customs officer fired into the crowd from the next house, killing Christopher Seider, an eleven-year-old boy. From *The Life and Humble Confession of Richardson, the Informer* Abs 1772–1 (Boston, 1770). (Courtesy of the Historical Society of Pennsylvania.)

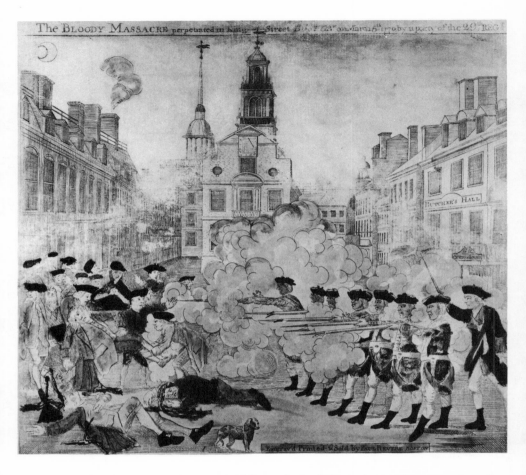

FIG. 2. A woman is a central figure in Paul Revere's popular engraving of the Boston Massacre. She stands to the left, in the midst of the crowd being shot down by British soldiers. Dressed in black, she is probably intended as a representation of a woman in widow's weeds, mourning the young victims of the British. From Paul Revere, *The Bloody Massacre Perpetrated on King Street* . . . (Boston, 1770). (Courtesy of the Library of Congress.)

boy, presumably her son; around her, a dozen wide-eyed boys; in the background, a smoking gun protruding from an upstairs window.[72]

Every year thereafter from 1771 until 1775 women attended the anniversary commemoration of the massacre, at which 5,000 or so people jammed the town's largest meetinghouse, Old South, to hear a doleful oration on the baneful effects of standing armies. In 1773, John Adams reported "that large church was filled and crowded in every pew, Seat, Alley and Gallery by an audience of several thousands of people of all ages and Characters and of both sexes." In 1775, when British officers mocked the annual speaker with cries of "Fie, Fie," which some heard as "fire," there was a near-panic as "women jumped out of the windows."[73]

The killings of Seider and the massacre victims probably did more to mobilize women in Boston than any other event of the decade.

Women as Exhorters

In Boston's climactic mass action of the era, the Tea Party in December, 1773, women assumed a new role. They did not attend the mass meetings of "the body of the people," the largest of the decade. Nor were they among the crews that boarded the three ships to destroy the chests of tea. Women very likely were among the large assembly of silent observers on the docks who watched the dramatic events in solemn silence in the moonlight.

More important, if one follows the public debate over the tea issue in the newspapers, there are suggestions that women were playing another role, seemingly for the first time: as exhorters of men to action. The vehicle was letters to the *Massachusetts Spy,* Isaiah Thomas's patriot paper catering to a mechanic audience. "Hannah Hopeful, Sarah Faithful, Mary Truth and Abigail Trust" signed a short letter that they began as "We the daughters of liberty." They thanked the "prerogative men" for arousing resentment in "our fathers, husbands, brothers and children."[74] The *Spy* also ran a short poem from "an aged and very zealous Daughter of Liberty, Mrs. M——s," identified as "a taylor by trade."[75]

Look out poor Boston make a stand
Dont suffer any tea to land
For if on it once gets footing here
Then farewell Liberty most dear.

A Boston seamstress also took her side with "the libe[r]ty boys" against "the tyranny [that] rides in our harbour and insults us in our fields and streets."[76]

IV

After the Tea Party, the popular leaders showed the importance they attached to women by their persistent, conscious efforts to mobilize them. Nowhere was this more apparent than in the Spring of 1774 in the climactic political contest of the era in Boston—the contest between popular leaders and moderates for control of the Revolution.

In the wake of the radical destruction of property in the Tea Party and the punitive British response, there was a conservative backlash among merchants, including many who earlier were part of the patriot coalition. To outflank the conservatives, the popular leaders turned to "those worthy members of society," the "tradesmen," i.e., the artisans, and the "yeomanry."[77] At the same time they also turned consciously to women.

Their tactic—working through the Boston Committee of Correspondence, an extralegal body—was to mobilize the country towns to adopt a boycott of British imports, presenting Boston's reluctant merchants with a fait accompli. They secretly distributed a petition, called the Solemn League and Covenant, to the towns with a specific request that it was "to be subscribed by all adult persons of both sexes."[78] The action was radical, not only in recognizing women as members of the political community. The initiating body was extralegal, not the official town meeting. It pledged the subscribers not only to boycott British imports, but to refuse to do business with anyone who did not sign the Covenant and to "publish their names to the world"—in effect, a secondary boycott and a ritual of shunning. Finally, in harking back to the English Solemn League and Covenant of 1643, patriots were donning the revolutionary mantle of their Cromwellian forebears.

Women responded. The Covenant, one Boston merchant reported, "went through whole towns with great avidity, every adult of both sexes putting their name to it, saving a few." Another heard that in some towns the clergy put the document on the communion table, telling congregants that "they who refused to sign were not worthy to come to that table." In Worcester in the western part of the state, which was rapidly becoming more radical than the seaboard,

a self-created American Political Society circulated a separate covenant "for all the women of adult age . . . to sign."[79] How widely the Covenant circulated is not clear; General Thomas Gage, assuming powers as governor, immediately declared it illegal. A few signed documents that have survived show some signatures of women next to their kin and others without the names of male kin—fairly clear evidence of a separate political will.[80]

V

From the spring of 1774, when Boston became a British garrison town and an occupied city, through the outbreak of hostilities in the spring of 1775, until March, 1776, when Boston became a city under siege by the patriots, women gave further testimony to their patriot allegiances. They assumed the roles first of military providers and then of refugees.

Women as Military Supporters

In response to the defiance of the Tea Act and the refusal to make restitution, the British closed the port of Boston, moved in a large occupying army, and replaced the crumbling British political establishment with military rule. If the aim of the Port Act was to turn the population against their leaders, it was a failure. Women suffered as did the poor as a whole.[81] With the port closed, most work at a standstill, and even the flow of food interdicted, the town depended on donations that soon poured in from surrounding villages and distant cities. The official town Committee on Donations chose work relief rather than outright grants to the destitute, putting men to work making bricks and repairing roads and distributing wool, flax, and cotton "to the spinners and knitters of the town," i.e., to women. The program was set up, Samuel Adams conceded, "to keep the poor from murmuring." As another put it, "some few among them mumble that they are obliged to work hard for that which they esteem as their right without work."[82] Even in the midst of crisis, destitute women and men attempted to maintain their traditional moral economy of relief as a right.

As tension with the British soldiers mounted in Boston and the countryside, women assumed a bellicose stance. In the fall of 1774, at a false alarm of a British attack on the militia at nearby Cambridge, women, according to one observer, "surpassed the Men for Eagerness & Spirit in the Defence of Liberty by Arms." In March, 1775, when

British troops attempted to cross over the river from Boston to the mainland in search of hidden arms, "large crowds of men, women & children assembled on both sides, some armed with guns" to prevent them from passing.[83]

In fact, as a Loyalist observed the scene near Boston, he was convinced "a certain epidemical phrenzy runs through our fair country women which outdoes all the pretended patriotic virtue of the more robustic males:—these little mischief making devils have entered into an almost unanimous association that any man who shall basely and cowardly give up the public cause of freedom, shall from that moment on be discarded [from] their assemblies, and no further contrition shall be able to atone for the crime."[84] If, in 1765, men had mobilized women, by 1775, women were mobilizing men.

Women as Refugees

After April, 1775, when war finally broke out at nearby Lexington, until the British army left in March, 1776, Boston was a city under siege by the patriot militia and army. Patriots deserted the city and Loyalists stayed, joined by other Loyalists flocking in for British protection. During the siege, Boston's civilian population of about 15,000 fell to 3,500, at least two-thirds of whom it is estimated were Loyalists. Thus, easily 12,000–13,000 Bostonians fled their city, inundating the towns of eastern Massachusetts as refugees.[85]

Women, we know, left en masse. To stay in Boston or to move into Boston clearly was a political choice indicating Loyalism, save for a small number of merchants who stayed to guard their property. To leave, it could be argued, was less a political decision than an act of self-preservation. To stay meant risking life and limb in the event of a patriot attack and, at the least, the prospect of extreme privation, if not starvation. That so many men and women left Boston for dangers unknown, especially poor women without families to turn to or resources to fall back on, should be taken as a testimony to their political convictions. These departures did not happen on the same scale when the British occupied New York City and Philadelphia.

The Quakers who came up from Philadelphia to distribute relief to these destitute refugees have left us a Domesday Book of the poor women of Boston. For each recipient, the Quaker keepers of the books methodically listed the name of the head of family and others in the family, the city of origin, church denomination, and, about half the time, the occupation. They did not calculate the number in each category, nor did they always make clear where the refugee was from;

but they put the total number of widows at 800. Widows with occupations were a minority, and a Quaker wrote revealingly: "Those women who have no Occupations Usually got their Living by their Hand Labour of various kinds, now obstructed & stopt by the present troubles & c." Most of the single women, on the other hand, seem to have been listed with occupations. Women in trades were in the needle trades only (seamstress, tailoress, mantua maker, weaver), and the largest single listing was spinster (which, in this context, meant an occupation, not single status). Only a few were retailers (shopkeeper, huckster, innkeeper); a large number were in nurturing professions (schoolmistress, nurse). All in all, women refugees clearly were predominantly of the laboring classes.[86] The same could not be said of women Loyalists who later left the city with the British; they were distributed more evenly among the middling and upper classes.[87]

VI

Patriot women thus played many roles. What was their importance? It is always difficult to analyze the relative weight of one group among many in popular movements. Clearly the resistance movement shaped events in Boston, and clearly women were an important part of the configuration. At times they were mobilized by males; at times they mobilized themselves; sometimes they helped mobilize males. Unmistakably, they broadened the base of support of the popular leaders; arguably they helped push resistance in a more radical direction.

The male contemporary who has left the fullest account of the impact of the women of Boston was the Loyalist Peter Oliver. It is not surprising; he was also the most sensitive and hostile recorder of the popular movement as a whole. His manuscript, *The Origins and Progress of the American Rebellion,* completed in 1781 and unpublished until 1961, is the fullest account of events in Boston by any contemporary. Peter Oliver—Chief Justice of the colony's Superior Court; brother of Andrew Oliver, the Stamp Act Commissioner; and brother-in-law to Lieutenant Governor Thomas Hutchinson, all major targets of patriot wrath—clearly was not an impartial witness. He dipped his pen in bile and spleen. His understanding of the reasons for popular participation was, to say the least, limited by his class bias: "the People," he wrote, "in general they were like the Mobility of all Countries, perfect Machines, wound up by any Hand who might first take the Winch."[88] He was a haughty, frightened, and misogynist

Tory. But he was a close observer of events in the city, and when he arrived as a refugee in England, he set down his recollections while they were still fresh.

As he narrated events chronologically, Oliver took account of the activities of women in Boston with regularity and contempt. He was amused at women from the laboring classes taking part in the boycott. "A Subscription Paper was handed about," he wrote, listing among the articles they would not purchase, "Silks, Velvets, Clocks, Watches, Coaches & Chariots." It was "highly diverting to see the names & marks, to the Subscription of Porters & Washing Women."[89] He also poked malicious fun at women who attempted to reduce English imports by foregoing the "custom of wearing expensive mourning at Funerals." "A Funeral now seemed more like a Procession to a *MayFair;* and Processions were lengthened especially by the Ladies, who figured a way, in order to exhibit their Share of Spite, & their Silk Gowns."[90] Oliver also branded the women's boycott of tea as hypocritical:[91]

> The ladies too were so zealous for the Good of their Country, that they agreed to drink no Tea, except the Stock of it which they had by them; or in Case of Sickness. Indeed they were cautious enough to lay in large Stocks before they promised; & they could be sick just as it suited their Convenience or Inclination.

Of all women's activities, spinning drew the lengthiest and most caustic description from Oliver, suggesting the importance it had for women. As he often did, he saw the Congregational clergy as the instigators:[92]

> Mr. [James] Otis's black Regiment, the dissenting Clergy were also set to Work to preach up Manufactures instead of Gospel. They preached about it & about it, untill the Women & Children, both within Doors & without, set their Spinning Wheels a whirling in Defiance of Great Britain. The female spinners kept on spinning for 6 Days of the Week; & on the seventh, the Parsons took their Turns, & spun out their Prayers & Sermons to a long Thread of Politicks; & to much better Profit than the other Spinners; for they generally cloathed the Parson and his Family with the Produce of their Labor: This was a new Species of Enthusi-

asm & might be justly termed, the Enthusiasm of the Spinning Wheel.

Of all activities by women, joining in tar and feathering crowds shocked Oliver the most.

In the year 1772, they [the male patriots] continued their laudible Custom of Tar & Feathers; even the fair Sex threw off their delicacy, and adopted this new fashion . . . one of those Ladys of Fashion was so complaisant; as to throw her Pillows out of Window, as the mob passed by with their Criminal, in order to help forwards the diversion.

This prompted him to his most blatant assertion of patriarchal values: "When a Woman throws aside her Modesty, Virtue drops a tear."[93]

As Oliver reviewed these years of upheaval in Boston, his account was dominated by his sense of outrage at the insubordination of all those orders who had stepped out of the sphere that hierarchy and patriarchy assigned them. That the activities of women registered on him so strongly is ample evidence of their importance.

VII

The evidence, biased and fragmentary as it is, is adequate to establish this broad panorama of what women did in Boston from 1765 to 1776. It is far more scarce when we try to probe the last of the questions we have posed: was there any change in the way women thought?

A long letter to the *Boston Gazette* under three female pseudonyms, "Aspatia," "Belinda," and "Corinna," suggests the way in which as early as 1767 participation in patriotic activities contributed to an assertion of female pride. The occasion was a number of letters to the paper by men who lectured women in a patronizing tone as to precisely what they should be doing for the cause. "Squibo" proposed that instead of drinking tea, they drink only rum and support New England's most important manufactured product. "Henry Flynt" hectored women "to lay aside all superfluous ornaments for a season" and then buy a new set of American-made clothes. Worst of all, "A Young American" in a supercilious way asked women to "Scorn such

trifling subjects as Dress, Scandal, and Detraction," stereotyping all women for such conversations.[94]

The tone of the women's reply—which the printers of the patriot *Gazette* considered important enough to publish as a supplement—combined anger, indignation, and pride. Their assumption in their opening words was that "the ladies of America" had "been divers times addressed as persons of consequence in the present oeconomical regulations." They felt "scandalously insulted" by the proposal of "Squibo" that they drink rum; they would replace Bohea and Tyson teas with what they saw fit, and the herbal teas from Labrador or their own gardens would be their choice. Their reaction to the advice of "Henry Flynt" as to what to wear was similar: "We will judge." It might be "practicable or prudent to wear out our old clothes as long as by good housekeeping we can make them look decent," and "when they are worn out," then they would replace them with "the produce of our American manufactories." As to "A Young American," he was beneath contempt because he "groundlessly insinuates" "characteristics of the sex." They concluded as they began, with an assertion of pride in "the ladies of Boston who for modesty of apparel, purity and delicacy of manners, improvement of mind and virtuous characters, are excelled by none."

The only surviving diary by a female from this period gives clues to the process of politicization. Anna Green Winslow was a girl of twelve and thirteen when she kept a diary from late November, 1771, through May, 1773.[95] Fortunately for us, she was a perfect mirror of a middle-class female youth in Boston, and fortunately she wrote at a point when the resistance movement among men and women was in full flower.

Anna was the daughter of an American-born British army officer stationed in Halifax and a mother from an old Massachusetts family, who sent her to Boston to live with Sarah and John Deming, her aunt and uncle, to acquire an education. The Demings were middle-class patriots. He was a deacon at Old South, a leading Congregational church; she kept a school for girls. Anna's diary took the form of letters dutifully sent to her parents. She went to several private schools (a reading school, writing school, and sewing school); she read novels (*Pilgrim's Progress* and *Gulliver's Travels* among them). She attended Old South meetinghouse, dutifully taking down sermons, and she read the Bible aloud to her aunt every day. She delighted in genteel assemblies at which she danced "cleverly"; she mastered the

art of embroidery and apologized to her mother for her extravagance in clothes.

A sponge of middle-class culture, she absorbed its politics as well. Her family instructed her. Colonel Gridley, a relative, "brought in the talk of Whigs & Tories & taught me the difference between them." Her Uncle John explained the nuances of religion and politics. The Revs. Pemberton and Cooper, she reported, "had on gowns In the form of the Episcopal cassock we hear," and this "at a time when the good people of N[ew] E[ngland] are threatened with & dreading the comeing of an episcopal bishop . . . Unkle says, they all have popes in their bellys."[96]

The spinning movement, her diary makes clear, politicized her. On February 8, 1772, at her aunt's suggestion, she resolved "to perfect myself in learning to spin flax. I am pleased with the proposal & am at this present, exerting myself for this purpose." She hoped "when two, or at most three months are past" to give a demonstration of "my proficiency in *this art.*" Ten days later she recorded, "Another ten knot skane of my yarn was reel'd off today."[97] And in March, after two weeks of spinning, she defined herself politically for the first time: "As I am (as we say) a daughter of liberty I chuse to wear as much of our own manufactory as pocible." At the end of May when she visited "the factory" set up by Molineaux "to see a peace of cloth cousin Sally spun for a summer suit for unkle," she clearly was aware of the political implications of the site. "After viewing the work we recollected the room we sat down in was Libberty Assembly Hall, otherwise called factory hall, so Miss Gridley & I did ourselves the Honour of dancing a minuet in it."[98]

If Anna Winslow was typical, we may say that by 1772 middle-class females in Boston had a sense of female patriotism. If we turn to the writings of the most publicly articulate Massachusetts woman of the pre-war period, Mercy Otis Warren, we can analyze its parameters.

Mrs. Warren's model was Catherine Macaulay, the English historian hailed by patriots for her multivolume account of the struggle for liberty in seventeenth-century England. Boston's Sons of Liberty toasted Mrs. Macaulay at their dinners; a Boston printer printed her engraving in his almanack; and patriots permitted her book into Boston when English books were under the nonimportation ban. Mrs. Macaulay was a republican, but in her historical writings women were absent and she never wrote as an advocate of women.

Mrs. Warren and Abigail Adams corresponded with her and admired her.[99]

Mercy Otis Warren lived in Plymouth but moved in a circle of Boston's leaders and published in Boston. She could hardly have been from a more prominent patriot family: her brother, James Otis, one of the province's leading lawyers, was a stellar if erratic figure in the patriot movement; her husband, James Warren, was a leader in Plymouth county as well as the colonial legislature. Her house was always abuzz with politics, and she corresponded with male patriot leaders such as John Adams.[100] From 1772 through 1775 she wrote poems and verse plays that appeared serially in the Boston papers and then in pamphlet form. "Dramatic sketches," as she called them, written in a florid neoclassical style, were meant to be read rather than performed. In *The Adulateur* (1772), the arch-villain was Thomas Hutchinson, satirized as Rapatio, ruler of the mythical country of Servia, who was trying to crush the "ardent love of liberty in Servia's freeborn sons." Hutchinson's brother and his relatives Andrew and Peter Oliver were co-conspirators; "Brutus" and "Cassius," the heroes, could be taken for James Otis and John Adams. In *The Defeat* (1773), she continued to flay Hutchinson as a satanic creature. In *The Group* (1775), her targets were the Massachusetts men who accepted royal appointment to the military Governor's council, acerbically portrayed as sycophants and "hungry harpies."[101]

Mrs. Warren's plays and poems appeared anonymously, and she was known and admired as the author only in inner circles of patriot men and women. In these pre-war plays she offered no female characters. Her poems, on the other hand, introduced allegorical women and spoke to women. In one lengthy poem she chided middle-class women to lay aside imported "female ornaments" to support the boycott. She contrasted "Clarissa" and "Lamira" to the "Cornelias and Arrias fair," who joined the cause. She celebrated the Tea Party in a poem in which Neptune's wives "Amphytrite" and "Salacia" debated the issue. Another poem of 1775 was a clarion to patriotism, female as well as male.[102]

Privately, Mercy Otis Warren was at the center of a network of female correspondents, wives of political leaders—Hannah Lincoln, Hannah Winthrop, and Abigail Adams foremost among them— whom she encouraged to express their opinions. But she did not go beyond encouraging women to patriotism. After the war, in her plays of the 1780s, women appeared for the first time as central characters, as heroines in the struggle for freedom in other times and countries.

And one woman scolds men for preferring in women "the fading short lived perishable trifling beauty" to their "noble exalted mental accomplishments."[103] But not until 1790 did she publish her plays and collected poems under her own name. And when she completed her three-volume history of the American Revolution in 1805, she had hardly a word to say about women. She defined female patriotism, one might say, as selfless.[104]

VIII

Our exploration over, it is now possible to return to the questions that framed it: what led Abigail Adams to raise the question of women's inequality, and what made it possible in the spring of 1776 for her to entertain the thought of "fomenting a Rebelion"? Were there other women who would have responded to her? My answer is yes, but in later years. By probing the combination of experiences that brought Abigail Adams to voice her "List of Female Grievances"—by examining her at the historic moment of the spring of 1776—we can gain insight into a process that would bring other women to do likewise.

What, we might ask first, were her "female grievances," and what did she intend by "the new Code of Laws"? She wanted to curb "unlimited powers" in "the hands of husbands." Her enemy was William Blackstone's *Commentaries on the Laws of England,* which codified the English common law under which a husband "controlled his wife's property, directing her labor and provided for her subsistence."[105] What prompted Abigail Adams to raise this particular aspect of women's unequal status? No one else seems to have raised the issue in public in Massachusetts in this decade. Probably, it was something she had already discussed privately with her lawyer husband, and that is why she did not have to spell out the reforms. (She often signed her letters to him "Portia." Was she assuming the persona of the woman lawyer in *The Merchant of Venice?*) Possibly she had thumbed through Blackstone's book or other law books in John's study, identifying the odious laws—as a young Elizabeth Cady Stanton would do in her father's law office a few decades later, so infuriated she wanted to cut out the offending passages from the books.[106]

What Abigail was doing was to make a leap from the Whig political language her husband had expressed so eloquently since 1765 and apply it to women's condition. His rhetoric was of "tyranny" and

"slavery" and especially of the danger of New England's yeomen becoming "vassals" to "lords." She leaped from the relation of subjects and rulers to wives and husbands. There should be "no unlimited power" in husbands. "Your sex are naturally tyrannical"; women should not be "vassals of your sex" was her language.[107]

But why did she make the leap at this particular moment? First, she had a strong sense of the contributions of women to the patriot cause, and especially of her own contributions. She had not only supported her husband in all of his political activities but she had become a "politician"—her word. She referred to Elizabeth Adams, Samuel's wife, as a "sister delegate" to the Philadelphia convention, and asked John, "Why should we not assume your titles when we give you up our names?"[108] She had seen other women express themselves in public, Mercy Otis Warren foremost among them. And she had witnessed the suffering of the "distressed women" of Boston, and since 1775 had done her best to succor the patriot refugees swarming through Braintree.

Second, she had a growing sense of empowerment as a result of the responsibilities she had assumed in her household in the eighteen months her husband had been away. John had been in Philadelphia since September, 1774, returning only for short intervals. She had managed the farm business, which meant the tenants and laborers. "I shall be quite a farmeriss in another year," she ended a recital of her accomplishments in farm management. Before long she would be writing of "our" farm.[109]

Third, she had become keenly aware of the limitations, including her own, of the education of women. In John's absence she also took on the burden of being "school mistress" to their four children, all under the age of ten. Educated by her own father beyond the level of most women, and confronted by John's ceaseless admonitions as to how she should instruct the children, she still felt inadequate to the task. She took up the issue with John with unmasked belligerence:[110]

> If you complain of neglect of Education in sons, what shall I say with regard to daughters who every day experience the want of it. With regard to the Education of my own children, I find myself soon out of my debth and destitute and deficient in every part of Education.
>
> I most sincerely wish that some more liberal plan might be laid down for the Benefit of the rising Generation, and that our new

constitution may be distinguished for Learning and Virtue, if we mean to have Heroes, Statesmen and Philosophers, we should have learned women.

It was an issue on which John could readily agree and that they would both return to, forging the accommodation Linda Kerber has named "Republican Motherhood."[111]

Fourth, the spring of 1776 was an extraordinary moment of radicalism in the American Revolution. Like tens of thousands of others, Abigail Adams and the women in her circle had read Thomas Paine's pamphlet, *Common Sense,* she in late February. In arguing for independence and a Republican government, Paine shattered the bonds of deference to more than monarchy, breathed a sense of equality and a confidence in the capacity of ordinary people to shape their future, and ended with the millennialist appeal: "we have it in our power to begin the world over again . . . The Birthday of a new world is at hand."[112] John Adams was not joking in his letter to Abigail when he listed the subordinate, dependent classes who were casting off deference to their betters. John was wary but Abigail was sympathetic to others making the leap from political liberty to personal liberty, most close at hand the slaves of Massachusetts who had petitioned the legislature for their freedom each year since 1773.[113]

Finally, it was also a moment that inspired optimism. The British army had evacuated Boston on March 17, the largest fleet ever assembled in America, 70 to 100 vessels, sailing away with troops defeated by the strategic maneuvers of the upstart American army. Boston, the siege of a year lifted, was in "a better state than we expected"; the immediate military threat was over. Abigail wrote on March 31 in her since famous letter: "I feel very differently at the approach of spring to what I did a month ago. I feel a gaiety de Coar [i.e., a lightness of heart] to which I was a stranger. I think the Sun looks brighter, the Birds sing more melodiously and nature puts on a more chearfull countenance." And from these words, she launched her "by the way . . . Remember the Ladies." It was hardly "by the way"— assertions of rights bloomed in a time of possibilities.

Other women, I would argue, would have to undergo some combination of Abigail Adams's experiences to bring them to the point where they were willing to raise female grievances either privately or publicly: the experience of participating in the making of the Revolution, the experience of war, a sense of personal empowerment in assuming male roles, a sense of exhilaration from the challenge to traditional authority, a sense of optimism as to the future.

In 1776, for most of the women returning to Boston, it was spring but not yet springtime. Women were straggling back by cart, on horse, and on foot, trying to reconstruct their lives from the chaos of war; many others would never return but attempt a new life elsewhere. Survival took priority. Boston would soon be smitten by a smallpox epidemic and then overwhelmed with shortages and runaway inflation. Men were going off to war, and women had to cope with making a living. In Massachusetts, framing a state constitution was put off until 1777. The war took priority. Wartime was hardly the time to raise the issue of "repealing masculine systems."

Were there other women, prepared by their experiences as female patriots from 1765 to 1776, who were ready to make the same leap that Abigail had made in asking to "Remember the Ladies" in writing a new code of laws? I think so. It is possible, of course, to argue that almost everything women had done in Boston in the decade gone by was in keeping with traditions of behavior long acceptable to a patriarchal society, that women in all of these roles had never left the domestic sphere and therefore would not have thought of themselves any differently.

Spinning was a traditional female domain, however atrophied in the cities. For churchgoing women to attend spinning bees and donate the yarn to their ministers was in the Congregational tradition. For women on poor relief to spin in the 1770s was to return to a method of work relief attempted in Boston in the 1750s. Decisions over consumption lay within women's sphere. The nonconsumption of luxury goods was a theme of Puritan ministers as old as the colony, and the campaign to curb extravagant displays in funerals predated the anti-British campaign by decades, albeit unsuccessfully. Women had always walked in funeral processions, and broadsides mourning children and youth cut down by death were the prototype of the Seider and Boston Massacre broadsides. For women to attend memorial services was equally time-honored. Large religious gatherings in which men, women, and youth jammed the churches to hear Whitfield preach were a feature of his five visits to Boston from 1740 to 1770; indeed, the annual Boston Massacre commemorations were resonant of such meetings. As to women exhorting their men to battle, this was their experience in the many wars New England fought against the Indians and the French.

Yet it is equally arguable that much in this decade was a departure from tradition in women's activities. It was new for women to be asked to come forward as a patriotic duty. It was certainly new for

women to be recognized as equals in a public cause—the unmistakable implication of the phrase "Daughters of Liberty" paralleling "Sons of Liberty." It was new for women alone to come together to sign secular agreements to boycott imports. It was not unusual for men and women to sign church covenants, but it was to ask adults of both sexes to sign the Solemn League and Covenant in 1774, an overtly political pledge cloaked in the language of the seventeenth-century Puritan revolution. Taken together, the totality of these experiences over a decade was new. And women who expressed their opinions on politics, whether in private in conversation or a letter, or in public in print or at a meeting or demonstration, were marking off new territory.

By the early 1770s, women who had taken part in such activities—who by 1775 would have been the overwhelming majority of the women of the city—developed a consciousness of themselves as female patriots. How a more explicitly feminist consciousness evolved is beyond the scope of this essay. The post-war decade, from 1784 on, would be the point at which a full investigation would be rewarding. For it is impossible to scan the newspapers, magazines, and printed matter that appeared in Boston after the war without feeling that a dam had burst and that there was an outpouring of public writing by and about women. What Abigail Adams had taken up from 1776 on only in the privacy of her letters to her husband was now a matter of public discourse.

If one thumbs through the *Massachusetts Centinel*, for example, there were articles on "Conjugal Love" and "The Causes of Unhappiness in Marriage" resonant of Abigail Adams's concerns with the domestic tyranny of husbands.[114] Education for girls was the subject of a major debate in which women took part that began in 1785 and led to the opening of the public schools to girls in 1789.[115] And in 1784 Judith Sargent Murray published "On the Inequality of the Sexes," the first of a series of newspaper essays, which when assembled in three volumes in 1798 constituted the first American body of feminist theory.[116]

Just as a diary of a school girl suggested the process of change in the 1770s, the oration of a school girl in 1791, very likely one of the first female graduates of the public schools, suggests the process at work after the Revolution. "With children of both sexes" acquiring an education, she had a sense of a new age dawning in which "the mists of superstition and bigotry are vanishing." Pointing to the achievements of women in Europe she then proclaimed that "here

on our own western shore we can justly boast of a WARREN, a MOR-TON, and ADAMS whose talents and virtues ornament their sex and excite emulation." And "may we not indulge in honest pride that this metropolis has been one of the foremost in exertions to promote female improvement."[117] She had a perception that we are still exploring of the ways in which "female patriotism" opened a path to "female improvements."

Notes

I would like to express my appreciation to Linda Kerber for her insightful criticism and to Darline Levy and Harriet Applewhite for their wise editorial counsel, and to the following for sharing their scholarship in progress: Laurel Thatcher Ulrich, Patricia Cleary, Lucy Eldersveld Murphy, and Elizabeth Reilly.

1. Abigail Adams to John Adams, March 31, 1776, *Adams Family Correspondence*, ed. L. H. Butterfield (Cambridge, Mass.: Harvard University Press, 1963), 1:369–71.

2. John Adams to Abigail Adams, April 17, 1776, ibid., 381–83.

3. Abigail Adams to Mercy Otis Warren, April 27, 1776, ibid., 396–98.

4. Abigail Adams to John Adams, May 7, 1776, ibid., 401–3.

5. For the pathbreaking institutional analysis, Joan Hoff Wilson, "The Illusion of Change: Women and the American Revolution," in *The American Revolution: Explorations in the History of American Radicalism*, ed. Alfred F. Young (DeKalb, Ill.: Northern Illinois University Press, 1976), 383–445; for the fullest exploration of women's activities and consciousness, Mary Beth Norton, *Liberty's Daughters: The Revolutionary Experience of American Women, 1750–1800* (Boston: Little, Brown and Co., 1980) and Linda K. Kerber, *Women of the Republic: Intellect and Ideology in Revolutionary America* (Chapel Hill: University of North Carolina Press, 1980).

6. This essay is based on evidence assembled for a forthcoming book, "In the Streets of Boston: The Common People in the Making of the American Revolution, 1745–1789." Some of the themes of this book are suggested in Alfred Young, "George Robert Twelves Hewes (1742–1840): A Boston Shoemaker and the Memory of the American Revolution," *William and Mary Quarterly*, 3d ser., 38 (October, 1981): 561–623, and Young, "English Plebeian Culture and Eighteenth Century American Radicalism," in *Origins of Anglo-American Radicalism*, ed. Margaret and James Jacob (London: Allen and Unwin, 1983), 185–212.

7. Charles Akers, *Abigail Adams: An American Woman* (Boston: Little, Brown and Co., 1980) is by the biographer most adept in the history of Boston during the Revolution. I have relied on Butterfield, ed., *Adams Family*

Correspondence, vol. 1, and Butterfield, Marc Friedlander, and Mary Jo Kline, eds., *The Book of Abigail and John: Selected Letters of the Adams Family, 1762–1784* (Cambridge, Mass.: Harvard University Press, 1975).

8. Gary Nash, *The Urban Crucible: Social Change, Political Consciousness, and the Origin of the American Revolution* (Cambridge, Mass.: Harvard University Press, 1979), chaps. 7, 9, 11, and the Appendix; Nash, "Urban Wealth and Poverty in Pre-Revolutionary America," *Journal of Interdisciplinary History* 6 (1976): 545–84, reprinted in Nash, *Race, Class, and Politics: Essays on American Colonial and Revolutionary Society* (Urbana, Ill.: University of Illinois Press, 1986), chap. 7. The pioneer essays are James Henretta, "Economic Development and Structure in Colonial Boston," *William and Mary Quarterly*, 3d ser., 22 (1965): 75–92, and Allan Kulikoff, "The Progress of Inequality in Revolutionary Boston," *William and Mary Quarterly* 28 (1971): 375–412.

9. Nash, *Urban Crucible,* 172–73, 188–89, 253–54; Alex Keyssar, "Widowhood in Eastern Massachusetts: A Problem in the History of the Family," *Perspectives in American History* 7 (1974): 83–119, touches neither on Boston nor on the underlying political causes of the growth of widowhood.

10. Douglas Lamar Jones, *Village and Seaport: Migration and Society in Eighteenth Century Massachusetts* (Hanover and London: University Press of New England, 1981).

11. William Pencak, "The Social Structure of Revolutionary Boston: Evidence from the Great Fire of 1760," *Journal of Interdisciplinary History* 10 (1979): 274–75; Nash, *Urban Crucible,* Appendix, table 5, 398; Alice Hanson Jones, *Wealth of a Nation to Be: The American Colonies on the Eve of the Revolution* (New York: Columbia University Press, 1980), 198–200, 322–25, 332.

12. For occupational breakdowns: Jacob Price, "Economic Function and the Growth of American Port Towns in the Eighteenth Century," *Perspectives in American History* 8 (1974): 171–86 and Kulikoff, "Progress of Inequality," Appendix, 411–12.

13. Frances May Manges, "Women Shopkeepers, Tavernkeepers and Artisans in Colonial Philadelphia" (Ph.D. diss., University of Pennsylvania, 1958). For the year 1774 Lucy Murphy counted the following female advertisers in the *Boston Gazette*: nine retail shopkeepers (four of seeds, two of groceries, one of fabrics, one of cheese); one in the needle trades (a milliner), two school teachers, thirty-six wet nurses, and three women who might be regarded as in male trades (one baker, one wholesale/retail merchant, and one farmer [who advertised for a lost horse]) (Seminar paper, Northern Illinois University, 1985). The standard earlier work is Elizabeth A. Dexter, *Colonial Women of Affairs, Women in Business and the Professions in America before 1776,* 2d rev. ed. (Boston: Houghton Mifflin, 1931). For suggestive analysis of Philadelphia, see Carole Shammas, "The Female Social Structure of Philadelphia in 1775," *Pennsylvania Magazine of History and Biography* 107 (January, 1983): 69–83.

14. The primary sources that might be used for an occupational analysis of the women of Boston are: Bettye H. Pruitt, ed., *The Massachusetts Tax*

Valuation List of 1771 (Boston: G. K. Hall and Co., 1978), 2–46 (unfortunately incomplete and with few occupations given); the Quaker records of relief distributed in 1775–76 referred to in n. 86; and the "Assessors 'Taking Books' of the Twelve Wards of the Town of Boston, 1780" in *Bostonian Society Publications*, 1st ser., 9 (1912): 15–59 (with occupations listed but in wartime and incomplete).

15. Nash, *Urban Crucible*, 194–95.

16. Patricia Cleary, "'She Merchants' of Boston: Women of Business on the Eve of the Revolution, 1745–1775" (Ms. Newberry Library Seminar in Early American History, Chicago, January, 1988), with additional information kindly provided by Ms. Cleary.

17. Mary Beth Norton, "A Cherished Spirit of Independence: The Life of an Eighteenth Century Boston Businesswoman," in *Women of America: A History*, ed. Mary Beth Norton and Carol Ruth Berkin (Boston: Houghton Mifflin, 1979), 48–60.

18. All citations, ibid.

19. Nash, *Urban Crucible*, chap. 9, *passim*.

20. Gary Nash, "The Failure of Female Factory Labor in Colonial Boston," *Labor History* 20 (1979): 165–88, reprinted in Nash, *Race, Class, and Politics*, 119–41.

21. L. H. Butterfield, ed., *Diary and Autobiography of John Adams*, 4 vols. (Cambridge, Mass.: Harvard University Press, 1961), 3:195.

22. Alan Day and Catherine Day, "Another Look at the Boston Caucus," *Journal of American Studies* 5 (1971): 27–28.

23. Samuel Adams to Arthur Lee, December 17, 1773, *The Writings of Samuel Adams*, 4 vols., ed. Harry A. Cushing (New York: G. P. Putnam's Sons, 1904–8), 3:73–74.

24. Dirk Hoerder, *Crowd Action in Revolutionary Massachusetts, 1765–1780* (New York: Harcourt Brace Jovanovich, 1977), 24–36, developed with statistical proof in Hoerder, *Society and Government 1760–1780: The Power Structure in Massachusetts Townships* (Berlin: John F. Kennedy Institut, 1972), 41–49; Edward M. Cook, Jr., *The Fathers of the Towns: Leadership and Community Structure in Eighteenth-Century New England* (Baltimore: Johns Hopkins University Press, 1976), 167, 172–74.

25. Richard D. Brown, "Emergence of Voluntary Associations in Massachusetts, 1760–1830," *Journal of Voluntary Action Research* 2 (1973): 64–73.

26. Mary Roys Baker, "Anglo-Massachusetts Trade Union Roots, 1130–1790," *Labor History* 14 (1973): 352–96. Baker offers no trace of petitioning in the Massachusetts Archives by women in trades.

27. Richard Dufour, "The Exclusion of Female Students from the Public Secondary Schools of Boston, 1820–1920" (Ed. D. diss., Northern Illinois University, 1981), chap. 1.

28. Clio, "Thoughts on Female Education," *Royal American Magazine*, January, 1774, 9–10; "Tanterbogas," *Massachusetts Centinel*, March 30, 1785.

29. Kenneth Lockridge, *Literacy in Colonial New England: An Inquiry into the Social Context of Literacy in the Early Modern West* (New York: W. W. Norton

and Co., 1974), 21; Linda K. Kerber, "'Nothing Useless or Absurd or Fantastical': The Education of Women in the Early Republic," in *Educating Men and Women Together,* ed. Carol Lasser (Urbana: University of Illinois Press, 1987), 37–48.

30. Cathy Davidson, *Revolution and the Word: The Rise of the Novel in America* (New York: Oxford University Press, 1986), chap. 4; Elizabeth Reilly, "Demography and Reading in Mid-Eighteenth Century New England," and "Cheap and Popular Print in Mid-Eighteenth Century New England," unpublished mss. that Ms. Reilly generously shared with me.

31. Franklin Bowditch Dexter, ed., *Extracts from the Itineraries and Other Miscellanies of Ezra Stiles* . . . (New Haven, Conn.: Yale University Press, 1916), 100–101.

32. Cited in Charles Akers, *The Divine Politician: Samuel Cooper and the American Revolution in Boston* (Boston: Northwestern University Press, 1982), 26.

33. Isaac Backus, *History of New England with Particular Reference to the* . . . *Baptists* (Boston, 1796), 3:125–26.

34. *Peter Oliver's Origins and Progress of the American Rebellion: A Tory View,* ed. Douglass Adair and John A. Schutz (San Marino, Calif.: Huntington Library, 1961), 42–45.

35. Richard D. Shiels, "The Feminization of American Congregationalism, 1730–1835," *American Quarterly* 33 (1981): 46–62, which includes data for three Boston churches.

36. Kenneth Silverman, *A Cultural History of the American Revolution* (New York: Thomas Y. Crowell Co., 1976), 198–209.

37. Lucia Bergamasco, "Amitié, amour et spiritualité dans la Nouvelle-Angleterre du XVII Siècle: L'Expérience d'Esther Burr et Sarah Prince," in *Autre temps autre espaces: Etudes sur L'Amérique pré-Industrielle,* ed. Elise Marienstras et Barbara Karsky (Nancy, France: University of Nancy Press, 1986), 91–109; *The Journal of Esther Edwards Burr, 1754–1757,* ed. Carol F. Karlsen and Laurie Crumpacker (New Haven, Conn.: Yale University Press, 1986) Introduction, 34.

38. Nash, *Urban Crucible,* chap. 8, citation at 219. See also Edwin Scott Gaustad, *The Great Awakening in New England* (New York: Harper and Brothers, 1957); and John William Raimo, "Spiritual Harvest: The Anglo American Revival in Boston, Massachusetts, and Bristol, England, 1739–1742" (Ph.D. diss., University of Wisconsin, 1975).

39. Charles Chauncy, *Seasonable Thoughts on the State of Religion in New England* . . . (Boston, 1742); George Whitfield, February 16, 1745, in Luke Tyerman, *The Life of the Reverend George Whitfield,* 2 vols. (London: Hodder, 1876–77), 2:73–74.

40. Citations from Nash, *Urban Crucible,* 204–19.

41. Clifford K. Shipton and James E. Mooney, comps. *National Index of American Imprints through 1800* (Worcester, Mass.: American Antiquarian Society, 1969), entries under George Whitfield dated 1770–71.

42. Young, "In the Streets of Boston," pt. I. For older studies see

W. deLoss Love, *The Fast and Thanksgiving Days of New England* (Boston: Houghton, Mifflin, 1895); Alice Morse Earle, *Customs and Fashions in Old New England* (New York: Macmillan, 1893), chap. 9; George Kittridge, *The Old Farmer and His Almanack* (Boston: W. W. Ware, 1904), 168–83.

43. Young, "In the Streets of Boston," chaps. 1–3.

44. Lawrence W. Towner, "True Confessions and Dying Warnings in Colonial New England," in *Sibley's Heir: A Volume in Memory of Clifford Kenyon Shipton, Publications of the Colonial Society of Massachusetts* 59 (1982): 523–39.

45. Young, "Plebeian Culture," 189–94.

46. Eric Hobsbawm, *Primitive Rebels: Studies in Archaic Forms of Social Movements in the 19th and 20th Centuries* (New York: W. W. Norton and Co., 1965), chap. 7 at 111.

47. Hoerder, *Crowd Action*, chap. 1; Nash, *Urban Crucible, passim;* Jesse Lemisch, "Jack Tar in the Streets: Merchant Seamen in the Politics of Revolutionary America," *William and Mary Quarterly*, 3d ser., 15 (1968): 371–407; Joel Shufro, "Boston in Massachusetts Politics, 1730–1760" (PhD. diss., University of Wisconsin, 1976), chap. 5; Pauline Maier, *From Resistance to Revolution: Colonial Radicals and the Development of American Opposition to Britain, 1765–1776* (New York: Alfred A. Knopf, 1972), chap. 1.

48. Laurel Thatcher Ulrich, *Good Wives: Image and Reality in the Lives of Women in Northern New England, 1650–1750* (New York: Oxford University Press, 1982), chap. 10, "Viragoes."

49. Cited in George Rawlyk, *Nova Scotia's Massachusetts: A Study of Massachusetts–Nova Scotia Relations, 1680–1784* (Montreal: McGill-Queens University Press, 1973), 105, brought to my attention by Bryan Palmer.

50. Young, "In the Streets of Boston," pt. II; G. B. Warden, *Boston, 1689–1776* (Boston: Little, Brown and Company, 1970), chaps. 8–15; for the crowd, Hoerder, *Crowd Action*, chaps. 2–11; for the popular leaders, Maier, *From Resistance to Revolution*, chaps. 3–8; for merchants, Arthur M. Schlesinger, *The Colonial Merchants and the American Revolution, 1763–1776* (1918; reprint, New York: Atheneum, 1968) and John W. Tyler, *Smugglers and Patriots: Boston Merchants and the Advent of the American Revolution* (Boston: Northeastern University Press, 1986).

51. Hoerder, *Crowd Action*, chaps. 2–3; Edmund S. Morgan and Helen M. Morgan, *The Stamp Act Crisis: Prologue to Revolution*, 2d rev. ed. (New York: W. W. Norton, 1963), chap. 8.

52. *Boston Gazette*, August 19, 1765; *Boston News-Letter*, August 22, 1765.

53. *Boston Gazette*, May 26, 1766; August 22, 1768; *Boston News-Letter Extraordinary*, May 22, 1766.

54. "A Stamp Dream," *Boston Gazette*, October 14, 1765.

55. *Boston Gazette*, February 24, 1766.

56. "William Jackson, an Importer at the Brazen Head . . ." (Boston, 1769–70[?] Broadside).

57. *Boston News-Letter*, November 5, 1767.

58. "Philagius," *Boston Evening Post*, February 5, 12, 1770.

59. *Boston Gazette*, February 12, 1770.

60. "A List of the Names . . ." (Boston, 1770, Broadside) also in *Boston Gazette,* Supplement, March 12, 1770; Betsy and Anne Cummins, cited in Norton, "A Cherished Spirit of Independence," 55.

61. *Boston Post-Boy,* November 16, 1767.

62. Cited in Oliver M. Dickerson, ed., *Boston under Military Rule, 1768–69 as Revealed in a Journal of the Times* (Boston: Chapman and Grimes, 1936), 33.

63. Laurel Thatcher Ulrich, "'Daughters of Liberty': Religious Women in Revolutionary New England," in *Women in the Age of the American Revolution,* ed. Ronald Hoffman and Peter J. Albert (Charlottesville, Va.: University of Virginia Press, 1989), 211–43. I am indebted to Ms. Ulrich for sharing the ms. version with me.

64. Norton, *Liberty's Daughters,* 164–70. The *Boston Evening Post* reported twenty-seven incidents of spinning in New England, May–December, 1769.

65. Cited in Hiller Zobel, *The Boston Massacre* (New York: W. W. Norton and Co., 1970), 151; the theme is developed in Maier, *From Resistance to Revolution,* chap. 5 and *passim.*

66. Samuel Adams, *Writings* 1:241–47; Governor Francis Bernard to Earl of Hillsborough, March 19, 1768, in *English Historical Documents: American Colonial Documents to 1776,* ed. Merrill Jensen (New York: Oxford University Press, 1955), 736–39.

67. Dickerson, *Journal of the Times, passim;* Melinda Munger, "Women's Activities in Boston, 1765–1776" (Seminar paper, Northern Illinois University, 1975), analyzes the entries Dickerson assembled in *Journal of the Times,* originally published in newspapers outside of Boston.

68. *A Short Narrative of the Horrid Massacre in Boston . . . to Which Is Added an Appendix . . .* (Boston, 1770), depositions nos. 2, 11, 12, 17, 20, 86, 90.

69. Young, "In the Streets of Boston," chaps. 11, 12; Zobel, *The Boston Massacre,* chap. 15; John Adams, *Diary and Autobiography* 1:349–50.

70. *Letters and Diary of John Rowe, Boston Merchant, 1759–1762, 1764–1779,* ed. Anne Rowe Cunningham (Boston: W. B. Clarke, 1903), March 8, 1770, 199.

71. Paul Revere, "The Bloody Massacre Perpetrated in King Street," (Boston, 1770, Broadside), reproduced and discussed in Clarence S. Brigham, *Paul Revere's Engravings* (New York: Atheneum, 1969), 52–78. The woman stands out especially in the prints Christian Remick colored in watercolors, less so in the several black and white versions.

72. "The Life and Humble Confessions of Richardson, the Informer," (Boston, 1770, Broadside). The cut is reproduced in Elizabeth Carroll Reilly, *A Dictionary of Colonial American Printer's Ornaments and Illustrations* (Worcester, Mass.: American Antiquarian Society, 1975), no. 1008. After consultation with Elizabeth Reilly, I attribute the engraving to Isaiah Thomas on the basis of Thomas's style and known political activities as a printer for this period.

73. John Adams, March 5, 1773, *Diary and Autobiography* 2:70.

74. *Massachusetts Spy,* December 2, 1773.

75. Ibid.

76. Mary Salisbury to Susanna Shaw, August 2, 1774, cited in Norton, *Liberty's Daughters*, 172; see also the exchange over the effects of tea in *Massachusetts Spy:* "A Woman," December 23, 1773; Dr. Thomas Young, December 30, 1773; "A Woman," January 6, 1774.

77. Thomas Young to John Lamb, June 19, 1774, in *Memoirs of General John Lamb*, ed. Isaac Q. Leake (Albany: J. Munsell, 1850), 89–91.

78. Letter of the Boston Committee of Correspondence to the People of Every Town, June 8, 1774, and the Covenant, in Peter Force, comp., *American Archives*, 4th ser., 6 vols. (Washington: M. St. Clair and Peter Force, 1837–46), 1:397–98.

79. Harrison Gray, cited in Tyler, *Smugglers and Patriots*, 219; John Andrews to William Barrell, July 22, 1774, in Winthrop Sargent, ed., "Letters of John Andrews, Esq. of Boston, 1772–1776," *Proceedings of the Massachusetts Historical Society* 8 (1864–65): 329; for the Worcester reference I am indebted to Edward Countryman.

80. "We the subscribers, inhabitants of the District of Charlton . . ." (Boston, June, 1774), Broadside with 132 signatures, "unusual because of the number of women represented among the signers," in *Massachusetts Broadsides of the American Revolution*, ed. Mason I. Lowance, Jr., and Georgia Bumgardner (Amherst, Mass.: University of Massachusetts Press, 1976), 42–43.

81. Hoerder, *Crowd Action*, 278–80; citation of Adams, ibid., 279.

82. John Andrews to William Barrell, "Letters of John Andrews," *Proceedings of the Massachusetts Historical Society* 8 (1864–65): 337.

83. *Boston News-Letter*, March 2, 1775.

84. *Middlesex Journal* (England), November 22–24, 1774, "An Extract from a Letter from Boston Dated October 25th," reprinted in R. T. H. Halsey, *The Boston Port Bill as Pictured by a Contemporary London Cartoonist* (New York: Grolier Club, 1904), 310–11.

85. Richard Frothingham, *History of the Seige of Boston* (Boston: C. C. Little and J. Brown, 1849).

86. Henry C. Cadbury, "Quaker Relief During the Siege of Boston," *Colonial Society of Massachusetts Transactions* 34 (1943): 39–149, a transcript of the manuscript records. The comment is at p. 63. My analysis is impressionistic.

87. Norton, *Liberty's Daughters*, 138; Norton, "Eighteenth Century American Women in Peace and War: The Case of the Loyalists," *William and Mary Quarterly*, 3d ser., 33 (1976): 393–95.

88. Oliver, *Origins and Progress*, 65.

89. Ibid., 61.

90. Ibid., 62.

91. Ibid., 73.

92. Ibid., 63–64.

93. Ibid., 97.

94. The letter is in *Boston Gazette,* Supplement, December 20, 1767, reprinted in *Providence Gazette,* January 9, 1768; for "Henry Flynt," *Boston Gazette,* November 2, 1767; "A Young American," ibid., December 21, 1767. "Squibo" is reprinted in *Providence Gazette,* January 2, 1768.

95. Alice M. Earle, ed., *Diary of Anna Green Winslow, a Boston School Girl of 1771* (Boston: Houghton Mifflin, 1894); introduction by Mrs. Earle is the source of biographical detail.

96. Ibid., 14, 59.

97. Ibid., 20, 25, 27.

98. Ibid., 32, 72.

99. Lucy Martin Donnelly, "The Celebrated Mrs. Macaulay," *William and Mary Quarterly,* 3d ser., 6 (1949): 173–207.

100. Robert A. Feer, "Mercy Otis Warren," in *Notable American Women 1607–1950,* 3 vols., ed. Janet and Edward James (Cambridge, Mass.: Harvard University Press, 1971), 3:45–56; Katherine Anthony, *First Lady of the Revolution: The Life of Mercy Otis Warren* (New York: Doubleday and Co., 1958); Maud M. Hutcheson, "Mercy Warren, 1728–1814," *William and Mary Quarterly,* 3d ser., 10 (1953): 378–402.

101. Silverman, *Cultural History of the American Revolution,* 212–13, 255–56; Bernard Bailyn, *The Ordeal of Thomas Hutchinson* (Cambridge, Mass.: Harvard University Press, 1974), 202, 244.

102. Mercy Warren, *Poems Dramatic and Miscellaneous* (Boston: Thomas, 1790).

103. "The Sack of Rome" and "Ladies of Castille," in ibid.; the line about women is from *The Motley Assembly* (1779).

104. Mercy Otis Warren, *The History of the Rise, Progress and Termination of the American Revolution,* 3 vols. (Boston: Manning and Loring, 1805); Lester Cohen, "Explaining the Revolution: Ideology and Ethics in Mercy Warren's Historical Theory," *William and Mary Quarterly,* 3d ser., 37 (1980): 200–218.

105. Akers, *Abigail Adams,* 31–47. For details, see Phyllis Lee Levin, *Abigail Adams* (New York: St. Martin's, 1987); for a variant interpretation, Edith B. Gelles, "Abigail Adams: Domesticity and the American Revolution," *New England Quarterly* 52 (1979): 500–521, and Gelles, "The Abigail Industry," *William and Mary Quarterly,* 3d. ser., 45 (1988): 656–83.

106. Elizabeth Cady Stanton, *Eighty Years and More: Reminiscences, 1815–1897* (New York: T. Fisher Unwin, 1898), 31–34.

107. Abigail Adams to John Adams, March 31, 1776, *Adams Family Correspondence* 1:369–71; for John Adams on this theme see Richard L. Bushman, *King and People in Provincial Massachusetts* (Chapel Hill: University of North Carolina Press, 1985), chap. 5.

108. Abigail Adams to John Adams, July 25, 1775, May 9, 1776, *Adams Family Correspondence* 1:263, 404.

109. Cited in Akers, *Abigail Adams,* 46.

110. Abigail Adams to John Adams, August 14, 1776, *Adams Family Correspondence* 2:94.

111. Kerber, *Women of the Republic,* chap. 9.

112. Thomas Paine, *Common Sense* (Philadelphia, 1776); for evidence of Adams and her female friends reading *Common Sense,* See *Warren-Adams Letters,* Massachusetts Historical Society Collections, vols. 72–73, 2 vols. (Boston, 1917–25), 1:204, 208–9.

113. Abigail Adams to John Adams, September 22, 1775, *Adams Family Correspondence;* for the petitions, Herbert Aptheker, ed., *Documentary History of the Negro People,* 2 vols. (New York: Citadel Press, 1951), 1:5–9.

114. For examples see the (Boston) *Massachusetts Centinel:* "Clarissa," April 7, 1784; "Conjugal Love," July 7, 1784; "Some Cases of Unhappy Marriages," January 26, 1785.

115. See in the 1985 *Massachussets Centinel:* "Humanus," February 19; "Daphne," February 26; "The Force of Education," March 2; "Humanus," March 9; "Mechanick," March 12; "Tantarbogas," March 30; "Lorenzo," April 6; "Semiramis," April 16, 1785.

116. Judith Sargeant Murray, *The Gleaner,* 3 vols. (Boston, 1798); for discussion see Norton, *Liberty's Daughters,* chap. 8, and Kerber, *Women of the Republic,* 204–6.

117. "An Oration upon Female Education Pronounced by a Member of the Public Schools of Boston, September, 1791," in Caleb Bingham, *The Columbian Orator,* 9th ed. (Boston, 1801), 47–51. Morton was Sarah Wentworth Morton of Boston, who wrote poetry as "Philenia" and to whom some attributed (falsely) *The Power of Sympathy* (Boston, 1788), the first American novel. See Davidson, *Revolution and the Word,* 85, 287n.

"I Have Don . . . much to Carrey on the Warr": Women and the Shaping of Republican Ideology after the American Revolution

Linda K. Kerber

I take my title from what I think is the most moving witness to the American Revolution left to us by a woman: the petition of Rachel Wells of Bordentown, New Jersey, to the Continental Congress.[1] Wells faced the loss of the repayment of her war bonds due to a technicality.

> To the Honnorabell Congress I Rachel do make this
> Complaint, Who am a Widow far advancd in years & dearly
> have ocasion of ye Intrust for that Cash I Lent the Stats. I was
> a Sitisen in ye Jearsey when I Lent ye Stats a Considerable
> Sum of Moneys & had I justice don me it mite be Suficant to
> Suporte me in ye Contrey whear I am now . . . Now
> gentelmen is this Liberty, had it bin advertisd that he or She
> that moved out of the Stats should Louse his or her Intrust
> you mite have sum plea against me. But I am Innocent.
> Suspectd no Trick. I have Don as much to Carrey on the warr
> as maney that Sett Now at ye healm of goverment. . . . God
> has Spred a plentifull Tabel for us & you gentelmen are ye
> Carvers for us pray forgit not the poor weaklings . . . Why Not
> Rachel Wells have a Littel intrust if She did not fight She
> Threw in all her mite which bought ye Sogers food & Clothing
> & Let them have Blankets . . .

Rachel Wells could not spell, but she had a high level of political consciousness. She had been deeply engaged in the war. She knew where her money had gone and what it had been used for. She had

a clear sense of what was due her. But the position she was forced to assume was that of a supplicant.

The political community that was fashioned by the American war was a deeply gendered community, one in which all white adults were citizens but in which men's voices were politically privileged. For men, political institutions—the army, the militia, the state legislatures, the Continental Congress, organizations of artisans—facilitated collective experience. A notable male elite—its patriarchal character encoded in its identification as the Founding Fathers—articulated political republicanism and embedded it in successive manifestos and institutions, acting in the name, they said, of all Americans, though they certainly did not formally consult women of any race or class, any black men, and only rarely propertyless white men. There was no female counterpart of the Founding Fathers. American women shared many experiences but only occasionally formalized their collective response or articulated their reactions as a group or on behalf of more than one. It has not been easy for historians to say much that is reliable about American women in the revolutionary era—either about their behavior or about their understanding of what that behavior meant. Reading the history of the American Revolution from the perspective of women is a little like entering the world of Tom Stoppard's *Rosenkrantz and Guildenstern Are Dead*: a world that has been turned inside out so that we can pay attention to voices that were present in the original telling but overpowered by the narrator's choice of central characters.

There is much merit to thinking of the era as an "age of the democratic revolution," and to melding the French and American upheavals into a single set of shared events on a large scale. Lafayette's career alone may furnish all the proof we need of the merits of that approach. But there were also enormous differences between the political cultures of the two revolutions, a difference that is underscored by the sharp differences in women's behavior. French women were early to claim their political tongues, beginning with the cahiers of the flower sellers of Paris and proceeding through Olympe de Gouges' "Declaration of the Rights of Woman" and the activities of the Society of Revolutionary Republican Women.[2] For these collective activities we, have no direct counterparts in America. When Rachel Wells petitioned the Continental Congress, she petitioned alone.

Indeed, virtually the only mechanism the American republic made available to Rachel Wells was the traditional mechanism of the individual petition, which forces deference and subservience on the

claimant. The music of her words is in the counterpoint: there is the tone of the forceful demand ("Now gentelmen is this Liberty") in which she addresses her readers as an equal; against it rings the tone of the mendicant ("God has spread a plentifull tabel for us & you gentelmen are ye Carvers"). Reading her petition, we learn something about her social status (poor), her role during the revolutionary war (contributor and supporter), and finally her hesitant articulation of the meaning and significance of that experience.

Rachel Wells faced the Revolution on her own, as an individual, with only her family for her support. It is this absence of a collective dimension to most of their activities that marks the greatest difference between the female experience of the French and American Revolutions, and between the experiences of American women and their brothers. Essays in this volume—especially those by Dominique Godineau, and by Darline G. Levy and Harriet B. Applewhite—emphasize the collective behavior of French women, especially urban French women, in the great *journées* that mark the major turning points of the French Revolution.

Two factors seem of particular significance. The first is the comparative scale of events. Paris was an urban place of more than 650,000 inhabitants; Philadelphia, the largest American city, was home to 40,000. Calling both places "urban" masks real differences in social dynamics. Second, Paris was a city with two important institutions that had long been engaged in providing at least the preconditions for women's consciousness of themselves as engaged in shared collective enterprise; neither institution existed in America. One was the established Roman Catholic Church. I am thinking here not only of religious orders, which would become part of the mobilization *against* the Revolution, but the theatre that the Church provided for ritual behavior by otherwise secular women. Levy and Applewhite have drawn attention to the women's processions to the Eglise St. Geneviève in Paris. Originally acts of supplication, the processions were gradually transformed during the summer of 1789 into the antecedents for the secular, political, and violent women's march on Versailles. Second were the women's guilds or guild-like organizations, which existed only in Paris and a few major cities, but that provided an institutional tradition in which women shared a collective experience and collective responsibilities. Thus the Fishwives of Paris had a responsibility to be present at the birth of the royal heir and to certify that the child had in fact been born of the body of the Queen. These groups—flower sellers, fishwives—seem to have been

core groups that served, like the grains of sand in the oyster, to facilitate the formation of politicized women's groups.

In America the Catholic Church was marginal. The only religious group that gave women space of their own and accustomed them to making institutional decisions was the Quakers, and they were deeply disaffected during the war.[3] There was no tradition of women's guilds. (In New York midwives were licensed, but apparently as individuals.) We have as yet been unable to identify the specific women who gathered in the few well-documented women's collective displays—the destruction of the stores of Peter Mesier in Westchester in 1777, the intimidation of the Boston merchant Thomas Boylston in 1778—or to ascertain what experiences these women had in common. The absence of a collective dimension makes the reconstruction of the gendered dimensions of the American experience a subtle challenge. But it is nonetheless an important challenge. Having established that events had an impact on women and also that women participated in events, historians must move on to examine political process, social experience, and the ways in which political discourse reflected relations between the sexes of which contemporaries were only dimly aware. Societies at war are societies engaged in a renegotiation of gender relations, usually in such a way as to emphasize and sometimes redefine the meaning of masculinity. An ideology that takes enormous pains to *exclude* women is, by that very fact, an ideology that is interactive *with* women. There is, as Joan Wallach Scott has suggested, "a politics of gender . . . [embedded] in the politics of war."[4] Republican ideology was a creation of the revolutionary generation, and in its shaping we can discern the subtle ways in which it reflected the gender dynamics of the generation that created it.

I

Thomas Paine's *Common Sense,* published in January, 1776, occupies a special place in the literature of the Revolution; it lucidly expressed a developing ideology and was widely quoted as a tract that gave words to what a large political community was ready to hear. In the informal language of ordinary people, *Common Sense* challenged reliance on authority, and promised that together the people of America could create a society without oppression. At a time when 4,000 copies was an impressive circulation for a pamphlet, 150,000 copies of *Common Sense* were published in its first year.[5] Usually treated simply as

a public political text, we have come to understand, thanks to the work of Michael Wallace and Edwin Burrows, that along with Paine's series *The Crisis,* it also offers an interpretation of private family dynamics that permeated the political discourse of both Patriots and Tories.[6] From Burrows and Wallace, it is a short step to appreciating what *Common Sense* suggests about the social relations of the sexes.

Paine addresses himself explicitly to the male reader; Paine's use of the male pronoun is emphatically not generic.

> In the following pages I offer nothing more than simple facts, plain arguments, and common sense; and have no other preliminaries to settle with the reader, than that he will divest himself of prejudice and prepossession, . . . that he will not put *off* the true character of a man . . .[7]

Paine wrote in the language of Enlightenment political discourse, in which the "state of nature" was well established as a standard trope in political literature. It was common for political philosophers to begin by visualizing a pre-political world and to draw on this *tabula rasa* what seemed to them to be a logical political community. In the classic state of nature as conceptualized by Locke, Hobbes, and Condorcet, the beginning point was usually a man and a woman who, by their creation of children, initiated the social relations of the community. As Locke and Hobbes warmed to their task the woman slipped out of their constructions. Although Paine acknowledges that "Male and female are the distinctions of nature," women do not figure in the original social community at all.

> In order to gain a clear and just idea of the design and end of government, let us suppose a small number of persons settled in some sequestred part of the earth, unconnected with the rest: they will then represent the first peopling of any country, or of the world. In this state of natural liberty, society will be their first thought. A thousand motives will excite them thereto, the strength of one man is so unequal to his wants, and his mind so unfitten for perpetual solitude, that he is soon obliged to seek assistance and relief of another, who in his turn requires the same. . . . Four or five united would be able to raise a tolerable dwelling in the midst of a wilderness; but *one* man might labour out of the common period of life without accomplishing any

> thing; when he had felled his timber he could not remove it, nor erect it after it was removed . . .

After men have built their homes, they were likely to find themselves to have different opinions, and they would gather themselves into a distinctly male political community:

> Some convenient tree will afford them a statehouse, under the branches of which the whole colony may assemble to deliberate on public matters. . . . In this first parliament every man by natural right will have a seat.

Eligibility for membership is measured by their relations to good women:

> . . . as a man, who is attached to prostitute, is unfitted to choose or judge of a wife, so any prepossession in favour of a rotten constitution of government will disable us from discerning a good one.

The reciprocal is absent: women do not prove their eligibility for membership in the political community by their marriage to a good man. Addressing the reader as "husband, father, friend or lover," Paine writes "to awaken us from fatal and unmanly slumbers." Later he observes, " As well can the lover forgive the ravisher of his mistress, as the continent forgive the murders of Britain," suggesting by his language that those inclined to negotiate, despite the Boston Massacre and other Patriot martyrs, are men who would not defend their private honor.[8]

The language of American resistance, not only Paine's, was suffused with an image of Britain as an unnatural mother and of Americans as vigorous youths ready to assume the responsibilities of manhood.[9] Burrows and Wallace found in Paine the culmination of this expression: "To know whether it be the interest of the continent to be independent, we need only ask this easy, simple question: Is it the interest of a man to be a boy all his life?"[10]

Increasingly republican ideology envisioned the single male individual, standing independently agaisnt the encroachments of royal power, joining as an individual with other men to form an intentional political community.[11] The more republicans reasoned in this way, the more gender-specific their ideology became, even when they did

not say so explicitly. Patriarchalism, under attack at least since the English Civil Wars, was eroding, but its erosion was more swift in the public realm than in the private, and more swift in the relations among men than between men and women. Indeed, there may even have been a heightened insistence during the years of the early republic that men validated their own claims to independence by, as Joan Gunderson has phrased it, "stressing the dependence of others (including women) on them. . . . Much of the discussion of independence during the Revolutionary period used a system of negative reference to define independence. Independence was a condition arrived at by exclusion . . . by *not* being dependent or enslaved."[12] As there gradually developed a political community that empowered the independent male citizen who controlled his own property, women remained marginalized as the objects of conflict and achievement; indeed women embodied all that was vulnerable. "The people," observed John Adams, "are Clarissa."

In the society of the early republic, the elements of political independence were denied to women by custom and by practice. This political marginality was sustained by the traditional inequality of property rights. In Anglo-American law, married women had little control over the property they earned or inherited. Although women were often defined in terms of their domestic duties, households and their property were controlled by men; only the dower "thirds" were assured to women after the death of their husband.[13] Marginality remained despite the hard fact that the work of women was central to the maintenance of the family economy, especially in laboring and artisan classes, as it is in every known society. It seems a reasonable generalization that the wages of laboring women approximated half of the wages of laboring men, even when performing similar work.[14] Families of the laboring class usually needed the work of women and children to meet the costs of simple necessities.[15] Widows had a high probability of continuing in their husband's craft or trade. Deserted women became heads of households and required their own income. In towns and cities, women worked as market women, seamstresses, laundresses, and as domestic servants. What we now call "the feminization of poverty" was already well underway. Women seem to have been more likely than men to have had to accept "indoor relief"— residence in almshouses—rather than "outdoor relief"—aid offered outside of institutions.[16]

The fact that women had to work was buttressed by a pervasive assumption that women ought constantly to be at work. The pathetic

phrase "women's work is never done" described the steady round of domestic labor within middle-class households. Poor women could demonstrate their worthiness for public assistance only by constant labor. Philadelphia vagrancy records show women confined to brief jail sentences on vague charges of "idleness" or "for following no employment."[17] Literacy, a skill that facilitated the acquisition of other skills, was substantially weaker among women than among men. Our best estimates suggest that women's literacy rates on the eve of the Revolution were half that of their male counterparts, whether the area studied is rural or urban.

Jürgen Habermas has urged us to understand the concept of the "public sphere" as something distinct from an antique distinction between the simply public and the private; by "public sphere" he means, as his translator Peter Hohendahl has put it, "the sphere of non-governmental opinion making." This realm is distinguished from legislative debate on the one hand and private conversation on the other; Habermas locates its emergence in a particular historical moment, the emergence of bourgeois society in the eighteenth century and particularly in the era of the democratic revolution. Its characteristic site is the political newspaper, "the mediator and intensifier of public discussion." By their published expressions of opinion, private individuals in effect assemble themselves into a "public body" which positions itself "against the public authority itself." "In those newspapers, and in moralistic and critical journals, they debated that public authority on the general rules of social intercourse."[18] In a society in which men controlled the press and were using it to explain to each other how good republicans could retain their manhood while eschewing the patriarchal role, women faced the challenge of making space for themselves in the public sphere and participating in the task of opinion-making. Judith Sargent Murray, who later published her "Gleaner" essays as a book sold by subscription, was one of the very few women who claimed regular newspaper space.[19] A few women found funds to publish pamphlets; a handful wrote occasional letters of opinion to newspapers or to journals that announced themselves receptive to women's contributions. Americans concluded from the Revolution that dependence was to be deplored. It is not surprising that women would seek space to articulate a vision of the sort of independence that they would find most pleasing. Their efforts to do so marks the deeply gendered nature of republican ideology after the American Revolution.

In short, American women, not unlike their French counter-

parts, were in a position of limited resilience when subjected to the added stress of the war, which would make thousands of them widows and leave others abandoned. An older patriarchal tradition had offered a rationale for women's dependence by linking it to other dependent relationships in society. But the more patriarchalism came under attack from republican ideology, the less "republican" adult married women seemed to be. If they were to enter the republic, they would have to devise their own, gendered variant of republicanism; they would have to explain how women could enter the political community.

II

For men and women alike, participation in some aspects of the Revolution could be empowering, making it possible to make claims on the republic. We find evidence of men's claims on the postwar republic everywhere: in artisans' parades and rallies, in voting on the ratification of the Constitution, in political positions articulated orally in legislatures, and in writing in the newspapers. Evidence of women's claims on the republic is more scattered, since women controlled virtually none of the usual fora in which politics were expressed. As one graduate of a girls' school explained in a graduation speech, "The Bench and the Bar are closed to us." Even in newspapers owned and published by women, it was assumed that men's words filled the columns. But evidence there is, in larger quantities and far richer than we have assumed, and this evidence increases substantially in quantity in the 1780s and 1790s. When governments stabilized, women turned to them with petitions for redress for griefs and wrongs experienced during the Revolution. The growing strength of dissenting churches meant audiences for accounts of religious experiences. And the successful demands for improved education meant an increase in literacy, complemented by more female writers to write and by more female readers to read; by the 1790s it was the unusual newspaper that did not print at least occasional letters signed with a female *nom de plume*. Female audiences for fiction—self-conscious but persistent—provided opportunities for women writers to claim a relationship with the public sphere. And in the absence of legislative action, what we might call women's support groups undertook to save the most desperate and "deserving" of the female and youthful poor shipwrecked

by revolutionary dislocations, testifying to what they were doing in handwritten minutes and published reports.

We will rarely find men initiating discussions of women's concerns or of women's relationship to the state; as Edward Countryman has remarked, white men of at least modest property thought of themselves as the makers of the Revolution, and it was to them—as voters, as soldiers, as citizens—that legislators, in turn, felt themselves responsible.[20] But if we turn to texts written by women, we can find women developing their own distinctive agendas, a politics congruent with their own understanding of reality. No single individual gathered all the elements of women's political perspectives into a single vision or text. But the elements of a female consciousness and the beginnings of a female agenda can be discerned in the writings of several women who "carried on the war" into the postwar years, articulating the issues that meant most to them. An authentic intellectual history of the founding generation will make room for these women's texts on bookshelves and in anthologies already crowded with the work of the men of their age.

The earliest Americans to encounter Mary Wollstonecraft's *Vindication of the Rights of Woman* were the readers of the Philadelphia *Ladys Magazine,* which published extensive extracts—nearly 5,000 words—in September, 1792. They appeared in the same issue that reported the introduction into the French National Assembly of a resolution to the effect that Louis XVI had forfeited his crown. The *Ladys Magazine* was edited by men, who aimed at a female audience characterized by "virtue and prudence." Wollstonecraft's message was packaged in a form that both contained and endorsed its radical import. The frontispiece of the issue included an engraving, by the Philadelphia artists James Thackara and John Vallance, of three women dressed in vaguely Grecian garb and framed by a classical temple. "The Genius of the Ladies Magazine, accompanied by the Genius of Emulation, who carries in her hand a laurel crown, approaches Liberty, and kneeling, presents her with a copy of the Rights of Woman." The Spirit of the *Ladys Magazine,* who kneels to present her text, is traditionally deferential, but the Spirit of Ambition who accompanies her bears the torch and laurel crown normally reserved for male heroes, and Liberty had long since absorbed from Minerva the Phrygian cap, the pole, and the shield. By associating traditional republican imagery with Wollstonecraft's claims for women, Thackara and Vallance enfolded her radicalism in familiar and powerful imagery.[21]

FIG. 1. James Thackara and John Vallance, "Frontispiece: Philadelphia *Ladys Magazine*, September, 1792. (Courtesy Library Company of Philadelphia.)

What the artists did visually, the editors did verbally, introducing selected passages as the common sense of the matter for a postrevolutionary republic. Nowhere was this strategy clearer than in their approval of Wollstonecraft's attacks on standing armies and her analogies between soldiers, who are trained to deference, and women of fashion. ". . . military men . . . are, like [women], sent into the world before their minds have been stored with knowledge, or fortified by principles. The consequences are similar; soldiers acquire a little superficial knowledge, snatched from the muddy current of conversation, and, from continually mixing with society, they gain [an] acquaintance with manners and customs [which] has frequently been confounded with a knowledge of the human heart."[22] The editors included in their selection only snippets of Wollstonecraft's attacks on Rousseau and other writers, but extensive selections from her call for practical education for women. They ended with her broadest claims, including her radical argument that women's status was itself a measure of the authenticity of men's civic virtue: "Moralists have unanimously agreed, that unless virtue be nourished by liberty, it will never attain due strength—and what they say of man, I extend to mankind . . . Let women share the rights, and she will emulate the virtues of man; for she must grow more perfect when emancipated, or justify the authority that chains such a weak being to her duty.— If the latter, it will be expedient to open a fresh trade with Russia for whips; a present which a father should always make to his son in-law, on his wedding-day, that a husband may keep his whole family in order. . . ."[23]

Judith Sargent Murray provides the most extensive and most fully developed texts in the history of women's thinking about American public issues in the revolutionary era; in that sense she is something of an American counterpart to Mary Wollstonecraft. Murray's "Gleaner" essays, published in serial form in 1792–94 and as a three-volume set of books in 1798, are nearly 700 pages in length and touch on issues of education, manners, fashion, religion, and politics. After a long period in which little attention was paid to them (the full work, for example, has never been reprinted), the essays in which she addresses women's education and need for independence have received fresh attention. But the entire work is more ambivalent than most who have quoted it have recognized. If there was much on which Murray and Mary Wollstonecraft would have agreed, there was also a great deal of Murray's work of which Wollstonecraft would have been bitterly skeptical. Set next to Murray, Wollstonecraft's liberal

formulations look stridently radical. The conservative context of Murray's liberal message requires attention.

Judith Sargent was born in 1751 into a prominent mercantile family in Gloucester, Massachusetts. Her family sent its sons to Harvard and encouraged her to study along with her brothers while they prepared for college with local tutors; when she was married, at the age of 18, to John Stevens, a sea captain and trader, her portrait was painted by John Singleton Copley. She was twenty-five in 1776. The years of the Revolution were intense ones for her. Although the fighting itself rarely touched Gloucester, her husband served on the Committee of Safety. The seagoing trade was badly affected; one historian estimates that a sixth of the population was living on charity. During the war years, Judith Sargent Stevens, her father, and her husband were also caught up in a liberal religious revival brought to Gloucester by John Murray, an itinerant Universalist preacher. Murray was English; he had been a follower of John Wesley before coming to America in 1770 to preach a doctrine of universal salvation. Finding a warm welcome among the Sargents and their friends in Gloucester's First Parish Church, Murray remained there, but his presence and the challenge of his message split the congregation. In September, 1778, fifteen dissidents (eleven women and four men), including Judith Stevens, her parents, and her brother (though not her husband), were suspended from the First Parish Church. She and her husband signed an "Appeal to the Impartial Public by the Society of Christian Independents, Gloucester," and were part of the community that formed the first Universalist meetinghouse in America in December, 1780.[24] Thus the years of the war were years of religious as well as political dissidence for Judith Stevens.

Judith Sargent Stevens's marriage fell victim to the financial dislocations of the post-war years. In the hope of avoiding creditors and bankruptcy, John Stevens apparently fled to the West Indies in 1786; soon after word came of his death. In 1779, while caught up in the religious struggles, she was "seized with a violent desire to become a writer." She had drafted an essay titled "Desultory Thoughts upon the Utility of Encouraging a Degree of Self-Complacency, Especially in Female Bosoms," that would not be published until 1784.[25] In 1792, Murray began to publish a series of essays, under the heading "The Gleaner," in the newly established *Massachusetts Magazine;* she signed them with the pseudonym "Constantia." These essays continued to run for two years. In 1798, one year after her marriage to John Murray, she published them in three volumes. Some seven

hundred people subscribed; the subscription list was headed, alpha-betically, by John Adams, President of the United States, who ordered two copies. The list was dotted with distinguished male subscribers— George Washington, the governors of Massachusetts and New Hamp-shire. There were 121 women on the list, also an impressive assort-ment, including the novelist and playwright Susannah Rowson, "Mary" (Mercy?) Warren of Plymouth, Martha Washington, and the poet Sarah Morton. Although heavily from New England, there were strong contingents from New York and Philadelphia, and scattered subscribers from Virginia and Georgia. The volumes were published in Boston by the distinguished firm of Isaiah Thomas and E. T. Andrews.

Thus *The Gleaner* essays are a product of the intense years of the new republic. While they were written, the precedent-making First and Second Congresses met, the first presidential election was held, and the French guillotined a king and queen. The format of an essay series permitted Murray to experiment with a variety of genres with-out committing herself to any single one. She could attempt a novel, a chapter at a time, without bringing it to closure; she could insert the texts of two dramatic plays that received single performances on the Boston stage and supplement them by a defense of theatre-going (*Gleaner*, 1:224). She could write about the Universalist perspective on life (1:182ff), comment on politics, and develop an elaborate defense of female education and intellectual development. When she wrote on this last topic she was at her least derivative, her most forthright and original; her essays on this theme are the most vigorous and fresh. It is an easy guess that they came out of her own experience and frustrations.

The most succinct way of summarizing Murray's extended com-ments on women and intellect is to say that she wanted men to rec-ognize that women were capable of substantial intellectual achievement, and that she wanted women to understand that a seri-ous education would make authentic independence possible. In sup-port of the first point she wrote a series of essays that amounted to a brief history of women, in a form that dated back to Christine de Pisan's *City of Ladies*, which was a discursive and anecdotal, but roughly chronological, overview that rambled through the centuries identifying women of accomplishment from Semiramis to Mary Woll-stonecraft. Like Wollstonecraft, Murray often seems to write without an outline, pouring her ideas out as they came to her, and badly in

need of formal editing. But she is very clear as to her intentions: she wants her reader to share her conclusion that women are

> *First,* alike capable of enduring hardships.
> *Secondly,* Equally ingenious, and fruitful in resources.
> *Thirdly,* Their fortitude and heroism cannot be surpassed.
> *Fourthly,* They are equally brave.
> *Fifthly,* They are as patriotic
> *Sixthly,* As influential
> *Seventhly,* As energetic, and as eloquent
> *Eighthly,* As faithful, and as persevering in their attachments
> *Ninthly,* As capable of supporting, with honour, the toils of government. And
> *Tenthly, and Lastly,* They are equally susceptible of every literary acquirement. (*Gleaner,* 3:198)

"The idea of the incapability of women is, we conceive, in this *enlightened age,* totally *inadmissible."* (3:191).

Murray was as insistent as Wollstonecraft on the point that women should be educated for independence and psychological integrity. Although she did not refer directly to the political claims of the Revolution, the implicit message of much that she wrote was that the new republic required a new woman: "I expect to see our young women forming a new era in female history." (3:189). The new woman of the republic would be forthright and practical; she would not be attracted by passing fashion or by frivolity. She would be prepared for a world that might literally turn upside down, a world in which violent changes of fortune (like those John Stevens experienced) would be the rule rather than the exception. She did not shape her life around the marriage market; she did not consider an "old maid" a "contemptible object" (1:167–68). As a model, Murray provided a fictional Penelope (named, obviously enough, for a woman who had had to find a way to sustain herself without a husband), who sought to cultivate her own talents and in that way sustain her own "noble ardour of independence" (1:176). To that end, Penelope rises every morning at sunrise to study reading, music, drawing, and geography because they "polish my mind; and when I have made sufficient progress therein, they will open to me, should there be occasion, new sources of emolument as well as pleasure" (1:177). The rhetoric of republican virtue and independence provided the language for

her insistence on the need for women to avoid subservience and docility, the need for women to be self-supporting and self-respecting. When Murray wrote that a serious education would put women in an independent stance in the world, she could well have been thinking of the adversity that she herself had faced in marriages to men with far less financial security than her father had provided, and to her own situation when her husband was driven to desperate flight and then left her a young widow.

Murray urged a constitutional provision or congressional legislation to provide an award for "*real genius,* whether it be found in the male or female world" (*Gleaner,* 1:52). She satirized the man who announced that "subordination . . . is so essential to the character of a woman . . . I shall expect *obedience from my wife;* that she must not only be very well taught, *industrious,* and uniformly economical, but also extremely docile" (1:66). And over and over again she defended the "learned lady" from the charge that she was sexually unappealing, or neglected her duties.

The advantage of the periodical essay form was the permission it gave to inconsistency. Murray's stance, forthright and demanding when she addressed the theme of women's education, changed abruptly when she turned to politics. Her dedication of the *Gleaner* volumes to John Adams was sycophantic, her vision of the American political order anything but relativist. The arrangements made by the American Constitution were not for her political solutions to political problems; they were the "*lineaments of nature—the lineaments of liberty*" (1:271). When Washington became Commander in Chief, "Confusion fled at his approach; discipline ranged itself under his banners . . . simple untrained villagers became a regular army of brave, patient and effective soldiers!" (3:92).

Her view of political parties echoed a crude, high Federalist line; in April, 1794, she joined high Federalist hysteria: "Faction hath introduced its cloven foot among us . . . and, drawing the sword of discord, it is preparing to sheath it in the vitals of that infant constitution, whose budding life expands so fair to view . . . Is not the idea of murdering in the very cradle so promising an offspring, a conception which can have received a form only in the maddening pericranium of hell-born monarchy?" (1:256–57). Entering the debate on whether American treaties with France were still valid after the change in government, she was sure that American obligations had evaporated in the face of the reign of terror, and she moved easily from criticism of Robespierre (1:256) to the assertion that liberty is not licentiousness and that "sacred and genuine Liberty . . . is fond

of the necessary arrangement of civil subordination . . ." (1:266). She illustrated her point by a brief tale of the mess her fictional household is thrown into when a brief attempt is made to conduct it on the rule of equality (1:264–65). Her dismay at the French example apparently was so great that she could not see the contradictions into which she had been drawn.

When *The Gleaner* was published in book form in 1798, it was signed forthrightly as "Constantia." But that signature was a shift from the original voice, which had been explicitly male. When the essays first appeared, the author introduced "himself": "I am *rather* a plain man, who, after spending the day in making provision for my little family, sit myself comfortably down by a clean hearth, and a good fire . . ." (1:13). Not until the final installment, "The Gleaner Unmasked," did Judith Sargent Murray identify herself as the Constantia who had "filled some pages" in the *Boston Magazine* and the *Massachusetts Magazine*. Her readers were owed, she acknowledged, an explanation of "why I have endeavoured to pass myself upon them in the masculine character. . . ." Her response to her own rhetorical question was straightforward: "ambitious of being considered *independent as a writer*; if I possessed any merit, I was solicitous it should remain undiminished . . ." (3:314). Recognizing that she had no chance of being taken seriously if she wrote as a woman—"Rousseau had said, that although a female may *ostensibly* wield the pen, yet it certain some man of letters sits behind the curtain to guide its movements"— she was anxious to assure her readers that she kept her secret even from her own husband (3:314). She had taken to heart the advice of "a celebrated writer of the present century" who had observed that "a *woman* ought never to suffer a *man* to add a *single word* to her writings; if she does, the man she consults, let him be who he may, will always pass for the original inventor, while she will be accused of putting her name to the works of others" (3:315). In so misogynist a culture, "observing, in a variety of instances, the indifference, not to say contempt, with which female productions are regarded . . ." she even now feared that "it will be affirmed, that the *effeminacy* and *tinsel glitter* of my style could not fail of betraying me at every sentence which I uttered" (3:313). She wanted her readers to know that she had done all her work alone, even, she observed ruefully, "To the toil of writing letters to myself, I have been condemned . . ." (3:316).

Murray sought an authoritative authorial voice. "I confess I love the paths of fame / And ardent wish to glean a brightening name," she wrote in the opening epigraph. She hoped to find her model in the British classical journalists; she envied "the smoothness of Addi-

son's page, the purity, strength and correctness of Swift. . . ." Eventually she "took shelter" in the more modest promise of *The Gleaner*: "With diligence then, I shall ransack the fields, the meadows, and the groves [of literature] . . . deeming myself privileged to crop with impunity a hint from one, and idea from another, and to aim at improvement upon a sentence from a third. . . . in this expressive name I shall take shelter . . ." (1:13–16).

The political voice was so deeply understood to be specific to men, that a woman who wished to enter into the dialogue needed, as it were, to dress in men's clothes. The secret, however, was soon out, and Murray's columns were known to an increasingly wide audience as those of a woman (3:316).

Judith Sargent Murray remains a lucid exponent—perhaps the most vigorous single voice—of the ideology I have called republican motherhood: the position that women have an obligation, both to themselves and to the political society in which they live, to educate themselves for economic competence and intellectual growth. This venture was assumed by Murray and her contemporaries to represent a departure from traditional practice ("a new era in female history") and one that promised to strengthen family relationships as well as to satisfy female ambition. For perhaps the first time in western culture, members of Murray's generation acknowledged and even welcomed female ambition, offering it support *if* ambition developed in a context that also involved companionable relationships with husbands and tutorial relationships with children. The model republican mother would raise her children to be decent and public-spirited citizens, and thus by her private decisions strengthen the civic order in which she lived.[26] In the intensity of her insistence that a woman be trained to respect herself, to take pride in her own competence, and to be prepared to support herself, Murray reveals herself a member of a generation of survivors who found in her faith and her own ambition the strength to persevere.

When Judith Sargent Stevens committed herself to the support of the itinerant minister John Murray and the new Universalist Church, she acted with a group that was disproportionately female. This disproportion was not uncommon in Protestant churches; indeed Cotton Mather had long since commented that the ratio established at the Cross ("three Marys to one Christ") persisted in modern churches. Demographers have confirmed the pattern that Mather saw; Richard Shiels reports that the percentage of women among the new members of Congregational churches in Massachusetts increased sharply in the

early stages of the war, rising from a low of 54 percent in 1768 to a high of 72 percent in 1777.[27] Women seem to have been particularly receptive to other forms of religious revival and recruitment; they made up large numbers of new Methodists, for example. Methodism had a particular appeal to women because its rhetoric of method and system was congruent with the practical lives of housekeepers, and also because of the important place it gave to John Wesley's mother, Susannah, as a teacher and founder of the sect. Mother Ann Lee, founder of the Shakers, arrived in America on the eve of the Revolution with a message that included equal rights for women and an equal role for them in the Shaker community; her audiences were heavily female, as were those of Jemima Wilkinson, the "Publick Universal Friend."[28] For many women, excluded from formal schooling and with limited access to reading material, intellectual development took the form of religious contemplation. Evidence of this remains in diaries that are primarily summaries of religious pamphlets and the Bible; a major example of this genre are the diaries of Mary Moody Emerson, who filled thousands of pages with religious speculation and meditation.[29]

In this context, a pamphlet bearing the title *Women Invited to War*, published in Boston in 1787, is less idiosyncratic than appears at first glance.[30] The author identified herself as a "Daughter of America" and addressed herself to the "worthy women, and honourable daughters of America." She observed that "it is our lot to live in a time of remarkable difficulty, trouble, and danger . . . yet blessed be God, we have had the honour and favour of seeing our friends and brethren exert themselves valiantly in defense of life and liberty" (3). While the author wrote, the Constitution was being prepared and ratified; the pamphlet begins as a predictable political exercise.

But the author quickly moved away from politics and war to another enemy, Satan, "who has done more harm already, than all the armies of Britain have done or ever will be able to do . . . we shall all be destroyed or brought into captivity, if the women as well as the men, do not oppose, resist, and fight against this destructive enemy" (3).

As she wrote, her voice shifted and the argument became exhortation:

> Are there not many in America, unto whom the Lord is speaking, as to his people of old, saying, The spoil of the poor is in our houses . . . Thou hast despised mine holy things, and hath profaned my sabbaths . . . Because of swearing the land mourneth

> . . . The people of the land have used oppression, and exercised robbery, and have vexed the poor and needy . . . Hath not almost every sin which brought destruction upon Jerusalem, been committed in America? (7–9)

Then the "Daughter of America" assumed an unusual voice—the voice of the minister, speaking to the special responsibilities of women and articulating the murmur that men were more prone to sin than were women:

> But perhaps some of you may say, there are some very heinous sins, which our sex are not so commonly guilty of, as the men are; in particular the vile sin of drinking to excess, and also prophane swearing and cursing, and taking the great and holy name of God in vain, are practiced more by men than by women . . .

There was a paradox: the same men who were particularly guilty of sin were generally thought to be the leaders in religious affairs. She suspected her audience would assert "therefore let them rise up first . . ." (10). To this she responded that all were equal in Christ, that Eve had been made from Adam's rib to walk by his side—not from his foot, to be trampled underneath—and that "in the rights of religion and conscience . . . There is neither male nor female, but all are one in Christ." (12).[31]

In a few pages the author had moved from the contemplation of women in war emergencies to the argument that women ought to conduct their wars according to definitions that were different from men's; that the main tasks that faced the republic were spiritual rather than political; and that in these spiritual tasks women could take the lead, indeed that they had a special responsibility to display "mourning and lamentation" (13).

"Daughter of America" can be located in a long Christian pacifist tradition of opposition to war. This tradition competed with religiously grounded claims for "just wars." In the era of the American Revolution conscientious objectors often found it hard to distinguish themselves from Loyalists, for the practical outcome of both positions was the same: failure to resist British rule. Philadelphia Quakers sometimes crossed the line from pacifist neutrality into Loyalism; in New York and Massachusetts Mother Ann Lee's supporters were explicitly accused of Loyalism. John Murray apparently volunteered for a stint as minister to Nathaniel Greene's troops in order to dispel suspicions that Universalists were Loyalist. But within the traditional denominations, even those whose ministers made up the "black reg-

iment" of the patriot cause, there were many skeptics who saw the Revolution not as an occasion for patriotic enthusiasm, but as a sign of human depravity. Laurel Thatcher Ulrich has called our attention to the 1779 broadside "A New Touch on the Times . . . By a Daughter of Liberty, living in Marblehead." Molly Gutridge refused to make distinctions between Patriot and Tory. "For sin is all the cause of this, / We must not take it then amiss, / Wan't it for our polluted tongues / This cruel war would ne'er begun." Tongues polluted by swearing and a society permeated by sin were the natural breeding grounds of war.[32]

The roles and functions of Protestant churches in revolutionary America were sharply different from the roles and functions of the Catholic Church in revolutionary France. The rejection of the Church meant that French revolutionaries needed to invent their own alternate public spaces and their own public ritual. In doing so they developed the dramatic formulations described in the Levy and Applewhite essay in this volume: parades, mass oath-takings on the Champ de Mars, armed processions—in all of which women participated in a structured and dramatic fashion. This need for mass public creation of new rituals was muted in America, where churches were more likely to be prorevolutionary and where patriotic clergy voluntarily offered ritual dramatization in support of the Revolution.

In the aftermath of the war, many women continued to define their civic obligations in this religious way; the way to save the city, argued the "Daughter of America," was to purify one's behavior and pray for the sins of the community. By the early nineteenth century, women flooded into the dissenting churches of the Second Great Awakening, bringing their husbands and children with them, and asserting that their claim to religious salvation made possible new forms of assertive behavior—criticizing sinful conduct of their friends and neighbors, sometimes traveling to new communities and establishing new schools, sometimes widening in a major way the scope of the books they read. Churches also provided the context for women's benevolent activity. Despairing perhaps of the hope that secular politics would clear up the shattered debris of the war, religious women organized societies for the support of widows and orphans in a heretofore unparalleled collective endeavor.[33] If women were to be invited to war, they would join their own war and on their own terms.

In her galaxy of women worthies, Murray mentioned the unusual career of Patience Lovell Wright. Patience Wright enjoyed minor fame as a wax portraitist, a medium that now lingers on in the guise

LIBERTY I am, and Liberty is RIGHT
And Slavery do abolish, with all my Might.

FIG. 2. A determined Patience Wright carries a liberty pole and cap in this drawing by John Downman. (Courtesy Trustees of the British Museum.)

of garish "Madame Tussaud" tourist ventures but that was in the eighteenth century a fashionable and reasonably inexpensive way of creating a likeness. In 1772, possibly with the encouragement of Benjamin Franklin, she established her trade in London. She was, wrote Murray, "a profound politician," and eventually ruined her business by her too-obvious sympathies with the rebel cause.[34]

Murray only knew the rudiments of Wright's story, but if any life could have demonstrated the proof of Murray's warning that women should be prepared to make their own way in the world, it was the lives of Wright and her sister, Rachel Wells. Wells is one of the rare members of the artisan class whose life it is possible to reconstruct with some degree of detail, and who left us reasonably clear testimony about her commitment to the Revolution and what she expected from it.

An important clue to Wells's identity is embedded in her petition, in a paragraph in which she mentioned her "Sister Wright" and Wright's activities as a spy in London in the years before the war. Rachel Lovell Wells seems to have assisted her sister in exhibitions in Philadelphia, Charleston, and New York. In 1772, encouraged by a meeting with Benjamin Franklin's sister, Jane Mecom, Patience Lovell Wright set out for England to seek fame as a portraitist. Arriving at a time when tension with the colonies was high, and entering houses of the upper class for portrait sittings, Wright apparently was in a good position to overhear comments that would be useful to Benjamin Franklin, in his role as colonial agent. As might be expected, her sister overestimated Wright's contributions. ". . . how did she make her Cuntry her whole atention," Wells wrote in 1786. "her Letters gave us ye first alarm . . . She sent Letters in buttons & picturs heads to me, ye first in Congress atended Constantly to me for them in that perilous hour. . . ."

Included in the papers of Benjamin Franklin and John Adams are indeed a letter to each from Patience Wright, and she does appear to have done some smuggling of information. But her spying appears to have been of the most minor sort, and it is of interest to us primarily in that it clearly encouraged Rachel Wells to believe that her own claims on the republic could be made with special force because another member of her family had also served the Revolution.[35] "I think gentlemen that I can ask for my Intrust as an individual on Her account Now She is no more I onley want my one."

The story of Rachel Wells does not have a happy ending. Her letter to Franklin asking for funds for a burial plot in America for Wright seems to have gotten no response. Her petitions to the leg-

islature of New Jersey were read but apparently no action was taken. Still unsatisfied, she petitioned the Continental Congress; there too her petition was tabled.[36] When she came to draw up her will in 1795 she had only a modest amount of property to dispose of; her furniture and her "waring apriall" was divided among her sisters. Her share in a building in Bordentown went to her sisters and perhaps nieces. But she did not forget her claim: "if there be any moneys Left on bonds Standing out my will is that it be kept out for the Intrust & use of it for Sarah Wright and Rachel Finkings. . . ."[37]

III

It is the common sense of the matter that no group can expect specific benefits from a revolution unless it has, as a collective body, been a force in making that revolution happen. Women had indeed served in and supported the American Revolution—as individuals, not as groups—but in 1787 were not in a strong position to make collective demands as a group. Political republicanism in America rested heavily on a definition of citizenship that privileged men for qualities that distinguished them from women; "luxury, effeminacy and corruption" was as much a revolutionary-era triad as "life, liberty and happiness."[38] If there were opportunities in the republican order that women would find useful, they would have to seize their opportunities and transform them into reality. Rachel Wells was not the only woman who could claim, "I did my Posabels every way . . . Ive Don as much to help on this war as Though I had bin a good Soger."[39] But as an individual she had only the most marginal hope of influencing the government to grant her petition. The petition itself remained in the archives of the Continental Congress and the New Jersey legislature; it never received a form in which it could hope to shape public opinion.

Republican ideology was antipatriarchal in the sense that it voiced, as Tom Paine had accurately sensed, the claim of adult men to be freed from the control of male governors who had defined themselves as rulers and political "fathers" in an antique monarchical system. But republican ideology did not eliminate the political father immediately and completely; rather it held a liberal ideology of individualism in ambivalent tension with the old ideology of patriarchy.[40] The men who remodeled the American polity after the war remodeled it in their own image. Their anxieties for the stability of their construction led them, in emphasizing its reasonableness, its solidity,

its link to classical models, also to emphasize its manliness, its freedom from effeminacy. The construction of the autonomous, patriotic, male citizen required that the traditional relationship of women with unreliability, unpredictability, and lust be emphasized. Women's weakness became a rhetorical foil for republican manliness.[41]

When we encounter women of the American Revolutionary generation articulating the conclusions they had drawn from that experience, we find them saying that what women needed was psychological independence, personal self-respect, a decent self-sufficiency, and a life over which they exercised some measure of control. Rachel Wells believed she had a right not to be ignored and to have her debts paid; the author of *Women Invited to War* asserted that women could pray without waiting for men to lead them; and Judith Sargent Murray called for "self-complacency," for psychological and economic self-sufficiency. These were precisely the grounds on which Tom Paine in 1776 had expressed men's views of the common sense of the matter.

Men who developed the new republican formulations developed them out of extended negotiations and struggle with other men; they assumed that women's part in the equation would remain constant. For all the emphasis on the need of the republican citizen to control his own property, for example, it does not seem to have occurred to any male patriot to attack coverture. "Put it out of the power of our husbands to use us with impunity," wrote Abigail Adams, suggesting that domestic violence should be on the republican agenda, but John Adams did not place it there.[42] Pensions were provided for retired officers, not for their widows.

If women were to devise a republican ideology that provided for autonomy, they first would have to destabilize and then renegotiate their relationships with men. We can follow the course of this effort in the newly formulated understanding of courtship and marriage that appeared explicitly in advice literature and implicitly in fiction. Advice literature counseled "friendship" and mutual respect between husbands and wives; it became a point of pride for republican spouses to address each other as "friend."[43] Fiction portrayed a world in which virtue was female, and must always be on guard against trickery and seduction; Judith Sargent Murray was one among many writers who counseled young women to take control of their choices in the major life decisions open to them.[44] Only in fiction was a language developed that made it possible to hint at the idea that women might have *interests* that were different than those of men. Extensively published and widely read, fiction reached more minds than theoretical political

pamphlets, and was used by its readers to shape their understanding of the world in which they lived.

In short, women could not leave it to men to express what women thought of republican politics. It is interesting but frustrating to speculate on the course of affairs had Quaker women been part of the republican community from the beginning. Quakers were the single group of women already explicitly socialized to conducting their own institutions, negotiating with men on terms of at least rhetorical equality, and to speaking out loud in public to audiences of both sexes. But the pacifism of Quaker women meant that they remained outside the republic during the war years, aligned, for the most part, with Tories. With the rest of their fellow believers, it would take time for them to regain credibility. The role that Lucretia Mott and others of her generation played in the 1840s in articulating the claims of women on the republic and in educating the next generation to a women's criticism of the Constitution and the law suggests that republican ideology was ambivalent from the beginning, but in ways that only the trained eye could see, and the voice that might have articulated a criticism lacked political credibility. Not even Tom Paine, though he came close, could comprehend that "common sense" was gendered.

Notes

1. May 18, 1786, *Papers of the Continental Congress,* Microfilm 247, Roll 56, Item 42, 8:354–55. National Archives.

2. Reprinted in Darline Gay Levy, Harriet Branson Applewhite, and Mary Durham Johnson, eds., *Women in Revolutionary Paris, 1789–1795* (Urbana: University of Illinois Press, 1979), 22–26.

3. On women's processions to the Eglise Sainte-Geneviève, see Harriet B. Applewhite and Darline G. Levy, "Responses to the Political Activism of Women of the People in Revolutionary Paris," in *Women and the Structure of Society,* ed. Barbara J. Harris and JoAnn K. McNamara (Durham, N.C.: Duke University Press, 1984), 215–31. On Quaker women, see Mary Maples Dunn, "Saints and Sinners: Congregational and Quaker Women in the Early Colonial Period," *American Quarterly* 30 (1978): 582–601.

4. "Rewriting History," in *Behind the Lines: Gender and the Two World Wars,* ed. Margaret Randolph Higonnet, Jane Jenson, Sonya Michel, Margaret Collins Weitz (New Haven: Yale University Press, 1987), 25–26.

5. See the useful introductory comments of Jack P. Greene, ed., *Colonies to Nation, 1763–1789: A Documentary History of American Life* (New York:

McGraw-Hill, 1967), 268–70. But also see Ceceila M. Kenyon, "Where Paine Went Wrong," *American Political Science Reivew* 41 (1951): 1086–99.

6. Edwin G. Burrows and Michael Wallace, "The American Revolution: The Ideology and Psychology of National Liberation," *Perspectives in American History*, 1st ser., 6 (1972): 167–308.

7. *Thomas Paine Reader*, ed. Michael Foot and Isaac Kramnick (Harmondsworth, England: Penguin Books, 1987), 79.

8. It is important, perhaps, to point out that despite the gendered subtext, Paine's work appealed to women as well as to men. We know, for example, that Abigail Adams (AA) admired his pamphlets and circulated them to her friends. She referred to *Common Sense* as "a Book [which] . . . carries conviction wherever it is read. I have spread it as much as it lay in my power, every one assents to the weighty truths it contains. I wish it could . . . be carried speadily into Execution." AA to John Adams (JA), 21 February 1776, *Adams Family Correspondence* (hereafter *AFC*), ed. L. H. Butterfield (Cambridge, Mass.: Harvard University Press, 1963), 1:350. See also AA to JA, 2 March 1776, *AFC* 1:352 and AA to JA, 7 March 1776, *AFC* 1:354. She was considerably more enthusiastic than was her husband, whose response was ambivalent: "Sensible Men think there are some Whims, some Sophisms, some artfull Addresses to superstitious Notions, some keen attempts upon the Passions, in this Pamphlet. But all agree there is a great deal of good sense, delivered in a clear, simple, concise and nervous Style. . . . Indeed this Writer has a better Hand at pulling down than building." JA to AA, 19 March 1776, *AFC* 1:363. In 1780, when the *American Crisis* essays were reprinted in Boston newspapers, AA quoted from them in her letters; see AA to JA, 5 July and 16 July 1780, *AFC* 3:371, 376.

9. Burrows and Wallace, "American Revolution," 206–13.

10. Burrows and Wallace, "American Revolution," 215, citing *The Crisis, III.*

11. For an important review of recent argumentation about the tensions implicit in early American political ideology—a review that does not, however, include considerations of gender—see James T. Kloppenberg, "The Virtues of Liberalism: Christianity, Republicanism, and Ethics in Early American Political Discourse," *Journal of American History* 74 (1987): 9–33, especially 30–33. See also Ruth Bloch, "The Gendered Meanings of Virtue in Revolutionary America," *Signs: Journal of Women in Culture and Society* 13 (1987): 98–120.

12. Joan R. Gundersen, "Independence, Citizenship, and the American Revolution," *Signs: Journal of Women in Culture and Society* 13 (1987): 75, 77. See also Elaine F. Crane, "Dependence in the Era of Independence: The Role of Women in a Republican Society," in *The American Revolution: Its Character and Limits*, ed. Jack P. Greene (New York: New York University Press, 1987), 253–75.

13. I have discussed the implications of this in chapters 4 and 5 of *Women of the Republic*; see also Marylynn Salmon, *Women and the Law of Property*

in Early America (Chapel Hill: University of North Carolina Press, 1986) and Michael Grossberg, *Governing the Hearth: Law and the Family in Nineteenth Century America* (Chapel Hill: University of North Carolina Press, 1985).

14. See Billy G. Smith, "The Material Lives of Laboring Philadelphians, 1750 to 1800," *William and Mary Quarterly,* 3d ser., 38 (1981): 163–202; Carole Shammas, "The Female Social Structure of Philadelphia in 1775," *Pennsylvania Magazine of History and Biography* 107 (1983): 69–84.

15. "Unskilled workers and their families in Philadelphia generally lived on the edge of, or occasionally slightly above, the subsistence level; simply to maintain that level both spouses had to work." Smith, "Material Lives," 189.

16. On the basis of the poorhouse list for Salem, Massachusetts, Elaine Crane argues that the Revolutionary War years saw a massive increase in the number of women unable to provide for themselves. "Dependence in the Era of Independence: The Role of Women in a Republican Society." Sharon Salinger finds that two-thirds of the residents of the Philadelphia poorhouse between 1787 and 1790 were women. "Female Servants in Eighteenth Century Philadelphia," *Pennsylvania Magazine of History and Biography* 107 (1983): 45. Robert E. Cray is less impressed by gender disparities among poor New Yorkers in the eighteenth century: see *Paupers and Poor Relief in New York City and Its Rural Environs, 1700–1830* (Philadelphia: Temple University Press, 1988), esp. 59.

17. E.g., Eleanor Garvin, "an Idle disorderly person not following any employment for an honest livelyhood." 8 June 1797, Prison Vagrancy Docket, 1790–1797, Philadelphia City Archives, RG 38.44. Nowhere does the occupational segregation by sex that prevailed in the early republic show up more sharply than in apprenticeship contracts, which indicate that boys and girls were apprenticed to different crafts, and which reveal substantial distinctions in the amount of schooling offered. As Alfred Young has shown for Boston, the ways in which a woman could be self-supporting were severely limited. A sharp contrast in apprenticeship records in all cities and towns is the disparity in skills that prospective masters offered male and female apprentices. A standard feature of apprenticeship contracts for boys was that by the completion of their term they were to have been taught a trade and have had some schooling; girls' contracts rarely promised to teach more than housework. See, for example, the apprenticeship list reprinted in the Pennsylvania German Society, *Proceedings and Addresses* 16 (1905); Philadelphia City Archives, Guardians of the Poor: Memorandum Book, Indentures 1751–1797.

18. Jürgen Habermas, "The Public Sphere: An Encyclopedia Article (1964)," *New German Critique,* no. 3 (Fall, 1974): 49–55, and Jürgen Habermas, *The Structural Transformation of the Public Sphere: An Inquiry into a Category of Bourgeois Society,* trans. Thomas Burger (Cambridge, Mass.: MIT Press, 1989), esp. 27–56. I am indebted to Michael Warner's formulations of this development in an American context. See "The Letters of the Republic: Literature

and Print in Republican America" (Ph.D. diss., Johns Hopkins University, 1985), and "Printing, 'The People' and the Transformation of the Public Sphere," unpublished paper, Organization of American Historians, Annual Meeting, 1988. For an effort to apply Habermas's conceptualizations to the era of the French Revolution, see Joan B. Landes, *Women and the Public Sphere in the Age of the French Revolution* (Ithaca: Cornell University Press, 1988), esp. Introduction and chap. 2.

19. Another was Gertrude Meredith of Philadelphia, who published in the *Portfolio* in the first decade of the nineteenth century.

20. Edward Countryman, *A People in Revolution: The American Revolution and Political Society in New York 1760–1790* (Baltimore: Johns Hopkins University Press, 1981), 288–89.

21. I am grateful to Gary Nash for his suggestions on this point.

22. *Ladys Magazine* (Philadelphia) 1 (1792): 192–93.

23. *Ladys Magazine* 1 (1792): 197.

24. Vera Bernadette Field, *Constantia: A Study of the Life and Works of Judith Sargent Murray, 1751–1820*, University of Maine Studies, 2d ser., no. 17 (Orono, Me.: 1931), 17–21. On John Murray's Universalism, see Richard Eddy, *Universalism in America: A History* (Boston: Universalist Publishing House, 1891); Russell E. Miller, *The Larger Hope: The First Century of the Universalist Church in America 1770–1870* (Boston: Unitarian Universalist Association, 1979), 34–51. On the continuing and distinctive appeal of Universalism to women, see Judy Nolte Lensink, ed., *"A Secret to Be Burried": The Diaries of Emily Hawley Gillespie* (Iowa City: University of Iowa Press, 1989).

25. The phrase is quoted in Janet Wilson James, "Judith Sargent Murray," in *Notable American Women*, ed. Edward T. James and Janet Wilson James (Cambridge, Mass.: Harvard University Press, 1971), 2:603–5.

26. Linda K. Kerber, *Women of the Republic: Intellect and Ideology in Republican America* (Chapel Hill: University of North Carolina Press, 1980) and "The Republican Mother: Women and the Enlightenment—An American Perspective," *American Quarterly* 28 (1976): 187–205. See also Jan Lewis, "The Republican Wife: Virtue and Seduction in the Early Republic," *William and Mary Quarterly*, 3d ser., 44 (1987): 689–721.

27. Richard D. Shiels, "The Feminization of American Congregationalism," *American Quarterly* 33 (1981): 46–62.

28. See the thoughtful discussions of Ann Lee and Jemima Wilkinson in Ruth H. Bloch, *Visionary Republic: Millennial Themes in American Thought, 1756–1800* (Cambridge: Cambridge University Press, 1985), 88–91, and in Stephen A. Marini, *Radical Sects of Revolutionary New England* (Cambridge, Mass.: Harvard University Press, 1982), *passim*.

29. Her extensive diaries, almanacs, and commonplace books are in the collection of the Emerson Family Papers, Houghton Library, Harvard University. See particularly Phyllis Cole, "The Advantage of Loneliness: Mary Moody Emerson's Almanacks, 1802–1855," in *Emerson: Retrospect and Prospect*,

ed. Joel Porte (Cambridge, Mass.: Harvard University Press, 1983), 1–32. See also the extended diaries of Elizabeth Drinker, Historical Society of Pennsylvania.

30. This pamphlet had traditionally, but unreliably, been ascribed to the historian Hannah Adams.

31. This is a common image for eighteenth- and nineteenth-century feminists to use; see, for example, [A Lady], *Female Advocate* (New Haven, 1801), 30; see also 19–20.

32. For clerical support of the Revolution, see Patricia U. Bonomi, *Under the Cope of Heaven: Religion, Society, and Politics in Colonial America,* (New York: Oxford University Press, 1986), 209–16; Laurel Thatcher Ulrich, "'Daughters of Liberty': Religious Women in Revolutionary New England," in *Women in the Age of the American Revolution,* ed. Ronald Hoffman and Peter J. Albert (Charlottesville: University Press of Virginia, 1989), 228–35.

33. For the career of one woman whose life was changed in this way, see Samuel Worcester, *The Christian Mourning with Hope: A Sermon . . . on the Occasion of the Death of Mrs. Eleanor [Read] Emerson . . . to which are Annexed Writings of Mrs. Emerson* (Boston: Lincoln and Edmonds, 1809). I discussed this episode more extensively in "Can a Woman Be an Individual? The Limits of Puritan Tradition in the Early Republic," *Texas Studies in Literature and Language* 25 (1983): 165–78. See also Anne M. Boylan, "Life Cycle Patterns Among Organized Women in New York and Boston, 1797–1840." *American Quarterly* 38 (1986): 779–97.

34. Constantia, [pseud.], *The Gleaner: A Miscellaneous Production* (Boston: I. Thomas and E. T. Andrews, 1798), 2:284–88.

35. Charles Coleman Sellers, *Patience Wright: American Artist and Spy in George III's London* (Middletown, Conn.: Wesleyan University Press, 1976), chaps. 5, 6, *et passim*; [Rachel Wells] to Benjamin Franklin, 16 December 1785, American Philosophical Society. I am grateful to *The Papers of Benjamin Franklin,* Yale University, for this reference.

36. See "Votes and Proceedings," 10th General Assembly, New Jersey Legislature, New Jersey Archives, Trenton.

37. Will of Rachel Wells, item 11709C, New Jersey Archives, Trenton. A "List of Ratables" for Chesterfield Township, Burlington County, the same year includes Rachel Wells as an individual householder with a house and lot valued at 12 pounds; her tax was 4 shillings 3 pence, which ranked her modestly in the town but not at the very bottom. She had no horses, cattle, nor slaves.

38. See, for one among many examples, George Washington to James Warren, 7 October 1785, *Writings of Washington, From the Original Manuscript Sources,* 1745–1799, ed. John C. Fitzpatrick (Washington, D.C.: U.S. Government Printing Office, 1931–44), 28:290.

39. "Rachel Wells Petition for Relief," 15 November 1785, New Jersey Archives, Trenton.

40. Thus George Washington quickly became the "father of his country"; at the Governor's Palace in Williamsburg, Virginia, the life-size portrait of George III was quickly replaced by a life-size portrait of Washington in the same pose.

41. See Christine Stansell, *City of Women: Sex and Class in New York 1789–1860* (New York: Knopf, 1986), 20–26, and Linda K. Kerber, *Women of the Republic: Intellect and Ideology in Revolutionary America,* (Chapel Hill: University of North Carolina Press, 1980), 31.

42. Nancy F. Cott, "Passionlessness: An Interpretation of Victorian Sexual Ideology, 1790–1850," *Signs: Journal of Women in Culture and Society* 4 (1978): 219–36.

43. See, for example, the comments in Lynne Withey, *Dearest Friend: A Life of Abigail Adams* (New York: Free Press, 1981). The transition from "My dearest girl" to "My friend" can be traced in the correspondence of Albert and Hannah Nicolson Gallatin, *Papers of Albert Gallatin,* Microfilm Reel 3, New-York Historical Society.

44. I have developed this point in chapter 8 of *Women of the Republic.* See also Jay Fliegelman, *Prodigals and Pilgrims: The American Revolution Against Patriarchal Authority 1750–1800* (New York: Cambridge University Press, 1982); Cathy Davidson, *Revolution and the Word: The Rise of the Novel in America* (New York: Oxford University Press, 1987); and Jan Lewis, "The Republican Wife: Virtue and Seduction in the Early Republic," *William and Mary Quarterly* 44 (1987): 689–721; and Carroll Smith-Rosenberg, "Engendering Virtue," in *Literature and the Body: Essays on Populations and Persons,* ed. Elaine Scarry (Baltimore: Johns Hopkins University Press, 1988).

Looking Back: Women of 1848 and the Revolutionary Heritage of 1789

Laura S. Strumingher

In response to the February Revolution of 1848, women writers, teachers, musicians, and artists, most of whom had participated in Saint-Simonian or Fourierist circles, met to formulate a response to the radically changed political climate. They were soon joined by groups of poor women whose immediate needs for jobs and child care became the focus of discussion. The optimism of the first weeks of March soon gave way to gritty determination as the government failed to include women in the planned expansion of suffrage, education, and jobs. Eugénie Niboyet, Jeanne Deroin, Gabrielle d'Altenheym Soumet, Desirée Gay, Suzanne Voilquin, Elisa Lemonnier, and others who sought solutions were determined to develop a course of action that would speak to the material, moral, and intellectual needs of all women.

In seeking to design their future, the women of 1848 looked to their past, specifically to the thoughts and actions of women in the Revolution of 1789, to learn from the successes and failures of their predecessors. In calling up the memories and histories of the earlier Revolution, Niboyet and her contemporaries reinterpreted, redefined, and created new images of women revolutionaries as part of their struggle to define themselves and their response to the challenges of 1848.

Though limited in their ability to assess women's actions in the previous Revolution by the incomplete and often misleading information that was available to them, women at mid-century were propelled by the sudden overthrow of the July Monarchy to search their memories and their histories for precedent that they could use to bolster their cause. Because they found the record wanting, they reformed it to meet their vision. For example, they claimed the moral

courage of Madame Roland as their own, while rejecting the subor-
dinate role for which she was valued by her male biographers. They
reclaimed Olympe de Gouges as an inspiring revolutionary fore-
mother, though she was routinely discounted as a charlatan by biog-
raphers. Finally, despite the unanimous denunciation of groups of
women revolutionaries—depicted in both images and texts as hags
and "furies"—the women of 1848 remained firm in their belief that
group solidarity was necessary to establish women's influence in the
political arena.

The dual response of the women of 1848—partial acceptance
and redefinition of the record—to the women of 1789 is also visible
in the statement of purpose of the *Voix des femmes* (*Voice of Women*),
one of hundreds of newspapers that burst into print in response to
the Revolution. On March 19, the editors declared: "The *Voix des
femmes* is the first and only serious tribune that is open to women.
Their moral, intellectual and material interests will be openly sup-
ported here and in the name of this goal we hereby issue an appeal
to all for sympathy and support."[1] Despite the claim, the *Voix des
femmes* was not the first and only serious tribune open to women. No
one knew that better than Eugénie Niboyet, the editor, who had pre-
viously edited the *Conseiller des femmes* (1834) and had been part of the
circle of contributors to the *Gazette des femmes* (1836). Among the con-
tributors to the *Voix* were the former editors of the *Tribune des femmes*
(1832–34) and others who contributed regularly to the *Journal des
femmes* (1830–51).[2]

Why did the editors of the *Voix* assert that they were the first and
only serious tribune open to women? Did they see their struggle as
part of a revolutionary tradition or, as their rhetoric would imply, as
something fundamentally different? This essay will introduce the
women leaders of 1848; show what they knew about their predeces-
sors, through a study of texts widely available in the 1830s and 1840s;
and analyze the references to women of the first French Revolution
in the *Voix des femmes* and other feminist writings of mid-century.
Understanding how the women of 1848 interpreted the tradition of
1789 to fit their own revolutionary agenda will explain the curious
reference to the *Voix* as the "first and only serious tribune open to
women."

The most influential of the women leaders of 1848 was Eugénie
Mouchon Niboyet. She was born in Montpellier in 1796 to a pros-
perous Protestant family whom she described as liberal. Eugénie's
father was a doctor, her grandfather a Swiss pastor. In 1822 she

married Paul-Louis Niboyet, a lawyer from a solidly bourgeois Prot-
estant family in Lyon. Nelly Lieutier, a close friend, described the
Niboyets as a model husband and wife.[3] Nevertheless, Eugénie led
an atypical, independent life for a middle-class woman of her era. In
later life, she claimed that she began to earn her living by writing as
early as 1830. Though Niboyet professed to believe in the idea that
woman's natural role in society was to be the moral guardian, rather
than the breadwinner, her own activities clearly did not fit her model
neatly.

Niboyet ventured into the world outside her home by writing
essays that she submitted to the *Société de la Morale Chrétienne*. Her first
essay on educating blind children shared a 1,000 franc prize, won
recognition from four other societies, and was translated into English
and German. Her next essay on the abolition of the death penalty
was also well received. Soon she was asked to join the *Société* where
she devoted particular energies to the prison reform committee. She
worked with Mmes. Lasteyrie (daughter of Lafayette) and Lamartine
and in a short time she was named Secretary General of the *Société*.

Niboyet was also attracted to Saint-Simonian circles. She was ap-
pointed chief of their chapter in the fourth *arrondissement* of Paris, the
only woman to achieve this distinction. Niboyet enthusiastically en-
dorsed the Saint-Simonian view that women, far from being blamed
for original sin, should be valued as men's moral guide through life.
But she parted company from the group that advocated "free love."
Niboyet was profoundly influenced by the Saint-Simonian concept
that progress could and should be achieved through industry, not
through conflict. In addition to her work on women's newspapers,
in 1844, following the International Pacifist Congress meeting in
London, Niboyet founded the first group of French pacifists and
launched another journal, *La Paix des deux mondes*. In this endeavor
she collaborated with Emile Souvestre, Michel Chevalier, and the
Countess Oleskewicz.

Niboyet's commitments to peace, prison reform, and the
improvement of education were complemented by her skills as a
translator. It is due to her efforts that Charles Dickens first appeared
in French. She also translated the work of Lydia Maria Child and
Maria Edgeworth. Niboyet also wrote several children's books: *Sou-
venirs d'Enfance, Cathérine II et ses filles d'honneur, les Deux frères, Dieu
manifesté par les oeuvres de la création*.

In 1848, Eugénie Niboyet was poised for leadership of the group
that was to become the Society of the *Voix des femmes*. She had ties to

the Saint-Simonian world, as well as to literary women, who special-ized in children's books, women's books, and works of moral reform; she also had substantial experience as a group leader. In reminiscing about what she came to call the worst year of her life—1848—she lamented: "I followed my principles; I had courage; it was my mis-fortune, the task was beyond my strength."[4] Niboyet died in Paris in 1883, having spent her last years struggling to earn a living.

Another of the central figures of 1848 was Jeanne-Françoise Deroin. Born in Paris on December 31, 1805, Jeanne witnessed the events of 1814, 1815, 1830, and 1848 before she chose exile rather than risk further imprisonment in 1852. Jeanne spent her youth as a seamstress while attending meetings of Saint-Simonians, Fourierists, and Cabetists. She was a self-taught woman who believed deeply in the abolition of all remaining privileges based on birth, including exclusive education; she also believed firmly in the equality of men and women.[5] In 1832 she married Desroches, a civil servant whom she had met at Saint-Simonian meetings. They had three children in the next few years; Jeanne devoted her time to caring for and edu-cating them. Her interests soon expanded to include the needs of other poor children. She opened a neighborhood school and began the long process of taking exams to qualify for a teaching license, which was delayed as much for her faulty orthography as for her deist views.

In 1848 Jeanne decided to assume a public role in the struggle for women's freedom. She reclaimed her maiden name in order not to implicate Desroches in her activities, a strategy that was not alto-gether effective. Deroin was clear in her demands: she wanted women to have the right to vote and the right to hold elective office; she demanded equal pay for equal work; and she demanded a maximum work day of eight to ten hours. Deroin was a frequent contributor to the *Voix des femmes*. After its demise she collaborated in the ephemeral *Politique des femmes* and then edited the *Opinion des femmes* until it was closed in August, 1849. During that time she also worked with Pauline Rolland to establish the Association of Socialist Teachers, unsuccess-fully ran for office in the elections of May, 1849, and collaborated on the development of the Fraternal Association of Democratic Socialists of Both Sexes for the Liberation of Women. Deroin was arrested on May 29, 1850, for her role in organizing the Union of Workers' Asso-ciations. She spent several months in prison. When she was released, she took the advice of friends and fled to permanent exile in England.

Shortly before her death in 1894 she explained that when she

came forward in 1848 it was not because she thought she had the talent for public debate, but rather because she was propelled to act out of her strong convictions. At the age of 70 she expressed both her convictions and her regrets in a letter to Leon Richer: "The love of justice and truth has not weakened in me, but one must have the skill to express one's convictions in a manner that will penetrate' souls."[6]

The identity of another important member of the inner circle of the *Voix des femmes,* Jeanne-Marie, remains uncertain. It is possible that she is Jeanne-Marie Fabienne Poinsard, born in Besançon in 1809, the daughter of Jean-Pierre Poinsard, a Lutheran from the nearby village of Héricourt, and his second wife, Marguérite-Alexandrine Brenet, of Swiss Calvinist origins. In 1832 Jeanne-Marie Fabienne Poinsard married Michel-Gabriel-Joseph Marie, an employee at the Palais Bourbon in Paris; they separated four years later.[7]

In February, 1848, Jeanne-Marie, using her given names only, organized a society of thirty women to claim civil enfranchisement, to establish in every *arrondissement* an evening school for workers of both sexes, and to influence the elections. Jeanne-Marie was also vice-president of the Society of the *Voix des femmes.* In 1860, Jeanne-Marie Fabienne Poinsard, writing under the name Jenny P. d'Héricourt, published *La femme affranchie: réponse à MM Michelet, Proudhon, E. de Girardin, A. Comte et aux autres novateurs modernes.* This book asserted women's right to respond to a variety of theories on the social relations of the sexes put forward by major male writers of the 1840s and 1850s. Nine years later, still using the name Jenny d'Héricourt, Jeanne-Marie Fabienne Poinsard published a thinly veiled memoir in *The Agitator,* a Chicago-based women's rights newspaper.

A fourth member of the *Voix des femmes* inner circle, Jeanne Desirée Veret Gay, was born in Paris on April 4, 1810, and died in exile in Brussels about 1890. Desirée Veret was the daughter of workers and was herself trained as a seamstress. She was attracted to Saint-Simonian circles in 1832 and later joined the Fourierist group. She was the co-founder, with Marie Reine Guindorf, of the *Tribune des femmes,* in 1832.[8]

A year later Desirée went to England to work as a seamstress and remained there for four years. It was during this time that she made contact with the Owenites. After returning to France, she married Jules Gay, a French Owenite. They had two sons: Jean, born in 1838, and Owen, in 1842. Concern for her own children's education soon

prompted Desirée Gay to set up an Institute for Childhood, but in this endeavor she met with failure. Desirée Gay was more successful in organizing workshops for women workers during the spring of 1848. She was an elected delegate of the women workers of the second *arrondissement* and head of the women's National Workshop of La Cour des fontaines. She was ousted from her position by the Minister of Public Works because of her repeated demands for more work for women.[9]

Following the debacle of June, 1848, Desirée Gay put her efforts into the short-lived *Politique des femmes* and continued to work for the improvement of education and for better working conditions for all workers. She went into exile during the Second Empire because of her husband's fears of reprisal for political activities. She died alone, nearly blind, and poor.

Like the women mentioned above, Suzanne Voilquin rallied to Eugénie Niboyet and the *Voix des femmes* in 1848. Suzanne was born in Paris in December, 1801, the third daughter of Raymond Monnier, a hatmaker and revolutionary. Despite her father's political sentiments, Suzanne attended school at the Sisters of St. Vincent for four years and remained deeply religious for a long time. In 1821, Suzanne's mother, who had been ailing for many years, died of cancer, which she had hidden from her doctor and her family out of modesty. Suzanne reacted to the news by declaring her intention to become a doctor, to treat women. But medical training was closed to women and Suzanne took up more traditional women's work; she became a seamstress.[10]

In the mid-1820s, after having been seduced and abandoned once, Suzanne was simultaneously introduced to Voilquin and Saint-Simonianism through her sister and new brother-in-law, Charles Mallard. Suzanne soon married Voilquin and the four lived together, becoming part of the Saint-Simonian family. In 1832 Suzanne rallied to the group of "femmes prolétaires" contributing to the *Tribune des femmes*. It was during this time that her husband, acting in accord with Saint-Simonian principles, left her and went to live in New Orleans with a new wife.

In 1834 Suzanne left for Egypt as part of the Saint-Simonian group whose members were searching for a female messiah. It was there that she finally began to take lessons in medicine. Disguised as a man, she took classes in a hospital and earned a certificate establishing her credentials as a midwife. Suzanne returned to France. Unable to earn sufficient funds for herself, her aging father, and an

adopted niece, she decided to go to Russia to work. She spent seven years in St. Petersburg. Frequently ill due to the harsh climate, she nonetheless managed to support herself and her family as a midwife. She returned to Paris in 1847 and tried unsuccessfully to establish a center for wet nurses. A year later she tried to form a midwives association with support from the Provisional Government. Suzanne Voilquin died in poverty in January, 1877, after several failed attempts to earn a modest income in New Orleans and finally in Paris.

Elisa Lemonnier, who was born Marie-Juliette Grimailh on March 24, 1805, in Sorèze and died in Paris on June 5, 1865, was, like Voilquin, devoted to the cause of working women.[11] Elisa was the daughter of Jean Grimailh and Etiennette Rosalie Aldebert, both of established families in the Tarn. Like Niboyet's family, Elisa's parents were liberal, Protestant, and devoted to helping others. Elisa's education was unusually good for the time and was enriched by substantial contact with her cousin, Madame Saint Cyr de Barrau, who encouraged the apt pupil.

In 1831 Elisa married a young professor of philosophy and student of law, Charles Lemonnier. Through her husband, Elisa was introduced to Saint-Simonian ideas. She became a strong supporter of the "new religion" until the schism over the issue of free love caused her estrangement from many former friends. The Lemonniers spent most of the years between 1832 and 1848 in Bordeaux, where he practiced law and they devoted themselves to living by Saint-Simonian principles. The Lemonniers had three children, of whom two, Paul and Louis, grew to adulthood.

By 1848, the Lemonniers were back in Paris, and Elisa joined the group meeting in Niboyet's home. The women encouraged Elisa's efforts to set up a sewing shop, which provided work for 200 mothers for two months. This was the first step towards her later creation of vocational schools for girls. Unlike all the women mentioned previously, Lemonnier was not in political trouble during the Second Empire. She worked on the plans and then on the establishment and running of her schools until her death.

The *Voix des femmes* was also enriched by the lyrical voice of Gabrielle d'Altenheym Soumet, illegitimate daughter of the celebrated poet, Alexandre Soumet, and Mme Blondel de la Rougerie.[12] Gabrielle Soumet was born in Paris on March 17, 1814, and died in the capital in May, 1886. Like her contemporary Delphine Gay (Girardin), Gabrielle achieved renown as a young poet in the literary salons of Paris. In 1834 she married d'Altenheym, who later became

inspector General of Public Instruction. In the early 1840s Gabrielle collaborated with her father on several plays and achieved fame for her theatrical writing as well as her poems. In 1848 Gabrielle d'Altenheym Soumet became a member of the central committee of the *Voix des femmes*. She contributed several articles to the newspaper professing the right to divorce, eloquently supporting the tradition of liberty, and reporting on the Citizens' Club organized by Cabet. Her contributions were often signed G. S. and were initially confused with the work of her more famous contemporary, Georges Sand. But, unlike Georges Sand, Gabrielle Soumet was proud to declare affiliation with women who were working for improved conditions for all women.[13] Following the Revolution, Gabrielle Soumet resumed her career as an author, publishing poems, stories, and many volumes of history aimed at the edification of young children.

The brief biographical sketches above suggest that the women leaders of 1848 were a diverse group who were better educated and more engaged with the social questions of their day than most of their contemporaries. All had previous experience with the major issues of importance to women through their own literary efforts. Like most of their generation, the women discussed above probably heard stories about family members who participated in the Revolution or whose lives were affected by the events of 1789–95. These stories formed the oral lore of their childhood; their echoes, regretfully, are largely lost to us. Family lore, however, was augmented by a growing literature about famous revolutionary women and by the publication of the memoirs and letters of Madame Roland. Trying to determine what the women of 1848 knew about the women of 1789 is fraught with methodological problems. Nevertheless, an obvious starting point in a study of literate women is the books they were likely to have read.

The works available to the generation of 1848 can be subdivided into several types whose messages complemented each other. First, there are the general books about the French Revolution, which include descriptions of individual women and of groups of women. These include the multivolumed works by Guizot, Michelet, and Lamartine.[14] Though all are of interest to the historian, it is Lamartine's *Girondins,* with its lyrical and detailed portraits of Marie Antoinette, Madame Roland, and Charlotte Corday, that probably contributed most to the education of Niboyet and her contemporaries regarding the question of foremothers. Lamartine's Marie Antoinette, far from being the Austrian enemy, "had the heart of a hero,"

which she demonstrated repeatedly in her attempts to protect her son and her husband. His Madame Roland, while "beaming with genius," was likewise noteworthy because of a virtuous heart. As in the portrait of Marie Antoinette, Lamartine found Madame Roland's devotion to her husband exemplary. However, he was moved to note the inner conflict that this produced in Madame Roland's memoirs: "I buried myself in my husband's work; I became his proof-reader; I fulfilled this task with humility . . . I respected my husband so much that I loved to believe that he was superior to me. . . ." Lamartine, with poetic license, pictured Madame Roland, during the long meetings of the Girondins that took place in her home, sitting outside the circle engaged in some form of hand work while "biting her lips to repress her thoughts." Thus, both Marie Antoinette and Madame Roland were presented to Lamartine's readers as women who rose to the occasion of revolutionary events. Their political views were secondary to their courage in times of crisis and their loyalty to husbands and family.[15] These were images that would confirm the experiences of Niboyet and her friends. But, as we shall see, they were not sufficient to inspire the revolutionary movement.

In the portrait of Charlotte Corday, the pattern repeats itself with even greater clarity, since it can be set against the historical reality of Corday's bloody political act. Lamartine's poetic skills are marshalled to create a sympathetic portrait of the young women. He points out that Charlotte was a descendant of the much-revered Corneille. Poets and heroes resemble each other in Lamartine's text, "the ones do what the others have conceived." And later on he notes, "her soul was visible on her face which foresaw her tragic destiny." Lamartine's Charlotte Corday could feel the terror hovering over Paris and was destined to act. She took the inspiration for her act from the underlined passages in her Bible: "Judith came out of the city adorned with marvelous beauty, a gift from the Lord, to deliver Israel." Ironically, women of 1848, while denouncing violence, chose to revere Charlotte Corday.

The second type of literature available during the July Monarchy belongs to the genre of women worthies, anthologies devoted to biographies of great women throughout the ages. These works sometimes included brief references to women who participated in the French Revolution. The most influential of this genre was Alexandre Joseph de Ségurs *Les Femmes, leur condition et leur influence dans l'ordre social chez differents peuples anciens et modernes,* first published in 1803 and reissued regularly twelve times through 1836.[16] *Les Femmes* presented a portrait

of womanhood as well as a cameo portrait of Charlotte Corday: "Born of honest parents, it seems that political fanaticism, not as it was first believed, personal passion, compelled her to free the earth of a monster who should have perished by the sword of justice and not the dagger of an innocent hand."

The most striking of this genre of literature was *Les Femmes célèbres de 1789 à 1795* by an otherwise unknown lawyer, E. Lairtullier. Lairtullier's work, published in 1840, was a conscious attempt to make up for the lack of attention paid to women's role in the Revolution. His two volumes contributed substantially to addressing the deficiency.[17] Lairtullier championed the ideas that a study of woman's nature and of her delicacy of perception is of equivalent value to a study of the invasion of territories and the changes in the form of government. His work is a development of Ségur's. Both men were curious about woman's nature. Lairtullier explained his reason for writing these biographies: "Let's concentrate on knowing her, on analyzing her, on following her slightest trace, on not losing a single movement of hers . . . according to the spirit of Scriptures, there will be more joy in heaven for the love, the grace, and a woman's smile than for the invasion of an empire or for the *spolia opima* hanging from the capitol."

Lairtullier's view of Madame Roland is similar to Lamartine's, but spoke even more directly to the concerns raised by the Saint-Simonian generation. Lairtullier saw Madame Roland as one of the most admirable women of modern times, a woman of grace, courage, charm, reason, and devotion to her family. Madame Roland's physical beauty, her youthful eyes and shining hair, remained with her until her execution. Lairtullier discussed Madame Roland's ideas of marriage with admiration. Like the literate women of the July Monarchy, Lairtullier's Roland saw marriage as a strong link, an association in which the woman took charge of the happiness of two individuals. Madame Roland gave up her own studies and writing in order to manage her household and to take over as her husband's secretary. Even during the Revolution, she did not change her idea about women's position in society. She believed that women must inspire the good and feed and stimulate feelings useful to the country without appearing to contribute directly to political life. Significantly, she believed that this was necessary because the customs of France would provoke ridicule for women who attempted direct participation in politics.

Charlotte Corday, in Lairtullier's eyes, was "a dazzling white

swan," not someone who committed a daring or heinous political act. Lairtullier saw Charlotte's "celestial self-abnegation" and pointed, as Lamartine did, to her source of inspiration—the Biblical story of Judith and Holophernes. Lairtullier portrayed Charlotte playing with young children and admired her natural maternal qualities. He concluded the story of her life with the observation, "It is surprising that no monument was raised in her memory."

Lairtullier's description of Olympe de Gouges deserves close attention since his is one of the early interpretations of this elusive figure.[18] Olympe de Gouges (1755–1793) was, according to Lairtullier, an explosive, provocative, and adventurous woman. Since she was illiterate, she dictated her dramatic works. She wrote many plays, working very rapidly. Few were dramatized. Some of her works were concerned with equality for women. She believed that since the principle of equality had been proclaimed without exception or limits, women could actively enter the discussion. In this, she differed from Madame Roland. Lairtullier reported that Olympe created popular societies of women, like those of men. She also proposed public workshops that provided employment for women as well as men. Olympe tried to engage the sympathies of Marie Antoinette in her struggle for women's equality. She reminded the Queen that she had helped usher in the Revolution by challenging the ancient court etiquette and changing the ceremonies. "We owe to you this first inclination towards liberty, and now you want us to lose it!" In 1792, Olympe sent the Queen her *Declaration of the Rights of Woman and Citizen*; the earlier *Declaration of the Rights of Man and of the Citizen* had been addressed to the King. Olympe ended her *Declaration* with a cry:

> Women, wake up, the tocsin of Reason resounds in the whole universe! . . . Women when will you stop being blind? What advantages did the Revolution bring you? More contempt and more scorn. In centuries of corruption you reigned over the weakness of men; your empire is destroyed. What is left for you? The conviction of men's injustice . . . Unite under the flag of philosophy: oppose men's strength and soon you'll see the arrogant not creeping at your feet like servile worshippers but proud to share with you the treasures of the supreme being!

Lairtullier explained that Olympe de Gouges's views were not in line with any political faction, though she was closer to the Girondins (in her loyalty to the Crown) than to the Jacobins. In July, 1793, she

was arrested, accused of having written books that denied the sovereignty of the people. Unlike Charlotte Corday and Madame Roland, Olympe de Gouges, Lairtullier explained, did not die heroically. She attempted to delay her execution by falsely claiming to be pregnant. On the way to the scaffold she called out to the children of the nation to avenge her death.

Her obituary in the *Feuille du salut publique* was cited by Lairtullier: "Olympe de Gouges, born with a vivid imagination mistook her delirium for nature's inspiration. She wanted to be a statesman. She adopted the projects of the treacherous who wanted to divide France. It seems that law punished this conspirator for having forgotten the virtues fitting for her sex." These few lines summed up Lairtullier's interpretation and simultaneously served as a warning to his readers: Madame Roland and Charlotte Corday were both well-educated, genteel, proper young women, one of bourgeois background, the other of the nobility; these were acceptable role models. Olympe de Gouges, poor and illiterate, was not. The women activists of 1848, however, came from all classes and levels of education. They would select and fashion their heroines to meet their goals.

Lairtullier also presented a picture of the "furies of the guillotine" as a further negative example of woman's nature gone awry during the Revolution. The "furies" were dedicated to the instruments of torture; they magnified the horror of the guillotine by the atrocity of their cries and by dancing the carmagnole at the foot of the scaffold. These women despised everything, especially anything resembling human affection. Their overwhelming cruelty and hardened hearts were in sharp contrast with the sublime nature of Charlotte Corday and Madame Roland. Their anger was the result of their shame; these women cursed good and honest women with a storm of menaces and maledictions. Sometimes called Robespierre's stocking knitters, these women claimed the right to punish other women, whipping them for not wearing the tricolor *cocarde*. The "furies" were invented by Lairtullier to frighten women away from political action in groups. Niboyet and her supporters were hounded by male detractors who labeled all women "furies." The women activists of 1848 felt constrained to make repeated statements about their orderly and peaceful actions to counteract the negative image of mobs of unruly women. Nonetheless, they were steadfast in their commitment to peaceful collective action.

A third type of literature that became available in the years between the Revolutions of 1830 and 1848 was the first-person tes-

timony of Madame Roland.[19] The first to be published were her let-
ters to Bancal des Issarts, introduced by Sainte-Beuve in 1835. Next,
in 1840, was a reedition of her memoirs, first published in 1820, with
a new introduction by J. Ravenel. And one year later Madame
Roland's letters to the Demoiselles Cannet written between 1772 and
1780 were published with an introduction by August Breuil.

The authors who introduced the volumes of letters and memoirs
contributed to the creation of the ideal image of the woman revolu-
tionary. While Madame Roland sometimes revealed her frustration
with the limitations in her role, Sainte-Beuve celebrated only her
reserve. Comparing Madame Roland to a Roman matron who hid
her stylet and her clay tablets out of modesty and pride in her role
of mother and wife, he praised her qualities of reason, order, and
humility. These he valued above emotions that led to excesses and
the Terror. Ravenel simply called her "the most remarkable woman
of this great and terrible era." Auguste Breuil believed that Madame
Roland showed the twin aspects of her personality in her letters: she
was graced with both the strength and the intelligence of man and
the sensitivity of woman. Breuil told the story of her courageous
mounting of the scaffold and of a sensitive gesture she made to a
fellow condemned prisoner. By insisting that he precede her to the
guillotine she kept him from seeing death before experiencing it.
Breuil put it this way: "She immortalized her last hour as much by
her courageous heroism as by her enchantment with Plutarch's *Lives*."
He recounted how she went to church during Lent at the age of nine
carrying Plutarch instead of the Bible. While it is impossible to know
whether Niboyet and her friends read these works, judging from the
actions and words of the women's rights activists of 1848, the ideas
of Breuil and Sainte-Beuve had a significant impact.

The fourth type of literature accessible in the 1840s was popular
in style; it appeared in the *Journal des femmes* and in published versions
of dramatizations that appeared on the stage. The most significant
author of this genre was Louise (Revoil) Colet.[20] Born in Aix on Sep-
tember 25, 1810, Louise died in Paris on March 8, 1876. She was the
daughter of a wealthy Lyonese businessman and a mother of ancient
noble lineage. Louise married the composer Hippolyte Colet (1809–
51) and came to Paris with him in 1835. She won awards for her
poetry given by the Académie française in 1839, 1843, 1852, and
1855. Unlike the male authors referred to above, Louise Colet shared
a profile with many in the leadership of the *Voix des femmes*. Her works
about Charlotte Corday and Madame Roland take on added signifi-

cance because they foreshadow both the references to and the silence about women revolutionaries that will be found during 1848.

In 1842 Louise Colet published a volume of two dramatic tableaux in verse, "Charlotte Corday" and "Madame Roland."[21] Given Colet's popularity as a poet and her renown as one of the editors of the *Journal des femmes,* it is likely that these plays were actually performed as well as published. The volume contained substantial introductory material, facsimiles of letters, and portraits of the heroines. Colet undoubtedly attracted a large audience to her work by publishing excerpts from the book in the *Journal,* including a personal anecdote illustrating the origin of her interest in Charlotte Corday. The article was written in the first person and explained that Louise Colet had grown up in the Chateau de Servanne in the home of her grandfather. There she had a tutor, George, whom she visited years later in his retirement in Marseille. Louise's story begins with her visit to the old man. She told him that he had inspired her love for Charlotte Corday. "You said you had seen her laughing, beautiful and resigned, going to her death." The old man reflected, "She was a saint, not according to the Church but for her devotion to her fellow man and for her enthusiasm for the good."

At Louise's urging, the retired tutor decided to unburden his soul and to tell her about his encounter with Charlotte Corday: It was during the summer of 1790 at her home near Rouen that George and a friend, Philippe, met the young woman. Both were immediately captivated by the nobility of her soul. Charlotte's father, an impoverished noble living off his poor soil, spoke to the men of his daughter's "hollow ideas" and her hopes for "social change" with no enthusiasm. He believed her reading of the *philosophes* had driven her insane. A state of perfect equality, which was Charlotte s goal, would lead, in her father's eyes, to his final ruination. He urged Charlotte's younger brother to serve the king and to strive to regain the family fortune. The young visitors, however, took little heed of the father and approved wholeheartedly of his charming daughter.

The story made scant reference to Charlotte's murder of Marat. It emphasized the heroism shown by Charlotte as she faced execution. The tale ended on a bizarre note with the violent death of Philippe, who ironically had been one of the jurors who voted along with all the others to condemn Charlotte Corday. For this perfidy, George never forgave his friend. Fourteen years after the execution, Philippe, still in love, died with her name on his lips. Colet's love story in the *Journal des femmes* kept alive the image of Charlotte Corday as

a beautiful, young, innocent woman who acted out of a sense of justice and duty and love of country; she was a victim of fanaticism.

Louise Colet's intense interest in Charlotte Corday is also evident in her dramatic presentation of the young woman's life. In the first scene of the drama she is compared to the goddess Diana: noble, virginal, beautiful, fearless. When she hears of the monstrous excesses of the Mountain, her first reaction is incredulity. When she is convinced that Marat is the force behind most of the killings, she does not understand why he has been allowed to live. Her Girondist compatriots urge caution, but Charlotte thinks of all those who will die because of a cautious response to Marat. Her fear disappears in the face of duty.

In the second scene, it is clear that Charlotte feels she is guided by God (to her viewers the association with Joan of Arc was obvious) and that she is an instrument of divine will. She remembers the Biblical story of Judith who kills the tyrant. She wonders if she would be remembered as an assassin or a hero.

In the third scene Charlotte meets a Vendéen woman who tells her a tale of horror, describing how her son joined the uprising and was killed. The victors came and took the women and children to Paris by order of Marat. Her dead son's wife was guillotined. The poor old woman feared for the life of her grandson. She asked questions at the orphanage and was told that Marat, the "friend of the people," had taken the child from his parents who were not patriotic and given him to the state. The grandmother declares, "I am a friend of the people too." She demanded Marat's blood to avenge the innocent blood of her family.

Charlotte's meeting with Marat takes place in scene four. She quickly confirms his intention to continue the bloodshed and kills him. At her trial she states: "I killed only one man; I saved one hundred thousand." She explained that she conceived of the project alone, in response to Marat's bloodthirstiness. Asked if she craved glory, she replied: "To save my country was my only hope." When her sentence was pronounced, she declared: "May my blood be the last to be shed."

Louise Colet's dramatic rendition of Charlotte Corday was perhaps influenced by the story of her old tutor, which may have been based on a popular story or a true acount. It was definitely in line with the writings of Lamartine, Ségur, and Lairtullier. In similar manner, her dramatic account of Madame Roland confirmed and popularized the interpretations of the male biographers. In "Mme

Roland," Louise Colet portrays her heroine as the soul of the Gironde. In the first scene of the play, she awaits death with no regrets. Though she is sorry not to be able to complete her daughter's education, she finds it impossible to live when France is dying.

In scene two the jailkeeper's wife, at great personal risk, out of devotion to Madame Roland, brings her a letter and flowers from her childhood friend Henriette Cannet. The next few scenes show visits between the two friends. Henriette hears from the lips of the condemned these noble words: "Fear is for cowards. . . . A person who does not feel terror or remorse must walk toward death with serenity."

Henriette begs her friend to resist, to hope, to live. Madame Roland says she prefers to follow in the path of Charlotte Corday and to die with dignity. Next, Henriette begs to trade places with her friend, to die in her place. Madame Roland is touched by the gesture of friendship, but refuses. Henriette begs Madame Roland to reveal the names of other Girondists in order to save her own life; again, Madame Roland refuses. She declares, "Wanting to save me, you push me to the abyss; let me die for death is forgetting."

The play ends with Madame Roland ascending the scaffold and declaring: "O Liberty! People have lost their minds. How many crimes are committed in your name?" But the publication did not stop there. Louise Colet included a facsimile of Madame Roland's letter to General Servan, which denounced Danton and asked for protection of Madame Roland's daughter, as well as notes about each of the individuals referred to in the play.

The images of Madame Roland and Charlotte Corday were probably made memorable for viewers on stage. For the reader, two carefully chosen portraits (see figs. 1 and 2) accompanied the text.[22] The portrait of Charlotte Corday is an engraving based on a painting by Jacques-Louis David. The one of Madame Roland is based on an unsigned painting belonging to the Roland family. Both women are lovely, youthful, conveying sincerity and charm. Madame Roland is portrayed as a young girl, clutching small flowers to her breast and looking at the world in wide-eyed wonderment. Charlotte Corday is more sedate, almost religious in her demeanor. Her bonnet, frequently mentioned in accounts of the assassination, is white, chaste, not red and revolutionary.

These portraits were not the only ones available for Louise Colet to choose from. Other portraits of Madame Roland, which emphasize

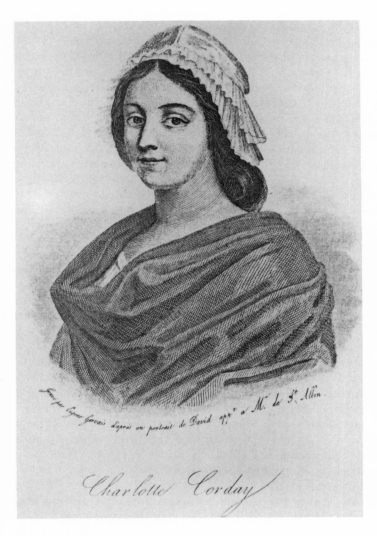

Gravé par Eugene Gervais d'après un portrait de David app.^t a M.^r de S.^t Albin.

Charlotte Corday

FIG. 1

her dignified, mature, and almost scholarly nature, and of Charlotte Corday, which stress her martyrdom, were available.[23] Neither of these two images would have been suitable in Louise Colet's volume.

Given the accessibility of the written material and the iconographic presence of women of the French Revolution during the 1840s, it is at first somewhat surprising how infrequently Charlotte Corday, Madame Roland, Olympe de Gouges, and the others are mentioned in the writings of the women leaders of 1848. Here, I will explore the texts in which reference is made to a tradition of women revolutionaries. The primary sources for this section are the feminist newspapers of 1848–49: the *Voix des femmes* (March 19–June 15, 1848), the *Politique des femmes* (June 18 and August, 1848), the *Opinion des femmes* (January 28, 1849–August, 1849), and memoirs of Eugénie Niboyet, the editor of the *Voix des femmes* and the president of its Society.

In the forty-five issues of the *Voix des femmes* there are only six references to women's revolutionary tradition. The first appears in the opening issue in a brief unsigned essay. The author reports on the activities of Pauline Roland, no relation to Madame Roland, but a friend and associate of Eugénie Niboyet and Jeanne Deroin. Pauline resided in Pierre Leroux's commune in Boussac in February, 1848. In response to the new freedoms promised by the Revolution, she was determined to vote for her friend Leroux in the local mayoral election. When the authorities refused to allow her to cast a ballot, she demanded an official explanation for the injustice. She dramatically declared her name to be Marie Antoinette Roland. This act was recorded in the *Voix des femmes,* followed by the comment: "This name, celebrated in history, was worthy of inspiring in our day an act of courage which later will be called an act of justice." The author of this article saw Marie Antoinette as an inspirational figure for women of her own day.

Marie Antoinette is referred to a second time in the 43rd issue of the *Voix* (June 10–13, 1848). In this unsigned essay the author passionately called out to other women, "Arise! Look to the past and march to the future . . . In the first revolution women acted politically by using posters, pamphlets, clubs, stormy debates, heated discussions—they took part in all and often were the impetus for them. Their spirit was not deterred by obstacles." This reference to stormy debates and heated discussions reflected the growing controversy surrounding the Club des femmes in May and early June, 1848. But the author quickly points the reader to safer revolutionary images. She

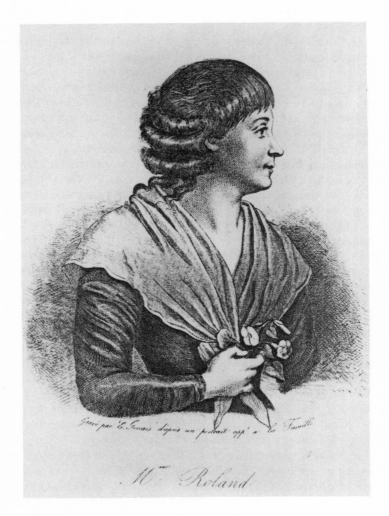

Gravé par C. Gervais d'après un portrait app^t à la Famille

M^{me} Roland

FIG. 2

commences her review of women revolutionary leaders with Marie Antoinette, who opened the door to change by banishing etiquette from the Court. The Queen, according to this author, "delighted in the intimate conversation of fraternal independence." She summed up the Queen's tragedy as follows: "From her reign to the scaffold was short; passion deceived justice; fairness wept for a woman." On the basis of a reading of Lamartine and Ségur, it is possible to understand how Marie Antoinette became a member of the revolutionary pantheon in 1848. The author continued her historic panorama with the assertion that from Marie Antoinette's rebellion at Court, to Madame Roland's activities, progress was swift. She portrayed Madame Roland as "a minister in skirts, formulating treaties, dictating theories; rising to the most sublime meditations and thoughts."

Madame Roland is identified in this article as the woman who best understood the revolutionary movement and the role women were to play in it. However, the author was aware that even Madame Roland did not believe that customs permitted women to act in the public arena yet. The author cited Madame Roland: "They [women] must inspire the good and nourish and stimulate feelings useful to the country; they must not be perceived as competitors in the political system. They will not be able to act openly until the French have earned the name 'free men.' " In 1848, this anonymous author had grown impatient waiting for men to become free. She concluded her essay with a line reflecting the more recent ideas of Flora Tristan, "Men, you will never be truly free until women are free and your equals within the family and the state."

Madame Roland also appears in an article signed by "Jeanne-Marie" (possibly Jeanne-Marie Fabienne Poinsard, as discussed earlier in this essay), published in the *Voix des femmes* on April 18. The article is a response to an attack on the idea of the emancipation of women that appeared in the newspaper *Liberté*. Jeanne-Marie attacked the *Liberté* with indignation. "Until now," she wrote, "we thought that the word *all* meant *everyone*, men and women, and that no exclusion was possible. We were mistaken; it would appear that *all* means *half*. It is only a matter of agreement; the words are conventional, but the idea they represented is everything."

Jeanne-Marie then turned her attention to the injustice of the Napoleonic Civil Code and the concept that a wife owed obedience to her husband. She stated somewhat ironically, "I beg the pardon of the gentlemen in the legislature but they really should have indicated the limits of obedience; for if one takes a look at the condition of marriage today, it is not unusual to find a pure and honest girl

fall into the hands of a cheating rascal. And when the unfortunate woman, now his wife, is provoked or encouraged by him to leave the path of honest living (a path which she has tread until now) then tell, legislators, we demand an answer, does she owe him obedience?"

Finally, Jeanne-Marie spoke directly to the biographers of famous women and asked them why they praised Joan of Arc, Jeanne Hachette, the warlike Sabine women, Madame Roland, and all the heroines of the first Revolution? Jeanne-Marie realized the limitations of these models: "instead of deifying them, one should dishonor them, send them back to their spinning wheels." Jeanne-Marie did not despair because of the lack of models from the past; she closed her article with a call to women not to lose courage and to continue to demand liberty.

In the next issue of the *Voix,* Jeanne Deroin, another active contributor to the journal and a member of the inner circle of the Society, continued the defense of women's equality spurred by the satiric article that appeared in *Liberté*: "Woman is not consecrated to obedience . . . she is not consecrated to silence . . . Each great year in human history offers proof that if she knows how to resign herself to the most humble and the most generous self-denial, she is also capable of the most heroic forms of devotion and commitment." Deroin sought to rescue the images of revolutionary role models, especially Olympe de Gouges. She concluded:

> The history of our first revolution is ringed by a shining halo of great women who honored their sex and their country. Their elegant words, found in the popular tribune of clubs and salons, or before the bloody courts of law where they carried their heads and their writings, all revealed a great deal of intelligence. They mounted the scaffold with courage and proved they could aspire to all categories of glory. It was the famous Olympe de Gouges who first proclaimed the rights of women when she said: Woman has the right to climb the scaffold, she must equally have the right to mount the rostrum.

From these excerpts it is clear that the leaders of 1848 were not merely reflecting the ideas of Lamartine, Ségur, and Lairtullier. While the *Voix des femmes* echoed the positive images of Charlotte Corday, Madame Roland, and even Marie Antoinette, it did not go along with the negative view of Olympe de Gouges. Indeed, despite the paucity of material about de Gouges, especially when compared to the biographies, dramatizations, and portraits of Charlotte Corday

and Madame Roland, it was Olympe who emerged in the women's writings of mid-century as the most significant revolutionary foremother.

In an article written in the *Almanach des femmes* of 1853, Jeanne Deroin reflected on the impact of the French Revolution on the struggle for women's rights. She expressed a view, which I believe to have been common to the contributors to the *Voix,* that the revolutionary era was a turning point in the struggle for women's rights. Until the Revolution, individual women made isolated attempts at change, but their voices were rapidly lost. The pre-revolutionary period was called the "Dark Ages" by Deroin. She went on, "Sixty years have passed since she (woman) awoke from this long sleep." Having identified the revolutionary period as the critical turning point, Deroin then identified Olympe de Gouges as the critical voice: "At the close of the last century, Olympe de Gouges responded in France to the Declaration of the Rights of Man, by the Declaration of the Rights of Woman—and ascended the scaffold saying: Woman has assuredly the right to ascend the rostrum, since she has the right to ascend the scaffold."

Deroin was not alone in recognizing the importance of group solidarity to insure that women's voices would be heard. On March 30, a brief unsigned article appeared in the *Voix des femmes* that lamented the proliferation of women's groups and urged unity. The author expressed regret that meetings of the Society of the *Voix* had coincided with meetings of a like-minded group of progressive women at the home of Madame Bourgeois-Allix. She stressed that "women need to count on numbers; their strength lies in union." But the author followed her observation with a disclaimer, disassociating herself from unruly groups of women; she could not understand why some women act to disturb the general order, thereby adding to the general confusion. In language reflecting references to 1789 she declared, "We will go to the marketplace in order to attract them (women) to our side, to quiet them down and to organize them; order is absolutely necessary to the general security of the masses." This disclaimer is easier to understand when one remembers the sharp critiques by Lairtullier against the "furies." Indeed the editor of the *Voix* was obliged to respond repeatedly to attacks on women's unruly behavior.[24]

On May 30, in a rhetorical question to the editor of *Liberté,* the *Voix des femmes* asked: "Surely sir, you are quite free to hold your own opinions, but one simple question please: 'How can you judge women with whom you are totally unacquainted? How can you cloak them with a *bonnet rouge* when you have never met them?' " Unlike the

Charlotte Corday bonnet, which was the fashion triumph of 1844, the *bonnet rouge* was associated with the unruly women and was a symbol that Eugénie Niboyet and others were eager to suppress. The very next issue of the *Voix* carried a citation from the *Pamphlet*, a satiric journal that often poked fun at women, reporting that Madame Niboyet had protested energetically against a deputation of women who visited citizen Cremieux to seek his support for the divorce decree. Madame Niboyet's protest is judged by the *Pamphlet* to have been reasonable since the deputation had all the characteristics of a true mob. Madame Niboyet begged the public not to confuse her group with the upheaval she protested. The *Pamphlet* concluded, "friends of public order are delighted that the tumult comes from the distaff side." The ready association of women's collective activities with unruliness, mob violence, disorder, and sexual excess plagued the women who were striving to achieve unity as the essential prerequisite for effecting social change.

Despite the sarcastic comments of outsiders, the women leaders of 1848 persevered in their goal of unity. Desirée Veret Gay, the editor of the ephemeral *Politique des femmes*, thought highly of women's clubs and listed several in her first issue (June 18, 1848). She noted that although the greatest concentration of clubs was in Paris, women's clubs had started in Lyon, Limoges, and even in smaller hamlets like Prayssas in Lot-et-Garonne. Italy, England, and the United States also had women's clubs. The next and last issue of the *Politique* was published in August and lamented the banning of women from clubs. But though Desirée Gay was aware of women's activities in other cities and countries, she did not refer to the history of women's activities in Paris. She probably did not know about the history of the *Société des républicaines révolutionnaires,* mentioned briefly and with derision by Lairtullier.

The women of 1789 who were remembered by their successors were individuals associated with martyrdom, as in a long article by Jeanne-Marie published in *Opinion des femmes* in January, 1849. "It was while staining the scaffold with their martyr's blood that Madame Roland, Lucile Desmoulins, Olympe de Gouges, and all the others, taught humanity that woman, the equal of man in intelligence and love, could also equal man in courage 'drawing her strength from her heart.' " Eugénie Niboyet and her contemporaries promoted precisely this image of woman as brave and honorable and deserving of equality because of, rather than in spite of, these and other attributes. At the same time they tried to limit the spread of the image of unruly mobs of women associated with the first Revolution and the Terror

by emphasizing in their writings that order and pacifism were part of women's nature.

Niboyet's personal commitment to pacifism predated 1848 and became central to her work in the decades following the closing of the *Voix des femmes*. In an autobiographical statement written in 1863, Niboyet recalled her concern with the crowds of people milling about after the February Revolution. She remembered confiding to a friend: ". . . a republic so wisely conceived should not be weighted down by the *tricôteuses* of old. We must organize women and educate them. . . ."[25] Niboyet spared no effort throughout her life in organizing and educating women. However, her efforts to suppress the image of "unruly mobs" appears to have had limited success.

Perhaps the most telling comment on the motivation for remaining silent about women's group activities came from an onlooker, not a participant, in the movement for women's rights in 1848. The Countess d'Agoult (1805–76), who wrote under the pseudonym Daniel Stern, published in 1853 a three-volume *History of the Revolution of 1848*. Stern made explicit the connection between the efforts of the women in 1848 and those of their foremothers in the first Revolution that had been implied in the articles in the *Voix*. But while Stern briefly applauded the activities of the early leaders—Olympe de Gouges, Madame Roland, and Charlotte Corday—she reserved her strongest admiration for the women of the people: "Then, among all classes, in the depths of the countryside, in the great federation movements which they animate, in the halls of the Assembly, in the clubs which are run by them, in the armies, on the Champ de Mars, at Versailles, at the Tuileries and down in the prisons of September, those inspired women, possessed by the flame of Revolution, turn to all the grandeur of thought, the heroism of action, the fury of revolution."[26] But Stern was quick to point out that the inspiration of these women was not efficacious. "After having encouraged them to show their faces on the political scene, the Revolution threw them back down, into the shadows of 9 Thermidor, without having brought about any essential changes in their social conditions." It was this truth that was so clear to Niboyet and her contemporaries.

The Society of *Voix des femmes* did not celebrate their connection to the activities of the large numbers of women who participated in the Revolution of 1789 for many reasons. First, as we have seen, the information they had was limited and biased to portray women who worked in groups as "the furies." Second, they understood that the revolutionary zeal of earlier generations of women who fought for humanitarian rights that would be extended to all had not changed

women's lot. They determined instead to direct their own energies and the energies of all women working together to establish women's rights. In pledging to work exclusively for women's rights they changed the direction of the earlier generation, which had fought for inclusion. The women of 1848 put women's rights first and asked rhetorically: "By working for women's rights are we not also extending rights for all?"[27]

The revolutionary activists of 1848 saw themselves as the "first and only serious group to articulate women's moral, intellectual and material concerns," because they challenged the Enlightenment principles of humanity and spoke instead of women's rights. While they recognized a debt to the women who began the struggle in 1789, especially to Olympe de Gouges, who spoke openly of women's rights, women at mid-century identified their cause as fundamentally new and distinct from previous efforts. Their goals were woman-focused and comprehensive: They demanded jobs for women with higher wages and fewer hours; they organized day care for children and vocational and higher education for women; they envisaged communal household arrangements to alleviate the burdens of cooking, laundry, and caring for the sick and elderly; they expected full citizenship. In an attempt to boost their confidence in the face of attacks from all sides, they periodically referred to the pantheon of women leaders of the past to claim a moral connection with those women whose reputations had improved with the passage of time.

Notes

1. The *Voix des femmes* appeared daily from March 19 to April 10, 1848, then every two days until April 29. It resumed publication on May 28 and closed on June 17. The statement of purpose appeared on the masthead from March 19 through April 16. It also appeared in the form of a large public announcement on March 28 and 30.

2. Niboyet reports her early affiliations in the first issue of *Voix des femmes* (March 19) and in an autobiographical section of *Le Vrai livre des femmes* (Paris: E. Dentu, 1863), 231. Contributors to the *Tribune des femmes* who wrote for the *Voix* included: Suzanne Voilquin, Desirée Gay, Jeanne Deroin, and Pauline Roland. Contributors to the *Journal des femmes* who wrote for the *Voix* included Gabrielle d'Altenheym Soumet and Amélie Prai.

3. Nelly Lieutier, "Mme Eugénie Niboyet," *La Vie domestique*, March 16, 1880. See also *Mme Eugénie Niboyet devant ses contemporains* (Paris: E. Dentu, 1883). In the volume published by the Société des Gens de Lettres there are

obituaries by Hippolyte Fournier, Honore Arnoul, Paulin Niboyet, and Nelly Lieutier.

4. *Le Vrai livre des femmes,* 234.

5. Adrien Ranvier, "Une Féministe de 1848: Jeanne Deroin," *La Révolution de 1848,* 4 (1907–8): 17–55, 421–30, 480–98. Hortense Wild, *Nos Contemporains: Jeanne Deroin et Julie Daubie* (Paris, 1889).

6. Letter to Leon Richer, undated, ms. collection, Bibliothèque Marguerite Durand.

7. Karen Offen, "A Nineteenth Century French Feminist Rediscovered: Jenny P. D'Héricourt, 1809–1875," *Signs: Journal of Women in Culture and Society* 13, no. 1 (Autumn 1988): 144–58. S. Joan Moon contends that Jeanne-Marie and Jenny P. D'Héricourt were not the same person, based on a comparison of signatures on 1848 documents, especially one in which Jeanne-Marie signs herself Jeanne-Marie Monniot.

8. Desirée Veret Gay awaits her biographer. See entry in *Dictionnaire biographique du mouvement ouvrier français,* ed. Jean Maitron (Paris: Editions ouvrières, 1964).

9. *Voix des femmes,* April 20, 1848.

10. Linda Anne Kelly Alkana, "Suzanne Voilquin: Feminist and Saint-Simonian" (Ph.D. Diss., University of California, Irvine, 1985).

11. Charles Lemonnier, *Elisa Lemonnier, fondatrice de la Société pour l'enseignement professionel des femmes* (Paris: Toinin, 1866). Caroline de Barrau, *Elisa Lemonnier, fondatrice de la Société pour l'enseignement professionel des femmes* (Paris: E. Voitelain, 1868).

12. Adolphe Chesnel [pseudonym A. de Montferrand], *Les Femmes Célèbres contemporaines françaises* (Paris, 1843), 339–56.

13. On April 6, 1848, Eugénie Niboyet called for the election of Georges Sand to the Constituent Assembly. Sand addressed a letter to the *Réforme* disassociating herself from the nomination and adding, "I do not have the honor of knowing a single one of the ladies who form clubs and edit newspapers." Reprinted in *Voix des femmes,* April 10, 1848.

14. François Guizot, *Essai sur l'histoire de France . . . pour servir de complément aux Observations sur l'histoire de France de l'abbé de Mably . . .,* 4th ed. (Paris: Ladrange, 1836), 6th ed. (Charpentier, 1844), 7th ed. (Charpentier, 1847). Jules Michelet, *Histoire de la révolution française,* 7 vols. (Paris: Chamerot, 1847–53). Alphonse de Lamartine, *Histoire des Girondins,* 8 vols. (Paris: Furne et cie, 1847).

15. Lamartine's descriptions of Marie Antoinette are primarily in vol. 1; Charlotte Corday appears in vol. 6, and Madame Roland in vol. 2.

16. Joseph Alexandre de Ségur, *Les Femmes, leur condition et leur influence dans l'ordre social,* vol. 3 (Paris: Treuttel et Writz, 1803), reissued 1820, 1825, 1826, 1828, 1829, 1834, 1836.

17. E. Lairtullier, *Les Femmes Célèbres de 1789 à 1795,* 2 vols. (Paris: France, 1840). An exhaustive search of biographical references has turned up no information on Lairtullier. The two volumes include a chapter on each of the following: Théroigne de Méricourt, Madame Necker, Charlotte Cor-

day, Suzette Labrousse, Madame Roland, La Mère Duchesne, Lucille Des-moulins, Olympe de Gouges, Mademoiselle de'Orbe, Rose Lacombe, Les Furies de la Guillotine, Mademoiselle Maillard, Sophie Momoro, Cathérine Théot, Madame Tallien, Aspaise Carlemigelli, Sophie Lapreire, and a chapter devoted to brief notes on Marie Antoinette, Madame de Stael, Madame de Stainville, Cecile Renaud, etc.

18. For an updated account see Olivier Blanc, *Olympe de Gouges* (Paris: Syros, 1981). The Société des Gens de Lettres saw Olympe de Gouges in a similar light. She was declared a beauty, a woman of spirit and imagination who belonged to the arts. She renounced her career as an author at the time of the Revolution to become a full-time political activist. She wrote pamphlets that were displayed on the walls of the city. She agitated in the waiting rooms of ministers and in the Jacobin club and at the National Assembly. She instigated popular societies of women.

19. For a complete list of Madame Roland's publications see Gita May, *Madame Roland and the Age of Revolution* (New York: Columbia University Press, 1970), 321–23. Works referred to in this article are as follows: *Mémoires de Madame Roland*, ed. J. Ravenel (Paris, A. Durand, 1840); *Lettres autographes de Mme Roland, Addressées à Bancal-des-Issarts*, ed. Sainte-Beuve (Paris, E. Renduel, 1835); *Lettres inédites de Mlle. Philpon, Mme Roland, adressées aux demoiselles Cannet, de 1772 à 1780*, 2 vols., ed. A. Breuil (Paris, W. Coquebert, 1841).

20. For a full analysis, see "La Légende de Marat et de Charlotte Corday dans le théâtre du XIX siècle," in *La Mort de Marat*, ed. Jean-Claude Bonnet (Paris: Flammarion, 1986).

21. Louise Colet, *Charlotte Corday et Madame Roland* (Paris: Berquet et Pétion, 1842). See also Colet's contribution to *Journal des femmes*: "Un juré de Charlotte Corday," October, 1844; "Charlotte Corday" poem written as if by Charlotte Corday in 1842; "Madame Roland," in 1842.

22. See Vivian Cameron, "Goddesses, Fishwives and Other Women in the French Revolution: Reality and Myth in Popular Imagery" (Paper presented at the Sixth Berkshire Conference of Women Historians, 1984); Elizabeth Colwill, " 'Just another Citoyenne'? Marie-Antoinette on Trial 1790–93," *History Workshop Journal*, no. 28 (September, 1989).

23. François Furet and Denis Richet, *The French Revolution*, trans. Stephen Hardman (New York: Macmillan, 1970), 155 (painting of Mme. Roland), 195 (tinted drawing of Charlotte Corday).

24. See my article, "Les Vésuviennes: Images of Women Warriors in 1848 and Their Significance for French History," *History of European Ideas* 8, nos. 4–5, 451–88.

25. *Le Vrai livre des femmes*, 233. See also 128–29 for mention of Charlotte Corday and Madame Roland.

26. Daniel Stern, *Histoire de la Révolution de 1848*, 3 vols. (Paris: G. Sandré, 1853), 1:33.

27. *Voix des femmes*, March 24, 1848.

Contributors

Harriet B. Applewhite, professor of political science and director of the Honors College at Southern Connecticut State University, holds a Ph.D. in political science from Stanford University. She has published articles on the French National Assembly from 1789 to 1791, and has completed a manuscript for a book entitled "Political Alignment in the National Assembly, 1789–1791." She edited, in collaboration with Darline Levy and Mary D. Johnson, *Women in Revolutionary Paris, 1789–1795*. She and Darline Levy are completing a book on women and citizenship in revolutionary Paris.

John Bohstedt, associate professor of history at the University of Tennessee, Knoxville, received his Ph.D. from Harvard University. He is the author of *Riots and Community Politics in England and Wales, 1790–1810*, and is currently writing a book, *Frontiers of Order: Riots as Popular Politics in Britain, France, Ireland and the United States, 1750–1985*.

Rudolf M. Dekker is lecturer in social history at the Department of History of the Erasmus University, Rotterdam, Holland. In 1982, he published a dissertation on riots in Holland in the seventeenth and eighteenth centuries. He has published, among others, articles on riots, strikes, humor, and the history of autobiographical writings. Together with Lotte van de Pol, he wrote *The Tradition of Female Transvestism in Early Modern Europe*.

Dominique Godineau received her doctorate in history from the University of Paris I, Sorbonne. She pursues research in collaboration with the Institute for the History of the French Revolution (Sorbonne), directed by Michel Vovelle. She has published various articles on women and the French Revolution and has published *Citoyennes Tricoteuses: Les femmes du peuple à Paris pendant la Révolution*.

Gary Kates, associate professor of history at Trinity University, San Antonio, Texas, received his Ph.D. at the University of Chicago. He is the author of *The Cercle Social, the Girondins, and the French Revolution*. His current work on the theme of gender and political culture during the eighteenth century concerns the case of the transsexual diplomat, the Chevalier D'Eon.

Linda K. Kerber is May Brodbeck Professor of the Liberal Arts and professor of history at the University of Iowa. In 1988–89 she served as president of the American Studies Association. She is the author of *Federalists in Dissent:*

Imagery and Ideology in Jeffersonian America and *Women of the Republic: Intellect and Ideology in Revolutionary America.* With Jane De Hart, she is editor of *Women's America: Refocusing the Past—An Anthology.*

Darline G. Levy is the author of *The Ideas and Careers of Simon-Nicolas-Henri Linguet: A Study in Eighteenth-Century French Politics.* With Harriet B. Applewhite and Mary D. Johnson she is coeditor of *Women in Revolutionary Paris, 1789–1795* and is currently completing a book with Harriet Applewhite on women and citizenship in revolutionary Paris. She received her Ph.D. from Harvard University and teaches at New York University.

Janet Polasky received her Ph.D. from Stanford University and is currently teaching at the University of New Hampshire where she is associate professor of history. Her research has focused on social theory and political movements in Belgium, 1780–1940. She is the author of *Revolution in Brussels, 1789–1793,* which won the prize in arts and letters of the Académie Royale de Belgique and the annual book award of the University of New Hampshire. She is presently working on a political biography of Emile Vandervelde.

Laura S. Strumingher is provost of Hunter College, City University of New York. Professor Strumingher has published widely in the social history of modern France, including two monographs, *Women and the Making of the Working Class, Lyon, 1830–1870,* and *What Were Little Girls and Boys Made of: Primary Education in Rural France,* and a biography, *The Odyssey of Flora Tristan.* Her recent work on the activities of Parisian women during the Revolution of 1848 has taken her into the area of representations of images of women.

Wayne Ph. te Brake teaches European history at the State University of New York, College at Purchase. He received his Ph.D. in history from the University of Michigan and was a research fellow of the American Council of Learned Societies in 1980–81. He has published *Regents and Rebels: The Revolutionary World of an Eighteenth Century Dutch City.*

Lotte C. van de Pol is a research fellow at the Department of the History of Erasmus University, Rotterdam, Holland. With Rudolf Dekker, she wrote *The Tradition of Female Transvestism in Early Modern Europe.* She has also coauthored a book on the history of the Western family. She has published articles on brothel paintings, prostitution, sexuality, and female criminality. She is currently writing a book on prostitution in Amsterdam in the seventeenth and eighteenth centuries.

Alfred F. Young is the author of *The Democratic Republicans of New York: The*

Origins, 1765–1797 and of "George Robert Twelves Hewes: A Boston Shoemaker and the Memory of the American Revolution," *William and Mary Quarterly*. He is the editor of *The American Revolution: Explorations in the History of American Radicalism*. Currently he is completing a book, *In the Streets of Boston: The Common People in the Making of the American Revolution, 1745–1790*. He teaches at Northern Illinois University.